Art in the Making
ITALIAN PAINTING
Before 1400

Art in the Making

ITALIAN PAINTING
Before 1400

David Bomford Jill Dunkerton Dillian Gordon Ashok Roy

With contributions from
Jo Kirby

National Gallery Company Limited, London
Distributed by Yale University Press

Sponsored by Esso UK plc

© National Gallery Company Ltd

First published in 1989
Reprinted 1990, 2000

National Gallery Company Limited
St Vincent House
30 Orange Street
London WC2H 7HH

British Library Cataloguing in Publication Data
Art in the making: Italian painting before 1400.
 1. Italian paintings, history
 I. Bomford, David II. National Gallery. Great Britain
759.5

 ISBN 0–947645–67–5

 525125

Printed in Great Britain by
White Dove Press Ltd

The cover shows a detail from a triptych
attributed to Duccio (Cat. no. 4) with
an infra-red photograph superimposed.

Exhibition design by Herb Gillman

Catalogue designed by Chris Millett
and edited by Diana Davies

This catalogue is dedicated with affection to Joyce Plesters
in her retirement. Her inspirational work pioneered the
investigation of paintings by scientific methods here
at the National Gallery

Contents

Sponsor's preface

No one can fail to be stirred by the results of that glorious artistic period before 1400, when Tuscany, Umbria and other parts of Italy were the centres of a burst of inspiration and innovation which is still having an artistic impact half a millennium later. But as the painstaking work of the staff at the National Gallery has revealed, behind the ornate and colourful panels on display were master artists who had to press to the limits the materials and methods available to them, to achieve the effects they themselves and their public wanted.

Having mastered the technology, these artists also needed to organise an army of assistants, apprentices and suppliers to get results. Calling on the services of carpenters who prepared the basic panels and a series of other craftsmen who carefully prepared the paint, the gold and other materials, the master painters combined a number of different roles. They were, in today's terminology, supervisors, quality inspectors, research and development managers, production directors, and heads of marketing.

This combination of roles and skills was also evident last year in the Rembrandt exhibition, the first of the *Art in the Making* series. Rembrandt was not only an inspired painter, he also ran a business and was the active head of a large training school, which helped to propagate his ideas and spread his influence.

It is fascinating to us in Esso to see all that was involved in the technology and business of painting before the machine age. We succeed today by harnessing technological know-how and organisational skills, and it is satisfying to realise that this basic approach is universal in application. There is increasing scope for imagination in business, where we are constantly searching for new products and for innovative ways to do a task more effectively or more safely, and of course to do these things in a way that anticipates what the customer wants.

It is a privilege to be associated with such an imaginative series as *Art in the Making*. We are confident that this year's exhibition will be as stunning in its impact as the Rembrandt exhibits were. Our thanks to all those involved in the original background work on which they are based, and to those who have mounted the display and prepared this informative catalogue.

Having savoured the first two exhibitions we look forward to the Impressionists in 1990, which will be the third in this series of technical and inspirational experiences.

Sir Archibald Forster
Chairman and Chief Executive
Esso UK plc

Foreword

A central duty of the National Gallery's role is to present to the widest possible public the results of recent research on the collection. This series of exhibitions, *Art in the Making*, generously sponsored by Esso UK plc, aims to examine, year by year, new work on different artists or periods. The first exhibition was devoted to paintings by Rembrandt. This year's focus is not on an artist, but a century – the years in Italy between 1270 and 1370, during which the whole tradition of European painting underwent a radical and enduring change of direction. We examine here the materials with which that transformation, the early Renaissance, was effected.

The National Gallery's holding of works from this critical period is rich but fragmentary. Many of the greatest panels in this exhibition are small parts rescued, or wrenched, from a monumental whole. Many have been seriously damaged. Yet the damage and the disruption have, paradoxically, made it easier to see how the original problems of making and assembling were tackled and resolved.

Drawing on the combined resources of the Gallery's Conservation, Framing, Photographic and Scientific Departments, the four authors have set out to discover the pigments with which the artists chose to work; the processes by which the panels were prepared, gilded and decorated; the carpentry techniques required to hold the huge Florentine and Sienese altarpieces safely together and securely in place; and the changes subsequently wrought on them by time and by man.

In preparing this exhibition, many discoveries have been made. Thanks to infra-red reflectography, we can now confidently distinguish Duccio's underdrawing in pen from that of his associates, and reconstruct something of the methods of his workshop. And pigment analysis has shown that the entire palette of Ugolino's high altarpiece for Santa Croce in Florence was determined by his initial decision to use for his blue pigment a greenish azurite rather than brilliant lapis lazuli. In a period of outstanding artistic innovation, we can, through this exhibition, watch artistic choices being made.

The National Gallery's staff is a small one, and the mounting of an exhibition such as this is possible only through much dedicated work. David Bomford, Sue Curnow, Diana Davies, Jill Dunkerton, John England, Herb Gillman, Dillian Gordon, Sara Hattrick, Jo Kirby, Jacqui McComish and Ashok Roy have worked unstintingly and good-humouredly. On behalf of all at the National Gallery I should like to express our sincere thanks to them and to our sponsors, Esso UK plc, who have supported this exhibition and this catalogue with outstanding generosity.

Neil MacGregor
Director

Acknowledgements

The authors have received help and encouragement from numerous people. In particular they would like to thank Dottore Giorgio Bonsanti, Opificio delle Pietre Dure, Florence; Dottoressa Franca Falletti, Accademia, Florence; Dottoressa Elisabetta Nardinocchi, Horne Museum, Florence; Alfio del Serra; Erling Skaug; Carl Strehlke; Ruth Wilkins Sullivan; and Dottoressa Fiorella Superbi, Berenson Collection, I Tatti, Settignano, for all their generous help; as well as the National Gallery for funding a research trip to Italy. The following institutions have kindly made available X-radiographs of paintings related to works in this exhibition: the Gemäldegalerie, Berlin; the Isabella Stewart Gardner Museum and the Museum of Fine Arts, Boston; the Los Angeles County Museum of Art; the Alte Pinakothek, Munich; the Metropolitan Museum of Art, New York; the Johnson Collection, Philadelphia Museum of Art; and the Berenson Collection, I Tatti, Settignano.

Within the National Gallery the authors would like to thank Raymond White; Anthony Reeve; John England; Christine Powell and Clare Keller for their help in conservation and framing; Jacqui McComish for obtaining illustrations; Sara Hattrick and the Photographic Department; Joan Lane and the Audio-Visual Department; and Erika Langmuir and the Director for reading the catalogue so diligently and making such perceptive comments. Finally Diana Davies has been an endlessly patient and conscientious editor.

INTRODUCTION

The paintings in this catalogue, which are all from the National Gallery's own Collection, span almost a complete century of medieval Italian panel painting. They range from a relatively simple Crucifix painted *c.* 1272–80 to an elaborate high altarpiece painted in 1370–1. The methods and materials used to execute these works are common to all of them, in that all are wooden panels prepared with gesso grounds, painted in tempera and gilded. Yet when they are examined in detail, they reveal notable variations in the materials chosen and considerable diversity in the techniques for their application. With the exception of the Crucifix (Cat. no. 1), which is by an Umbrian painter, the paintings discussed here are all by Florentine or Sienese artists. Both Florence and Siena were wealthy cities – particularly through banking and the wool trade – and could afford to be generous patrons and to employ the best painters. Florentine and Sienese painters dominated central Italian painting during the thirteenth and fourteenth centuries.

The leading painters in these two cities at the beginning of the fourteenth century were Giotto in Florence and Duccio in Siena, both represented in this catalogue (Cat. nos. 2, 3 and 4). Both ran large workshops: Duccio's pupils and collaborators may have included Ugolino di Nerio (Cat. no. 5), Ambrogio and Pietro Lorenzetti, and Simone Martini. Giotto's pupils included Taddeo Gaddi (see pp. 15ff) and possibly Bernardo Daddi. After the devastation caused by the Black Death in 1348 the development of Italian painting suffered something of a hiatus, but recovered during the second half of the century to produce major painters such as Bartolo di Fredi, Paolo di Giovanni Fei, Taddeo di Bartolo and Andrea Vanni in Siena, and Andrea di Cione (known as Orcagna) and his brothers Nardo and Jacopo in Florence (Cat. nos. 6, 7 and 8). While the work of the painters of the second half of the century precedes the Renaissance chronologically, it in no way prefigures it stylistically.

It is perhaps not too much of a simplification to say that Sienese painters working in Florence influenced Florentine painters in the actual craft of painting, while Sienese painters were influenced intellectually by the Florentine interest in the creation of a three-dimensional space and most, if not all, Sienese painters were affected by the more naturalistic style of Giotto.

Sienese painters excelled in designing

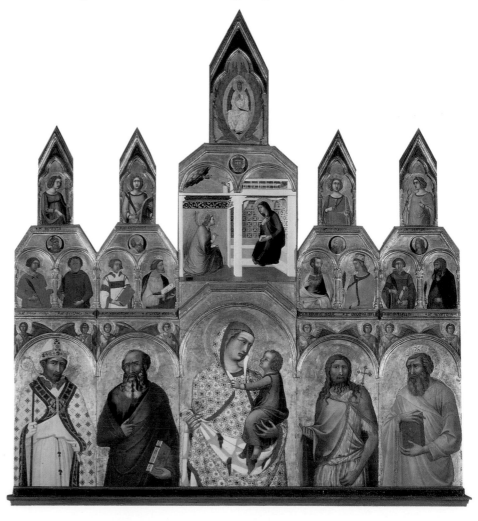

Plate 1 Pietro Lorenzetti: Polyptych. 1320. Santa Maria della Pieve, Arezzo

complex altarpieces, particularly polyptychs (Plate 1). Polyptychs not only emphasised the individual importance of the figures, especially those of the Virgin and Child, placed in the central wider panel with saints on either side, but also indulged the fashion for Gothic architectural ornament in their frames, which could be encrusted with finials, crockets etc. Sienese painters were in demand all over central Italy for this type of commission: Duccio in Perugia; Segna di Bonaventura and Pietro Lorenzetti in Arezzo; Simone Martini in Pisa, Orvieto and San Gimignano; Ambrogio Lorenzetti and Ugolino di Nerio in Florence; a follower of Pietro Lorenzetti in Borgo San Sepolcro, and so on. It seems to have been the Sienese painters who first gave the Florentines a taste for vibrant colours and the rich decorative effects of *pastiglia*, punchwork, *sgraffito* etc. How these effects were achieved is very much the subject of this catalogue.

Knowledge of the techniques of medieval Tuscan painting has in modern times been vastly extended by technology. Identification and analysis of support, medium, and pigments, as well as X-radiography and infra-red reflectography, have all helped to clarify the methods and materials used by medieval painters. The single most valuable source remains, however, the treatise called *Il Libro del l'Arte* (*The Craftsman's Handbook*), written *c.* 1390 by Cennino Cennini, a painter who was himself a Tuscan and who himself practised the very techniques he describes.

Cennino Cennini

Cennino was a pupil of Agnolo Gaddi, son of Taddeo Gaddi, so he rightly claims to belong to a master-pupil sequence reaching back to Giotto. None the less, he describes himself as 'an unimportant practising member of the profession of painting'. Although attempts have been made to attribute a number of works to him, no painting survives which is definitely known to be by him.

His treatise explains the practice of making a panel painting from the very beginning – from the preparation of the wood panel to the final touches of paint and varnish – and includes detailed instructions on every process of gessoing, drawing, gilding, punching, painting and

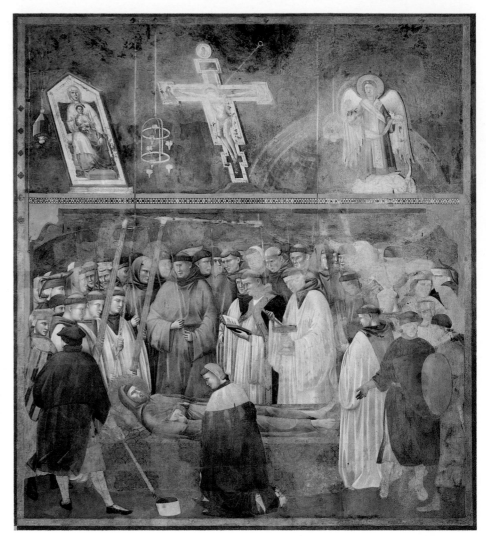

embellishing. He also describes the techniques of a number of other crafts he considers necessary to a painter: how to make colours, how to make tinted and tracing paper, and brushes, how to paint in fresco, how to mend glass, and make gilded glass for reliquaries, how to make a cast of oneself, how to paint on fabrics etc. Cennino describes painting as requiring imagination and skill of hand 'in order to discover things not seen, hiding themselves under the shadow of natural objects and to fix them with the hand, presenting to plain sight what does not actually exist'.

Apart from learning from a master painter – Cennino says he himself trained under Agnolo Gaddi for twelve years – a painter learns from copying nature, and from copying the great masters so that 'you will eventually acquire a style individual to yourself, and it cannot help being good; because your hand and your mind, being always accustomed to gather flowers, would ill know how to pluck thorns'.

Plate 2 St Francis Master: *The Verification of the Stigmata*. Fresco. Assisi, Upper Church of San Francesco

2

He also describes the painter's way of life, which he compares to that of a student of theology or philosophy, eating and drinking in moderation, and avoiding straining the hand with heavy labour, and also, he says: 'There is another cause which, if you indulge it, can make your hand so unsteady that it will waver more, and flutter more, than leaves do in the wind, and this is indulging too much in the company of women.' The motivation of a painter he describes as likely to be the impulse of a lofty spirit, natural enthusiasm and pecuniary need.

The modern reader is struck not only by how many of the materials a painter used were made or prepared in the workshop, but also by how very lengthy the processes for making them were. For example, bone for priming a panel for drawing had to be 'ground diligently for two hours'. Cennino's text is very much like that of a cookery book and full of homely details. He compares making gesso to making batter for pancakes, and beating egg white for laying bole is like 'beating up spinach or a purée' until the egg white forms 'a solid foam like snow'. For making charcoal for drawing he recommends taking bundles of willow sticks to the baker 'in the evening, after he has stopped work' to bake in his oven. The materials are often those one would find around the house: for drawing he recommends adding two drops of ink to 'as much water as a nutshell would hold'; drawing in lead can be erased with a piece of bread; a charcoal drawing can be erased with chicken or goose feathers. Black pigment can be made from burnt almond shells or peach stones. For representing the faces of young people he recommends the yolk of a town hen's egg 'because those are whiter yolks than the ones which country or farm hens produce; those are good, because of their redness, for tempering flesh colours for aged and swarthy persons'. It is also interesting to note how dependent medieval painters were on the weather: goat-skin glue was to be made in March or January during strong frosts and winds; gessoing was to be done in dry and windy weather. Often this practical advice is interspersed with invocations, usually to

Plate 3 Sassetta: *The Miracle of the Eucharist.* *c.*1423–6. Barnard Castle, Bowes Museum

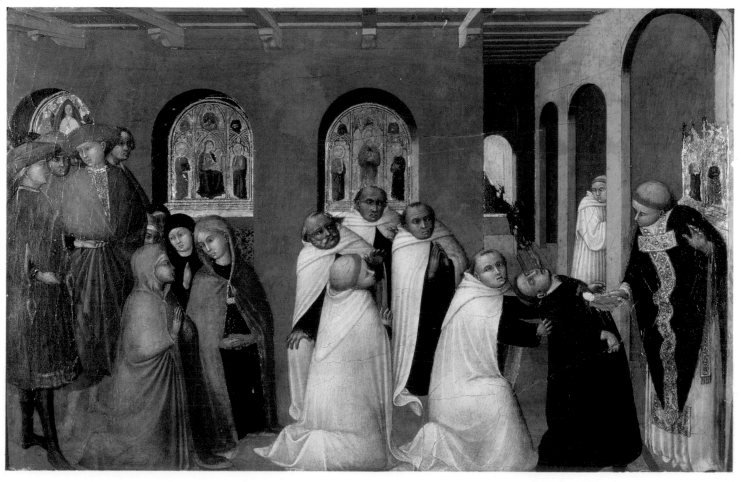

3

the Holy Trinity; Cennino, in common with all medieval painters, must have been constantly aware of the religious function and destination of the products of his skills.

Function and Setting

The medieval Italian paintings in the National Gallery are among the most prized treasures of the Collection. Nonetheless, they can be difficult for the modern eye to appreciate fully. Although we may admire their beauty, the story does not end there. Often they have been shorn of their original frames, disfigured by the buffeting of over 500 years' wear and tear, divorced from their original settings and context or even fragmented. Many of them require a thorough knowledge of the Old and New Testaments and of legends about the lives of the saints. All the paintings featured in this catalogue are, with the possible exception of the Crucifix (Cat. no. 1), either altarpieces or fragments of altarpieces. The art of medieval Italy was primarily religious and even civic art generally had religious overtones.

Two factors largely account for the vast number of elaborate altarpieces produced in Italy in the thirteenth and fourteenth centuries. A change in liturgical practice in 1215 required the priest officiating at Mass to hold up the Host high above the altar table to show to the worshippers. The earlier low horizontal form of altarpiece, or dossal, did not provide a suitable background for this important moment in the service, and a taller, more ornate form had to be devised. Secondly, towards the end of the thirteenth century there took place in Italy a tremendous upsurge of religious feeling, fostered largely by the mendicant orders, particularly the Franciscans and Dominicans, who ministered to the growing urban population. A large number of churches were built in all Italian towns, requiring an altarpiece on the high altar, a Crucifix suspended over the altar, or hung on rood screens (Plate 2), sometimes altarpieces for their side chapels, frescoes on their walls, stone pulpits, huge painted candelabra, stained-glass windows, and so on. The wealthier the church, the more elaborate and expensive its church furnishings and liturgical objects. Nowadays, with so many churches depleted of their treasures, it is hard to imagine altarpieces in their original settings – dark chapels with only the chance sunbeam or glitter of candlelight setting off their brilliant colours against the glow of burnished gold. Sassetta's paintings of the *Miracle of the Eucharist*, c. 1423–6 (Barnard Castle, Bowes Museum), and the *Funeral of St Francis*, 1437–44 (National Gallery, no. 4763) (Plates 3 and 4), give

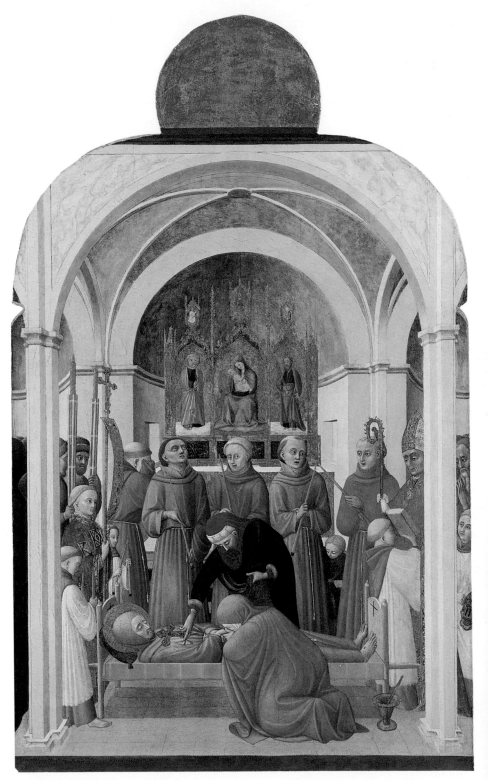

Plate 4 Sassetta: *The Funeral of St Francis*. 1437–44. London, National Gallery

4

Patronage

In thirteenth- and fourteenth-century Italy patronage of painting was primarily for religious purposes. Sometimes altarpieces were paid for by corporate patronage such as Duccio's *Maestà* (Cat. no. 3), which was commissioned by the Opera of Siena Cathedral (the Cathedral Committee of Works). Sometimes private patrons bore the cost. For example, the Santa Croce Altarpiece by Ugolino di Nerio (Cat. no. 5) was probably paid for by the Alamanni family, since it once bore their arms; the altarpiece by Nardo di Cione (Cat. no. 6) was probably paid for by the Benini family; and the high altarpiece of San Pier Maggiore (Cat. no. 8) was probably paid for by the Albizzi family. A few high-ranking clerics commissioned small private altarpieces for their own use, such as the portable triptych attributed to Duccio (Cat. no. 4), which may have been commissioned by a Dominican cardinal.

In general it is unlikely that sacred pictures were commonly commissioned for domestic use, although later in the fourteenth century there is evidence that wealthy laymen had religious paintings in their own homes. The so-called Merchant of Prato, Francesco Datini (d. 1410), a cloth merchant who imported his wool from the Cotswolds and worked mostly in Avignon, wrote over 140,000 letters to his household in Prato, of which 11,000 were the private correspondence on which Iris Origo based her fascinating account of his life (see Bibliography). From these letters we know that he had religious paintings in his bedroom, guest-rooms and office. The advice on subject-matter from a Dominican friar he admired, particularly on what should be shown to children, was: 'The Virgin Mary is suitable, with the Child on Her arm and a little bird or pomegranate in its hands. Other good figures are Jesus sucking milk, or Jesus asleep in His Mother's lap . . .' Religious paintings were intended to move the spirit to devotion, particularly for those who were 'hard of heart and caught up in this world's toils'.

The choice of subject-matter was never arbitrary. Individual commissions reflected the wishes of the patron. Scenes or saints reflected such things as the dedication of the church: for example, Ugolino di Nerio's altarpiece for Santa Croce emphasised the Cross in its central scenes – the *Way to Calvary* and the *Crucifixion*; the San Pier Maggiore Altarpiece gave pride of place to St Peter holding a miniature model of the actual church; and Nardo di Cione's altarpiece (Cat. no. 6) contained one of the name saints of the commissioning family. Indeed, iconography often provides the best clue to the patron, as in the case of the triptych attributed to Duccio.

Fig. 1 Jacopo di Cione: *Madonna dell'Umiltà*. Florence, Galleria dell'Accademia. The Merchant of Prato may have dealt in this type of relatively small altarpiece

5

Not all works were individually commissioned. Franco Sacchetti related that there were always four or five unfinished Crucifixes waiting to be sold in the shop of Master Mino da Siena, and a man called Antonio Karoli da Gorenna bought 80 florins' worth of painted panels in Siena in 1348. Also, after the devastation caused by the Black Death in 1348, many commissioned altarpieces were, presumably, never finished by the painters nor claimed by the patrons.

There is some evidence of a trade in panel paintings in the second half of the fourteenth century. The Merchant of Prato ordered altarpieces of a generalised subject-matter and not tailored to individual wishes to sell in Avignon:

> A panel of Our Lady on a background of fine gold with two doors, and a pedestal with ornaments and leaves, handsome and the wood well carved, making a fine show, with good and handsome figures by the best painter, with many figures. Let there be in the centre Our Lord on the Cross, or Our Lady, whichever you find – I do not care, so long as the figures are handsome and large, the best and finest you can buy, and the cost no more than 5½ or 6½ florins. Also a panel of Our Lady in fine gold, of the same kind, but a little smaller, to cost 4 florins, but no more. These two panels must contain good figures: I need them for men who want them to be fine.

He also bought four panels 'of fine gold, with good figures of Our Lord and Our Lady and several Saints, without flowers, by Jacopo di Cione' (see p. 124 and Fig. 1).

Image and Imagination

The effect of religious images on the popular imagination was profound. Just as a relic provided a direct link with the actual saint or holy person, so images were often identified with the person worshipped. For many people there was no dichotomy between the real and the imagined world. Mystics often had visions whose pictorial symbolism can be traced to popular imagery. The case of the Crucifix which talked to St Francis (Plate 40) is well known. Blessed Angela of Foligno (d. 1309) had a vision of Christ holding St Francis which stemmed from the stained-glass windows in the Upper Church of San Francesco, Assisi. Painted images of the Passion of Christ had to be hidden from her so greatly did she identify with Christ's suffering. Blessed Clare of Rimini (d. 1346?) had a vision connected with contemporary painting when a painted image of Christ assumed reality and spoke to her. In the Life of Blessed Clare of Montefalco (d. 1308), a woman describes a vision of the Virgin Mary sheltering people under her cloak, evidently deriving from paintings of the *Madonna della Misericordia* (Madonna of Mercy).

Painters' Guilds

Medieval Italian painters were acutely aware of the religious function of the altarpieces they painted. The inscription on Duccio's *Maestà* (Plate 5) calls for the protection of the Virgin on the painter, as well as on the city of Siena. Altarpieces were not only supposed to be visual manifestations of religious worship, but also to teach a largely illiterate populace. The statutes of the Guild of Sienese painters of 1355 show the painters fully conscious of their role: 'For we are by the Grace of God illustrators for those simple men who cannot read of those things which are brought about by virtue and by virtue of holy faith.'

All professions were organised into guilds – associations regulating production, sales, demarcation, ethics, etc. A number of guild statutes survive (for example those of Florence, Siena, Perugia; see Bibliography) which give an idea of the extent to which the guilds controlled the life and work of painters. It was obligatory to belong to the guild and no one could practise his craft without doing so. In Florence painters were subsidiary members of the Arte dei Medici e Speziali (Guild of Doctors and Apothecaries), to which belonged also a number of other craftsmen who dealt in many of the same materials, such as barbers and saddlers.

Painters' guild regulations varied from town to town. Generally they obliged their members to keep certain feast days, including usually the feast of St Luke (18 October), the patron saint of painters, and to take part in civic religious processions. All of them controlled the materials to be

used by the painters. For example, the guild statutes of Siena of 1355 forbade the substitution of gilded silver for pure gold, tin for silver, German azurite for ultramarine, indigo for azurite and red earth or *minium* (red lead) for cinnabar (vermilion). The Florentine statutes of 1315–16 prescribed punishments for the selling of German azurite as ultramarine or saffron from Catalonia mixed with saffron from Tuscany.

The work of the painter was controlled not only by the guild but also by the contract drawn up for each individual commission.

Contracts

Very few contracts survive, although one may assume that they were drawn up for all major commissions. No contracts are known to survive for the paintings in this catalogue, but there are what are thought to be interim agreements for Duccio's *Maestà* (Cat. no. 3; see also Appendix II). The surviving contracts vary a great deal in their detail, for example in how specific they are regarding the size and content. The contract for Duccio's *Rucellai Madonna* (Plate 6), painted in 1285 probably for the high altar of the main Dominican church in Florence, Santa Maria Novella, says only that Duccio is to paint a Virgin and Child and 'other figures': the precise composition is left to the painter.

Sometimes the patron reserved the right to dictate the subject-matter. One unusually detailed early contract to survive is that for the polyptych painted by Pietro Lorenzetti for Santa Maria della Pieve, Arezzo, in 1320 (Plate 1), which details that the figures are to be very beautiful ('de pulcherrimis figuris'). It outlines the subject-matter (the Virgin and Child with four lateral figures and with prophets and saints) – to be chosen by the patron, Bishop Guido Tarlati – the materials (the altarpiece is to be of gold and the best silver, and the best ultramarine is to be used for the five main panels and elsewhere), the measurements, and something of the design – two columns painted with six figures; the work is to be approved by the Bishop, paid for in three stages and no other work is to be undertaken in the meantime; the wooden structure to be painted was provided by the Bishop (see below).

Later in the fourteenth century the tendency is for contracts to become even more specific concerning the subject-matter as patrons had more examples to draw on. For example, a contract of 1385 for Francesco di Michele to paint a tabernacle for the church of San Matteo, Florence, describes how the Nativity is to contain shepherds and sheep, animals, mountains,

Plate 5 Duccio: *The Maestà: Virgin and Child Enthroned with Saints and Angels.* Siena, Museo dell'Opera del Duomo

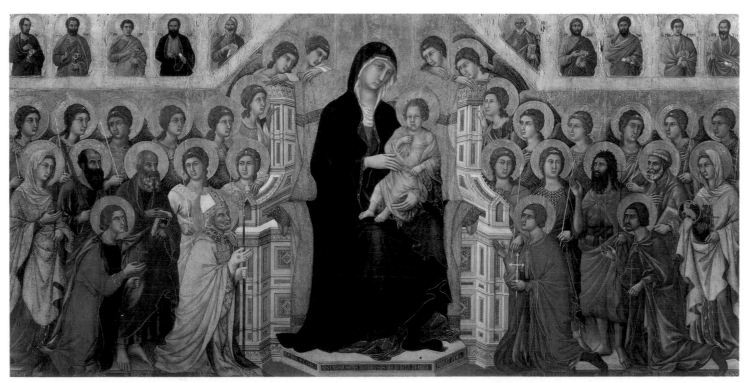

7

angels announcing to the shepherds and adoring the Christ Child; the Coronation of the Virgin is to contain seraphim, saints, angels playing instruments; and so on.

Some contracts are very precise regarding size because generally altarpieces were commissioned for a specific site and a specific altarblock, sometimes to replace an old altarpiece considered to be outdated. Contracts also usually detail the amount of time given for the commission. For example, in 1354 Andrea Orcagna agreed to complete the Strozzi Altarpiece (Plate 114) for Santa Maria Novella within twenty months.

Payments were generally in three phases: preliminary, interim and upon completion. Often the painter had to agree to deliver the altarpiece to its destination, since transporting huge altarpieces from the workshop to the church must have been difficult, even if they were designed in sections to be assembled *in situ* on the altar (see, for example, pp. 14ff. and Cat. nos. 3, 5 and 8). When Duccio agreed to paint the *Rucellai Madonna*, it was also agreed that if it failed to please, it was to stay with the painter, who would then have had an altarpiece 450 cm high and 292 cm wide to dispose of.

The obligation to use only the best materials is also commonly stated – only the best gold and the best ultramarine are to be used; lake is also occasionally mentioned. Sometimes the materials were bought by the painter, who was then reimbursed. At other times the materials were provided by the patron, as for the front and back of Duccio's *Maestà* (see Appendix II). A payment of 6 *libre* to Pietro Lorenzetti in 1326 made by the Opera del Duomo in Siena was intended to pay for gold, indigo, azurite and cinnabar, as well as other pigments. Sometimes the patron also provided food and drink for the painter. In a list of accounts for the painting of a fresco, now lost, in the Chapel of San Jacopo in the Cathedral at Pistoia, by Bonaccorso di Cino and Alesso d'Andrea (see p. 10) in 1347, a number of payments for wine for the painters are included, starting in February with a payment of 2 *libre* for 2 *vasili* of wine. The daily ration, apparently for each painter, was one *metadella* (about 1.14 litres or 2 pints), costing 6 *denari*. In later entries the daily allocation had increased to 7 *denari*

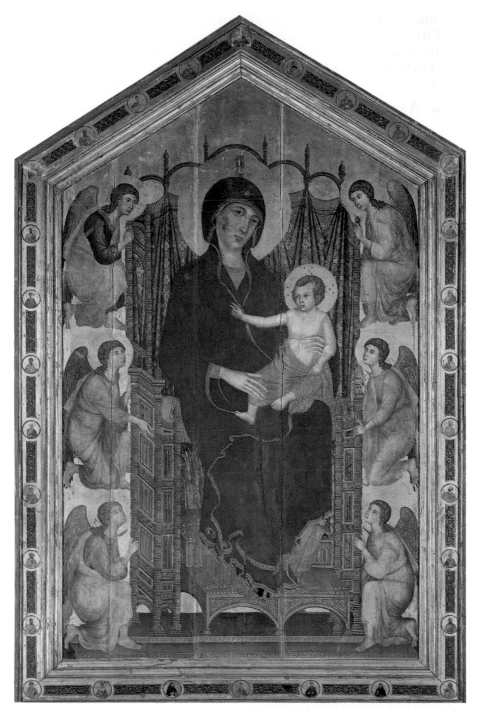

Plate 6 Duccio: *Rucellai Madonna*. 1285. Florence, Galleria degli Uffizi

(for example the payment for Alesso on 30 June), suggesting either an increased quantity or a better quality of wine.

There is often also a written-in moral obligation on the part of the painter to do his best. Duccio promised to do all he could to contribute to the beauty of the *Rucellai Madonna*. Regarding the *Maestà*, Duccio promised to paint and make the altarpiece as best he could and knew how ('pingere et factere dictam tabulam, quam melius poterit et sciverit'). In 1367 Maestro Jacomo di Mino and Bartolo di Fredi

promised to paint a vault of the chapel of Sant'Ansano in Siena Cathedral with half-figures and to make them as beautiful as they knew how ('come più belli li sapranno fare').

The Artist

The medieval artist was very much an artisan. Much of his work involved, as Cennino has shown, the preparation as well as the application of the materials used (Plate 7), and also was not confined to the making of pictures. Florentine artists sometimes sold saddlery in their workshops; saddles and harnesses were, one assumes, decorated with similar materials, that is, painted and punched. Skilled painters such as Duccio and Simone Martini carried out comparatively lowly tasks, including the painting of book covers and the decoration of banners. The status of painters ranked low among other professions, even among other crafts. Professional categories depended largely on the materials and techniques employed. There were of course painters who rose in status: Simone Martini was a friend of the poet Petrarch, and Giotto was described in 1330 by the King of Naples as 'familiaris et fidelis noster' (our faithful and familiar [friend]). When Giotto was elected *capo-maestro* (Master of Works) of the building works of Santa Reparata (the Cathedral) in Florence, it was in order that many should profit from his knowledge and learning ('quamplures ex sua scientia et doctrina proficient'). It was in fact rare for an artist to combine the skills of painter and architect. Another example was Andrea di Cione called Orcagna (see p. 124) who was an architect and sculptor, but seems to have preferred to be known as a painter, since he still called himself *pictor* in the sculptured tabernacle for Orsanmichele and was generally named as a painter in the documents. Often painters provided designs to be executed by others in stained glass, mosaic, or sculpture.

As far as is known, the painters in medieval Italy were nearly all men. One woman, a certain *domina uxore Acci pictoris*, is documented in Florence in 1295 when she takes on an apprentice for four years to teach him the art of painting. Unlike Northern painting, there are no illustrations from Italy of women at the easel. Nor indeed are there any surviving fourteenth-century illustrations of a painter at work. In general there was no iconographic tradition in Italy as there was in the North of showing St Luke painting the Virgin. But one exception was probably the lost painting by Jacopo del Casentino, described by Vasari, which showed St Luke painting the Virgin, with members of the Confraternity of St Luke.

Workshops

From documentary evidence we know that medieval Italian painters were assisted by apprentices and sometimes by other masters. The period of apprenticeship varied a great deal. The statutes of the Florentine guild of Medici e Speziali ruled that apprenticeship should not be less than three years if paid for by the apprentice and not less than six years if paid for by the

Plate 7 A French manuscript illumination of 1403, showing the woman painter Thamar at her easel, with, in the foreground, some of her painting materials, and, in the background, an assistant grinding her colours. Paris, Bibliothèque Nationale, ms 12.420, fol. 86

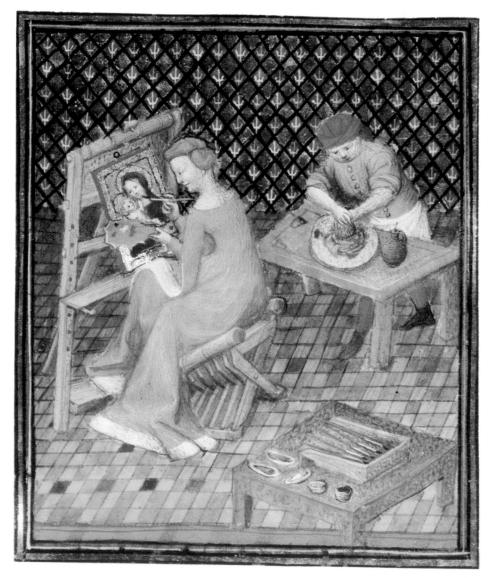

master. Each master could take only one apprentice. There were 20 days' probation and the contract between master and apprentice had to be authorised by a notary. A painter could not take on an apprentice until he had practised his art for at least three years. No apprentice could be more than 25 years old or be taken on for less than three years. A number of Florentine contract documents from the end of the thirteenth century survive, showing painters taking on apprentices for three, four or even eight years. It is unlikely that Cennino's recommendations for training were actually followed in practice: he recommends that a painter should spend a year practising drawing, six years learning to prepare panels, make colours and handle gold leaf, and then six years actually painting panels. Sometimes the contract included an undertaking on the part of the painter to feed and clothe the apprentice as well as teach him the art of painting, and in return the apprentice promised to work faithfully and not to steal or run away. The Florentine and Perugian statutes ruled against painters poaching apprentices from each other.

Workshops often contained members of the same family, particularly father and son or brothers. In the Florentine guild a son did not have to pay an entry fee to the guild if his father was already a member. Pietro Lorenzetti and his brother Ambrogio worked separately, but are also documented as having collaborated in 1335. The di Cione brothers also worked separately and together: Nardo and Andrea worked together in the Strozzi Chapel in Santa Maria Novella, the one on the frescoes (Fig. 83), the other on the altarpiece completed in 1357 (Plate 114), and Jacopo completed commissions which Andrea was unable to finish through illness. Simone Martini had a brother who was a painter, and collaborated with his brother-in-law Lippo Memmi, who had himself worked with his own father, and so on.

Within a workshop the members could vary in status, working at correspondingly varied rates of pay: for example, the accounts for the frescoes painted in 1347 in the Chapel of San Jacopo in the Cathedral at Pistoia, show that as well as the two master painters, who were paid at a rate of 12 *soldi* per day, four assistants were employed at a daily rate of between 7 and 8 *soldi*, and finally one Laurentio Cambini *pictor* was engaged solely to grind colours ('macinare colores pro picturis') at the meagre rate of 2 *soldi* per day, no more than the cost of a pound of glue or of lead white.

In this instance there were two master

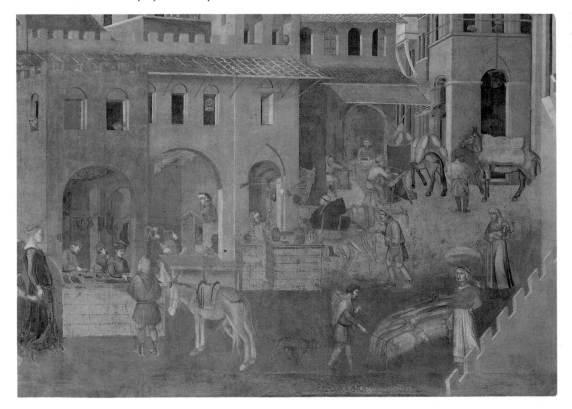

Plate 8 Ambrogio Lorenzetti: *Allegory of Good Government.* Detail. 1338–9. Fresco. Siena, Palazzo Pubblico, Sala 'dei Nove'

painters, which was not unusual; painters often collaborated with each other on equal terms. For example, Orcagna had a master painter, a certain 'Maestro Francesco', working in his *bottega* (shop). Jacopo di Cione worked with several other master painters, including Niccolò di Pietro Gerini (see pp. 185ff.), Matteo di Pacino and a certain Simone (see Cat. no. 8). Sometimes painters formed a partnership or *società* of several painters which would give the painters financial security. Sometimes painters rented workshops together, for instance Bartolo di Fredi and Andrea Vanni, who in 1353 rented a workshop from Santa Maria della Misericordia in Siena for eight gold florins per year.

Little is known about the appearance of painters' workshops in the fourteenth century. As we have seen, there was no iconographic tradition like that of Northern Europe in the fifteenth and sixteenth centuries whereby St Luke was represented as a painter surrounded by the tools of his trade. However, illustrations of other shops (Plate 8) and scenes from the lives of St Matthew and St Eloi which depict the moneylenders' and goldsmiths' shops supply a few clues (Fig. 2). Generally they are shown operating from workshops which open on to the street. This would provide the daylight needed by the painter or any other craftsman. For the painter, another obvious requirement would have been ease of access, so ground-floor premises were probably desirable. The documents for the San Pier Maggiore Altarpiece (Cat. no. 8) suggest a surprising readiness to transport large panels from workshop to workshop for the various stages in their execution. To accommodate the taller panels the ceilings would have had to be relatively high. A further need, stressed by Cennino and many other medieval writers on technique, was for clean and dust-free spaces and equipment. When the Opera of San Giovanni Fuorcivitas in Pistoia decided to commission a new altarpiece (see p. 15 and Fig. 12) they realised that they would have to employ a visiting painter from Florence, so they set up a temporary workshop by partitioning off part of the church. For this enclosure they bought six straw mats ('sei stuoie per lo rinchiuso del dipintore'), almost certainly not for the comfort of the painter but to help keep down the dust and dirt.

Fig. 2 Attributed to Taddeo Gaddi: *St Eloi in his Goldsmith's Workshop*. Madrid, Museo del Prado

Panel Construction

Italian panel paintings from the earliest surviving examples right through to the seventeenth century were almost always painted on planks of poplar, either the white poplar (*Populus alba* L.) or the inferior black poplar (*Populus nigra* L.) (Figs. 3 and 4). It is not clear whether the now familiar Lombardy poplar (a variety of *P. nigra* L.) was growing in Italy as early as the fourteenth century. Poplar wood has few uses today: apart from a traditional application for the construction of keyboard instruments like harpsichords, it is now considered fit only for the making of matchsticks. This is because the poplar is a fast-growing tree, especially when near water, so the timber is soft and weak with large open cells (Fig. 5). As a result, with changes in climatic conditions it tends to shrink and swell more than harder, slow-growing woods such as the oak used by Northern European painters. This can lead to warping and sometimes splitting of the planks. In addition poplar is particularly prone to infestation by the larvae of furniture beetles (*anobiidae*) like woodworm and death-watch beetle, and if damp it can be affected by dry rot and other forms of fungal attack.

However, despite its many failings, Italian painters probably had little choice but to use poplar. Due to deforestation through agriculture and over-grazing there was a chronic shortage of timber

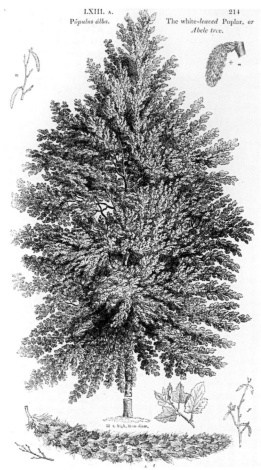

LXIII. A. 214
Pópulus álba. The white-*leaved* Poplar, or
Abele tree.

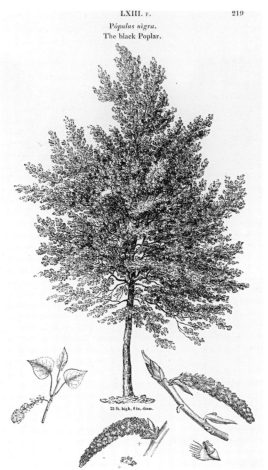

LXIII. F. 219
Pópulus nigra.
The black Poplar.

Figs. 3 and 4 The white poplar (*Populus alba* L.) and the black poplar (*Populus nigra* L.). From J.C. Loudon, *Arboretum et Fruticetum Britannicum; or the Trees and Shrubs of Britain*, London, 1838. Royal Botanic Gardens, Kew

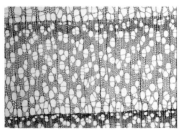

Fig. 5 Transverse thin section of poplar wood showing its characteristic wood cell structure

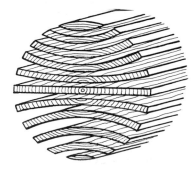

Fig. 6 Diagram showing the division of a log into planks. The plank cut across the diameter of the log is described as quarter sawn. The remaining tangentially sawn planks are likely to warp as shown in the drawing, mainly because of the asymmetry of their growth rings

throughout the Mediterranean. Wood for important construction purposes such as housebuilding and shipbuilding had to be obtained from the Alps and Dolomites and beyond. Native poplar was therefore the only wood freely available and in planks of reasonable size. The scarcity of good timber may explain why the carpenters of Italian panels always made the most out of a single log, cutting it so that there were tangentially sawn planks as well as the better quality and more stable quarter-sawn planks cut across the diameter of the log (Fig. 6). The panel makers do not seem to have been unduly concerned by the cut of the wood: if a quarter-sawn plank occurs it is probably by chance rather than by intention. Axes and saws were used to divide the logs, always into relatively thick planks, because of the weakness and lack of density of the poplar.

The planks would have been stored until seasoned and ready for use. Although he gives no indication as to how long the wood should be seasoned, Cennino was aware of the need for it to be 'thoroughly dry'. While wood should never be allowed to become too dry, insufficiently seasoned

planks can shrink as they continue to lose moisture, leading to premature warping, as well as cracking and splitting of the panel.

Unless the painting was to be very small, or long and narrow as in a predella, it was necessary to join several planks to make up the panel. The planks were butt-joined, using, according to Cennino, a strong casein glue made from quicklime mixed with a skimmed milk cheese. The presence of a casein glue has been reported on the main panel of Duccio's *Maestà*. Traditional carpenters' glues made from skins, bones and other animal waste, were probably also used: Cennino describes an all-purpose goat-skin glue and among its uses mentions 'fastening pieces of wood and foliage ornaments together'. Sometimes the butt joins were reinforced: for example, wooden dowels originally secured the vertical planks of the front panel of the *Maestà*, while rectangular wooden plates, pegged across the joins with short lengths of dowel, or shaped wooden butterflies were occasionally employed (see Fig. 7 and Cat. no. 8). Wooden dowels also played an important role in the

assembly of certain altarpieces, for example Cat. no. 5. There are indications that some carpenters were aware of the danger of joins splitting open and spoiling the appearance of the painting. The panels of the altarpieces by Nardo and Jacopo di Cione (Cat. nos. 6 and 8) have mainly been constructed from the widest available planks, extended if necessary only at the outer edges where the join was masked by the columns of the frame.

The penalty for using such wide planks is that they often include major flaws like knots and areas of erratic grain caused by branches growing out from the main trunk (Fig. 8). There are signs in some of the X-radiographs that on the front faces of the panels attempts were made to repair and smooth these faults, for example by cutting away the weakness and plugging it with a small piece of wood, or by filling the knots with a paste made of sawdust and glue as recommended by Cennino. Inevitably with time the faults break through to produce distortion and cracking on the picture surface (Figs. 9–11).

The backs of the panels were often left in a very rough-and-ready state with the marks of the tools used to gouge and chisel the wood clearly visible (Fig. 117). These marks usually cross the joins, showing that the back of the panel was only 'finished' after the planks had been glued. A few painters, mainly from early in the century, treated the backs of their panels with greater care: for example the backs and sides of the panels from the Santa Croce Altarpiece by Ugolino (Cat. no. 5) were coated with a red lead paint and there is evidence to suggest that the reverse of the work of which Giotto's *Pentecost* (Cat. no. 2) is a fragment was originally protected by canvas, gesso and paint. Since the triptych by Duccio (Cat. no. 4) was made as a portable altarpiece to be folded when not in use, its back has been treated in the same way as the painted surfaces on the front.

To support large panels and to assist in the setting up of the works on the altars, cross-battens were attached to the backs of the panels. Unfortunately, no original battens remain on the works in this catalogue, but a few altarpieces and crucifixes have survived, mainly in Italy, with their structures relatively intact. The battens vary considerably: often they look no

better than old fence posts, the circular pattern of the end grain showing that a whole sapling or branch has been used. Others, notably those on Giotto's *Ognissanti Madonna* (Florence, Uffizi) and on his Crucifix for Santa Maria Novella (Plate 9), have been beautifully assembled and finished. Here, because the backs would have been visible (see Plate 10), the joins have been neatly dovetailed and the outer edges of each batten carefully rounded and decorated with a chiselled groove.

In general the battens were attached using long nails hammered through from the backs of the panels, although there are some instances of nails being driven in from the front, for example the predella of the Santa Croce Altarpiece (Cat. no. 5). Painters were aware of the problems likely to be caused by the rusting and swelling of the nail heads beneath the gesso – Cennino recommends that they should be covered with tin foil – which makes the construction of Duccio's *Maestà* (see Cat. no. 3) seem all the more extraordinary. Equally they do seem to have tried to avoid damage to the paint and gilding which might be caused by hammering nails in from behind. In most cases, although perhaps not the San Pier Maggiore Altarpiece (see Cat. no. 8), the battens appear to have been

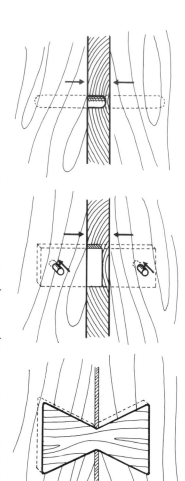

Fig. 7 Drawings to show some of the methods occasionally employed to reinforce joins in panels. From the top: dowels, wooden plates pegged across joins, shaped wooden butterflies

Fig. 8 A plank of poplar of the size likely to have been used in the fourteenth century. Many flaws and knots can be seen

13

fitted before any work was carried out on the front of the panel. For the Santa Croce Altarpiece this necessitated the use of a complex system of interlocking battens. Because the battens on neither of these altarpieces have survived, their positions and the way in which they were attached have had to be determined by matching the clean marks left by their removal with the broken remains of the nails as seen in the X-radiographs. Since these were nailed from behind only the points of the nails remain. Where the heads of nails have survived their handmade irregularity is clearly visible: large nails tend to have either square or polygonal-shaped heads, with slightly faceted rather than rounded surfaces, while the smaller nails look more like those still in use by farriers for shoeing horses.

These small nails, together with long, narrow panel pins, were mainly used to secure the various elements of the frame which were attached to the panels before any of the preparations for gilding and painting began. Medieval Tuscan artists seem to have gone about the whole problem of designing and framing a large structure very differently from, for example, their Venetian counterparts. In fourteenth-century Venice it seems that the frame was constructed as a separate entity and the panel first painted and then fitted into it. In Tuscany an altarpiece was a combination of framing elements which were integral to the panels and an outer frame which contained or supported the whole (see, for example, Cat. nos. 3, 5, 7 and 8).

From the documents it is also clear that large altarpieces were thought of as being composed of several separate sections, which divided into either vertical or horizontal units: only when they were on the altarblock did they become a single, unified whole. The Santa Croce Altarpiece was made up of seven vertical units and one horizontal unit; the San Pier Maggiore Altarpiece was basically formed of horizontal units and seems to have been made in sections. The documents concerning the altarpiece include payments for transporting a main tier panel from the house of one of the craftsmen involved, and for carrying first the *tavola* and then the predella to Santa Maria Nuova for varnishing.

In contracts the predella, if there was to

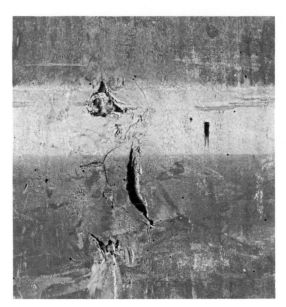

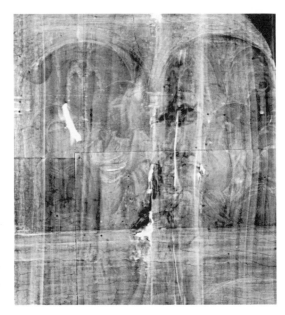

Figs. 9, 10, 11 Jacopo di Cione: *The Pentecost* (Cat. no. 8). Detail of the back of the panel, showing a serious fault in the timber; an X-radiograph of the same area showing how the knot has been filled on the front surface, the filler producing an opaque X-ray image; the front of the panel in raking light, after cleaning, before restoration, demonstrating the disruption to the surface of the painting

14

be one, is usually mentioned separately. In 1339 a certain Maestro Paolo Bindi was paid specifically for the wood and the making of the predella for the panel of San Crescentius painted by Ambrogio Lorenzetti and completed in 1342. Similarly the accounts for the altarpiece for San Giovanni Fuorcivitas, Pistoia (Fig. 12) – eventually completed in 1353 by Taddeo Gaddi following the presumed death in the plague of 1348 of the original painter Alesso di Andrea – record first a payment to Maestro Francesco da Siena for 'the making and the wood of the panel of the high altar' ('per la faccitura e lo legname della taula dello altare magiore'), and then a separate payment for the remainder of the work including the predella and the carved columns ('per resto e conpimento della taula di san Giovanni, e della predella e colonne della decta taula'). The uppermost tiers were apparently sometimes constructed separately. The gigantic altarpiece for the Collegiata of Santa Maria in Impruneta (Fig. 121) was inscribed in 1375 by Pietro Nelli working with a collaborator, possibly Tommaso del Mazza, but he was not paid the balance for the upper compartments until 1384, suggesting that these were left until last.

The enormous amount of carpentry involved in the making of an altarpiece was almost certainly not carried out by the painter. Passages in contracts confirm that although the painter or the designer of the altarpiece – not necessarily one and the same (see Cat. no. 8) – was probably responsible for overseeing the manufacture of the panels, the actual carpentry was carried out by a specialist wood-worker (legnaiuolo). For example, in 1320 the contract for the Pieve Polyptych (Plate 1) in Arezzo states that Pietro Lorenzetti is to begin work 'after the wooden panel has been made' ('postquam facta fuerit ipsa tabula de lignamine') and the Bishop actually promises to have the panel made ('promisit eidem facere dari et assignari ipsam tabulam constructam de lignamine') by a carpenter possibly following Pietro's design; in 1342 Taddeo Gaddi agreed to paint a panel once it had been carpentered; in 1372 a Pistoian painter Jacopo di Lazzero agreed to paint 'in a panel of wood which had been made for the said altar' ('in una tabula ligni que fabricata est ipsum altare'). On these occasions the panels were consi-

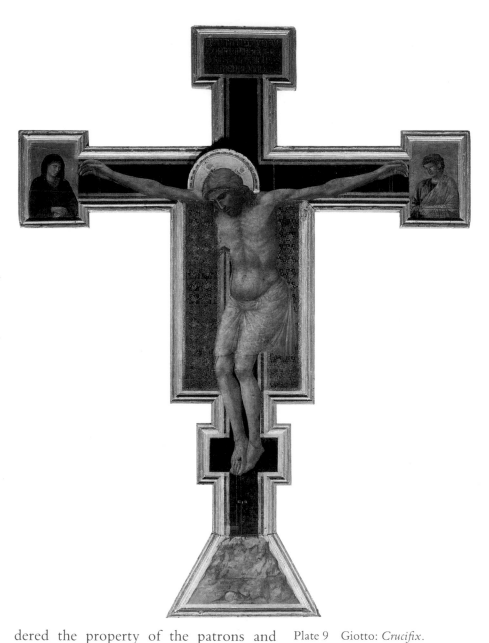

dered the property of the patrons and were, in a sense, only lent to the painter for the duration of the painting process. In 1341 various items (see also p. 27) belonging to the painter Maso di Banco were sequestrated at the request of the Bardi company, among them two panels and a predella from an altarpiece, but a second document dated a few days later records that the panels had in fact been confiscated in error as they already belonged to Rodolfo de' Bardi and the Bardi company, and were with Maso just for painting.

However, there are also instances of the painter supplying the wood. In 1393 Taddeo di Bartolo contracted to paint two altarpieces for the church of San Luca in Genoa and to provide the wood, gold (?), nails, pictures and colours ('de propriis

Plate 9 Giotto: *Crucifix*. Florence, Santa Maria Novella

ligneminibus, autis [sic], clavis, picturis et
coloribus'), but even in this instance the
painter is unlikely to have constructed the
panels himself. Either way it is doubtful
whether the carpenter was actually a mem-
ber of the workshop, although it may have
been more common for the painter rather
than the patron to provide the carpenter.
Certainly Giotto seems to have used the
same careful carpenter for both the *Ognis-
santi Madonna* and the Santa Maria Novella
Crucifix.

The manufacture of the more complex
elements of the frames would also have
been assigned to carpenters, or sometimes
perhaps to specialist woodcarvers: for
example, the documents concerning the
Annunciation painted by Simone Martini
and Lippo Memmi in 1333 for the chapel of
Sant'Ansano in Siena Cathedral (now in
the Uffizi, Florence) include a payment
specifically to an unnamed 'master who is
making the frame for the said altarpiece'
for 'wood (?) and twisted columns' ('uno
maestro che fecie l'armadura de la detta
tauola . . . e per lengi [legni?] e tortizi').
Payments for timber and the making of the
panels of the altarpiece had previously
been made to a named, and therefore
presumably different, carpenter, a 'Maes-
tro Duccio' from San Maurizio.

The carpenter may have been called
again to assist in the setting up of the
finished altarpiece on the altarblock.
Among the last payments in the accounts
for the San Pier Maggiore Altarpiece (see
Appendix III) is one for the transport of a
length of timber to the workshop of one
Bartolo Lana, perhaps the same carpenter
who constructed the altarpiece; payments
were also made to a stonemason for boring
holes, presumably in the church floor, for
supporting side buttresses and possibly for
struts behind the altar as well (see Cat. no.
8), and to an unnamed person for the loan
of block-and-tackle to hoist the upper tiers
into position. Quantities of nails were
purchased, some specifically for the col-
umns and other carved ornaments, and
others perhaps for the battens, and also a
piece of tin. This may have been used for
the same purpose as the lead bought from a
tin-merchant (*stagnataio*) to coat the iron
rings (or possibly weights) for the curtain
which protected the altarpiece for San
Giovanni Fuorcivitas (see above) ('per
libre XX di pionbo per pionbare i ferri

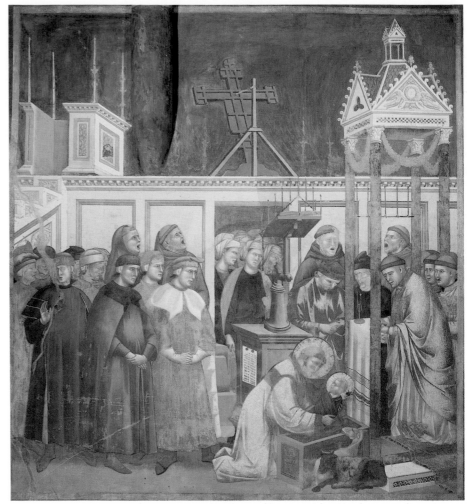

Plate 10 St Francis Master: *The Christmas Crib at Greccio*. Assisi, Upper Church of San Francesco. This fresco shows how the battens can become visible when a Crucifix is hung on a rood screen

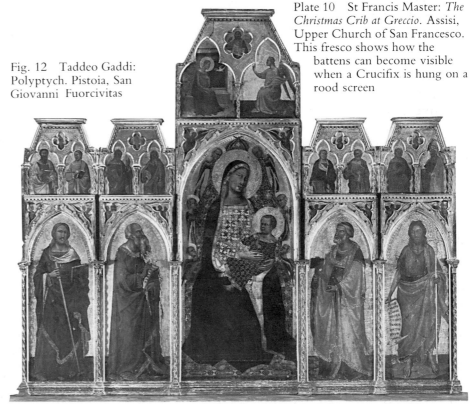

Fig. 12 Taddeo Gaddi: Polyptych. Pistoia, San Giovanni Fuorcivitas

16

della cortina'). The San Pier Maggiore Altarpiece was supplied with a similar protective curtain, hung on twenty-four rings and decorated with orpiment and red lead.

The Gesso Ground

Bare untreated wood is not a suitable surface for painting, let alone gilding. Gilding needs to be carried out on an ivory-smooth surface if the desired illusion of a solid gold background is to be achieved. The wood has first to be prepared with a gesso ground. The ground is an important part of the structure of a painting as its long-term preservation depends largely on the continued good adhesion of the ground. Its importance was not underestimated by Cennino, who spends longer describing the preparation of a panel for painting than he does the actual application of the paint.

The first stage was to give the whole panel, including any attached parts of the frame, several coats of glue size. Ordinary animal skin glues, boiled to a jelly and then dried in leaves for later reconstitution, were probably used, but according to Cennino the best size was made from parchment clippings soaked and boiled in water. These parchment clippings were a waste product of the cutting of sheep or goat skins into rectangular sheets for manuscripts. The resulting glue is clear and pure, rather like modern cooking gelatine. The first applications of size were primarily to reduce the absorbency of the wood, preventing it from soaking up the adhesive from the later ground layers, giving it as Cennino says 'a taste for receiving the coats of size and gesso' just as though 'you were fasting and ate a handful of sweetmeats, and drank a glass of good wine, which is an inducement for you to eat your dinner'.

Pieces of linen canvas, usually of a quite fine and open weave, were then soaked in size and laid over the flat areas of the panels. In some instances, the canvas has where possible been eased around the frame mouldings as well (for example Cat. no. 3). The canvas weave and the frayed edges of the fabric can be detected in X-radiographs showing that while some painters used torn strips and scraps of canvas, as suggested by Cennino, others preferred large continuous pieces. For the altarpiece of San Giovanni Fuorcivitas, Pistoia (see p. 15), a total of twenty-six *braccia* (see Appendix IV) of linen cloth were bought especially for covering the panels ('panno lino per impannare la taula dell'a[l]tare'). The main purpose of this canvas appears to have been to reinforce any joins and to even out flaws on the surface of the panel. It would also have provided tooth for the adhesion of the subsequent gesso layers and may have been intended to reduce subsequent cracking of the ground.

When the size used to attach the canvas was completely dry, the panel was ready for the application of the layers of gesso. Basically gesso consists of the powdered white mineral, hydrated calcium sulphate, mixed with an animal glue, ideally the same as that used to size the panel. A common name for calcium sulphate is gypsum – the word gesso is simply Italian for gypsum. There were several gypsum mines in Tuscany, notably at Volterra, well known for its alabaster (a crystalline form of gypsum), and at Cavallano, a village not far from Colle Val d'Elsa where the ancient quarry and kilns can still be seen.

Cennino describes the application of two forms of gesso. He calls the first of these *gesso grosso*. *Gesso grosso* is the coarse, anhydrite form of calcium sulphate made by heating the lumps of mined gypsum in a kiln to drive off the molecules of water from the crystals. It is powdered and sifted and then ground with size to form a paste which is laid over the flat surfaces of the panel using a broad slice or putty knife. When dry this *gesso grosso* should be scraped down to an even level and ready for the second form of gesso which Cennino calls *gesso sottile*.

Gesso sottile is made when either the raw gypsum or the burnt *gesso grosso* is slaked by prolonged soaking in water, changing and refining the texture. Cennino describes the process: 'It is purified for a whole month by being soaked in a bucket. Stir up the water every day, so that it practically rots away, and every ray of heat goes out of it, and it will come out as soft as silk. Then the water is poured off, and it is made up into loaves, and allowed to dry.' When ready to apply the *gesso sottile*, these loaves should be re-soaked in water and thoroughly ground on a porphyry or

marble slab. The ground gesso is gathered up into a piece of cloth and formed into a lump by squeezing out the excess moisture. Thin slices can then be pared off and added to the parchment size, mixed 'with your hand, as if you were making batter for pancakes, smoothly and deftly, so that you do not get it frothy'. The gesso should be kept warm, but not too hot, over a pan of water. The warning about frothing of the gesso (also caused by overheating) is important as the bubbles of froth will burst when the gesso dries causing pin-sized pits in its surface. While all the panels in this catalogue have been skilfully gessoed, some fifteenth-century paintings have badly pitted gesso.

The warm *gesso sottile* is applied with a large, soft bristle brush over both the flat surfaces and any mouldings and other built-in frame ornaments. The first coat should be rubbed in with the fingers and palm of the hand to make 'the *gesso sottile* unite well with the *grosso*' (Plate 11). The remaining coats are brushed on in alternating directions, never leaving too long between coats – if necessary the painter must work through the night – until there are 'at least eight coats of it on the flats. You may do with less on the foliage ornaments and other reliefs; but you cannot put too much of it on the flats.'

One suspects that Cennino is describing the ideal gesso ground and that many painters would have reduced the number of layers of *gesso sottile*. In most of the cross-sections from paintings in this catalogue it is difficult to see any stratification in the gesso layers, perhaps because they are so well united. However, in the few samples which include a substantial amount of gesso, the lowest layer is noticeably coarser and more granular in texture. By applying X-ray diffraction analysis to samples of gesso known to be from the lowest layer (for example from the exposed canvas on the spandrel angels from the Santa Croce Altarpiece and from the cut edges of the San Pier Maggiore Altarpiece – Cat. nos. 5 and 8) and to samples carefully scraped from the uppermost ground layers it has been possible to confirm that these fourteenth-century painters did indeed use the two forms of gesso as described by Cennino (Figs. 13 and 14). However, it has been noted that in the fifteenth century paintings from Flor-

ence and Siena tend to have grounds consisting mainly of the burnt anhydrite form of calcium sulphate, whereas those from north of the Apennines, and in particular Venice and Ferrara, are nearly always of the slaked dihydrate form. This suggests that as gilding became less important and there was no longer a need for a perfectly smooth ground, painters began to dispense with one form or another and that this followed a local pattern.

To achieve the ivory-smooth ground needed as a base for burnished gold leaf the brushed coats of gesso had to be scraped down, but only when they had thoroughly hardened. Cennino has a clever method for ensuring the smoothness of the gesso, whereby the surface is dusted with powdered charcoal: as it is worked over with the straight edge of the scraper the raised

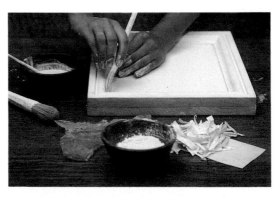

Plate 11 Brushing on the *gesso sottile*. In the foreground are a bowl of powdered gesso, a leaf of glue and some parchment clippings

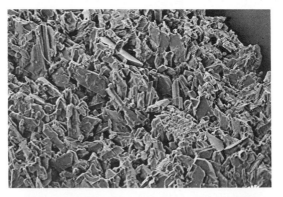

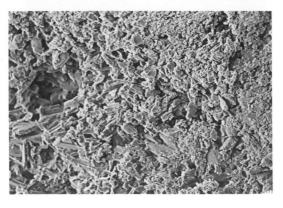

Figs. 13 and 14 SEM micrographs of samples taken from the lower layer of *gesso grosso* and from the upper layer of *gesso sottile* of the San Pier Maggiore Altarpiece (Cat. no. 8). The difference in texture is evident. Gold-coated. Magnification, 1,080×

bumps and ridges are scraped off leaving the charcoal in the hollows (Fig. 15). Only when no charcoal can be seen is the surface perfectly smooth and flat. For scraping the frame mouldings small specially curved blades were used, although Cennino does slip in a quick method of simply smoothing the gesso with a damp linen rag. These methods were also used in the finishing of the raised gesso decoration known as *pastiglia*, described at greater length under Cat. no. 7. Sometimes carved and modelled gesso occurs in place of curved wood mouldings around the arches of frames (see Cat. nos. 4 and 5).

While Cennino in his introduction to the profession of painting emphasises the importance of the painter having a knowledge of the processes involved in the application of gesso, it is unlikely that all this preparatory work was carried out by the painter at the head of the workshop. Equally, given the skills involved and the extent to which things could go wrong, for important commissions at least the task would almost certainly not have been assigned to an inexperienced apprentice. Possibly the larger workshops retained the services of a specialist who may well have been concerned with the gilding as well. Additions to the Sienese guild statutes made in 1533 list workers in gesso and stucco and similar materials as though they were a separate category ('Tutti li formatori di gessi, cartepeste, stucchi, ed altre cose'). While this distinction between the crafts may have been added because of changes in workshop practice which occurred only during the fifteenth and sixteenth centuries, it could equally reflect earlier practice, especially given the repetitive nature of the guild statutes. The work of these 'formatori di gessi' is likely to have consisted mainly of the gessoing of ornamental boxes and other three-dimensional objects, but there is no reason why they should not have assisted the painter as well, particularly when there were gesso mouldings to be made. Certainly in later centuries documents record payments to specialist gilders for the gessoing of altarpieces.

Preliminary Drawing

Very few fourteenth-century Italian drawings have survived, so little is known about the processes involved in working

out the design of a panel painting. To calculate the dimensions and relative proportions of the components of an altarpiece the painter or designer is likely to have applied the same proportional systems thought to have been in use among architects and stonemasons of the time (see Cat. nos. 4, 5, and 8). Often the figure compositions were at least partly dependent on earlier examples: most of the

Fig. 15 The stages in the application of a gesso ground: from top left the wood and frame; linen fabric; *gesso grosso*; *gesso sottile*; dusting its surface with charcoal; smooth gesso ready for gilding and painting. In the spandrel is some *pastiglia*

19

scenes on the predella of Ugolino's Santa Croce Altarpiece derive from the equivalent scenes on the reverse of Duccio's *Maestà*. As Ugolino can hardly have painted his altarpiece sitting in front of the *Maestà*, detailed drawings must have existed.

From the fifteenth century onwards elaborate drawings of altarpieces complete with their frames have survived. These were presumably made to show the patron. Occasionally the colours were indicated as well. No drawings of this type have survived from the fourteenth century although they may well have existed, so nothing is known about how the painters worked out the distribution of colour.

In contrast to his silence as to how a painting was designed, Cennino is precise in his instructions for the drawing of the composition on to the white gesso. He suggests a first sketch made with a stick of charcoal tied to a cane to allow the artist to stand back from his work. Any mistakes and alterations can be erased by dusting the charcoal off with a feather. When satisfied with the design (and Cennino recommends brooding over it for a few days to be certain), the drawing can be fixed by going over it with a small brush and dilute black ink (Fig. 16), shading it carefully so that 'you come out with such a handsome drawing that you will make everyone fall in love with your productions'.

Infra-red photography and reflectography have revealed at least some preliminary underdrawing on all but one of the works in this catalogue. None shows any traces of a first sketch with charcoal, so if used it must have been erased after the design had been fixed. Only three (Cat. nos. 3, 4 and 6) exhibit any form of shading and hatching to indicate the modelling of the drapery folds, and in each case the hatching appears to have been done using a quill pen rather than a brush. The others show a generally cursory outlining of the forms, with just an occasional line to place a drapery fold. A possible explanation for the rather summary underdrawing found on most of these works is that as the painting process involved the systematic modelling of forms from the shadows through to the highlights, the very first application of paint was to the shadowed areas and therefore served to fix the forms in the

same way as Cennino's carefully shaded drawing.

As yet few fourteenth-century panel paintings have been examined by up-to-date infra-red methods, but judging by the results obtained from works in this catalogue they should justify further investigation, particularly when underdrawings on panel can be related to *sinopie*, a connection

Fig. 16 A reconstruction of the techniques for preliminary underdrawing as described by Cennino. The figure has first been sketched with charcoal and some of the drawing has been fixed with dilute ink applied with a brush

which has proved instructive in the case of the San Pier Maggiore Altarpiece (Cat. no. 8).

Gilding

The divisions between those areas of the work to be gilded and those to be painted were usually lightly scored with a stylus into the gesso (Fig. 17). The design had therefore to have been decided upon by this stage, and any haloes and other gilded details which were to be surrounded by painted areas needed to be incised.

With one notable exception (Cat. no. 2), all the panels in this catalogue have been prepared for gilding with a layer of bole (Plate 12). Bole is a soft, greasy-textured, orange or red-brown clay, pigmented by the same iron oxides which constitute the red earth pigments (see p. 34). It serves two main functions: the first is to provide a smooth cushioned surface against which the gold leaf can later be burnished, and the second is to impart a warm rich colour to the gold. This is necessary because gold leaf is beaten out so thinly that it can appear rather green and cold in colour when laid directly over a white surface, particularly if there are flaws in the gilding.

The bole, which is now supplied in small conical lumps (Plate 13) and probably was so in Cennino's day, is ground with water and brushed on in a number of layers using dilute size or glair – egg white which has been whisked to a foam and then allowed to liquefy again. When ready to gild, the bole can be lightly burnished (see below), or simply polished up with a piece of linen cloth to ensure a smooth, grit-free surface.

Cennino does not describe the method of beating gold to make gold leaf. A description is, however, given by the twelfth-century monk Theophilus, which is reminiscent of the method used today. A piece of gold is first beaten on a smooth surface until thin and then cut into square pieces. These are interleaved with squares of thin parchment or paper, specially prepared with a coating of very finely ground red ochre, such that the piece of gold is positioned in the centre of the square of parchment. The whole pile of parchment and gold is then placed in a vellum pouch, just large enough for the squares to fit inside. Using a broad-faced hammer, the pouch is hammered lightly

Fig. 17 Detail from *The Crucifixion* by Jacopo di Cione (Cat. no. 7) showing the incised lines to indicate the areas to be gilded

Plate 12 A cross-section of a sample taken from the gilded background of the altarpiece by Nardo di Cione (Cat. no. 6) showing the orange-red bole between the gesso and the gold leaf. Magnification, 300×

Plate 13 Some of the tools and materials used by modern gilders. With a few exceptions they remain much the same as those used in Cennino's day

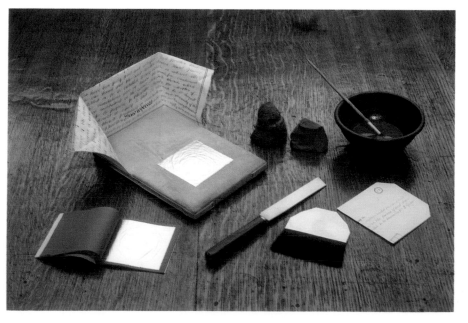

21

on a flat stone until the gold has spread to the edges of the squares: any gold protruding out of the pouch may be trimmed off. Theophilus describes the squares of parchment or paper as being '4 fingers wide' – perhaps 7 or 8 cm square – and gold leaf of these dimensions is reported to have been used in medieval Italian painting.

Cennino recommends the use of thicker leaf if it is to be burnished flat: thinner leaf is appropriate for use with mordant gilding (described on p. 43). He also indicates that gold coins were used as a source of leaf. Analysis of gold leaf backgrounds suggests that the metal used is reasonably pure, with only copper detectable as a minor impurity: the Florentine florin, the *fiorino d'oro*, was of nominally pure 24 carat gold and a great deal of trouble was taken to ensure its purity. If the weight of a gold coin is known, as well as the size and the number of leaves obtained, knowing the density of gold it is possible to make a very approximate calculation of the thickness of a square of gold leaf. The weight of the florin varied slightly throughout the century: from 3.52g in 1324, down to 3.33 or 3.34g in the middle years and back up to 3.52g in 1390. Cennino writes that only one hundred sheets of gold leaf should be beaten from a coin to give the leaf of a quality suitable for burnishing 'whereas they do get a hundred and forty-five'. The contract of 1320 for the polyptych (Plate 1) by Pietro Lorenzetti for Santa Maria della Pieve, Arezzo, required the painter to use the best gold, of one hundred leaves to the florin. Taking the lighter, mid-century florin as an example, one leaf of gold, assumed to be 8 cm square, might have a weight of around 0.033g and a thickness of about 269 nm or so (that is, 0.000269 mm). It was, in fact, possible to measure the thickness of a fragment of leaf from the background of a panel from the San Pier Maggiore Altarpiece (Cat. no. 8) of 1370–1: the result obtained – 256 nm – is surprisingly close to the estimate obtained by calculation.

The application of such thin delicate leaf requires considerable care. A sheet of gold leaf is placed on a padded leather cushion – the version used today (Plate 13) is in fact very traditional and is exactly like that described by Cennino, but with the addition of a parchment shield to prevent the fine leaf from blowing away in a

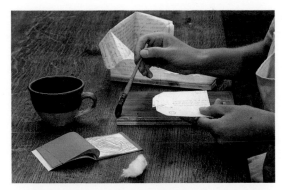

Plate 14 Laying the gold leaf using a gilder's tip cut from parchment

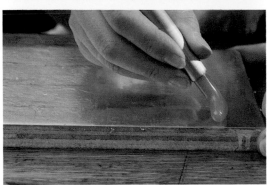

Plate 15 Burnishing gold leaf

draught – cut if necessary to the required size with a straight-edged knife, and picked up with a gilder's tip (Plate 14). Nowadays a gilder's tip is a brush made of long hairs set between two pieces of card, but in the fourteenth century the gold leaf was thicker and easier to handle than modern gold leaf, so a simple piece of card with diagonally trimmed corners could be used. The trimmed corners of the modern gilder's tip are quite superfluous but reflect its ancestry.

The gilder's tip with its piece of gold leaf is held just above the bole which has previously been wetted by painting with

Fig. 18 Detail from *The Way to Calvary* by Ugolino (from Cat. no. 5) showing overlapping pieces of gold leaf

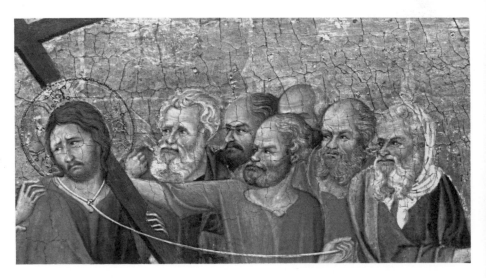

water (hence the modern term 'water-gilding') to which can be added a little glair, preferably slightly stale. When the gold leaf comes into contact with the wet surface, it is sucked down on to it. After a short while any part of the leaf which has not quite adhered can be patted down with a soft pad of textile waste (*bambagia* – the modern equivalent would be cotton wool). The process is repeated, each piece slightly overlapping the other (Fig. 18) until the whole area to be gilded is covered. Often small breaks and tears appear in the fragile leaf so the gaps have to be patched with scraps of gold, a process known among gilders as faulting.

At this stage the gold leaf looks crumpled and rather matt (Plate 16). As the whole point of gilding was to make the altarpieces look as though they were made of solid gleaming gold, the leaf had to be gently rubbed or burnished (Plate 15), so that it formed an intimate bond with the smooth greasy bole beneath (Figs. 19 and 20). Only then did it acquire its full shining intensity. The burnisher could be made of crystalline haematite or any hard polished stone mounted on a wooden handle. Agate is now commonly used, but for the extravagant, Cennino suggests sapphires, emeralds or rubies. Humbler burnishers

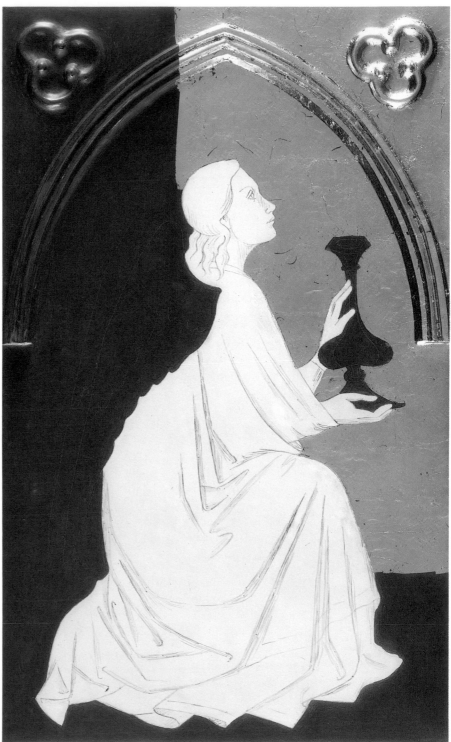

Figs. 19 and 20 SEM micrographs of a sample of gilding from Cat. no. 8. At a lower magnification four layers are visible: from left to right, *gesso grosso*; *gesso sottile*; bole; and finally the gold leaf. At a higher magnification the *gesso grosso* does not appear. Gold-coated. Magnification, 1,060× and 4,760×

Plate 16 A reconstruction of the gilding techniques described by Cennino, showing the gold leaf in the process of being applied over the bole, but still not burnished. The bole covers all the areas to be gilded, including the angel's wings, the vase and the floor

made from the canine tooth of a dog or any 'animal which feeds decently on flesh' were also acceptable. To avoid scratching or tearing the leaf the burnishing has to begin very gently and carefully, only gradually increasing the pressure until the gold 'becomes almost dark from its own brilliance'. Unfortunately, with time this illusion of solid gold is lost, partly through the unavoidable cracking of the gesso, but also because the leaf is so thin that it is very vulnerable to abrasion during cleaning and even dusting.

Tin and silver leaf were laid in exactly the same way as gold. These white metals could be glazed with a yellow-tinted varnish or lacquer to produce a cheap imitation gold, described by Cennino as though it were fairly common practice. In addition, silver leaf was widely used in its own right and for specific decorative and illusionistic purposes. Despite its propensity (known to Cennino) to tarnish through the formation of brownish-black silver sulphide, it was used not just by painters whose customers could not afford gold leaf; it is also found on a surprising number of works by painters such as Giotto, Duccio, Ugolino and Orcagna, both on the frames and on the picture surface. The silver used was reasonably pure; copper and traces of lead are found. Of the panels discussed here only the San Pier Maggiore Altarpiece (Cat. no. 8) has silver in leaf form, but it appears as a powdered pigment on the *Crucifixion* (Cat. no. 7) as well.

Tooling and Punching

Once burnished, the gilded surface was ready for what Cennino rightly calls 'one of our most delightful branches', its decoration with patterns of incised lines, tooling and ornamental punching. The purpose of this decoration was partly to distinguish details such as haloes from their gilded backgrounds, but it also greatly increases the surface interest of the gilding. The light, which would then have included flickering candlelight, catches on the edges of the indentations causing the gold to sparkle and shimmer.

Lines were indented into the gold (Fig. 21) with a stylus, made according to Cennino of silver or brass, and haloes were inscribed with compasses or dividers (Plate 17). Often the hole made by the

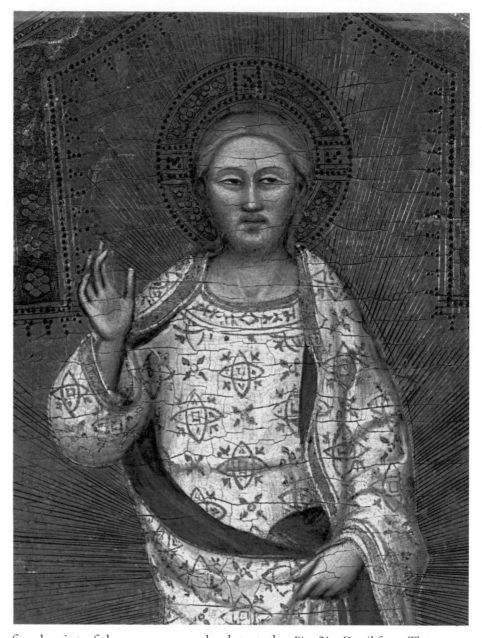

fixed point of the compass can be detected (for example, Cat. nos. 3 and 8). The extent and type of decoration of the gold vary considerably among the works in this catalogue, ranging from the simple austerity of the panel by Giotto (Cat. no. 2) to the richly tooled patterns of the San Pier Maggiore Altarpiece (Cat. no. 8). The earlier works, the Crucifix (Cat. no. 1) and the panels by Duccio (Cat. nos. 3 and 4), rely mainly on incised foliate patterns for their effects. While the former includes a little punching and Duccio used a few punches on some of his works, notably the *Rucellai Madonna* (Plate 6), the decoration of gilding with elaborate motif punches seems only to have become common practice among Sienese painters of the next

Fig. 21 Detail from *The Ascension* from the San Pier Maggiore Altarpiece (Cat. no. 8), showing lines incised into the gilding with a stylus

generation (see Cat. no. 5). Towards the middle of the century as Florentine painting became increasingly decorative, the fashion for ornamenting the gold with composite punch marks caught on in Florence, apparently stimulated by the import of punching tools from Siena by Giovanni da Milano in 1363 (see Cat. no. 6). However, barely ten years later, the very complex and ornate patterns on the San Pier Maggiore Altarpiece (Cat. no. 8) and other related works were actually executed using the simplest of punches.

Some artists are presumed to have had their own punches, and since the punch marks tend to differ on the products of different workshops, the study of tooled and punched haloes has provided valuable evidence for the reassembly of panels from dismembered altarpieces. Investigations into the diffusion of motif punches, particularly the more complex and unusual designs, may assist in the attribution of some works.

Modern metal punches (made principally for tooling leather) are usually cast, but irregularities in many punch marks on early Italian panels are generally taken to suggest that the punches then used were not cast but cut by hand and that consequently each was unique. It is also thought that the technology of metal working was not then sufficiently advanced for the casting of these relatively complex objects. The cutting and filing of ring punches is described in the twelfth-century treatise by Theophilus and a collection of punches, some possibly of considerable age, which belonged to the restorer and forger Federico Ioni (1866–1933), has been examined; all the motifs appear to have been cut rather than cast, the simplest ring punches by turning on a lathe, and others by engraving, drilling and filing (see Bibliography). However, it is not impossible that at least the plainer designs were made initially by casting and that any roughness and imperfection in the cast was cleaned up and filed by hand, resulting in slight individual variations. Punches were certainly not manufactured solely for use on the gilded backgrounds of paintings. They must have been in widespread use and circulation in the tooling and decoration of metalwork and leather, for example, not just bookbindings, but also ornate saddles and harnesses.

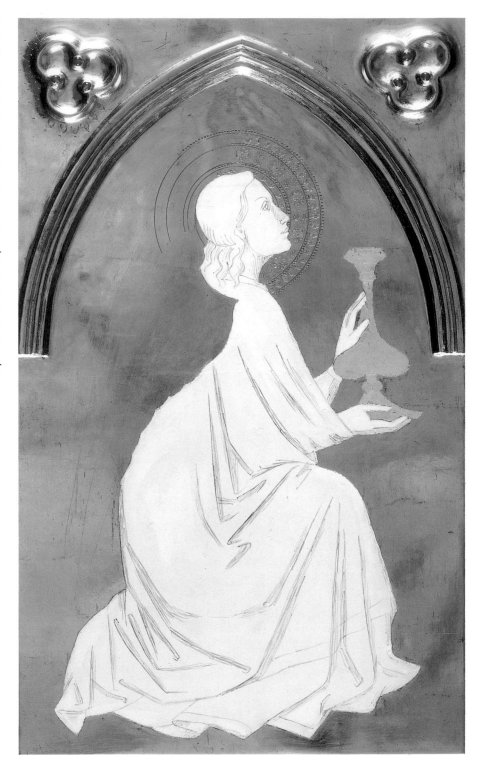

To stamp a pattern into the gilding, the punch is held perpendicular to the surface of the painting and lightly but sharply tapped with a hammer (Plate 18). The consequences of not being able to hold the punch straight are illustrated in Cat. no. 7. If the gesso has been correctly made and applied and the punching is done on a reasonably humid day, the punch should

Plate 17 A reconstruction of the gilding techniques described by Cennino, showing the circles of the halo incised into the burnished gold and the decoration in the process of being punched. Silver leaf has been applied to the vase

just indent the still-flexible ground and the film of gold leaf remain unbroken. As Cennino says, it is necessary to be well-practised, and breaks in the gold attributable to careless or inexperienced punching can sometimes be seen. It can also be difficult to indent the gesso to a consistent depth. One of the punches used on the Santa Croce Altarpiece produces two noticeably different motifs depending on how hard the punch has been tapped. These inconsistencies add to the complications of trying to trace the possible sharing and transfer of particular punches between different workshops.

Punching and tooling were not necessarily restricted to haloes and the borders of gilded backgrounds: they were also used to render details of the pictorial design. Cennino suggests that in depicting angels the highlights be punched so as to leave the burnished gold to act as the shadows: a similar technique appears on the angels' censers in the triptych by Duccio (Cat. no. 4).

Finally, punching played an important role in the execution of elaborate cloths of gold by the technique of *sgraffito* described in the entry for Cat. no. 6. *Sgraffito* textiles also appear on the San Pier Maggiore Altarpiece (Cat. no. 8) and a possible connection between the punching of the *sgraffito* and an entry in the accounts for that work suggests that a specialist gilder may have been concerned.

A more precise reference to a separate gilder occurs in the documents concerning the altarpiece for San Giovanni Fuorcivitas, eventually painted by Taddeo Gaddi (see p. 15 and Fig. 12): a payment is recorded to a certain Filippo di Lazaro for gilding (although not necessarily punching) the altarpiece ('per metere l'oro in nella taula'). The gold had previously been purchased in Florence; expenses for the hire of a horse are listed. On the other hand, during the decoration of the crypt of San Miniato al Monte, Florence, in 1342, Taddeo Gaddi was himself paid for the gilding of the capitals of some columns as well as for the painting of the choir ('dipigne e mette a oro i capitelli delle colonne').

The same 1533 additions to the Sienese guild statutes which indicate the existence of experts in the craft of gessoing, also list both gilders and stampers as if they were by then independent professions: 'all the

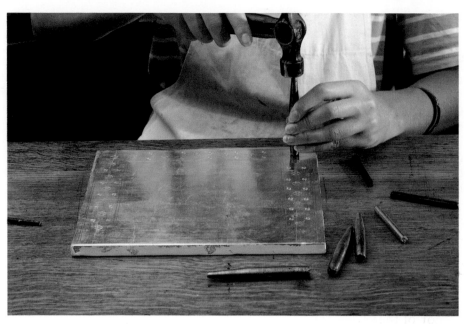

gilders of gold, of silver by brush or in whatever way, except by fire' ('Tutti li mettitori d'oro, d'argento a penello o in qual si vogli cosa, escetto che a fuoco') – presumably the plating of metal objects with molten precious metals – and 'all the stampers of all things, except the stampers of books ('Tutti li stampatori d'ogni cosa, escetto li stampatori di libri'). Again this may reflect earlier practice, but in the absence of further documentary evidence it seems reasonable to assume that in the fourteenth century the division of labour was still fairly flexible. Most painters were probably trained to gild and could do so if necessary, but for larger projects the gilding may often have been subcontracted, or separate arrangements made by the patrons, as in the case of the altarpiece in Pistoia cited above.

Plate 18 Executing punched decoration. In the foreground are some modern punches

The Paint Film

The pigments used in fourteenth-century Italy for panel paintings are described below (pp. 30–43). The painter was responsible for combining them with a medium to make them up into a paint and in many cases for their preparation and refinement into suitable materials for painting. Most pigments were obtained from apothecaries: some had alternative medicinal purposes but, judging by the materials listed in their statutes, apothecaries stocked materials for a wide range of professions and crafts (Plate 19). Occasionally the pigments were supplied direct to the painter by the clients, as for example

the pigments for the reverse of the *Maestà* (Cat. no. 3), but most painters probably retained a basic stock of pigments. Indeed the Sienese painter Luca di Tommè seems to have acted as a supplier of materials: in 1366 he sold pigments to the Sienese Cathedral authorities for the decoration of the vault of the Baptistery, and in 1374 he was paid for 934 sheets of gold leaf to be used by Ugolino Ilario for the choir of Orvieto Cathedral. When Maso di Banco had his property sequestrated in 1341 he lost not only the panels he was painting (see p. 15), but also his box of pigments ('una capsetta fulcita coloribus ad pingendum') and his stone slab for grinding the colours ('unus lapis actus ad macinandum super ea [sic] colores').

Both Cennino and the anonymous author of the more-or-less contemporary treatise on manuscript illumination, *De Arte Illuminandi*, devote sections to the selection of pigments and where necessary to their processing. Some, such as vermilion, were usually bought in a lump and subsequently pulverised; others, notably natural ultramarine, involved complex processes to extract the coloured particles from the mineral. While Cennino describes this extraction at length (see p. 35), it is quite likely that in major centres such as Florence and Siena the pigment was available in a powdered form. A few pigments could have been made by the artist's workshop: Cennino describes the making of vine and lampblacks, and the coloured earth pigments may sometimes have been dug by the artist himself (see p. 39). Only the ochres and sinopers were suitable for painting without further processing and appear to have needed no more than careful washing and grinding.

The grinding of pigments to remove lumps and to reduce the particle size was carried out on a hard stone slab – Cennino favoured porphyry, considering serpentine and marble too soft – using a stone with a flat bottom and dome-shaped top called a muller, also ideally made of porphyry (Plate 20). Initially the pigments were ground in water. As the liquid colours spread across the slab, they were scraped back towards the centre with a wooden slice. It was an arduous and skilled task since each colour needed a different amount of grinding: some, according to Cennino, needed half an hour or longer;

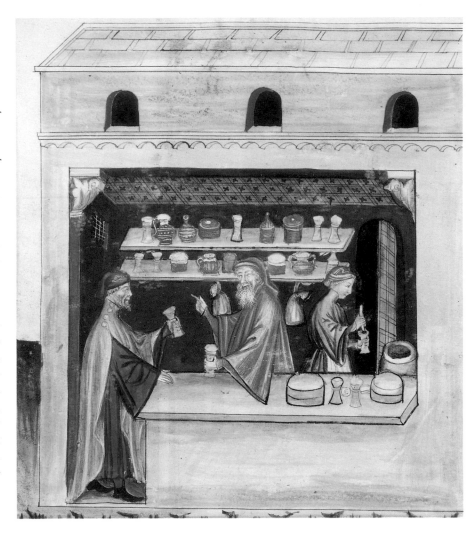

others, and in particular the expensive blue and green mineral pigments, could lose their colour and appear grey if ground down to too small a particle size. The colours were then stored in small jars or pots topped up with water to prevent them from drying out.

Because of the way in which egg tempera dries and sets (see below), the pigments ground in water could not be combined with the paint medium until the

Plate 19 An apothecary's shop. Fourteenth-century manuscript illumination from a *Tacuinum sanitatis*. Codex Vindobonensis, Series Nova, 2644. Vienna, Österreichische Nationalbibliothek

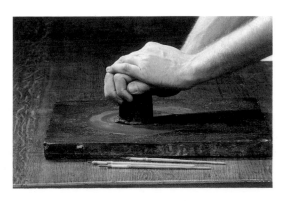

Plate 20 Grinding the pigments with water. In the foreground are some paint brushes resembling those described by Cennino

last possible moment before beginning to apply that particular colour. Cennino suggests the use of only the yolk of the egg for panel painting: whole egg seems to have been reserved for applying colours *a secco* in fresco painting. Different pigments need slightly different amounts of medium, but Cennino's recommended proportion of approximately equal volumes of egg yolk to pigment (bearing in mind that there is quite a lot of water with the pigment) makes a paint that is workable and dries to the correct, almost velvety, sheen.

The paint was applied to the panel using brushes made of the hairs from the tips of the tails of the minever or ermine, a member of the stoat and weasel family (*Mustelidae*) and related to the Russian sable which is now farmed to supply fur coats and high-quality paint brushes. Cennino gives directions on how to bunch the hairs together and to tie them into the quills of various-sized feathers to produce a range of brushes, the largest being that based on a vulture's quill and the smallest on a dove's feather. The quills were then trimmed and fitted on to turned wooden handles (Plate 20). Larger hog-bristle brushes were made in much the same way, but they were used mainly for fresco painting and for the application of the gesso.

Egg yolk is an emulsion consisting of droplets of fatty material suspended and emulsified in a matrix of egg proteins in water. The first stage in the drying of egg tempera paint is therefore the evaporation of the water, followed by the denaturing of the egg proteins to a hard waterproof film (familiar to anyone who has delayed the washing up of an egg-coated plate or utensil). The egg fats are largely non-drying in character and, in part at least, survive little changed, perhaps serving to plasticise the paint. Providing the pigment to medium ratio is correct, the resultant paint film is arguably the toughest and most long-lasting of all the media used for easel painting, hence the astonishing freshness (considering their age) of many of the works discussed here.

However, the way in which egg tempera dries affects its handling properties and restricts the techniques for its application. For example, unlike oil paint it cannot be thickly painted to achieve a

brushmarked, thickly textured surface because as the water evaporates the paint loses much of its bulk, shrinking and subsequently cracking and flaking from the gesso. Neither can it be blended or manipulated with the brush while wet: the tempera will simply peel away from the surface, often lifting with it any previously applied paint layers. The paint has therefore to be applied with some form of hatched or stippled technique, the modelling and blending of the colours being achieved by the painstaking application of layer upon layer of fine intermeshed brushstrokes (Fig. 22).

This demands a very organised and

Fig. 22 Macro detail of St John the Evangelist from *The Deposition* by Ugolino (Cat. no. 5), showing the hatched brushstrokes

systematic approach to painting. Conventions evolved to overcome the inherent difficulties in handling the medium. These include the method of modelling draperies from dark to light using carefully pre-mixed shades described by Cennino – discussed at greater length in the entry for Nardo di Cione's altarpiece (Cat. no. 6), the work which represents the most precise application of the technique – and the underpainting of areas of flesh paint with green earth (Plates 21 and 22). This was not completely obscured but was allowed to show through slightly in the shadows and mid-tones, giving the flesh a cool, greenish cast which is not so very unnaturalistic. The shadows were generally modelled in a greenish-brown pigment mixture called *verdaccio* and the highlights contained varying proportions of red or brown pigments mixed with lead white (see Cat. no. 4). In fact, in the sixteenth and seventeenth centuries when underpainting with green earth had long been out of use, Italian painters sometimes had to add green pigments to their flesh colours to give them the desired olive tint.

When paint samples from tempera paintings are made into cross-sections, the overlapping of the different tones can give a false impression of a complex multiple layer structure. This is particularly the case with paintings on a small scale where highlights and shadows lie close to one another (see Cat. no. 3). However, samples from two works, the Crucifix (Cat. no. 1) and the Santa Croce Altarpiece (Cat. no. 5), did reveal techniques of some optical sophistication. In the former the rich but flat unmodulated colours have been gradually built up by applying ever more saturated tones mixed with decreasing amounts of white; while the latter displays unusual effects achieved by superimposing semi-transparent colours over undercolours often based on quite different pigment mixtures. The upper paint layers cannot strictly be called glazes, since, because of its low refractive index, egg tempera does not form a completely transparent paint even when combined with low refractive index pigments such as the red and yellow lakes. For truly transparent and saturated glazes, oil and/or oleo-resinous media are needed. There is a possibility that oleo-resinous glazes were used on the Crucifix (Cat. no. 1) and on a

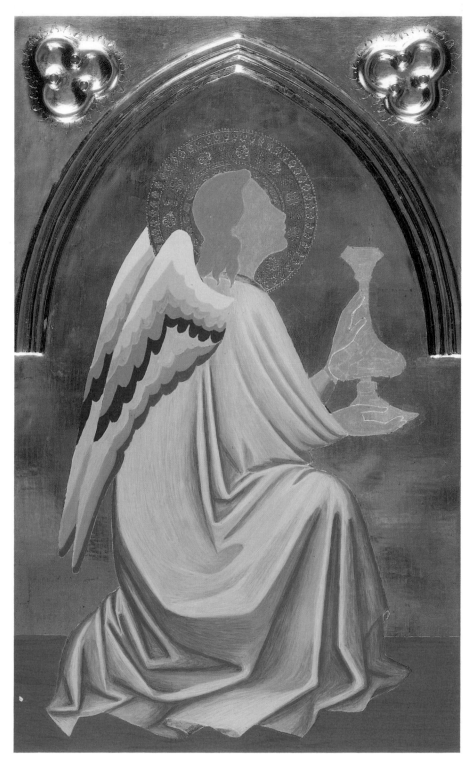

small area of the *Crucifixion* (Cat. no. 7), but in neither case could suitable samples be taken for identification of the paint medium.

As might be expected, medium analysis on samples of paint from panels by Duccio, Ugolino, Nardo and Jacopo di Cione (Cat. nos. 3, 5, 6 and 8) proved all to be egg tempera.

Plate 21 Reconstruction of the painting techniques described by Cennino, showing the underpainting of the flesh with green earth. The draperies have been painted using pre-mixed shades of colour. The wings and the floor covering have been painted over the gold in preparation for the technique of *sgraffito*

Pigments and Colour

The second section of Cennino's treatise begins with his discussion of the pigments available to painters, how they are ground and prepared for use, offering also helpful comments on their suitability and their drawbacks in various applications. The perennial concern of the painter to select materials which will undergo the minimum changes with time is reflected in the author's judgements on the stability of the pigments he prescribes; he also specifies the best pigments for particular painting techniques. By the 1390s when the treatise was compiled, Cennino had clearly been influenced by the effects of time on the pigments and materials used by his predecessors. Red lead, for example, is correctly stated to be 'good only for working on panel, for if you use it on the wall it soon turns black . . .', and equally soundly, when referring to arzica, a pigment probably based on a vegetable yellow, he observes: 'It fades in the open; it is not good on the wall; it is alright on panel.' In this way, although there are pigments such as ultramarine which are guaranteed to be universal in application, those to be applied in fresco are generally distinguished from those for panel painting and for the manuscript illuminator working on parchment.

The treatise is particularly useful in directing us to the core of the materials and practices of the fourteenth century, and the examination of the panels described in this catalogue reveals the use of all the main pigments described in Cennino's chapters that refer to panel painting. The scale of the work, the importance and cost of a commission as well as the individual preferences of a particular workshop all bear on the choice of palette in any painting or group of paintings. But there is a consistency of pigment selection and combination underlying a tradition of panel painting practice that extends beyond Cennino's account. For example, pigments of the strongest colour and purity of tone, particularly deep blue ultramarine from lapis lazuli and brilliant scarlet vermilion, set against gilded backgrounds were widespread in their appeal. Others such as the opaque yellow artificial pigment called *giallorino* and the manufactured red tetroxide of lead (red lead, or *minium*) seem to have peculiarly Florentine connections.

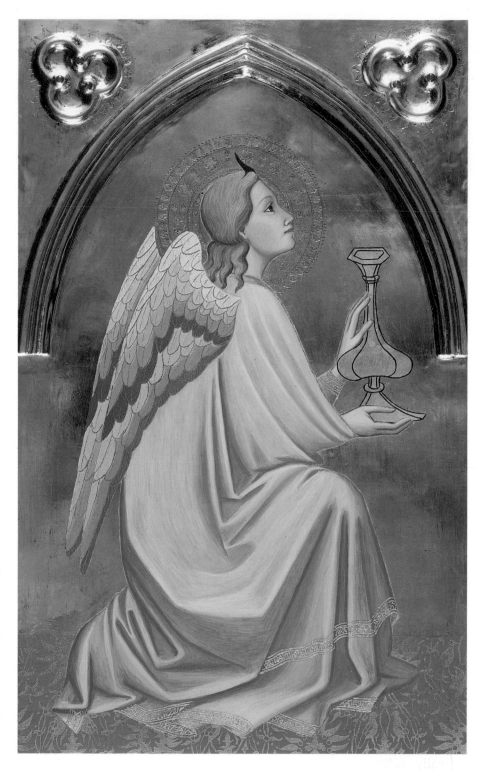

Certain colours were the products or by-products of technologies not directly connected with the craft of painting. There was a close relationship between the textile dyeing industry in fourteenth-century Florence and the manufacture of red lake pigments: scale-insect dyestuffs were employed in both arts. Similarly, Florentine coloured glass production is likely to have

Plate 22 The completed reconstruction, with the flesh tones modelled over the green earth. The pattern of the floor covering and the feathers have been scratched into the paint to reveal the gold beneath

been the origin of the yellow pigment *giallorino* as an artists' material. Siena, by contrast, was rather better placed for naturally occurring pigments, with supplies of good quality blue mineral azurite, and a variety of earth pigments, close to hand. Both these centres would have relied to a greater or lesser extent on the ports of Venice and Genoa, and perhaps also Pisa, for the more exotic imported materials – lapis lazuli from Afghanistan to provide ultramarine, gum lac from India, indigo imported via Baghdad, and so on.

With the exception of materials based on more recent synthetic dyestuffs, the modern categories of artists' pigments were in common currency for panel painting in the fourteenth century. These consisted in the first instance of pigments from natural mineral or earthy deposits; secondly, of artificially prepared colours of an inorganic character (some were the chemical equivalents of mineral materials while others had no naturally occurring counterparts); and lastly, coloured materials derived from plant or animal sources, often further processed to make pigments suitable for painting. The mineral pigments ultramarine and azurite, as well as earths such as yellow ochre and green earth, come within the first category. Artificial vermilion, chemically identical to the mineral cinnabar, and lead white, red lead, *giallorino* and verdigris, none of which occurs in nature, belong to the second category. Plant resins such as 'dragonsblood' and plant and insect dyestuffs such as indigo, weld, lac and kermes, many of which were used to prepare lake pigments, fall within the third group.

Cennino's own classification is quite simple. He says: 'Know that there are seven natural colours, or rather, four actually mineral in character, namely black, red, yellow and green; three are natural colours, but need to be helped artificially, as lime white, blues – ultramarine, azurite – *giallorino*.' This is not entirely accurate, and is included by Cennino only as a learned reference to Classical colour theory, for he soon passes on to a thoroughly practical account of a good many more than the seven pigments of an ideal palette. Gold and silver are not included in this section of the treatise, but they play an important part in the overall conception of colour on panel paintings.

Reds: opaque and translucent

The well-understood synthesis of **vermilion** (red mercuric sulphide, HgS) as an alchemical art in Europe from at least the eighth century ensured the availability of a pigment of the most powerful red colour for painting on panel (Plate 23). So familiar was artificial vermilion in Cennino's time that he dismisses its preparation as 'too tedious to set forth . . . you will find plenty of receipts for it, especially by asking the friars'. He does bother, however, to 'teach you how to buy it, and to recognise the good vermilion'. The main method of preparation involved direct combination of metallic mercury with sulphur in a heated retort, followed by sublimation (condensation of the vapour) on a colder surface. The pigment collects as a dark red formation which when split open has the radiating pencil-like structure often seen in cinnabar, its mineral form. It is the most delicate part of this structure that Cennino says is the best, and he suggests it should always be bought in unbroken lump form, since it is 'generally adulterated either with red lead or with pounded brick'. Nevertheless, the accounts for the frescoes in the Chapel of San Jacopo in the Cathedral in Pistoia (see p. 8) include payments for ready-ground vermilion ('incinabri macinati').

Vermilion was prepared for painting by grinding very finely with water before tempering in egg, and was generally held in high regard as one of the most useful, stable and pure-coloured pigments. Samples confirm a very small regular particle size in the paint films, with only occasionally larger crystalline fragments present. Natural cinnabar seems neither to have been recommended nor used for panel painting, but if it were also very finely ground it would be difficult to distinguish from artificial vermilion.

Vermilion in egg tempera is completely opaque. It was a pigment of sufficient chromatic purity and forcefulness to be regarded as a natural counterpoint to ultramarine and to gold. Used rather pure, although occasionally shaded in outline with more translucent red lake pigments, it forms the unbroken vivid red draperies of the San Pier Maggiore Altarpiece (Cat. no. 8). On these panels the vermilion is sometimes highlighted with orange-red brushstrokes containing red lead (see below). The *Crucifixion* ascribed to Jacopo di Cione provides one of the clearest examples of solid vermilion drapery painting, as well as vermilion set alongside red lead and ultramarine for the patterned floor coverings within the four compartments to the left and right of the main scene. The small panel ascribed to Giotto (Cat. no. 2) makes use of pure vermilion and azurite for the red and blue mosaic decoration of the architecture, and vermilion also in one of the disciples' draperies. The examples from Duccio and Ugolino here show more sparing use of the pigment for drapery painting, but it does occur, particularly as small areas in the Ugolino predella panels (Plate 24).

The other application for vermilion is not so easily deduced by eye. It is the tinting pigment with lead white used almost without exception for the painting of flesh, just as Cennino prescribes.

The confidence in the stability of vermilion in egg tempera was misplaced. Many of the formerly scarlet draperies are marred by a surface film of black or dark purplish grey, the unfortunate product of a colour change to which vermilion is subject, particularly when bound in aqueous media. This discoloration is the result of a physical change in the crystalline structure of the pigment, where the material is transformed from a red to a black form, but generally only on the surface. The effects of light seem to be in part responsible for this darkening, but pressure and friction are known also to induce the change. It is possible that vigorous grinding of the pigment during its preparation for painting predisposes the red pigment to turn to the black form after a period of exposure to light. The black product merely coats the surface of the red particles, but is so opaque and dark that the effect is quite dramatic. The discoloration

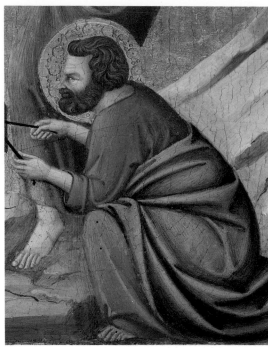

Plate 24 Detail from *The Deposition* by Ugolino (Cat. no. 5) showing the use of vermilion

can be seen in perhaps its most severe state in the turned-back lining of St James's vermilion robe on Nardo's altarpiece (Cat. no. 6) and in the book-cover on the same panel.

A second artificial pigment, **red lead**, which ironically had a less sound reputation for stability than vermilion, has generally held up rather better in egg tempera medium. Cennino dismisses it briefly as 'manufactured by alchemy' and 'good only for working on panel'. It seems to have been a fairly regular component of the Florentine palette, frequently set against the more fiery scarlet of vermilion paint. Red lead is chemically lead tetroxide (Pb_3O_4), made by heating another artificial pigment, lead white (see below), while stirring with an iron rod. It ranges in colour from brick red to a quite bright orange, depending on the conditions of preparation. The use of this pigment is shown to best advantage in the *sgraffito* floor-covering of the Nardo di Cione altarpiece (Cat. no. 6), where an orange-coloured specimen of lead tetroxide is used for a large area of the background design. It seems here to remain virtually undiscoloured. It may be that the orange tone of *minium* was specifically sought, since curiously, Cennino gives no direction for mixing orange colours from red and yellow.

The second important category of red pigments is quite different in character and composition to vermilion and red lead. These are the **lake pigments** for which a red dyestuff is absorbed on to, or co-precipitated with, a colourless base material or substrate. Early recipes make it clear that considerable variation in the sources of the red dyestuffs, in the chosen substrate and in the method of preparation were possible. The overriding characteristic of lake pigments is their relative translucency when combined with the painting medium, allowing their use as glazes (Plate 25). The optical properties of a dried egg-tempera paint film are such that the fullest transparency of these pigments cannot be exploited; the best developed lake glazes are seen only with the later introduction in Italy of the oil medium for painting. However, some of the rather richly coloured translucent red draperies in works by Jacopo di Cione are made simply of a single layer of pure red lake glazed over a thin white underpaint of lead white to assist the luminosity of the surface colour.

In common with all pigments which make use of dyestuffs as the colouring matter, red lake pigments are vulnerable to fading on exposure to light, and this was understood in Cennino's time. When lakes are used in pigment mixtures rather than as glazes, their propensity to lose their colour is reduced, and a number of the panels shown here have pink draperies painted in lead white tinted with red lake pigment, the colour apparently surviving perfectly well. The pink draperies in the Giotto *Pentecost* (Cat. no. 2) and of St John the Baptist in Nardo's altarpiece (Cat. no. 6) provide good examples of the technique. Many of the lilac draperies in the San Pier Maggiore Altarpiece involve mixtures of red lake, ultramarine blue and lead white, without any obvious change in the freshness of the colour.

By the end of the fourteenth century one of the main methods of preparation for red lake pigments made use of clippings of red dyed cloth from which the colour was re-extracted by boiling with aqueous alkali and alum. From this solution the lake pigment separates out by precipitation, and was carefully washed and dried before use. In the process the red dyestuff attaches itself to a substrate of hydrated alumina.

Florentine textiles dyed with the red colour secreted by a Mediterranean species of scale insect, kermes (*Kermes vermilio* Planch.; Plate 26), seem to have been the source of these glazing pigments. It was not the only species available: other insects such as Polish cochineal (*Porphyrophora Polonica* L.) may also have been used. Cennino is doubtful of the permanence of this kind of lake, warning that 'it is very attractive to the eye. Beware of this type . . . [it] does not last at all, either with temperas or without temperas, and quickly loses its colour.' Instead he recommends red lake prepared specially for painting made from imported gum lac, the secretion of the Asian scale insect *Kerria lacca*. Lac lakes prepared directly as pigments were probably the most widespread for painting on panel, but were less richly coloured and purplish in tone than those prepared from textile shearings.

In addition to scale insect sources, there were red dyestuffs available from several species of *Caesalpinia* or 'brasilwood', dyewoods from parts of Eastern Asia. These seem to have been prepared as lakes (*verzino*) from quite early times. Combinations of lakes were also made. Cennino, for example, suggests the addition of both lac and brasilwood lakes to improve the colour of ultramarine by enhancing its slightly violet undertone.

The base material or substrate for the red dye in these lakes was also varied. When alum was included in the preparation, the substrate formed was hydrated alumina. Calcareous substrates were also employed, particularly from one or other source of calcium carbonate, for example crushed eggshells, marble dust or chalk. Calcium sulphate in the form of gypsum, the material also of gesso grounds, was considered suitable, and a white clay,

Plate 25 Fragment of a red lake glaze from the San Pier Maggiore Altarpiece (Cat. no. 8) by transmitted light. Magnification, 125×

Plate 26 Some of the sources for the dyestuffs used in red lake pigments: top left, chips of brasilwood; top right, kermes on the leaves of *Quercus coccifera*, an evergreen oak. A waxy coating secreted by the insects gives them a whitish colour. In the foreground is lac on a twig of the host tree (species unknown). In this form it is known as stick lac

perhaps china-clay, is recorded as a lake pigment substrate.

Another fully organic colour is noted by Cennino in the context of illumination on parchment. It is a red resin, known as **'dragonsblood'**, an exudation from the damaged branches of *Dracaena* species (*Liliaceae*) found, for example, on the island of Socotra in the Indian Ocean. Its role in panel painting was probably quite limited, perhaps only as a glaze in a varnish medium to embellish gilding. The tongues of flame painted over the disciples' haloes in the small Giotto *Pentecost* (Cat. no. 2) are likely to be 'dragonsblood', but positive identification in microsamples is difficult. No other example seems to occur on the pictures shown here, and its fugitive nature must have limited the usefulness of the material for panel painting.

The final reds of importance in this period are **red earth pigments** in various forms; all contain ferric oxide (Fe_2O_3) as the colouring matter. These are painting materials known from Antiquity, and deposits of high quality red iron oxide were abundant in the Mediterranean region. The prototype pigment is 'sinopia' or 'sinoper', a fairly pure earthy form of anhydrous ferric oxide. Many sources and qualities are known, differing mainly in the relative translucency imparted by mineral impurities found in the deposit. Red bole for gilding (see p. 21) might be regarded at one extreme of the range of composition, where clay-like minerals exceed the iron oxide content. Cennino says of sinoper: 'It stands working up well; for the more it is worked up, the finer it becomes. It is good for use on panel or anconas, or on the wall, in fresco or in secco.' Earth pigments in general are not greatly used for large areas of colour on panel paintings since their tone is often a little weak in comparison with the brighter components of the palette such as vermilion. The attraction is their adaptability to different painting techniques and their great durability.

A crystalline mineral form of anhydrous iron oxide known as haematite is also mentioned by Cennino for two purposes: to be ground up as a pigment for fresco painting, and to be shaped into small 'crooks' for burnishing gold leaf on panel. Haematite is extremely hard with a deep brownish-purple tone; a colour often seen in fresco but less frequently on panel. The more muted tones of earth pigments limited their application in panel painting, although particles of red iron oxide are frequent components of certain flesh paints and are also used in the depiction of hair. The Ugolino panels (Cat. no. 5) are an exception, since here there is a more prominent use of earth colours, including red, for the less highly coloured draperies which are set against those based on chromatically brilliant pigments. Red earth occurs also in backgrounds, for example in the brownish-pink architectural setting of Duccio's *Annunciation* (Cat. no. 3a) and as a continuous layer beneath the yellow-green background in the Giotto *Pentecost* (Cat. no. 2).

Blue: ultramarine and azurite

Among the pigments available to painters in Italy in the fourteenth century, one is pre-eminent as the most precious and sought-after of all the traditional artists' materials. It is genuine **ultramarine**, a blue mineral extracted from the semi-precious stone – lapis lazuli (Plate 27). Ultramarine offers a most desirable pigment: it is a blue of unequalled purity and enduring intensity of colour; it can be used safely in a great variety of painting media; and it is sufficiently transparent to be suitable as a glazing pigment while also

Plate 27 Polished specimen of lapis lazuli from Badakshan, Afghanistan. London, British Museum (Natural History)

retaining a high tinting strength when mixed with white and other pigments (Plate 28). These qualities were well appreciated not only by artists but also by their patrons. Many contracts for commissions specified the use of genuine ultramarine, providing sometimes for separate payment to cover the high cost of the pigment. Cennino's praise of ultramarine was characteristically enthusiastic: 'Ultramarine blue is a colour illustrious, beautiful, and most perfect, beyond all other colours; one could not say anything about it, or do anything with it, that its quality would not still surpass.'

Ultramarine was very expensive, more so than pure gold. Not only was lapis lazuli a rare imported commodity, the pigment had also to be extracted by a long and laborious process which yielded merely a small fraction of the weight of the stone from which it came. The only known source for lapis lazuli (before other discoveries of the mineral in the nineteenth century) were famous ancient quarries at Badakshan, in what is now north-eastern Afghanistan. This site was visited and described by Marco Polo in the latter part of the thirteenth century. An overseas origin for the pigment is implied in the name *azzurro oltremarino* which distinguishes it from the second mineral blue pigment, azurite, called *azzurro dell'Allemagna*, *azzurro citramarinum* and by other names.

It is insufficient merely to crush lapis lazuli to prepare the pigment in high-quality form, even if the colour of the specimen of the stone is strong. The blue fraction, a mineral called lazurite, requires to be separated from the colourless materials, particularly calcite, with which it always occurs in lapis lazuli. Several processes to achieve this were developed in Europe in the thirteenth century, but the technique described in great detail by Cennino represented the most successful general method. The essentials involved pulverising lapis lazuli, selected for its good colour, in a bronze mortar, followed by dry grinding on the slab. Cennino warns against excessive grinding since this results in a final product lacking the violet undertone which was much admired in the pigment. The powder was then combined with a melted mixture of pine rosin, gum mastic and beeswax and kneaded into a

Plate 28 Particles of ultramarine extracted from the mineral lapis lazuli. Transmitted light. Magnification, 320×

plastic mass which would be worked daily over a period of two to four weeks. To extract the blue pigment itself, this 'dough' was manipulated with a pair of sticks in a basin containing ley (an alkaline solution of potassium carbonate made by extracting wood ashes with water). The ultramarine particles floated out of the wax-resin ball and the pigment was collected by decanting the ley and allowing the blue to settle out. The process continued with fresh ley in stages, until no more of the ultramarine blue appeared. Cennino points out that the first extractions yielded the finest quality pigment, subsequent fractions containing increasing proportions of colourless mineral impurities. The earlier extracts were combined to make the best grade and subsequent extractions collected to make intermediate qualities. The last extracts are pale coloured and greyish, but this product was not discarded, rather it was treated as a distinct pigment called **biadetto d'oltremare** and reserved for particular painting purposes. The greyish-blue harnesses of the horses in the Jacopo di Cione *Crucifixion* (Cat. no. 7), for example, seem to be painted with

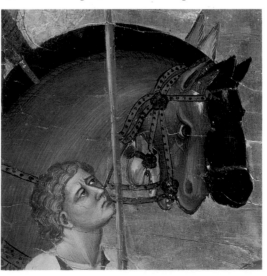

Plate 29 Detail from *The Crucifixion* by Jacopo di Cione (Cat. no. 7), showing the use of 'ultramarine ash' on the harness

35

this rather than with the high-quality pigment (Plate 29). As the name *biadetto* translates as 'bluish' (derived from *biado* or *biavo* meaning light blue), it can be applied to any of the less intensely coloured blue pigments, including the artificial copper blue pigments, described in, for example, the Bolognese Manuscript. Only when it is specifically described as *biadetto d'oltre-mare* can it be identified with the final extraction of ultramarine from lapis lazuli which is now commonly called 'ultramarine ash' (see Appendix III).

The mineralogical constitution of lapis lazuli and the chemical structure of lazurite itself are complex. It is therefore not surprising that ultramarine was not duplicated synthetically until the nineteenth century with contemporary refinements in chemical analysis. Until then the natural pigment had held the imagination of European painters for six centuries; for some it amounted almost to an obsession. The geological conditions required for the formation of lapis lazuli are unusual, and this accounts for its scant supply. Lazurite is unique among artists' pigments in the origin of its intense blue colour and its tendency also to reflect some red light. The colour of the particles arises from the entrapment of unstable polysulphide radical anions within the three-dimensional basket-like aluminosilicate framework of the mineral's crystal structure. The composition of lazurite corresponds roughly to $(Na,Ca)_8(AlSiO_4)_6(SO_4,Cl,S)_2$, but the true origin of its colour has only quite recently been established.

Many of the paintings in this catalogue show the use of genuine ultramarine, sometimes very lavishly applied. Ultramarine is often used for the intensely coloured blue draperies of the iconographically most significant subjects, particularly Christ and the Virgin, but there are subsidiary roles for the pigment as well. The exceptions are the panels by Ugolino where a distinctive palette calls for the more greenish-blue pigment azurite (see below), in place of ultramarine. The colour quality of ultramarine is best appreciated when it is mixed with some white. Where it is used on its own as an egg-tempera glaze, the tinting strength is so high that a very intense deep blue paint film results, often further darkening with age. The pigment particles themselves in

these darkened blues are remarkably stable and generally very well preserved.

Combined with white, ultramarine blue is the pigment of the Cross in the Crucifix attributed to the Master of St Francis (Cat. no. 1), and of the Virgin's vivid blue mantle in the Duccio *Virgin and Child with Saints* (Cat. no. 4). The three *Maestà* panels included here all make use of high-quality natural ultramarine blended with varying quantities of lead white: for the Virgin's robe and the angel's dress in the *Annunciation*, and for Christ's deep blue cloak in both *Jesus opens the Eyes of a Man born Blind* and the *Transfiguration* (Cat. nos. 3a, b and c). Perhaps the finest effect of the pigment is to be seen in St James's blue drapery on Nardo di Cione's altarpiece (Cat. no. 6) and in St John the Baptist's turned-back cloak on the same panel. The San Pier Maggiore Altarpiece (Cat. no. 8) also makes use of much ultramarine in its drapery painting, both in tint with white for the light blues and unmixed for deep blue glazes. St Peter's robe on the main panel is a striking example of ultramarine combined with white, while the Virgin's robe on the *Pentecost* provides a clear case of the glaze-like technique. A less prominent role for the pigment can be seen, for example, in the painting of the tunics and stockings of the sleeping soldiers in the *Resurrection* (Cat. no. 8).

On Giotto's panel of the *Pentecost* (Cat. no. 2) the method for the blues is rather different. The centre disciple's blue-green cloak is painted mainly in azurite with only the thinnest surface glazes of natural ultramarine to heighten the colour. This is a technique Cennino suggests for fresco painting, but it was sometimes used as a way of economising on the quantity of ultramarine needed for a passage of painting on panel.

Mineral **azurite** (Plate 30) used on its own is the other important blue pigment for painting in egg tempera on wood. It is an ore of copper, chemically a basic carbonate, with the composition $2CuCO_3.Cu(OH)_2$. There are deposits of azurite in Italy, southern France, Spain, and particularly in Germany which was the main source for the pigment in the fourteenth century. Cennino says that azurite is 'a natural colour which exists in

and around the vein of silver' and that it occurs extensively in Germany, the common name *azzurro dell'Allemagna* indicating this origin. Azurite was also called *azzurro della magna* suggesting the connection with mined deposits in mountainous regions.

The pigment was prepared for painting simply by selection of specimens of ore of good colour, and by grinding with water or ley, rather coarsely, as Cennino says, 'because it is very scornful of the [grinding] stone.' If too finely worked up, azurite becomes pale and poor in its covering power. Many of the paint samples containing azurite that have been taken for this study show large angular particle sizes for the pigment. The colour of azurite varies considerably from a deep faintly greenish blue to pale blue with a pronounced green tinge, far less satisfactory as a pure blue than natural ultramarine (Plate 31). Accordingly, azurite was often used in mixed greens where yellow pigments were combined (see below). Examples can be found on the San Pier Maggiore Altarpiece and the small altarpiece of the *Crucifixion* ascribed to Jacopo di Cione.

Pure azurite is the blue for the draperies in the panels from Ugolino's Santa Croce Altarpiece, where its slightly greenish tone is evident. King David's cloak provides a clear example (see Cat. no. 5) as well as several smaller-scale draperies on the predella panels. The pigment occurs too as a final modifying layer for the construction of greens in this altarpiece, over green earth for Moses' cloak (see Cat. no. 5) and in conjunction with yellow ochre and yellow lake pigments elsewhere. Azurite is the only blue pigment that appears to have been used for this group of panels, also finding an application in mixture with red lake pigments for the muted lilac and deeper mauve draperies (see also below). The foreground figure to the right clothed in greenish blue in the Giotto *Pentecost* (Cat. no. 2) is painted in mineral azurite, with the smallest touches of ultramarine in the folds of the drapery, while the very dark blue mosaic pattern above is azurite alone.

Yellows: artificial and natural

A single bright yellow opaque pigment is a common feature of the Florentine panels, and is identifiable with a material Cennino

Plate 30 Mineral azurite

Plate 31 Particles of natural azurite by transmitted light. Magnification 320×

calls **giallorino**, the diminutive signifying pale yellow. He describes it thus:

> A colour known as *giallorino* is yellow, and it is a manufactured one . . . This colour is used in fresco, and lasts forever, that is, on the wall; and on panel, with temperas . . . And as I understand it, this colour is actually a mineral, originating in the neighbourhood of great volcanoes; so I tell you that it is a colour produced artificially, though not by alchemy.

This contradictory statement regarding the pigment underlies a confusion as to its origin that has been repeated and compounded in painting treatises until recent times.

The chemical composition and structure of *giallorino* is now known by modern methods of crystallographic analysis to be an artificially produced compound of lead and tin oxides, containing silicon as an essential constituent ($Pb(Sn,Si)O_3$). The modern name is **lead-tin yellow 'type II'**, to distinguish it from another lead-tin oxide artists' pigment, 'type I', which has a distinct crystal structure and was made in a different way. Recent research has shown that of the two varieties of lead-tin yellow, 'type I' may have its source in the technol-

ogy of yellow and white ceramic glazes, whereas 'type II' is related to the production of yellow glass. This origin for 'type II' is suggested by the occurrence of the pigment in fourteenth-century panel paintings from Florence and from Bohemia, both of which were glass-making centres. Further evidence is provided by contemporary treatises concerned largely with coloured glass – that of Antonio of Pisa and an anonymous manuscript published by Milanesi in 1864. Recipes in the Bolognese Manuscript of the early fifteenth century also note the manufacture of 'yellow glass for paternosters or beads' involving heating lead and tin together in a furnace, followed by a second stage 'to make *zallolino* [*giallorino*] for painting', which specified roasting the yellow glass with *minium* (red lead) and finely ground sand from the Arno Valley. This process would have produced the compound now termed lead-tin yellow 'type II'.

To confirm a connection with glassmaking, lead-tin yellow 'type II' is also found in Venetian sixteenth-century painting, whereas it seems to have fallen into disuse elsewhere. Venice was at this time a centre for production of coloured glass, particularly enamel glass. In Venetian pictures of the sixteenth century, both forms of lead-tin yellow occur. 'Type I' was probably introduced to Italy from Northern Europe in the fifteenth century.

Cennino's statement regarding an origin 'in the neighbourhood of great volcanoes' is almost certainly a reference to Naples, and there is documentary evidence from a fourteenth-century manuscript known as *De Arte Illuminandi* that *giallorino* was being made there, again in connection with glass-making ('et aliter fit ex vitro et vocatur giallulinum').

The association with Naples and the mistaken opinion that the pigment was a mineral rather than a manufactured material has come down to us in the technical literature on painting. The problem was partly one of terminology and partly of chemistry. To complicate the history further, yet another artificial opaque yellow artists' pigment, which came to be known as Naples yellow, began to be used in painting in Italy from the early seventeenth century. This was made in a similar way to lead-tin yellow, but contained antimony in addition as a main consti-

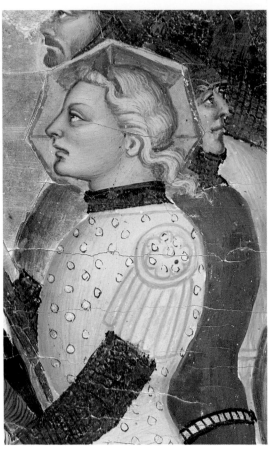

Plate 32 Detail from *The Crucifixion* by Jacopo di Cione (Cat. no. 7), showing the use of lead-tin yellow 'type II' (*giallorino*)

tuent, developing in later paintings into a pure antimonal yellow from which the tin was omitted. From the seventeenth century the literature on painting, particularly secondary sources, seems misleadingly to describe *giallorino* as Naples yellow.

Giallorino, crystallographically identified as true lead-tin yellow 'type II', is well represented in the paintings ascribed to Jacopo and Nardo di Cione. All the bright, daffodil-yellow draperies of the San Pier Maggiore Altarpiece are painted in this pigment, St Peter's robe on the main panel providing the clearest example. *Giallorino* is mentioned in documents relating to the commission. The light yellow robes of the foreground figures in the *Crucifixion* (Cat. no. 7) are the same composition in the lights, shaded with yellow or orange-coloured earth pigments and reinforced with yellow lake (Plate 32). The *cangiante* green and yellow draperies combine *giallorino* and azurite, while in others the yellow is replaced by a yellow lake pigment (see below). In the same way Nardo's almond-green shot drapery for St John the Evangelist (see Cat. no. 6) makes use of an unusual combination of ultramarine and lead-tin yellow 'type II'.

This type of lead-tin yellow also occurs in the Giotto panel, for the flat greenish-yellow background colour, but it is entirely absent in any form in Duccio and Ugolino, where the yellows are either ochreous or lake pigments.

Yellow lake pigments prepared in ways similar to those for red lakes were widely used, most commonly occurring in pigment mixtures for greens (see below), but sometimes also added to strengthen the colour of yellow ochre. Cennino mentions only a single yellow which may be a lake, calling it '*arzica*'. There is some uncertainty in early technical writings on painting regarding the identity of this yellow, but Cennino says that it is used 'more in the neighbourhood of Florence', that it is a 'very thin colour . . . [and] fades in the open'. He recommends *arzica* for making green by combining it with azurite and *giallorino* to work on panel. The evidence is that *arzica* is a lake prepared from the yellow dyes produced by the weld plant (*Reseda luteola* L.; Plate 33), although later sources, for example the Paduan Manuscript (see Bibliography), give recipes for yellows prepared in a similar way from buckthorn berries (*Rhamnus* spp.). As with red lake pigments, a number of different base materials to support the yellow dyestuffs were used; some were calcareous, others contained mainly hydrated alumina, derived from rock alum. Lead white as a substrate was another possibility; this would give an opaque pigment.

On the whole the yellow lakes seem not to have been used on their own, but rather were incorporated into mixtures with other pigments. A number of the duller yellow draperies are worked in yellow or yellowish-orange earth pigment lent a more powerful hue by the addition of yellow lake. The drapery of the foreground figure to the left in Giotto's *Pentecost* (Cat. no. 2) may be cited as an example; similarly the robe worn by St Peter on the *Pentecost* by Jacopo di Cione (Cat. no. 8) and the translucent brownish-orange decorative bands on the draperies of the main panel of the San Pier Maggiore Altarpiece. In these cases the lake has an orange-yellow tinge.

Yellow lake pigments are, however, generally rather cold and acid in tone, and combined with blue mineral azurite make suitably powerful greens for drapery painting. The San Pier Maggiore Altarpiece reveals a number of cases of this technique; the draperies of St Stephen on the main panel (Cat. no. 8) and of the foreground figure with a sword to the right on the *Pentecost* (Cat. no. 8) are good examples. The green and bluish-green passages in the *Crucifixion* (Cat. no. 7) are closely similar in their method, although the lightest yellow-green brushstrokes contain *giallorino* in addition to the yellow lake pigment. Certain of the greens in works by Ugolino di Nerio also make use of yellow lakes, for example the robes of Sts Simon and Thaddeus in Cat. no. 5, where in the first case a yellow glazing pigment incorporating azurite passes over a layer of yellow earth, and in the second, the same mixture is painted over a thin layer of white.

The role of **yellow ochre** pigment for painting on panel mirrors that for the red earths. The pigment characteristics are similar, and the colour was considered not strong enough on its own for key parts of a composition. Cennino knew it to be a natural pigment, and recounts a visit with his father to a local valley where he 'beheld seams of many kinds of colour: [yellow] ochre, dark and light sinoper, blue and white', and goes on to describe the fine quality of the yellow earth at this site.

Yellow ochre is composed of hydrated iron oxide ($Fe_2O_3.H_2O$) and, like its red counterpart, contains also a range of mineral impurities. More orange and brownish varieties are possible. It is entirely stable both for fresco and in egg tempera on panel. Certain functions for the pigment, particularly in association with yellow lake, are mentioned above. Yellow ochre occurs also in the translucent greenish-khaki pigment mixture known as *verdaccio*, in which ochre is combined with lead white and one or other form of black. *Verdaccio* forms the greenish-brown shadowing for the painting of flesh. On some of the smaller panels of the San Pier Maggiore Altarpiece it has been used in the darker olive-brown foreground and foliage colours painted over a layer of a vegetable black pigment.

Cennino and other contemporary writers mention another yellow for painting on

Plate 33 Weld (*Reseda luteola* L.), one of the sources for dyestuffs used in yellow lakes

panel. This is **orpiment**, the trisulphide of arsenic (As_2S_3), which occurs in mineral form but was also artificially made as an artists' pigment. It was never a popular painting material, partly because of its poor stability, but mainly on account of its very poisonous nature. No example of orpiment occurs on the panels discussed here, the requirement on the palette being met by *giallorino*, a variety of yellow lakes and by yellow earth pigment.

Mauve: colour mixtures

No single violet-coloured pigment was available for painting on panel, although a range of shades of mauve was desired, particularly for drapery painting. This lack was solved by using combinations of red and blue pigment often diluted with white to give light pastel lilac-coloured tints. There were two main methods. The first consisted of glazing or scumbling a layer of blue pigment over a pink underpaint comprising red lake mixed with white, the reflected light from both layers producing the mauve colour (see Cat. no. 5). The second method was more direct; it involved simply mixing red lake pigment, together with either ultramarine or azurite, and adjusting the lightness with white. The proportions of the three pigments were carefully varied in order to get the middle tone, light and shadow values. The lilac draperies on the San Pier Maggiore Altarpiece reveal this practice most clearly. In the examples examined here, the red component is invariably a strongly coloured red lake pigment, never vermilion or red earth, either of which would have resulted in a denser and brownish-violet tone. The chosen blue was ultramarine or azurite; the white always lead white.

Ultramarine with red lake and white gives the most vibrant mauves and lilacs, in which the slightly violet tinge of the best ultramarine is exploited. Some draperies, for example in the *Crucifixion* by Jacopo di Cione (Cat. no. 7), are essentially painted in ultramarine and white, shifted slightly in tone towards lilac by the addition of very small quantities of red lake. The azurite-containing mixtures are different in effect, the greener blue of the pigment imparting a greyer, more muted tonality to the mauves. This method can be seen in Ugolino's Santa Croce Altarpiece, for which the draperies are painted as scum-

bles of azurite over pink underpaints. St Bartholomew's cloak is an example (Cat. no. 5). Where a similar complex layer structure is found, but the blue pigment is ultramarine, as in the shadows of the angel's cloak on the Duccio *Annunciation* (Cat. no. 3a), the distinction in colour is made plain.

On the Crucifix attributed to the Master of St Francis (Cat. no. 1), Christ's mulberry-coloured loin-cloth, decorated with lines of mordant gilding, is unique in technique, painted as a glaze of pure red lake over a solid mauve of ultramarine, red lake and white.

Green: pure pigments and colour combinations

Painters have always found some technical difficulty in depicting intense greens, since no single strongly coloured pigment was available, or sufficiently stable, to fulfil all requirements. Instead, mixtures were usually made, essentially of the range of blue and yellow pigments but also sometimes incorporating other colours, particularly black and white, to adjust tone. Certain of these techniques are mentioned below, and in the section under yellow pigments.

One true green pigment does, however, play an important role in fourteenth-century painting. It is the natural earth pigment called **green earth** or **terre verte** (*terra verde*), which takes its colour from one of two green-coloured complex aluminosilicate minerals containing as characteristic constituents iron, potassium and magnesium (Plate 34). The minerals are glauconite and celadonite and arise from quite different geological conditions. Glauconite is ultimately of marine sedimentary origin, while celadonite has its source in deposits associated with volcanic activity. Cennino, who describes the pigment as a versatile, stable colour, would not have been able to distinguish these two varieties, and it is difficult even by modern analytical methods, since their structures and compositions are very similar. There is no fixed constitution for green earth; clay-like and silicaceous mineral grains always occur in the deposit with the glauconite or celadonite, rendering the pigment generally poor in colour and slightly greasy in nature. This unctuous quality arises from the clay mineral con-

Plate 34 Particles of green earth by transmitted light. Magnification, 130×

tent, much in the way that red bole for gilding is slightly slippery to the touch. For this reason green earth was occasionally used as the foundation for gold leaf (see p. 21), as in the upper gilded part of Giotto's *Pentecost* (Cat. no. 2), but although Cennino says 'know that the ancients never used to gild on panel except with this green', it actually appears to be a rather uncommon technique.

As a variety of natural deposits, green earth is fairly widely distributed, with important supplies in Italy, particularly in Verona and Venice, but the source of the pigment in the fourteenth century has not been established. Green earth types of high quality are also found on Cyprus and in Bohemia. The colour of specimens of green earth is variable, ranging from dull sage-greens to much bluer varieties, depending on the geological source. More olive-green types also occur, but the typical colours on fourteenth-century panels are cold bluish greens or duller grey-greens.

Green earth is stable in all painting media, including fresco under most circumstances, and its most important function on panel painting is as the underpaint for the flesh tones, as in the figure of Christ in the early Crucifix (Cat. no. 1). The slightly abraded paint of the Virgin's face in the Duccio triptych (Cat. no. 4) reveals an underpaint of a quite strong green composed of terre verte with white, and the same method for the flesh is evident also in Duccio's *Maestà* panels. The figures of Ugolino's Santa Croce Altarpiece are modelled with a green-toned underlayer which is clearly visible in the faces, particularly those of the pinnacle panel figures (Cat. no. 5).

Green earth was also sometimes used to colour draperies on panel, Ugolino's Santa Croce Altarpiece providing evidence for this. For example, the cold sea-green of Moses' robe (see Cat no. 5) is constituted as a thin layer of azurite drawn over an underpaint of fairly pure green earth, while Duccio's deep green draperies in two of the *Maestà* panels (Cat. nos. 3b and c) and in the *Virgin and Child* triptych (Cat. no. 4), employ the pigment as the principal colouring agent. In these cases quite specific colour effects must have been sought.

Another wholly green mineral pigment is listed by Cennino, but seems not to have

been much used for tempera painting on panel at this time. It is **malachite** ($CuCO_3.Cu(OH)_2$), a naturally occurring ore of copper, closely similar chemically and in distribution to azurite (Plate 35). So intimately associated are these two copper minerals that it was Cennino's opinion that malachite (*verde azzurro*) was formed alchemically in the earth from azurite (*azzurro della magna*). It was recommended for wall painting in secco, but like azurite needs to be coarsely ground for its colour to be retained. Malachite is often fairly pale and weak in tone, and probably was too granular for underpainting flesh on panel, and of unsuitable range and intensity for drapery painting, for which separate additional pigments would have been needed to express the lights and shadows. The only instance of the extensive use of malachite on the pictures discussed here is in mixture with white, used for the unmodelled mid-green paint over gold of the *sgraffito* textile design on the San Pier Maggiore Altarpiece main panel (Cat. no. 8). Elsewhere the equivalent greens are generally mixtures of azurite and yellow lake.

The last pure green pigment mentioned in the treatise is an artificial one. Cennino says, 'A colour known as verdigris is green . . . it is manufactured by alchemy, from copper and vinegar.' **Verdigris** is one of several possible basic acetates of copper formed as blue-green crusts when sheets or strips of the metal are exposed to acetic acid vapours. This product was then collected and recrystallised from vinegar to yield a deep green pigment called *verde eterno*, chemically neutral copper acetate, which was said to be a permanent material. Cennino, however, notes that although verdigris is beautiful to the eye, it does not last, recommending it only for painting on

41

paper or parchment. The importance of verdigris on panel is to be found on later Italian paintings, where it was used as the basis of colour in a green glaze, having the characteristics of a tinted oil- and resin-containing varnish, now loosely termed 'copper resinate'.

The Crucifix (Cat. no. 1) shows some restricted areas of translucent green, which may be of the **'copper resinate'** type: as fragmentary remains of glaze over the gold leaf of Christ's nimbus, and as the original surface layer (now overpainted) for the dark green trellis pattern at Christ's feet, although here the green has darkened. It is likely that these green glazes are based on verdigris combined either with a drying oil or a natural resin or both, although no sample could be analysed for its medium. Elsewhere, for example on the green drapery of the figure to the right, a translucent continuous green copper-containing surface layer, in which no individual particles are detectable, passes over a mid-green underlayer of verdigris mixed with lead white, to give a rich dark green effect. This kind of glazing technique for the greens seems to have largely passed out of use in the fourteenth century, but was later revived as a fundamental feature of painting practice with the full development of oil painting, to which it is better suited.

While verdigris was used as a pigment in its own right, particularly for the most powerful greens in illuminated manuscripts, it seems also to have been added to oil mordants for gilding (see pp. 43ff.), a technique described by Cennino, and confirmed by analysis of samples.

With the exception of the green earth undermodelling for flesh, green on fourteenth-century panels appears to be dominated by pigment mixtures of blue and yellow. Every possible combination seems to have been used to get the best effects and range for highly coloured draperies. The panels from the San Pier Maggiore Altarpiece make use of a variety of mixtures based on azurite, yellow lake pigments and white as well as occasional additions of ultramarine. Ultramarine and *giallorino* form the almond-green drapery in the Nardo di Cione, while the *cangiante* yellows, greens and blues of Jacopo di Cione's *Crucifixion* (Cat. no. 7) employ yellow lakes and *giallorino* combined with azurite. Mixtures of yellow ochre with azurite occur on the panels from the Santa Croce Altarpiece.

White and black

A single manufactured material made from lead, known since ancient times, provided a key white pigment for all aspects of painting on panel. **Lead white** is made by exposing sheets of metallic lead to the corrosive action of acetic acid vapour in the presence of carbon dioxide, whereupon the basic carbonate $(2PbCO_3.Pb(OH)_2)$ forms as a pure white crust. It was collected and compressed into cakes of various forms – Cennino mentions 'goblet' shapes – then finely ground in water before tempering with egg. It is the only white of major importance for panel painting, fulfilling the universal role that lime white plays in fresco. The white is without problems in egg tempera medium (Plate 36).

Lead white is the staple choice for lightening all other colours and making them opaque; it is the basis for certain flesh tints, and is sometimes used as a pure white underpaint to provide luminosity to paint layers laid on top. Where it is used on its own, as in any of the areas of white on the pictures here, the great stability of lead white when locked in a paint film is clear to see.

Just as the choice of a white pigment presented the panel painter with no difficulties, a variety of easily made **black pigments** was suitable. Some, such as willow charcoal, black earth (Piedmont stone) and lampblack, were of importance as drawing materials and for inks employed in the initial designs on gessoed panels, but were also used as pigments for painting. In addition, Cennino mentions charred almond shells, peach stones and vine twigs as the sources of fine black pigments. He also describes collecting condensed soot from a lamp burning linseed oil for a black pigment requiring no further grinding. All these materials principally composed of elemental carbon are permanent in egg tempera.

There seems to have been no preferences in the choice of black pigments for various painting purposes. True charcoal black, for example, seems to be incor-

Plate 36 Macro detail of the dove from *The Annunciation* by Duccio showing the use of lead white

porated into the very dark paint of the saints' shoes in the Nardo di Cione altarpiece (Cat. no. 6), while on the San Pier Maggiore Altarpiece panels, including the main scene, the black pigment is microscopically a vegetable char, but lacks the fully developed splintery appearance of willow charcoal. Examples of this kind of black are to be found added to deepen the landscape colours and for the very dark foliage of the trees, as well as for the paint of the black interior of the model church on the main panel. Identifiable wood charcoal occurs on the Ugolino panels, for example in the black lines of decoration on Moses' gilded crown, while a single example of bone black has been detected as one component of Nardo's brown mordant for the lines of gold decoration on the draperies (see p. 138). Bone black, otherwise, seems not to have been much used.

Mordant Gilding and 'Shell Gold'

The final stage in the execution of a painting was the embellishment of the painted draperies with lines of gilding in imitation of gold embroidery. In the fourteenth century the most commonly used method for this was mordant gilding whereby small pieces of gold leaf were laid on to an adhesive or mordant previously applied to the areas to be so decorated. The mordant could be one of several materials or combinations of materials: the only requirement was that it should be sufficiently tacky for the gold leaf to adhere.

Cennino's standard mordant recipe consisted of linseed oil, already thickened and pre-polymerised by boiling or by leaving it to stand in the sun, to which was added a little varnish (*vernice liquida*) and some lead white and verdigris, not so much to colour the mordant but rather to act as driers. If the painter wanted to accelerate or delay the drying of the mordant, then greater or lesser amounts of verdigris should be added. The ingredients were boiled together and then left to stand in a glazed earthenware dish. The lines and patterns of mordant decoration were painted on, using a pointed minever brush of the size predetermined by the quill of a dove or chicken feather. Since oil mordants have the consistency of thick treacle, Cennino's advice to use a firm, short-haired brush is sound. The mordant was left for a day or longer – depending on the proportion of drier in the mixture – before being tested with a finger tip to see if it had attained the right degree of tackiness for the adhesion of the gold. If the mordant was ready, a piece of gold leaf cut to approximately the correct size was laid over the mordant. Theoretically the leaf should stick to the mordant alone and it should be possible to lift any loose scraps from the surface of the non-adhesive tempera and transfer them to further along the line of mordant. However, when areas of mordant gilding are examined closely sometimes small pieces of leaf can be seen adhering to the paint surface.

Because oil mordants of this type are applied when they are thick and sticky the lines are nearly always raised, a characteristic which helps to distinguish them from other types of mordant and from 'shell gold' (see below). Most of the final decorative gilding on the works in this catalogue appears to have been executed using some form of oil mordant. That on the panel by Giotto is closest to Cennino's recipe in composition. Although it has darkened with age, essentially it is unpigmented as Cennino recommends, containing lead white merely as a drier. Most of the other examples contain admixtures of assorted red, yellow, brown and black pigments (see Table on p. 47), producing mordants varying in colour and thickness from the very raised brown lines on the Crucifix (Cat. no. 1) and the panels by Duccio and Ugolino (Cat. nos. 3, 4 and 5) to the much flatter and brighter red lines on the San Pier Maggiore Altarpiece (Cat. no. 8). Presumably the red and brown colours were intended to enrich the colour of the gold in the same way as the bole beneath the water-gilding, and for the quickest-drying version of his oil mordant Cennino does in fact suggest the addition of some red bole.

It has not always been possible to confirm by analysis that these mordants are definitely all oil-based, although this is presumably the case. One paint sample analysed from the Santa Croce Altarpiece happened to include some mordant, and traces of a drying oil were indeed detected along with the expected egg. There is additional evidence that drying oils formed the basis of the mordants used by Duccio on the *Maestà* panels (Cat. no. 3).

a 540×

b

c 570×

d

e 440×

f

g 360×

h

i 595×

j

Plate 37 (a–t) Mordant gilding. The cross-sections show the variety of mordant-gilding methods used for the paintings in the catalogue. In each case a detail from the painting accompanies the sample. The compositions, colours and relative thicknesses of the mordant layers are collected in Table 1 (p. 47)

(a,b) Christ's mulberry-coloured loin-cloth from the Master of St Francis Crucifix (Cat. no. 1)

(c,d) Greenish-yellow foreground partition, right, from the Giotto *Pentecost* (Cat. no. 2)

(e,f) Christ's blue cloak from the Duccio *Transfiguration* (Cat. no. 3c)

(g,h) St Bartholomew's mauve cloak in the Ugolino di Nerio *Sts Bartholomew and Andrew* from the Santa Croce Altarpiece (Cat. no. 5)

(i,j) Brown border on left-hand angel's dress in the Ugolino di Nerio *Two Angels* from the Santa Croce Altarpiece (Cat. no. 5)

44

(k,l) St John the Evangelist's green cloak from the Nardo di Cione Altarpiece: *Three Saints* (Cat. no. 6)

(m,n) Foreground soldier's yellow tunic, left, from the Jacopo di Cione *Crucifixion* (Cat. no. 7). The mordant layer is too thin to be discernible, and no pigment is present

(o,p) St Mary Magdalene's vermilion cloak from the left-hand main panel of the San Pier Maggiore Altarpiece, *Adoring Saints*, by Jacopo di Cione (Cat. no. 8). The form of mordant gilding is similar to that in Cat. no. 7 above

(q,r) St Stephen's green sleeve from the *Adoring Saints* from the San Pier Maggiore Altarpiece (Cat. no. 8)

(s,t) Mauve cloak of the male figure in the foreground, left, in the Jacopo di Cione *Pentecost* from the San Pier Maggiore Altarpiece (Cat. no. 8)

k 490× l

m 490× n

o 490× p

q 570× r

s 490× t

45

All the samples of supposed oil mordants have one interesting similarity when seen in cross-section – the presence of a thin layer of what appears to be pure unpigmented medium at the interface between the mordant and the paint film. This is difficult to account for. The mordant gilding methods described by Cennino fail to provide a clue, so three possible explanations can be proposed: the first, and most likely, is that the oil and varnish medium has tended to separate out from the pigment, perhaps drawn by the relative leanness of the egg tempera; the second is that to improve the adhesion of the pigmented mordant, or to mark out the pattern, a preliminary line of colourless oil or varnish was applied first, in which case traces of lines which failed to coincide might be expected; and finally, and extremely unlikely, that the layer represents an application of varnish and that the panels were varnished before the execution of the mordant gilding. This seems contrary to all Cennino's comments about varnishing and to the working order suggested by the documents concerning the San Pier Maggiore Altarpiece (Cat. no. 8).

The only painter represented in this catalogue who seems not always to have used an oil mordant was Jacopo di Cione. None of the decorated borders and hems on the *Crucifixion* (Cat. no. 7) shows any sign of the raised lines characteristic of oil mordants, nor do the gilded patterns over certain draperies on the San Pier Maggiore Altarpiece. In the cross-sections nothing can be seen between the paint surface and the gold leaf. Occasionally on the *Crucifixion* faint greyish lines remain where the gilding is worn, so either the gold was attached using an adhesive like egg white, gum or size according to some method not described by Cennino, or just possibly Jacopo used a technique which does appear in Cennino's treatise whereby the gold is adhered to a quick-drying mordant made from garlic juice mixed with a little bole and lead white – omitted in this instance if this type of mordant was indeed used. Even with modern analytical methods the traces of garlic are unlikely to be detected. Garlic mordants dry in about half an hour. Either they could be gilded upon almost immediately, or they could be left to dry and later moistened by breathing on them to restore their tackiness. This last piece of practical advice comes not from Cennino but from the collection of recipes in the early sixteenth-century Marciana Manuscript. The anonymous author writes as though garlic mordants were the most common general-purpose mordants, and used for panel paintings among other things. It is therefore interesting that the only possible occurrences of garlic-based mordants are on works by the latest painter included in this catalogue. Possibly they came into use only in the later fourteenth century.

Jacopo di Cione's gilding techniques also look forward to those of the next century in that he is the only painter included here to have used powdered gold and silver to embellish his paintings. Powdered gold, which was made by grinding up sheets of gold leaf with glair, is often called 'shell gold' because traditionally it was kept in a mussel or similar shell. According to Cennino it was applied with 'enough tempera to make it flow from the quill or brush' – the 'tempera' was presumably the same as the medium of the work, so for a panel, egg would have been employed, whereas for a manuscript, gum arabic was more appropriate.

The identification of powdered gold and silver on works of this date is of considerable interest. Apart from the one given by Cennino, other Italian recipes for their manufacture date from the fifteenth century or later. Cennino is believed to have picked up the technique when in Padua in the 1390s. Powdered gold appears frequently on Venetian manuscripts and panel paintings of the early fifteenth century – its use is thought to have originated in Northern European manuscript illumination – and in 1441 Matteo de' Pasti wrote from Venice to Piero di Cosimo de' Medici in Florence announcing that 'since being in Venice I have learnt . . . a technique of using powdered gold like any other colour . . .' and boasting that 'you may see a thing that has never been done like this before, embellishing with this powdered gold'. In fact, by this date paintings with 'shell gold' were in Florence, but it would seem that even they were not so novel. Nevertheless, the 'shell gold' and silver found on the

Table 1 Mordant gilding[1]

Cat. No.	Picture	Colour of Mordant Layer	Thickness[2] (microns)	Composition[3]/Analysis[4]	Plate Ref.
1	Master of St Francis: Crucifix	Dark red-brown	c.40	Carbon black, red lead (verdigris?) Pb, Cu (Al, Si, K, Ca)	37a
2	Giotto: *The Pentecost*	Light grey-brown[6]	12–14	Mainly oil with some lead white Pb	37c
3	Duccio: panels from the *Maestà*				
	The Annunciation	Mid-golden-brown[6]	max. 80	Lead white,[5] ochre, red lead (verdigris) Pb, Fe, Cu (Al, Si, Ca)	—
	The Transfiguration	Mid-golden-brown[6]	45–50	Composition as above	37e
5	Ugolino di Nerio: panels from the Santa Croce Altarpiece				
	Sts Andrew and Bartholomew	Dark brown	c.40	Lead white,[5] ochre (red lead,[5] verdigris) Pb, Fe, Si (Cu)	37g
	Two Angels	Dark brown[6]	25–30	Composition as above	37i
6	Nardo di Cione: *St John the Baptist with St John the Evangelist (?) and St James*	Mid-brown	max. 20	Yellow and red ochres, bone black (lead white) Pb, Ca, P, Fe (Si, Al)	37k
7	Jacopo di Cione: *The Crucifixion*	Not discernible	Too thin to measure	—	37m
8	Jacopo di Cione: panels from the San Pier Maggiore Altarpiece				
	Adoring Saints (on St Mary Magdalene's red drapery)	Not discernible	Too thin to measure	—	37o
	Adoring Saints (on St Stephen's green drapery)	Red-brown	40–50[7]	Granular red-brown earth, some lead white Fe (Si, Al, Pb, Ca, Cu, P)	37q
	The Pentecost (on foreground figure's mauve drapery)	Red-brown	20–40	Composition as above	37s

Notes to the table

1. Mordant gilding refers to the application of gold leaf to the surface of painted passages, commonly in the form of linear decoration to draperies. It is distinct in character and purpose from the leaf gilded backgrounds to the panels ('water-gilding'). The mordant is the layer of adhesive laid on to the surface of the painting to accept the gold leaf. Frequently pigment was combined with a drying oil to produce the mordant, although occasionally a very thin unpigmented film was used. For a full description of mordant gilding, see pp. 43–6 and illustrations on pp. 43–4.

2. The thickness of the mordant layers was measured directly on paint cross-sections under the microscope. Average thicknesses or thickness ranges are given. One micron is equal to one-millionth of a metre, or one-thousandth of a millimetre.

3. The composition noted is based on a combination of optical microscopy of cross-sections, and analysis by one of the instrumental methods described in the Glossary. The materials noted in brackets are present as a small proportion of the whole.

4. Results from energy-dispersive X-ray microanalysis (EDX) or laser microspectral analysis (LMA). See Glossary. Minor components are recorded in brackets.

5. Constituents confirmed by X-ray diffraction analysis (XRD). See Glossary.

6. The presence of a drying oil in these specimens was suggested by staining tests with Sudan black 10B and by heating tests on the microscope hot-stage.

7. In other areas of Cat. no. 8, the thickness of the red-brown mordant was as little as 10 microns.

altarpieces by Jacopo di Cione do appear to be the earliest reported examples of their use on Italian panel paintings.

Varnishing

The question of whether painters preferred to leave their tempera with its own matt sheen or whether they varnished it, both for its protection and to alter its optical properties, is discussed in the entry for the San Pier Maggiore Altarpiece (Cat. no. 8). The varnishing of panel paintings is described by Cennino, but he is somewhat confusing and contradictory as to the extent of the practice. Guild statutes take into account the varnishing of paintings: for example in Florence the statutes of 1315 state that gilding and varnishing were permitted on Feast Days provided that one quarter of the resulting profit was given to the guild. Painting, on the other hand, was strictly forbidden.

Condition, Conservation and Restoration

All paintings begin to change from the moment they are finished. The complex process of natural ageing starts at once and all the hazards of environment and human intervention begin to take their toll. No painting can survive in its exact original state since, over the first years or decades of its life, it is undergoing almost imperceptible changes within its structure. Later, much more serious changes can occur when the surroundings alter dramatically, or when human hands interfere.

In the present catalogue nearly all of the panels could be described as being in 'good' or even 'excellent' condition, and yet not one of them has survived intact. Description of condition is a relative assessment and historically has usually referred to the state of the painted image. But attitudes have altered and we no longer regard a painting as simply a painted image but as a whole object. It has a back and edges, as well as a front: every part of it is a physical document providing clues to its maker and the manner of its making. This approach is especially significant in the present context because fragments of larger works of art are being pieced together here with the aid of tiny clues, perhaps meaningless in isolation but highly significant in conjunction with observations on other works. A panel that has been transferred to a new support or even only thinned may appear superficially intact, but it has lost much of its original documentary value as a work of art.

In general terms, what are the factors that determine the physical state of fourteenth-century panels such as these? We must consider the materials of which they are made and how they age, and also the layer structure and how it responds to varying conditions. Causes of change in paintings may be broadly classified in four ways:

1. Inherent properties of materials used
2. Change of materials and structure due to environment
3. Accidental damage
4. Deliberate human intervention of many kinds

In practice, all four of these are usually inextricably linked in the long and precarious life of a fragile picture. The materials of fourteenth-century painting are described in detail elsewhere in this catalogue. Here we will consider briefly some of the changes that may befall them.

Poplar, the standard panel material, is a relatively unstable wood which can have a fairly knotty, wild grain. It shrinks or swells markedly as the humidity varies, and splits or broken joints often occur as a result of this constant movement. The warping of poplar panels is due to a combination of factors. First, for any plank not sawn directly through the centre of the log, there is a natural tendency to warp with the convex side nearest the centre (Fig. 6). Fourteenth-century painters were clearly prepared for this and usually took care to paint on the side that was likely to become convex, since paint will stretch more successfully than it will compress. The second and major cause of warping is the fact that a panel is usually painted on one side only: repeated cycles of high and low humidity on the unprotected back cause collapse and shrinkage of the wood cells there and lead to a permanent warp in which the painted side is again convex. Panels that are gessoed and painted on both sides (for example Cat. no. 4) usually remain much flatter and

more stable than those painted on only one. The warping of panels is considered natural and today is normally left untreated, except for strict control of the environment. In the past, however, warped panels were not tolerated: restorers flattened panels with pressure and moisture and then tried to keep them flat by attaching heavy battens or cradles. Often this resulted in splits and cracks developing in the panel as it dried out and tried to warp against the applied constraints. Such restrictions are now usually removed and the panel is allowed to find its own equilibrium position.

All of the panels described in this catalogue have been treated and mistreated in various ways over the centuries. Duccio's triptych (Cat. no. 4) is well preserved and, with only a few minor repairs, is very close to its original appearance. Fragments of larger altarpieces, such as those by Duccio (Cat. no. 3), Ugolino (Cat. no. 5) and Jacopo di Cione (Cat. no. 8), are very much changed, although the painted images are often superficially intact. Roughly sawn apart, their frames totally or partially removed, their edges trimmed, these panels are now confusingly out of context, displayed in an isolated way that was never intended. Some panels have, in addition to the remains of their original frames, new mouldings added to give a spurious completeness to the now separated fragments. Parts of the Santa Croce Altarpiece by Ugolino (Cat. no. 5) are good examples of this, and without very careful examination it is difficult to determine what is original and what is not.

Changing environment and movement between the panel, ground and paint layers result in the *craquelure*, the characteristic network of cracks seen on these paintings (Fig. 23). The craquelure develops as the paint and ground age, become brittle and can no longer accommodate stresses imposed by the composite layer structure. It is a perfectly normal, safe condition and only becomes problematic when the paint and ground curl away from the panel and threaten to detach: this may start in the area of a knot or grain fault where adhesion to the wood can be poor. Paint that overlaps smooth burnished gold is also especially vulnerable to flaking (Fig. 24). Where paint has flaked away in the past, the old losses are usually filled and

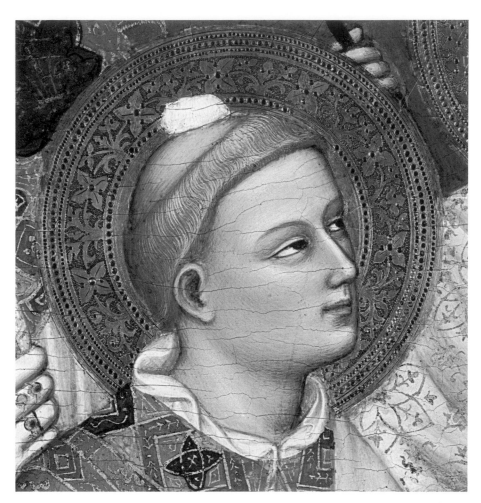

Fig. 23 Detail of St Stephen from the San Pier Maggiore Altarpiece (Cat. no. 8), after cleaning, before restoration. A characteristic network of cracks can be seen even though this figure is exceptionally well-preserved

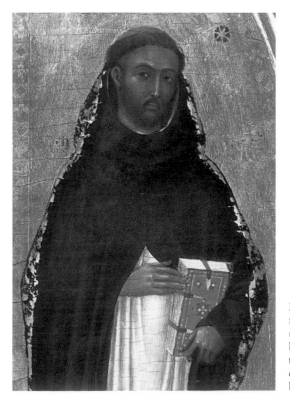

Fig. 24 Detail of St Dominic from the Triptych by Duccio (Cat. no. 4), after cleaning, before restoration, showing how the paint has flaked off where it overlaps the gold of the background

49

retouched; it is now considered imperative to treat potential flaking with appropriate adhesives before it becomes dangerous.

Some materials in the paint layers undergo irreversible changes as they age or are exposed to different conditions. Particular examples will be described in the following pages: here three notable changes may be mentioned. First, the blackening of silver: the use of silver leaf was more widespread than has generally been supposed, but very little now remains in anything like its original form. Applied over red bole in a way similar to gold leaf, it rapidly tarnishes and blackens until it resembles a dark uneven paint layer over the red. Examples of this may be seen in the San Pier Maggiore Altarpiece (Cat. no. 8). The second change, also a darkening process, is the conversion of the red pigment vermilion to a black variant. This appears to be a surface phenomenon and its cause is not altogether clear in these pictures, although friction is known to be one factor which can bring about the conversion. It is most evident in the lining of St John the Baptist's robe in Nardo di Cione's altarpiece (Cat. no. 6) and on the book held by St John the Evangelist. There is no treatment yet devised that will reverse the blackening of vermilion, and the somewhat unsightly purplish-black patches have to be accepted as part of the ageing process of the picture. A third general type of change is the fading of lake pigments: Cennino was well aware of the impermanence of both red and yellow lakes exposed to light. This is often a change that is difficult to detect since the faded pigment can become quite colourless: only if an unfaded part survives under a covering layer can we be sure that the paint was originally more colourful. A well-known example elsewhere in the National Gallery collection occurs in the *Coronation of the Virgin* by Lorenzo Monaco (no. 1897): the Virgin's robe was originally a deep pink colour which has faded, leaving only white. None of the paintings in the present catalogue has a dramatically faded red lake such as that, but there are almost certainly yellow lakes that have lost some of their colour on the San Pier Maggiore Altarpiece.

These are all examples of alterations to materials that have an inherent instability. They are changes that undeniably affect the appearance of a painting, but that are accepted as signs of natural ageing. Less acceptable are some of the interventions by human hands over the centuries. The dismemberment and cutting-down of altarpieces and the unwise flattening of panels have already been mentioned, but other examples of drastic treatment and neglect are numerous. Many paintings of the period have simply not survived and it is remarkable after six hundred years of war, disaster and misguided restoration that we have as many fourteenth-century paintings as we do. Present-day philosophy stresses *conservation* rather than *restoration* and this implies the importance of the preservation of a work of art. Emphasis is now placed on external factors such as environmental control in slowing down ageing and deterioration. Interference with the structure is kept to a minimum; old confusing restoration and previous damaging treatments are reversed and new treatment is carefully controlled with strict ethical guidelines. For example, flaking or raised paint is now painstakingly re-attached with adhesives and heated spatulas. In past times it was often scraped off and replaced. It seems almost inconceivable today that a restorer at some stage and for a reason not altogether clear scraped off and replaced the entire gold backgrounds of the terminals of the Crucifix (Cat. no. 1) and of two of the upper panels of the San Pier Maggiore Altarpiece (Cat. no. 8). Sometimes ultramarine was even scraped away for re-use: in two paintings in the Pinacoteca Nazionale, Siena – by Simone Martini and Francesco di Giorgio – the ultramarine has evidently been scraped off the robes of the Virgin.

Paintings have been cleaned from the earliest times, but the process is now carried out with a control that was sometimes lacking in the past. Cleaning implies the removal of later dirt, discoloured varnishes and overpaints, while leaving all original material scrupulously untouched. Particular attention is paid to the possibility of original coatings and varnishes having partially survived. The remains of original egg-white varnishes have been reported elsewhere, but none was found on any of the pictures described here: however, on the San Pier Maggiore Altarpiece traces of what appears to be an original *vernice liquida* were found and are

reported below for the first time.

Cleaning solvents and reagents in the past could be quite corrosive and some of the paint in these pictures has become thin and worn as a result of repeated cleaning. Fourteenth-century panel paintings on gesso grounds with aqueous gilding are particularly vulnerable to erosion by water-based solvents. The gold backgrounds on many of these paintings are now worn and scratched and some of the intended illusion of solid tooled gold is inevitably lost. The paint layers, too, can become thinned and more transparent, both by cleaning and by natural ageing of the paint medium. Underlayers such as the green earth below flesh tones and *pentimenti* (changes in composition) can become more prominent than perhaps intended.

When a painting has been cleaned, old damages and losses will usually become evident and some kind of retouching or *inpainting* will generally be carried out to disguise the missing area. The choices available to the restorer for retouching range from a completely deceptive reconstruction (that is, imitating the original paint as exactly as possible) to complete non-intervention (that is, leaving a hole in the fabric of the painting). There are many intermediate compromise solutions. All of these can be seen in the pictures in this catalogue. All retouching methods require that the condition of the painting and the losses are recorded in detailed photographs; that no retouching should encroach on to original surface paint; and that retouching materials should be readily removable in the future. Once those principles are established, historical, aesthetic and practical grounds will determine what the nature of the retouching will be.

Small losses are normally retouched deceptively since there is usually no ambiguity about what was originally there. However, where a figure or form cannot necessarily be reconstructed with certainty, some sort of compromise retouching may be carried out. The three panels from the *Maestà* by Duccio (Cat. no. 3) illustrate this to different degrees. All three panels have suffered significant losses of paint in key areas. On the *Annunciation* (3a) paint has been lost in strips along the bottom and left side: at the bottom it is retouched in a neutral grey and at the side the gilding has been imitated in yellow-toned paint. No attempt at reconstructing the form has been made. On the *Transfiguration* (3c) all of the upper body of St John has flaked away in the past. Here, a neutral brown retouching has been used, but the probable form of the figure has been indicated in a linear reconstruction; in addition, the level of the filling underneath the retouching has been left slightly below the surrounding paint as an added indication of the area of loss. On the *Man born Blind* (3b) the major loss of paint is especially ironic: the face of the cured blind man is missing – the focus of the entire episode. Here, a more or less deceptive reconstruction was essential in order not to destroy the narrative power of the scene. However, in order to indicate that this is not original paint, the craquelure of the original has not been imitated.

It is important that retouching should always be kept to a minimum. The age of a painting should not be disguised, but only those damages resulting from neglect or accident that divert the eye and interfere with the viewer's appreciation. Final varnishes applied to these pictures (and others) should be as clear as possible and discolour as little as possible with time. Traditionally, restorers have favoured slightly matt finishes on fourteenth-century paintings, imitating the silky effect of unvarnished paint. However, evidence from Cat. no. 8 suggests that where an original *vernice liquida* was used, the surface may have been intended to look very glossy indeed. Further research will, it is hoped, throw light on this intriguing question.

CATALOGUE

MASTER OF ST FRANCIS

active *c.* 1260–*c.* 1272

The Crucifix (Plate 38) is attributed to an anonymous painter called the Master of St Francis after a panel painting of that saint in Santa Maria degli Angeli, near Assisi. He was active in Umbria, mainly around Assisi and Perugia. Only a handful of works survive. The dates for his activity are fixed by a monumental Crucifix, dated 1272, painted for the church of San Francesco al Prato, Perugia, and now in the Galleria Nazionale dell'Umbria, Perugia. He seems to have worked chiefly for the Franciscans. *In the middle of the thirteenth century he painted a fresco cycle in the nave of the Lower Church of San Francesco, Assisi, paralleling the lives of St Francis and Christ. In about 1272 he painted a double-sided altarpiece probably for San Francesco al Prato in Perugia. His work is characterised by intensely dramatic compositions, painted with a clarity of line, brilliance of colour and precision of technique which make him one of the outstanding painters of the thirteenth century.*

1. Crucifix

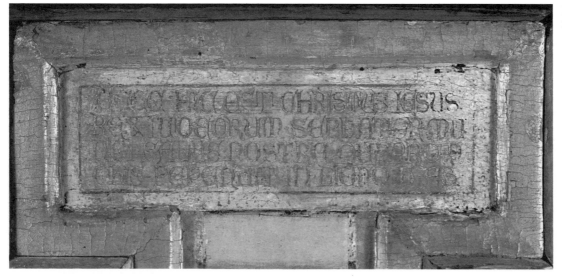

Fig. 25　Infra-red photograph of inscription

The inscription in the top terminal (Fig. 25) is not original but perhaps an erroneous transcription of the original:
ECCE·HIC·EST·CHRISTUS·IESUS
REX·IVDEORUM·SERVATOR(sic)MV
NDI·SALVUS·NOSTRE·QUI·PRO·N
OBIS·PEPENDIT IN LIGNO
VITAS(sic)
(Behold, this is Jesus Christ, King of the Jews, Saviour of the World and our Salvation, who for us hung on the Tree of Life.) On the arm of the Cross is written in gold REX GL(ORI)E (from Psalm XXIII, 24).

Painted in the apron on the left of the crucified Christ are the two Maries supporting the Virgin Mary, and on the right St John the Evangelist and the Centurion who recognised at the Crucifixion that Christ was the Son of God.

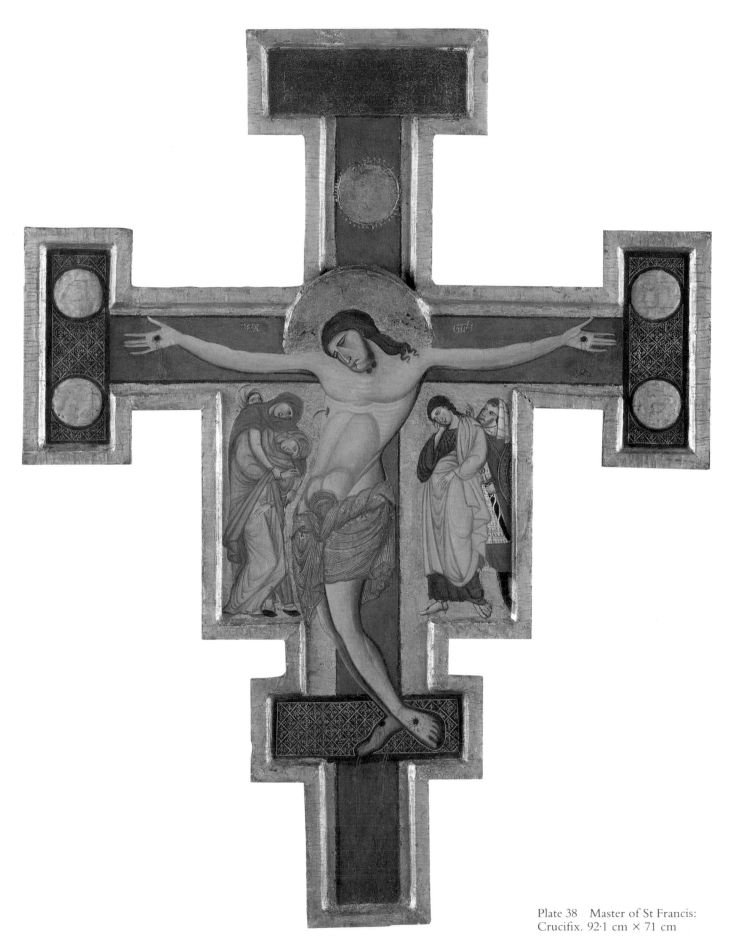

Plate 38 Master of St Francis:
Crucifix. 92·1 cm × 71 cm

55

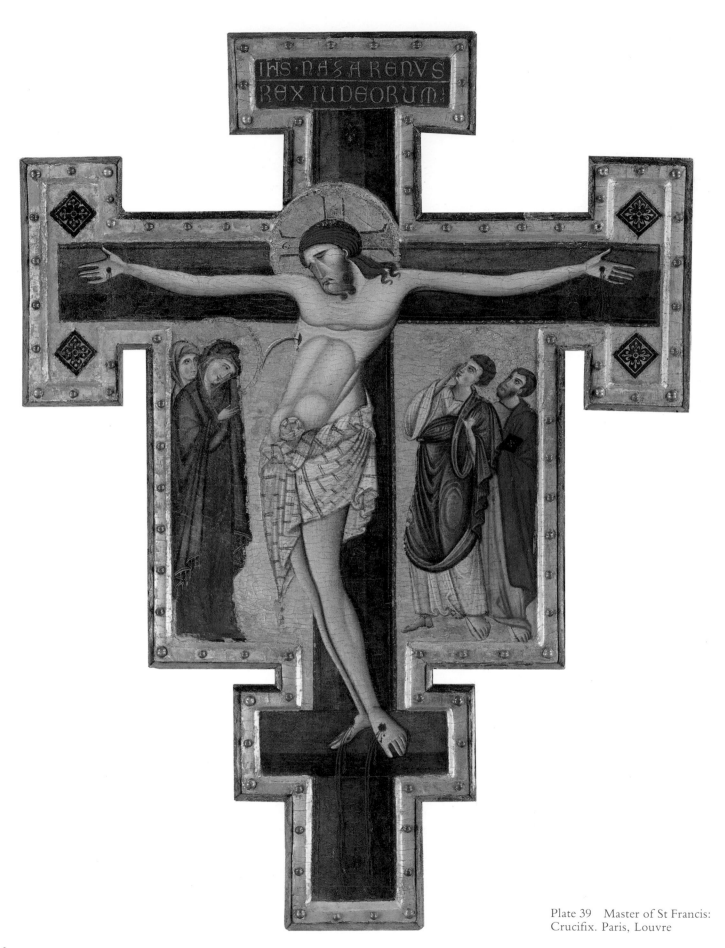

Plate 39 Master of St Francis:
Crucifix. Paris, Louvre

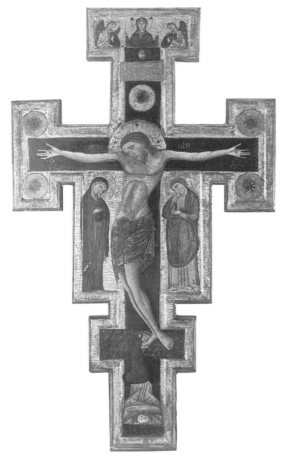

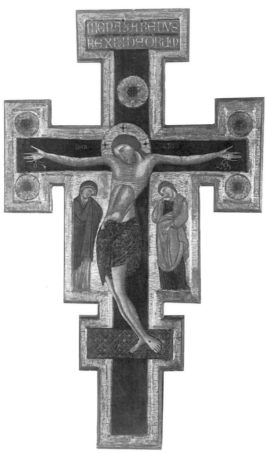

Fig. 26 Workshop of the Master of St Francis: Crucifix, front. Perugia, Galleria Nazionale dell'Umbria

Fig. 27 Workshop of the Master of St Francis: Crucifix, reverse

A stylistic comparison of this Crucifix with the much larger Crucifix dated 1272 painted for San Francesco al Prato in Perugia suggests that the London one was painted later. This type of fairly small Crucifix was especially common in Umbria and a number were produced by the St Francis Master and his workshop. Particularly interesting in relation to the London Crucifix is a Crucifix in the Louvre, Paris (Plate 39): although it is identical in height and width, the internal proportions of the apron on the London Crucifix are narrower and the outward swing of Christ's body more accentuated. There is also a weakness in the structure of the Paris Crucifix which was corrected in the carpentry of the London version. All this suggests that the artist refined his design and that the London Crucifix was painted after the Paris one, possibly even as late as the 1280s.

The Crucifix probably originally fulfilled several functions. The hollowed-out roundel in the top vertical arm of the cross contains traces of adhesive and may once have contained a roundel of coloured or, more likely, gilded glass. It may be that the roundel concealed a relic, possibly that of the True Cross, as suggested by the inscription.

Other medium-sized Umbrian Crucifixes of this date, including one from the workshop of the Master of St Francis (Figs. 26 and 27), show that they were often double-sided and therefore probably designed to be carried in liturgical processions. On the back of the London one rough saw marks and the clean longitudinal worm channels suggest that it was once much thicker and has been reduced to its present thickness of c. 1.8 cm by sawing. It may well have originally been much thicker and painted on both sides.

When they were not being carried in processions smaller Crucifixes such as these were probably set up on altars in small chapels, like the one shown in the painting of the Crucifix talking to St Francis in the fresco in the Upper Church of San Francesco, Assisi (Plate 40).

Technical Description

Taking into account the great age of the Crucifix and the fact that it probably retained its liturgical function for several

hundred years, it is not surprising to discover that some parts have been much damaged and repaired. Not before the nineteenth century is it likely to have been regarded primarily as a work of art and treated accordingly. It may have been then that the Crucifix was sawn through, reducing it to its present depth, and fitted with its lattice of supporting cross-pieces (Fig. 28). The painting thought to have been on its reverse was probably discarded as being irretrievably damaged. The reverse of a similar thirteenth-century double-sided Crucifix in the church of San Francesco, Assisi, attributed to the so-called Blue Crucifix Master, has survived but is so damaged that the image is barely legible (Plates 41 and 42).

Unlike the Paris Crucifix where the side terminals have been constructed separately and then attached with wooden dowels (Fig. 29), the London Crucifix has been cut from a single plank of poplar. The semicircular wedge for Christ's halo (Plate 43) and the mouldings of the frame have been glued to the front, the halo additionally secured with a nail (visible in the X-radiograph; Fig. 32) and the whole assemblage covered with fine linen canvas before the application of the gesso ground. Although the wood of the vulnerable side terminals is cracked and damaged they are clearly original. The X-radiograph shows that the linen canvas is also still present. The gesso, on the other hand, has been replaced. It produces a denser, lighter image on the X-radiograph and the cracks are more marked, perhaps because of the deliberate introduction of too much glue in the mixture to induce cracking to simulate the effects of age (Fig. 30). This false gesso is also slightly different in composition from that on the main part of the Crucifix, consisting of a mixture of the two forms of calcium sulphate whereas the upper layers of the original gesso are gypsum (*gesso sottile*) alone.

Presumably the paint and gilding on these terminals were so badly damaged by flaking and by the knocks and blows that a portable Crucifix is likely to have suffered, that the nineteenth-century restorer felt that rather than fill and patch the losses, a neater result would be obtained by complete replacement of the gesso and gilding. The readiness of some nineteenth-century restorers to sacrifice surviving fragments

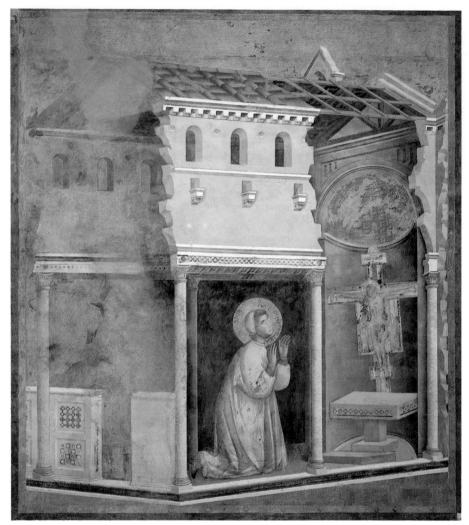

Plate 40 St Francis Master: *Crucifix talking to St Francis.* Fresco. Assisi, Upper Church of San Francesco

Fig. 28 Crucifix (Cat. no. 1), reverse

58

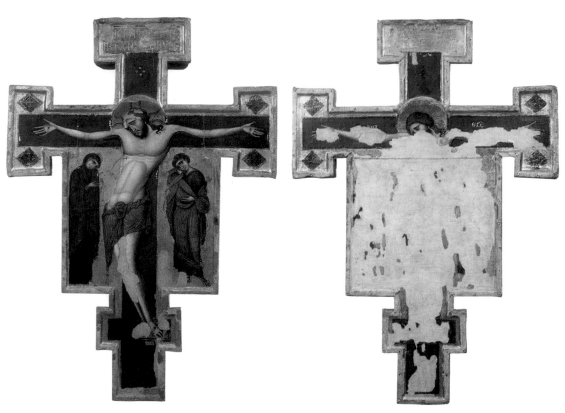

Plate 41 Attributed to the Blue Crucifix Master: Crucifix, front. Assisi, San Francesco.

Plate 42 Attributed to the Blue Crucifix Master: Crucifix, reverse

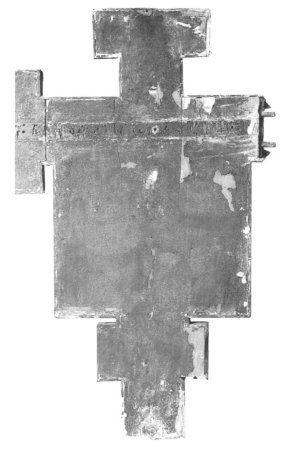

Fig. 29 Master of St Francis: Crucifix, reverse with terminal removed to show dowels. Paris, Louvre

for the sake of a smooth finish is also illustrated by the new gilded backgrounds on two of the panels of the San Pier Maggiore Altarpiece (Cat. no. 8).

Since the restorer who supplied the present decoration of the terminals may also have been responsible for the removal of any remains of the original design, it is reasonable to assume that the raised gilded roundels and the green and gold trellis pattern now visible reflect what was once there. This is further suggested by examination of a cross-section of dark green paint from a similar area of trellis patterning around the feet of Christ (Plate 44). Here, beneath the upper paint layer containing chrome and cadmium yellows, pigments not introduced until 1818 and 1846 respectively, are traces of the original green paint layers (described below).

Similarly samples from the top terminal include original layers of red lake over vermilion but concealed beneath a confusing and discontinuous sequence of restorations. The X-radiograph shows that this terminal is badly damaged with a particularly large loss towards the centre. It is likely to have been restored on more than one occasion with each restorer copying the remains of the previous restorer's lettering, hence the errors in transcription. Neither of the cross-sections taken con-

59

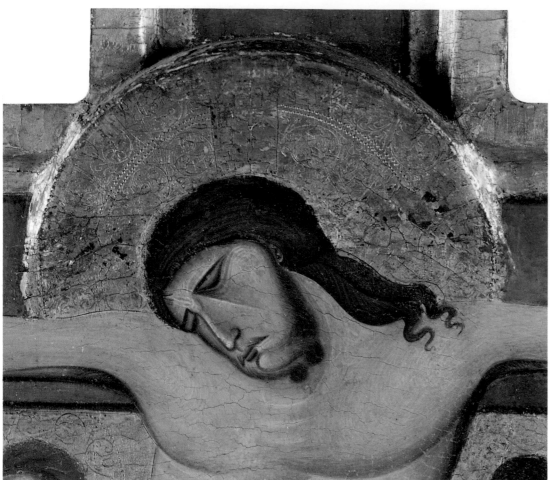

Plate 43 Detail of Christ's head
and halo

tained a layer which could be identified as the remains of the original inscription.

While the readiness of the previous restorers to obscure and even to remove damaged paint and gilding would not accord with modern conservation practice, the reconstruction has been skilfully executed. Most of the false paint was therefore left in place during the cleaning and restoration of the Crucifix on its acquisition in 1965. The cleaning was limited to the removal of the discoloured varnish together with some of the retouchings from smaller losses on the better preserved areas. Some of these losses are associated with a split in the panel which runs down from the right shoulder of the Crucifix (Fig. 31). Others are due to the tendency of the paint to flake when applied over gilding. Although the boundaries between gilded and painted areas have been defined with incised lines, the sheets of gold leaf extend well beneath the painted figures. The most curious form of flaking is the loss of small pieces of paint from all along what must once have been the darkest and most intense parts of the

linear drapery folds (Fig. 33). The dark outlines of Christ's body and even some of the facial features are also affected. To emphasise the design and modelling of the forms and the draperies the painter may have applied the egg tempera paint too thickly, causing it to crack and flake. These losses show on the X-radiograph as broken dark lines due to the absence of the lead-containing paint (Fig. 34).

Apart from these losses, the better preserved areas of the Crucifix indicate the work of a painter of considerable technical skill and refinement. To define the haloes the gilding has been embellished with a delicate foliate pattern incised into the gold and gesso (Plate 43). A plain dot punch has also been used. The indentations are neat and unusually evenly spaced, without the accidental breaking and tearing of the gold leaf sometimes seen on punched decoration.

The figures have been painted with care and precision, probably over a simple, linear underdrawing. A few lines of underdrawing can be detected in infra-red photographs and reflectograms, mainly in

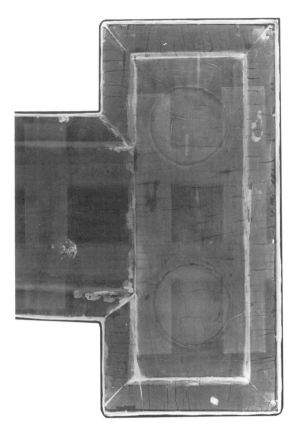

Fig. 30 X-radiograph – right terminal

Fig. 31 Crucifix with the main areas of non-original paint and gilding shaded

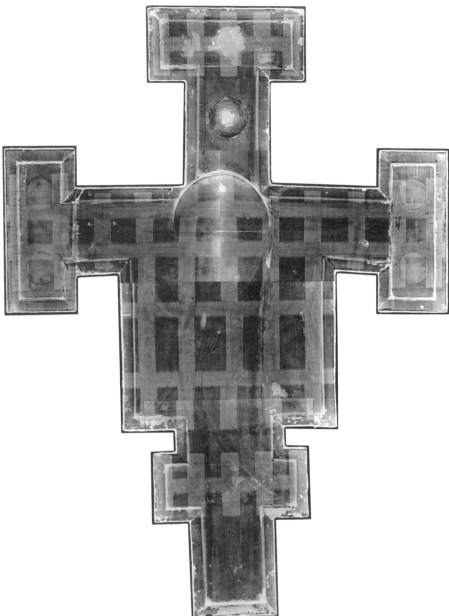

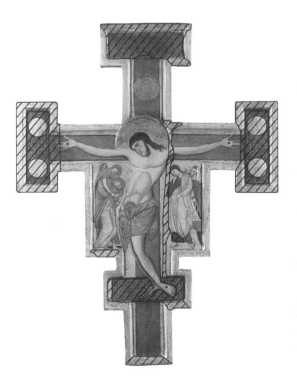

the red tunic of the centurion on the right (Fig. 35), and traces of black underdrawing appear in some of the cross-sections. Unfortunately, most of the drawing would have coincided with the dark outlines and the lines indicating the depth of the drapery folds, so it has either flaked off with the paint or it is obscured in infra-red by the later retouchings.

A very limited palette of verdigris, vermilion, red lake, and natural ultramarine, together with lead white and a vegetable black, has been used to achieve rich and subtle colour combinations. Sadly, little of the verdigris is now visible. Some remnants of the original green trellis pattern appear beneath the nineteenth-century repaint on the patterned area

Fig. 32 X-radiograph

61

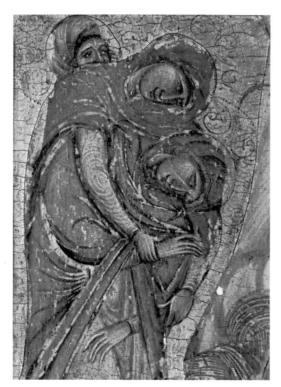

Plate 44 Overpainted green at Christ's feet: two layers of verdigris and lead white, with a 'copper resinate' glaze. Cross-section, 380×

Plate 45 Christ's thumb where it overlies the blue background comprising ultramarine and lead white in three layers. Over this are the two layers of flesh paint. Cross-section, 130×

Fig. 33 Detail after cleaning, before restoration, showing paint losses from the gold and along the drapery folds

Fig. 34 X-radiograph. Detail of the same area

around Christ's feet. In the cross-section (Plate 44) three layers of original paint can be seen: first an underpaint of verdigris mixed with lead white, followed by a similar but slightly darker layer, and finally a transparent and discoloured glaze of what appears to be a 'copper resinate' type green. The same green glaze occurs, again over verdigris and lead white, on the now dull green robe of St John the Evangelist, and further traces of green glaze have survived on Christ's gilded halo (Plate 43). Here the pigment has retained much of its colour. If it is a true 'copper resinate', then an oleo-resinous medium rather than egg tempera must have been used, but because of the extensive over-paint – itself probably oil-based – there was little point in attempting to confirm this by analysis. The use of oleo-resinous green glazes, particularly in conjunction with gold, is discussed further in the entry for the *Crucifixion* (Cat. no. 7).

In contrast to the quite complex layer structure of the greens, the areas of brilliant red consist basically of a single layer of vermilion. The red paint applied to the sides of the Crucifix is also vermilion but is

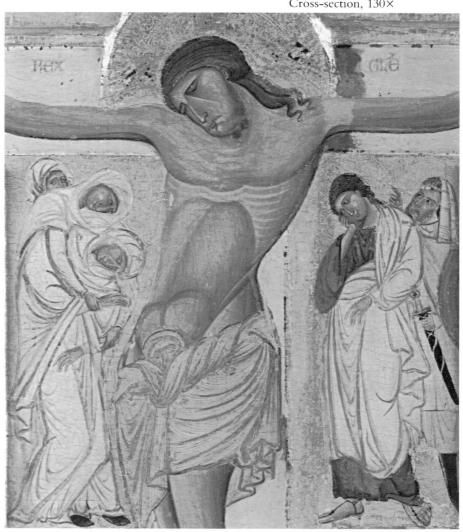

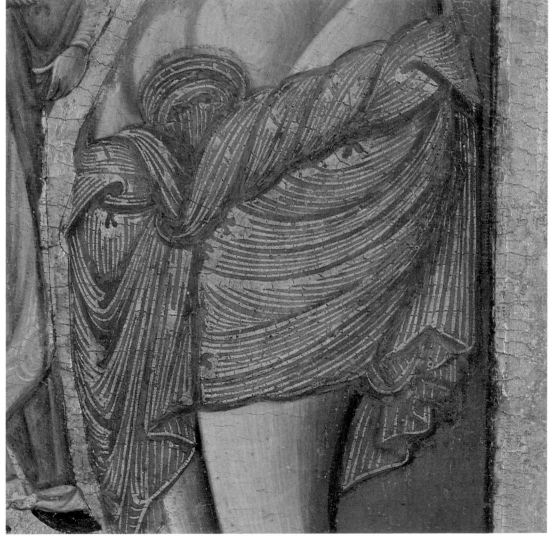

clearly not original. Often it lies over new gesso. The deep blue of the background has been painted with ultramarine and white over a lighter underpaint, also of ultramarine but with more white. For the darker borders a third layer of even more saturated ultramarine has been applied (Plate 45). The ultramarine is of notably high quality.

Between the intense red and blue lie various shades of violet and mauve. They have generally been achieved by combining lead white, ultramarine and red lake in different proportions, but Christ's loin-cloth shows a technique of greater complexity: over an underpaint containing all three pigments lies a substantial layer of pure red lake (Plates 46 and 47). Unlike the putative 'copper resinate' layers, this is not fully a glaze since the egg tempera medium is insufficiently transparent, but it is another example of how this painter builds up his rich flat areas of colour by superimposing increasingly saturated layers of semi-transparent pigments mixed with little or no lead white. The folds have then been decorated with gilding applied over a thick, raised oil mordant of unusually dark colour due to the addition of a black pigment.

A sample of flesh paint from the very tip of Christ's left thumb includes the blue paint of the Cross, so five separate paint layers can be seen (Plate 45). Immediately below the flesh paint itself is the expected layer of green earth underpaint, but green earth has also been added to the lead white, vermilion and earth pigments used to model Christ's flesh, presumably to emphasise his death-like pallor. A small adjustment to the outline of the loin-cloth shows that the areas of flesh were painted after the draperies but before the application of the mordant gilding, exactly the order of working described more than a century later by Cennino Cennini.

GIOTTO DI BONDONE

1266/7–1337

Giotto worked chiefly in Florence, but also in Rome (where he may well have trained), Padua, Naples and probably Rimini and Milan. He had a large workshop and the problem of what works are autograph, and the extent of the participation of assistants, is by no means straightforward. His oeuvre is complicated by the fact that none of the three panel paintings which bear his 'signature' – namely the Stigmatisation of St Francis *(Paris, Louvre), the polyptych from Santa Maria degli Angioli, Bologna (Bologna, Pinacoteca) and the Baroncelli Altarpiece in Santa Croce, Florence – is unanimously agreed to be by him. Panel paintings generally accepted as autograph include a* Crucifix *in Santa Maria Novella, Florence (Plate 9), the* Ognissanti Madonna *and the* Badia Polyptych *(both Florence, Uffizi), the* Dormition of the Virgin *(Berlin–Dahlem) and, with some disagreement, the* Stefaneschi Altarpiece *(Rome, Pinacoteca Vaticana).*

The extent to which Giotto himself was involved in the several fresco cycles in the church of San Francesco, Assisi, or indeed whether he painted there at all, remains a subject of intense debate. His undisputed fresco cycles are in the Arena Chapel, Padua, probably completed c. 1305, and in the Bardi and Peruzzi Chapels in Santa Croce, Florence, probably completed by 1328. In 1327 he was inscribed with the Arte dei Medici e Speziali in Florence. During the years 1328–32 he worked for the king of Naples, Robert of Anjou, and was granted an annual pension by the king in 1332. In 1334 Giotto became the Master of Works of the Opera of the Duomo in Florence. He died in 1337.

Already Giotto's contemporaries, such as Dante, recognised that he changed the course of painting. Cennino Cennini (see p. 2) said that he changed the language of painting from Greek to Latin, meaning that he forsook the Byzantine iconic style for a more classical, more 'naturalistic' style. His work contrasts sharply with that of his near contemporary, Duccio (see pp. 72ff). Even his small-scale figures have the bulk and monumentality of those painted life-size in fresco and stand in a credible three-dimensional space, framed by architecturally convincing buildings. The laws of perspective had not yet been formalised, but Giotto was one of the first painters to take into account the viewpoint of the spectator in designing coherent compositions intended to be seen from a particular angle, and with a coherent light source.

2. The Pentecost

The Pentecost (Plate 48) is described in Acts II, 1–13: after the Resurrection the Apostles gathered together and were filled by the Holy Ghost (here represented by a dove with rays emanating from it), and tongues of fire settled upon their heads; outside a multitude of people from different nations was gathered and all marvelled at hearing the Apostles speak in their own language of the wonderful works of God. It is unusual for the Virgin Mary to be omitted from the scene (compare, for example, Cat. no. 8, Plate 148), but Giotto does the same in the fresco of this scene in the Arena Chapel at Padua.

The panel, which was probably painted between 1305 and 1317, is one of a series which includes six other scenes: the *Nativity with the Epiphany* (New York, Metropolitan Museum), the *Presentation* (Boston, Isabella Stewart Gardner Museum), the *Last Supper* and *Crucifixion* (both Munich, Alte Pinakothek), the *Entombment* (Settignano, I Tatti, Berenson Collection), the *Descent into Limbo* (Munich, Alte Pinakothek), and finally the *Pentecost.* The panels are linked by style, narrative, measurement and their unusual

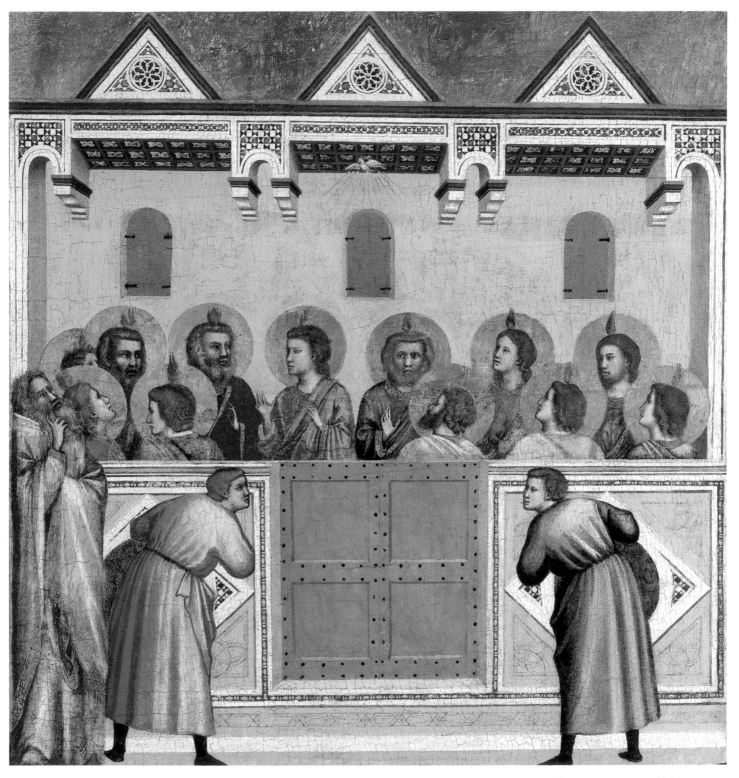

Plate 48 Giotto and his workshop: *The Pentecost*. Painted surface 45·5 × 44 cm

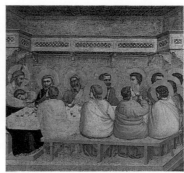
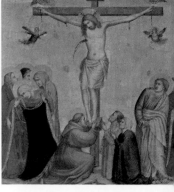

gilding (see below). Although it is rare for a series to include only two scenes of the Childhood of Christ before moving on to the Passion scenes, it is not unknown, and it is virtually certain that the series is complete and that no scenes are missing.

Technical Description

If the panels mentioned above are reconstructed in a horizontal sequence (Plate 49 and Fig. 36) the pattern of wood grain which is visible in X-radiographs (Fig. 37) runs continuously. This confirms the hypothesis that they were all originally painted on a single plank of wood and therefore formed part of a single altarpiece. Moreover, the panels which in such a reconstruction fall at the beginning and end of the sequence – namely the *Epiphany* and *Pentecost* – have a lip of gesso rising at the left and right edges respectively where, perhaps, integral frame mouldings have been removed; this would seem to confirm that they were originally the terminal scenes. Both these scenes have been made up with a wedge of poplar at their left and right base edges respectively: a plank as long and consistently broad as this would be difficult to find, and clearly this one narrowed slightly at each end. The scenes

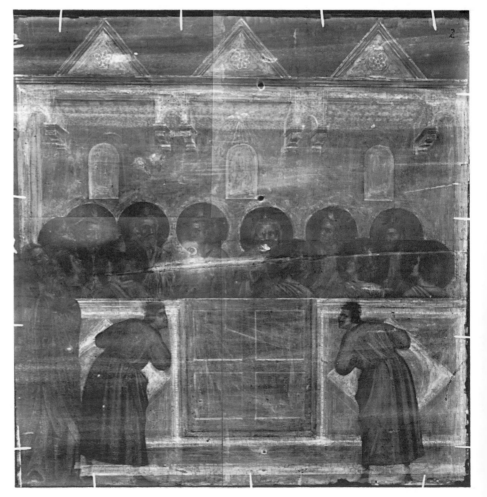

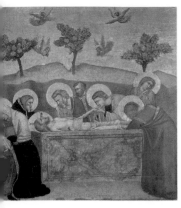
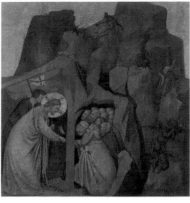
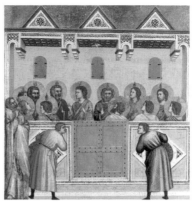

Plate 49 The series of panels reconstructed in their original order. From left to right: *The Nativity with the Epiphany* (New York, Metropolitan Museum of Art), *The Presentation* (Boston, Isabella Stewart Gardner Museum), *The Last Supper* and *Crucifixion* (both Munich, Alte Pinakothek), *The Entombment* (Settignano, I Tatti, Berenson Collection), *The Descent into Limbo* (Munich, Alte Pinakothek) and *The Pentecost* (Cat. no. 2)

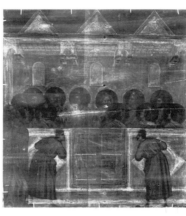

Fig. 36 X-radiographs of the series of panels

Fig. 37 *Below left* X-radiograph of *The Pentecost*

Fig. 38 *The Pentecost*, reverse

seem to have been divided internally one from the other by incised lines, possibly on either side of bands of plain or decorated gold. It seems that relatively little was lost when the scenes were sawn apart and the absence of any lip of gesso between the scenes suggests that there was no raised moulding here.

The *Pentecost* has been cut down at the top and bottom; therefore we cannot now tell whether there was an integral frame which has been trimmed away. The alternative would be for the panel to have slotted into a separate containing frame: at either end there may have been thin raised strips bearing the arms of a patron, the removal of which would have left the lipped edges.

On the backs of four alternate panels, the *Epiphany*, *Last Supper*, *Entombment* and *Pentecost* (Fig. 38), are vertical batten marks which clearly indicate how the horizontal plank was supported. If there was an all-round integral frame, these battens may simply have held the altarpiece upright on the altarblock, or they could have held it within a second, outer frame. However, if, as seems more likely, there was no all-round integral frame, then substantial battens would have been neces-

67

sary to hold the panel in a separate frame and to prevent it from bowing.

The batten marks are not centred on any of the now separated panels, but they form a regular and symmetrical sequence if the panels are reassembled: one near either end and one each side of the centre. The panel appears to have been fixed by nails driven through each batten from the back, rather than from the front before gessoing, as was the case with the predellas of Duccio's *Maestà* (Cat. no. 3) and Ugolino's Santa Croce Altarpiece (Cat. no. 5). However, the nails penetrated almost to the front surface since there are holes in the paint layers where each nail has been withdrawn from the back, causing the paint and ground to collapse inwards. The nail holes are visible as black dots in the X-radiograph, in a vertical line just to the right of centre: one of the nails is still embedded in the panel and appears white in the X-radiograph, on the chin of the Apostle third from the right in the back row.

The irregular distribution of nail holes in the back of the *Pentecost* is almost identical to that on the *Entombment*; the carpenter clearly had a working sequence which he repeated on both battens, and presumably on all the others. Once the battens had been attached, the back of the long panel and the battens were covered with a layer of fine linen and gesso, and then finished with paint resembling deep red porphyry. That this was the final stage is clear from the clean wood where the battens have been removed. Remains of the porphyry-coloured coating are present on the *Epiphany*, *Entombment*, *Descent into Limbo* and *Pentecost*: on the *Pentecost*, only a tiny fragment is left (Plate 50), but the pattern of the linen in the gesso is visible everywhere.

This coating shows that the altarpiece was finished to an unusually high degree for one which was evidently not portable. It also implies that it would have been visible from the back – otherwise there would have been no need to finish it in this way – and this has implications when considering where the original location of the altarpiece might have been. If the horizontal reconstruction is correct, then the entire altarpiece would originally have measured approximately at least 308 cm. Normally one would expect such a long

Plate 50 Macro detail of a fragment of the porphyry-coloured coating on the reverse

horizontal structure to have formed the predella supporting an altarpiece above. However, the sheer size of the whole would seem to preclude such a solution and it seems more likely that it was an independent altarpiece in the form of a long low dossal.

The original location of the altarpiece is unknown. The earliest certain references to the panels are in the nineteenth century: the Munich panels were acquired in 1805 and 1813, and four others were offered in the sale of the collection of Stanislas Poniatowski in 1839. The presence of St Francis in the *Crucifixion* indicates that the altarpiece must originally have come from a Franciscan church. It has sometimes been said that Vasari may have been referring to this altarpiece when he said that Giotto painted an altarpiece with small figures which was subsequently fragmented and which was brought from Borgo San Sepolcro to Arezzo during the fourteenth century. It has been suggested that the altarpiece came from the church of San Franceso in Borgo San Sepolcro where an altarblock dated 1304 still survives.

The key to the problem of the altarpiece's original location lies in the identity of the two figures who kneel opposite St Francis in the *Crucifixion*. One possible solution is that the donors are Riminese. In Riminese painting the Nativity and Epiphany are often combined as in the New York panel, and there are other iconographic features which seem to

imply a Riminese context. It is therefore possible that the altarpiece could have come from San Francesco, Rimini, a church which was refurbished by Alberti in the fifteenth century. The two supplicants could represent Malatesta di Verucchio (d. 1312), who was buried in San Francesco, Rimini, and either his sister, who was also buried there, or his wife Margherita, who survived him.

The extent to which Giotto himself was involved in the altarpiece is problematic. The powerful draughtsmanship of some of the figures, for example the two foremost figures in the *Pentecost* or the donor figures in the *Crucifixion*, certainly suggests his hand, while some of the weaker figures confirm workshop participation. It seems likely that Giotto designed the altarpiece and painted some of it, leaving the rest to assistants. Certainly the apparently sophisticated experimentation with colour suggests the close involvement of Giotto himself.

Technically, the most notable feature that links the seven scenes is the unusual method of gilding. Instead of the usual red bole beneath the gold, there is on all the panels a thin layer of green earth, which gives the gold a very cool tonality. Seen from above, through scratches and flaws in the gold, the preparation appears almost white (Plate 51), but in cross-section a thin but dense layer of terre verte can be seen lying between the gesso and the gold (Plate 52). Cennino mentions the use of green earth as a preparation for gilding, but it is seldom encountered. Examples in works by Giotto have been noted – for example the *St Stephen* in the Horne Museum, Florence – but, apart from linking the *Pentecost* with its six companion scenes, no coherent pattern in its use by Giotto's workshop has yet been established.

The practical method of gilding would have been identical to that using red bole. Terre verte does not burnish with quite the same lustre as red bole, but this would add a slightly granular, diffused quality to the gilding which enhances its characteristic appearance.

Both the backgrounds and haloes of these panels are gilded in this manner and the gold invariably extends under the surrounding paint for some way. In the *Pentecost*, gold quite clearly underlies the background paint around the haloes and

the Apostles' heads within (Plate 54), and the outlines of the gold visible in the X-radiograph are greater than those visible on the surface of the picture. This is consistent throughout the series.

In the Boston *Presentation* a great deal of the composition is painted over the gold. The side gables of the roof are entirely on top of gilding – perhaps indicating that they were something of an afterthought – but so too are the columns which support the roof. The outlines of the columns are incised, but they are so narrow that it was probably impractical to miss out these thin strips during gilding. Also in the *Presentation*, there appear to be

Plate 51 Macro detail showing green earth under the gold

Plate 52 Cross-section showing layer of green earth applied over the gesso as the preparation for gilding. Magnification, 360×

Plate 53 The greenish-yellow background: lead-tin yellow 'type II' with a little black pigment painted over red earth mixed with lead white. No gesso present. Cross-section, 300×

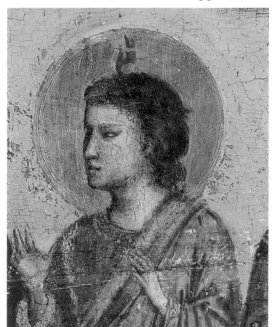

Plate 54 Detail of head, after cleaning, before restoration, showing the gilding extending under the surrounding paint, causing it to flake

no incised lines around the heads inside the haloes. Neither are there on the National Gallery *Pentecost*. Clearly the painter was quite empirical about these passages, finalising their form only at the painting stage. In the *Presentation*, all the outstretched hands are completely over gold and there appears to be little or no incising around them.

The tendency of tempera paint to flake from smooth gold is a risk which is inherent in this sort of practice, and is well demonstrated on the *Pentecost*, in which the background paint has flaked away from many points around the outlines of the haloes (Plate 54). A particularly interesting passage is visible on the *Entombment* at I Tatti: at the lower left, gold extends beyond the outline of the halo, as usual, but here it has quite obviously been scratched to provide a key before painting the pink robe of the figure behind over it.

There is also mordant gilding (see p. 43) in the *Pentecost*, picking out the decorative patterns on the partition wall, the rays of the dove and the coffered ceiling. The mordant contains drying oil and a little pigment – principally lead white added mainly as a drier rather than for any colour effect. In places there appear to be two layers of gold on top of the mordant: this may be due to original patching of missed pieces overlapping the first layer on either side. In other areas – the rays from the dove, for example – there is very little gold remaining, and only traces of the mordant lines can be seen.

The mordant used here (see Plate 57) in Giotto's workshop is similar in principle to that observed on the panels of Duccio (see Cat. nos. 3 and 4), but it is used in a much less dramatic way. In Duccio's work, the mordant is piled up into a three-dimensional relief, giving an almost illusionistic effect to his drapery highlights and decorations; moreover, it is a very dense yellow brown, so that even when the gold is worn away it still imitates the gold detailing. In the *Pentecost* and the other panels in this series from Giotto's workshop, the mordant is flat and dark and performs very little optical function – it is merely a line of tinted adhesive attaching the gold decoration.

Some of the colour effects on the *Pentecost* are striking. Perhaps the most unusual experimentation with colour

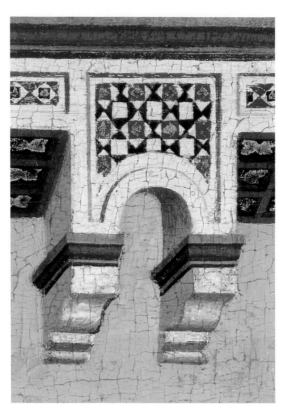

Plate 55 Cross-section from the mosaic pattern of the architecture: thick layer of mineral azurite over vermilion on the background of white. No gesso present. Magnification, 350×

Plate 56 Detail of the mosaic pattern of the architecture

occurs in the yellow-green background wall and partition wall. Even a cursory examination will reveal that below the upper yellow layer is a warm pink which shines through in many places (see Plate 54). Its effect now is considerable, mainly because of wearing in the layer above, but it was probably always meant to have some tonal influence.

Cross-sections show that the upper layer consists of lead-tin yellow (*giallorino*) with a few particles of black giving it a slightly greenish cast (Plate 53). The strong pink underneath is a mixture of red earth and white and, significantly, a few red particles from this layer have been picked up and dispersed into the lower part of the yellow layer above. This indicates that the second layer was painted quite soon after the first and suggests that a deliberate juxtaposition of contrasting colours was being constructed, rather than a simple change of mind about the background colour.

This distinctive greenish yellow occurs elsewhere in the series – for example on the Boston *Presentation* and the New York *Epiphany*. Nowhere does it seem to be superimposed on red in quite the same radical way as in the *Pentecost*, but in both of the other pictures it is placed quite deliberately alongside strong reds, so it

Plate 57 Pink drapery with mordant gilding of the standing figure, left, made up of three layers of lead white with red lake pigment. Over this is the mordant for the gold leaf. Cross-section, 350×

Plate 58 Fragment in transmitted light of orange-coloured glaze representing tongue of fire: possibly based on the red resin known as 'dragonsblood'. Magnification, 90×

was clearly a favoured colour contrast in the workshop.

An interesting colour effect on the *Pentecost* is the orange robe of the monumental figure in the left foreground. Here the orange browns are essentially earth colours, but in the highlights there is a mixture of yellow earth and an unidentified yellow lake. This combination may also be present on the king at the left of the *Epiphany*.

As well as using colour in novel combinations, the painter has also handled paint in ways that anticipate textural effects that were sought much later. It is relatively uncommon to see egg paint being used thickly, mainly because painters were well aware of the dangers of crumbling and flaking. A considerable thickness of tempera paint containing azurite is seen on the San Pier Maggiore Altarpiece (Cat. no. 8) and here, on the *Pentecost*. The mosaic pattern of the architecture stands up in low relief also because of the use of thick raised azurite-containing egg paint. The vermilion red patterning was put on first very thinly over the white base colour, and then the coarse azurite applied last: in places it overlaps the vermilion (Plates 55 and 56).

There are various other reds in the picture: the pink drapery at the left consists of a mixed white and red lake underlayer with in the shadows a lake glaze in egg (Plate 57). The use of transparent pigments such as lakes for glazes was considerably restricted by the egg medium, because of its relatively low refractive index.

There is a transparent red in the *Pentecost* which has not yet been identified – the paint used for the dark orange-red tongues of fire above the Apostles' heads (Plate 58). It is certainly not a conventional pigment and medium mixture. Possibly this is a rare use of the natural resinous exudation 'dragonsblood'. It is normally considered fugitive unless locked into a resin film: Cennino mentions it in connection with parchment illumination, but says: 'leave it alone and do not have much respect for it; for it is not of a constitution to do you much credit.' The material on the *Pentecost* has not been positively identified, but the intriguing possibility of its being dragonsblood remains.

Both azurite and ultramarine blues are present on the *Pentecost*. The greenish-blue draperies have an underlayer of azurite and white with glazes of pure azurite and a little ultramarine on top (Plate 59).

It is instructive to compare the flesh passages of these paintings with the classic system described by Cennino and practised by Duccio. In Duccio's faces we see the terre verte underpaint followed by hatched pink and *verdaccio* detailing, with a little local variation for highlights, eyes, mouths and so on. In the *Pentecost* and the related six paintings, there is no green underpaint at all for the flesh tones (Plates 60 and 61). There may be a rudimentary sketching out in brown on the ground (no underdrawing has been detected), but the first colour layer is a pale pink mixture of white and vermilion, given a slight greenish tinge in the half-tones by the use of a little black. The detailing on top for eyes, noses, mouths and so on is carried out in a hot brown-red tone quite unlike the olive green-brown of conventional *verdaccio*.

By painting faces in this way, Giotto and his workshop would not have had the approval of Cennino: 'some begin by laying in the face with flesh colour; then they shape it up with a little *verdaccio* and flesh colour touching it with some highlights: and it is finished. This is a method of those who know little about the profession.'

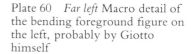

Plate 59 Fragment in transmitted light of greenish-blue drapery showing particles of ultramarine used to glaze the azurite undercolour. Magnification, 380×

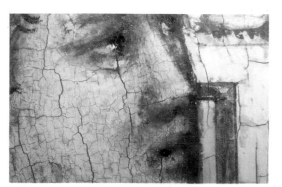

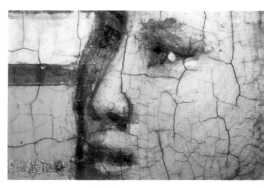

Plate 60 *Far left* Macro detail of the bending foreground figure on the left, probably by Giotto himself

Plate 61 *Left* Macro detail of the foreground figure on the right, probably by Giotto himself

DUCCIO DI BUONINSEGNA

active 1278, died 1318/19

The Sienese painter Duccio di Buoninsegna was one of the most important painters of the fourteenth century in Italy. Despite the large number of works attributed to him and his workshop, only two are documented: the Rucellai Madonna *(Florence, Uffizi; Plate 6), which he contracted to paint in 1285, and the* Maestà *completed for Siena Cathedral in 1311 (see below, Cat. no. 3), which names Duccio as its painter in the inscription and for which documents survive (see Appendix II). Apart from the* Rucellai Madonna *and a polyptych in Perugia, the surviving works attributed to Duccio come from Siena and the surrounding area, where he is documented from 1278 onward and where he apparently spent most of his working life, although Stubblebine has suggested that he may be identifiable with a certain 'Duch de Sienne' and 'Duch le lombart', documented in Paris in 1296 and 1297.*

Ghiberti, writing in the fifteenth century, said that Duccio held to the Greek manner. Certainly he appears to have modelled himself on Byzantine sources, as well as on earlier local Sienese and possibly also on northern Gothic works. He was also deeply influenced by the sculpture of Nicola Pisano, particularly by the pulpit, executed in 1265–8, which is in Siena Cathedral. Although his style is basically linear and iconic, his interpretation of human relationships is increasingly naturalistic and charged with emotion.

Duccio evidently had a large workshop and probably collaborated with other master painters and although the names of his pupils are not known, they may have included Pietro and Ambrogio Lorenzetti, Simone Martini and possibly Ugolino di Nerio (see pp. 98 ff.).

3. The Maestà

The following three panels, Cat. nos. 3a, b and c, all come from the front and back predellas of Duccio's *Maestà*, the altarpiece which was carried in triumph from Duccio's workshop to be placed on the high altar of Siena Cathedral in 1311 (Fig. 41). The *Maestà* bears the inscription: MATER SCA DEI/SIS CAUSA SENIS REQUIEI/SIS DUCCIO VITA/TE QUIA PINXIT ITA (Holy Mother of God be thou the cause of peace for Siena and life to Duccio because he painted thee thus). It has been described as 'the richest and most complex altarpiece to have been created in Italy'. It measured originally approximately 468 cm wide and 500 cm high. It was made up of two composite panels and painted front and back (Figs. 39 and 40). The main front scene (Plate 5) shows the Virgin and Child enthroned among saints and angels, including the four patron saints of Siena. Above were pinnacles with scenes from the Death of the Virgin. The front panel was supported by a predella with scenes from the Infancy of Christ beginning with the *Annunciation* (Cat. no. 3a) and ending with the *Teaching in the Temple*. The back panel is divided into a series of twenty-six scenes from the Passion of Christ, beginning with the *Entry into Jerusalem*. Above it were pinnacle panels with post-Resurrection scenes. It was supported by a predella with scenes from the Ministry of Christ, of which the opening scene is probably lost; they include: *Jesus opens the Eyes of a Man born Blind* (Cat. no. 3b) and the *Transfiguration* (Cat. no. 3c). The last scene was probably the *Resurrection of Lazarus* now in Fort Worth, Kimbell Art Museum.

The altarpiece was removed from the high altar of Siena Cathedral in 1506 and was eventually sawn into several fragments in 1771. Thereafter the fragments led a peripatetic existence and although most of the fragments, including the main panels, are now in the Museo dell'Opera del Duomo in Siena, several have been dispersed in collections throughout the world (see Appendix I for the present location of all the surviving panels), and the precise original appearance of the altarpiece remains a subject of debate.

Another subject of debate concerns which parts of the altarpiece were painted by Duccio himself and which by members

Fig. 39 Duccio: *The Maestà*. Reconstruction of the front by White

73

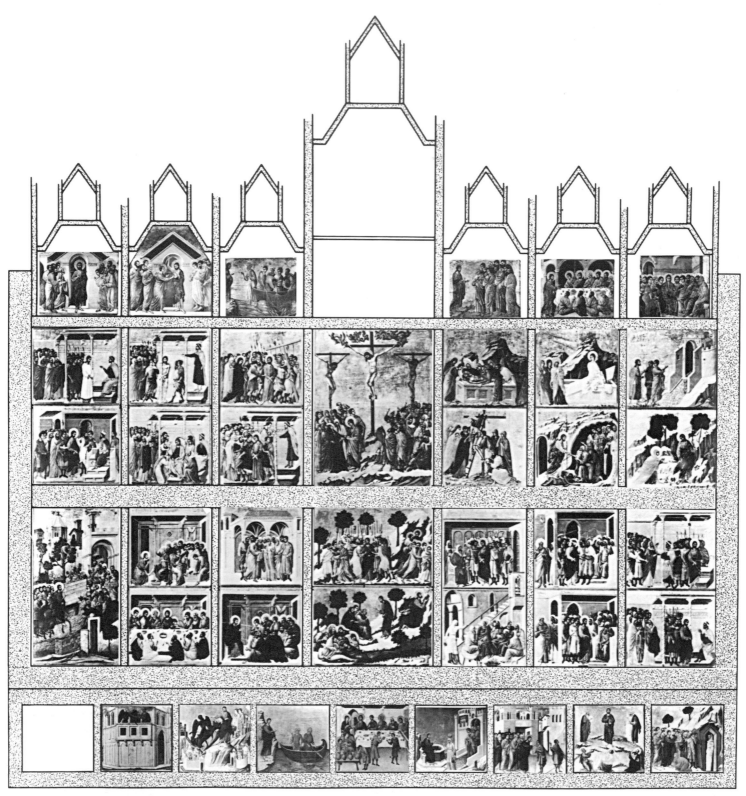

of his workshop. A document survives dated 1308 (see Appendix II) in which Duccio promises to work continuously on the altarpiece, not to accept any commissions in the interim, and to work on the altarpiece with his own hands. It has been argued that this is not a commissioning contract, since it does not specify the subject-matter etc., but rather an interim agreement. Another document, recorded in the nineteenth century, undated but usually considered to date 1308–9, is a further agreement concerning payment for 'thirty-four histories' on the back and for 'the little angels above', which presumably went above the pinnacle panels. It is

Fig. 40 Duccio: *The Maestà*. Reconstruction of the back by White

impossible to summarise even briefly the complexities of the altarpiece in a catalogue entry and the reader is referred to the monographs on Duccio and his workshop by Stubblebine and White listed in the Bibliography.

The *Maestà* was possibly the first altarpiece of such magnitude to be painted on both sides, and the planning and designing in the initial stages must have been crucial, although there is also some evidence to suggest that the design progressed in a somewhat piecemeal fashion. It is almost certain Duccio looked at a large fresco cycle, namely the Arena Chapel in Padua by Giotto, probably completed *c.* 1305, for inspiration on how to give visual unity and coherence to a large number of scenes. The result is that the altarpiece is drawn together by a web of references and by unity of design. The narrative impetus opens on the front predella with the *Annunciation*, and on the back progresses steadily from the bottom left-hand corner with the *Entry into Jerusalem* to the top right-hand corner with *Christ on the Road to Emmaus*. There is unity of place, for example in the scenes showing Christ together with the Apostles which all take place in the same room. Even without knowing what the central lost pinnacle scenes were, one can see that the narrative scenes on the back and front were organised around a central axis: on the front the whole altarpiece balances visually on the arch of the ciborium in the predella *Presentation*, and on the back the central axis runs through the compositions of the *Crucifixion*, *Agony in the Garden* and *Betrayal*.

The predella is the earliest surviving narrative predella. It is known that in 1301 Cimabue painted an altarpiece with a predella for Santa Chiara in Pisa and that in 1302 Duccio painted an altarpiece with a predella for the Palazzo Pubblico in Siena, but both of these altarpieces are now lost.

The original physical construction of the *Maestà* is not known with certainty. John White's reconstruction (Figs. 39 and 40) is generally accepted as the basis for the arrangement of the various scenes in relation to each other. However, some panels are missing and many details remain unresolved: the dismemberment of the altarpiece was so radical that a definitive reconstruction of the whole – the panels,

the frame, the precise dimensions – is no longer possible, although, it must be said, each new examination seems to throw fresh light on the problem. Before considering the three National Gallery predella panels in their specific context, it is worth summarising the known facts about the structure of the *Maestà* as a whole.

The main scene on the front of the Virgin and Child enthroned with saints and Apostles is made up of eleven vertical planks of varying width, joined and dowelled edge to edge. The joins do not correspond to natural divisions within the composition, such as the arcade of Apostles – they run between some of the figures but bisect others. The surface of the main panel today is riven with many vertical lines, both joins and cuts, because, confusingly, it was sliced up into seven vertical pieces (corresponding to the vertical divisions between the scenes on the *back* panel, rather than to the joins on the front panel) when the front and back panels were separated in 1771.

The front panel was originally about 7 cm thick. The rear panel was hardly more than one cm thick and was made up of five *horizontal* planks running the entire width of the altarpiece. By contrast with

Fig. 41 Sienese School. Detail from a *Tavoletta di Gabella* (a painted book cover) of 1482, showing the interior of Siena Cathedral. Siena, Archivio di Stato

the front, the joins between the planks do correspond to the horizontal divisions between the various scenes. In the 1771 dismemberment, the rear panel was cut up into its vertical sections, but the horizontal wood grain, running continuously across adjacent scenes, can still clearly be observed.

The front and back main panels were originally nailed directly together, back to back, using nails driven in from the rear side and subsequently gessoed over. In the operation to separate the two faces, the composite whole was first cut vertically into seven pieces, and then the two faces were separated by sawing within the thickness of the wood, avoiding the nails: this necessitated cutting much closer to the front surface than to the back and in one or two places (most seriously in the Virgin's face on the front panel) the saw actually slipped through the front of the picture, causing significant damage.

Surmounting the main scene were pinnacle panels depicting scenes from the last days of the Virgin on the front and scenes after Christ's Resurrection on the back. With two exceptions (see below), they have been drastically cut down from their original truncated gable shape into rectangles of different sizes. Curiously, the wood grain on all these pinnacle panels runs horizontally and, whereas the original structure of the main panels and the predellas (see below) has been clarified by several writers, that of the pinnacles remains unclear. X-ray examination would probably settle the matter, but in the absence of radiographs, we may consider two alternative structures for the pinnacles.

White suggests that the thin front and rear pinnacle panels were separated by battens deep enough to bring the painted surface into line with those of the respective main panels below. He argues that if they had been set back they would not have been visible from below. However, it would appear to the present writers that the pinnacles may well have been single panels painted on both sides, subsequently (in 1771) sawn down the centre to make the thin panels that we see today. This would explain the otherwise striking coincidence that the only two pinnacles to have remained complete are the *Funeral Procession of the Virgin* and the *Incredulity of*

St Thomas which were probably originally one piece of wood painted on both sides. It would also explain why certain visible wood-grain faults seem to be mirrored in corresponding front-back pairs: for example the *Gathering of the Apostles* and the *Apparition in Galilee*, which share a common fault caused by a prominent knot. X-radiographs would confirm this hypothesis.

Above the pinnacles, it has long been assumed, were the 'little angels' detailed in the undated agreement as being above the 'thirty-four histories'. Four possible panels have been identified (the John G. Johnson Collection, Philadelphia; Mount Holyoke College, South Hadley, Mass.; J. W. van Heek Collection, the Netherlands; and formerly the Stoclet Collection, Brussels), all of similar angels, but each now cut down or altered in shape. Interestingly, at least two of these panels have horizontal wood grain, as the pinnacles also do. If there were originally angels at both front and back above each pinnacle, then a great number have been lost or remain to be discovered.

The front and back predellas were each a single massive horizontal plank. The structure of this part of the altarpiece is discussed below, but here the relationship between the predella and the rest of the altar should be mentioned. It is now thought probable that this was an early example of a box predella – an autonomous structure which supported the altarpiece above it. In later examples, the box projects substantially in front of and to the sides of the main panels, but whether this was the case for the *Maestà* is not clear. Certainly the total lengths of the front and back predella scenes are about 25 cm longer than the width of the main panel, but this difference may have been accommodated within the frame structure. Whether the predella box did project at the sides, whether it was painted at either end, and what the nature of the framing was around the main panels, would have a profound significance on the supporting structure of the entire altarpiece.

One of the main problems concerning the *Maestà* is how this mammoth structure was actually kept in place on the altarblock. Since it was double-sided, supports at the back were not possible and metal

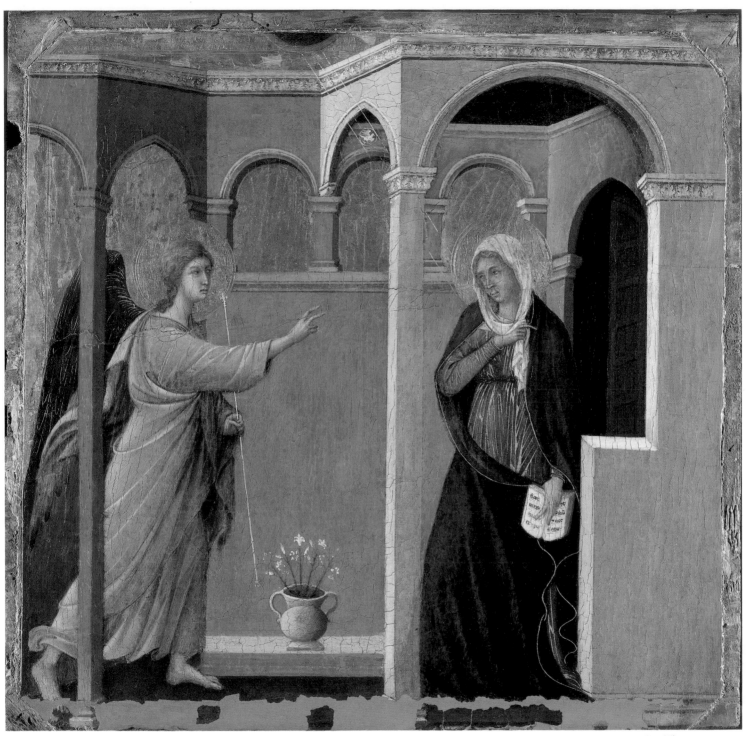

Plate 62 Duccio: *The Annunciation*. Painted surface 43 × 44 cm

struts to distant piers were unlikely. Iron bars fastened inside the predella box and slotted into the altarblock would be a possibility, but the upper altarpiece would remain very unstable. Even a rigid frame-box of the type proposed by White would have had to be supported by substantial vertical struts of some kind.

Alternatively, it has been argued by Gardner von Teuffel that on either side were heavy supporting buttresses, which were in use on other fourteenth-century Tuscan altarpieces; and she further suggests that they may have been painted with the kind of fictive marbling found on the Virgin's throne.

The problem of how the *Maestà* was fixed in place remains unresolved. Since the original frame was destroyed, we can never know for sure. In any case, it was surely unlikely that the enormously heavy altarpiece was carried to the Cathedral already complete, but rather was carried in separate manageable pieces – consisting of the predella, main panel and pinnacles – and was, like the Santa Croce Altarpiece by Ugolino di Nerio (Cat. no. 5), assembled *in situ*.

3a The Annunciation

This panel (Plate 62) shows the moment when the Angel Gabriel tells the Virgin that she is to bear the Son of God, as described in St Luke's Gospel (I, 26ff). In her hands she carries a book inscribed with the prophecy of Isaiah (VII, 14): 'Ecce virgo concipiet et pariet filium et vocabitur . . . (Behold a Virgin shall conceive and bear a son and shall call his name [Immanuel]).'

The iconography of the *Annunciation* is firmly rooted in Italian painting of the thirteenth century. Stubblebine suggested that it was painted after a journey to Rome and that Duccio copied from Cavallini's mosaics in Santa Maria in Trastevere, Rome, the vase of lilies in the foreground which symbolise the Virgin's purity.

Duccio was also influenced by paintings by Guido da Siena (active *c.* 1260– *c.* 1280) with whom he may have trained, and his circle. The composition and colouring are close to that of the *Annunciation* in a dossal of *c.* 1275 from the circle of Guido (Fig. 42 and Plate 63), as are other scenes from the *Maestà*. Duccio has evidently refined the design and the modelling of the drapery in delicate hatching and the feathers of the Angel's wings have been highlighted with gold.

Technical Description

The *Annunciation* was at the left-hand end of the front predella of the *Maestà*. At its right side it was originally joined to the narrower *Isaiah* which is still attached to the *Nativity* in Washington. The front predella was composed of one massive horizontal plank, with a narrow (original) addition *c.* 5 cm wide attached with nails at the bottom. This join runs along the entire length of the predella and is present on the *Annunciation*: here, however, it is only about 2·5 cm from the bottom edge because the panel has been cut down by about 2·5 cm. The plank which formed the main part of the predella was about 6–7 cm thick, about 2 cm thicker than the back predella, and sawn fairly close to the centre of the tree, although not precisely quarter-sawn (Fig. 6). All the panels of the front have remained remarkably flat, in contrast to those of the back predella, indicating that a dimensionally stable length of timber was chosen.

The *Annunciation* was, at some time after its separation from the rest of the predella, thinned down to about half its original thickness and, until a few years ago, had modern battens attached to the back which have since been removed, but the shadow of their shape is still visible. The prominent horizontal grain, which shows clearly both on the back and in the X-radiograph (Fig. 43), has caused some structural problems on the panel, most noticeably a series of splits across the upper centre where paint has been lost, and a knot just above which has also moved, causing paint to flake in the past.

The *Annunciation* no longer has its original frame, and a border of bare wood around the painted image marks where it once was. The linen and gesso layers, which would have been applied over both the frame and the panel continuously, were cut through with a sharp knife along the inner edge of the frame moulding when it was taken off and can be seen clearly at the present edges of the paint and gold.

The frame of each front predella scene is slightly different in form from that of the rear predella scenes as the square corners of each scene are marked off by a small diagonal moulding. This integral framing clearly fitted inside another overall frame which probably formed the outer moulding of the whole predella. Evidence for this is seen on the panels still in Siena, which retain their attached frames: the top and bottom of the mouldings are rebated to fit into an outer frame.

The long panel with its various scenes was supported in the structure of the predella by two vertical battens, the remaining traces of which are visible on the backs of the *Adoration of the Magi* and the *Massacre of the Innocents*, symmetrically placed around the centre of the panel. Fixing was done by nails through the front of the panel into the battens. In the *Adoration*, the three square nail heads are clearly visible as disturbances on the surface of the painting in a vertical line to the left of centre, and the points of the nails still protrude at the back.

In addition to these battens, the predella panel was also fixed at each end. The National Gallery *Annunciation* has three ragged indentations along its left-hand edge where nails or dowels seem to have been extracted (Fig. 44). Significantly, the *Teaching in the Temple* (the scene at the other end of the predella) has three plugs of new wood in identical positions on its right-hand edge, indicating that the panel was fastened into position by nailing or dowelling through the outer framework into the end-grain of the plank at either end.

These observations give some clues about the way the predella panel was supported, but cannot confirm the nature of the overall structure. Clearly the front and back predellas were not simply nailed together back to back as the main panels

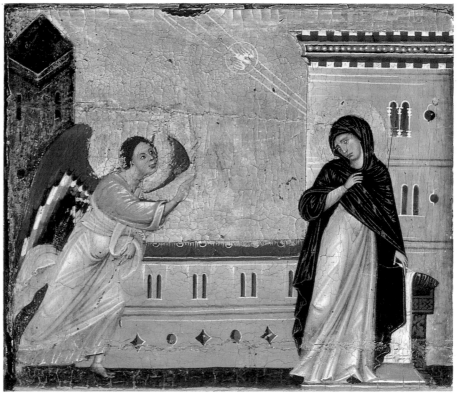

were: the batten marks indicate at least some space between the two great horizontal planks.

It seems probable, as White has suggested, that the predella structure was deeper than the frame of the main panel and was an early example of the autonomous box predella. That the predella and the main panel were in fact separate is indicated by the extant documents concerning the painting of the *Maestà* – which

Fig. 42 Circle of Guido da Siena: *St Peter Enthroned, with four stories from his life, The Annunciation and The Nativity.* Siena, Pinacoteca Nazionale

Plate 63 Circle of Guido da Siena: *The Annunciation.* Detail from Fig. 42

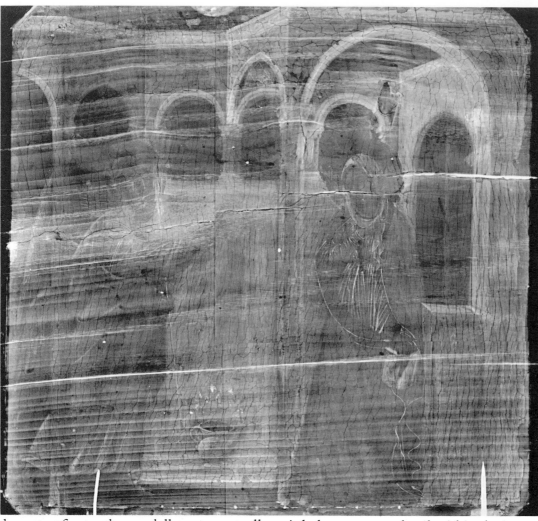

Fig. 43 Duccio: *The Annunciation*. X-radiograph

Fig. 44 *The Annunciation*. Left edge of panel

do not refer to the predella scenes at all (although lost documents may have done so) – and by an inventory of 1423 in which the provision of hanging draperies for the altarpiece specifies separate hangings for the main panel and predella. If the predella had been in the same plane as the panels above, a single set of hangings would have been sufficient.

Furthermore, if the predella was in the form of a box painted on both long sides, the vertical marks that have already been noted would indicate the positions of vertical partitions used to strengthen the structure of the box. The box-ends would have been attached to each end of the predella plank at the three indentations already described above. It is logical to assume that they were attached similarly to the rear predella plank, but the evidence is lost. Whether the box-ends were painted with additional scenes has been the subject of some debate, principally by Stubblebine and by Ruth Wilkins Sullivan. As they have shown, additional scenes could cer-

tainly be accommodated within the iconographical scheme, but there is no firm evidence that they did in fact exist. It should be pointed out that the presence of scenes on the ends of the predella box would almost certainly preclude the existence of substantial lateral buttresses supporting the altarpiece, since the paintings would have been obscured by the buttresses.

In the *Annunciation*, Duccio evidently had some difficulty in arriving at his final design. For example, infra-red reflectography shows that the receding architecture above the Angel's head and outstretched arm was originally drawn somewhat lower, the parapet closer to the tops of the arches than it is now; the tops of the receding walls sloped down more sharply and the back wall was the same height as the interior back wall behind the Virgin. Despite the fact that the perspective of this arrangement made more sense, Duccio had abandoned it by the time the gilding was done, since the present parapet is

marked by an incised line at the edge of the gold. When the basic outlines of the architecture were established by drawing and incision, Duccio was able to place the two figures and establish their relationship to each other. The heads of the Virgin and the Angel are connected by the white parapet behind, which is incised precisely as far as the outer curve of each halo.

Underdrawing is visible in the Angel in infra-red photography and reflectography (Figs. 45 and 46) and appears to be of two kinds. In the upper part, around the arm and shoulder, the drawing is scratchy and slightly hesitant, clearly showing the double line of a quill (Plates 64 and 65): this highly characteristic drawing is also found on the *Transfiguration* and, significantly, on the *Virgin and Child with Saints* (Cat. no. 4). Lower down, the drawing becomes softer, more fluent, perhaps done with a brush: Duccio apparently designed the figure in more than one stage. There is little doubt that all the drawing here is by his hand – the two styles result directly from the different handling qualities of the pen and the brush.

Duccio appeared to be uncertain how to develop the area within the left-hand

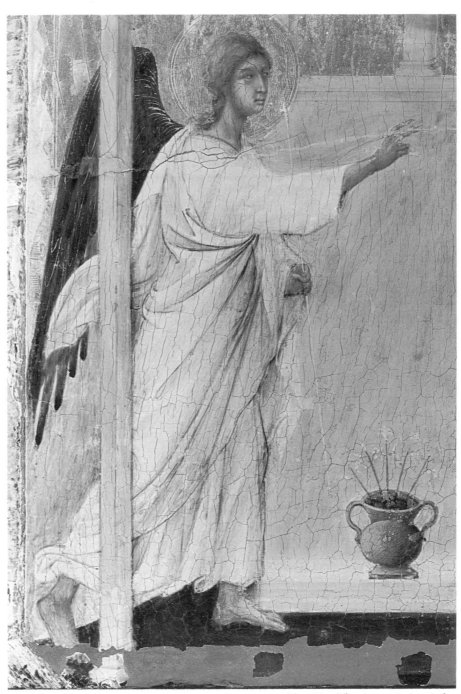

Fig. 46 *The Annunciation*. Infra-red detail of the Angel

Fig. 45 *The Annunciation*. Infra-red reflectogram detail of the underdrawing in the Angel's mantle where it adjoins the sleeve

Plate 64 *The Annunciation*. Macro detail of the underdrawing in the same area of the Angel's mantle as Fig. 45

Plate 65 *The Annunciation*. Macro detail of the underdrawing in the Angel's mantle where it meets the skirt of his robe

81

arch. It is possible that he originally contemplated making it a solid wall, balancing that to the right of the Virgin, and that the Angel was intended to be seen emerging from an arched doorway rather than through an open arch. But, once the open arch was decided upon, Duccio failed to resolve one area within it: the space below the Angel's wing at the left side of the composition. After the drawing stage, the upper line of the wing was incised as a guide for the application of bole and gold. Red bole seems to have been applied both above and below the wing, but only the part above was gilded.

There was clearly considerable confusion here as to what precisely should be seen beyond the Angel. Duccio presumably forgot or decided not to gild the area below the wing, perhaps intending to paint in some background feature over the bole; but, by the time he had painted the rest of the picture, he had still not resolved what to put there. In the end he simply glazed over the bole with deep orange paint (which overlaps both the Angel's foot and the pink and blue drapery) and left it as a featureless unexplained area (Plate 66). To suggest a kind of continuity, the deep orange was also extended to the right of the column, and to a little triangular patch above the Angel's left foot, where it is overlapped by the brown of the floor.

Apart from these particular areas, the general sequence of painting seems to have been: first the pink architecture, followed by the figures, then the grey architecture and finally the brown floor and ceiling. Evidence for this sequence may be seen in the overlapping of the various colours. For example, the low grey wall at the right passes over the edge of the Virgin's blue robe which was broader here. The robe also extended further to the left at the bottom, and the grey column in the centre was at one stage narrower in order to accommodate it. Despite the fact that the column is clearly incised at its present width, the pink wall behind was at first extended inwards to make it narrower at the right and allow room for the robe. Only when the grey was painted on top were the widths of the column and the robe finally decided. The pink under the grey and the original line of the robe can still be seen. The flesh areas of the figures were painted first over their terre-verte

underpaint. There is a small but significant *pentimento* in the Angel's right hand. The Angel originally had the little finger extended, as is often shown in Byzantine paintings. In the final version Duccio changed the blessing hand to conform with Western tradition, either at his own or at the patrons' instigation.

The Angel's blue drapery was painted after the lilac drapery. On the Virgin, the red robe underlies the blue to some extent, indicating that the final shapes of the draperies were determined only at the painting stage. These changes, during both drawing and painting, reflect Duc-

cio's practice elsewhere on the *Maestà*. For example, it has recently been discovered by Ruth Wilkins Sullivan that Duccio changed the composition of the *Raising of Lazarus* on the back predella (Fort Worth, Kimbell Art Museum) away from the Byzantine model to a Northern Gothic and therefore more fashionable convention. Many changes of composition throughout the entire altarpiece have been documented by Brandi, White and others. Clearly Duccio was constantly revising the compositions.

There are two types of gilding present on the *Annunciation*. The background and haloes are conventionally water-gilded over a layer of warm red bole and then

Plate 66 *The Annunciation.* Orange-brown background near the Angel's heel: earth pigments with a little black and lead white over a layer of ungilded bole. Cross-section, 380×

Plates 67 and 68 *The Annunciation.* Macro detail of the mordant gilding on the Virgin's sleeve in normal and in raking light

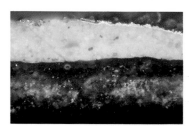

Plate 69 *The Annunciation.* The Virgin's ultramarine cloak with mordant gilding. No gesso present. Cross-section, 180×

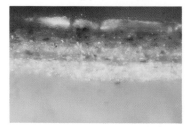

Plate 70 *The Annunciation.* Lilac from gathered folds of Angel's cloak: several overlapping layers of varying tones containing lead white tinted with red lake and ultramarine. Cross-section, 380×

incised freehand with a stylus. The circles of the haloes were inscribed with compasses and the trace of the hole left by the compass point can still be seen in the Angel's head by the hair-line, to the left of the eyebrows. The gold highlighting and decoration of the draperies – seen on the Virgin's red dress, on her blue robe and also on the Angel's wing – have been mordant gilded (Plates 67, 68 and 69). In raking light the lines of the mordant can be seen to have substantial thickness, due, not to the gold, but to the yellow-brown mordant layer beneath. A cross-section of this mordant shows it to consist largely of lead white (thus these lines show strongly white in the X-radiograph) tinted with earth colours and a little red lead. Staining tests show that the medium is a drying oil, and not egg tempera, which is the medium of the rest of the painting.

The pigments present in the *Annunciation* are of the same fairly limited range found on the panels in Siena. Duccio's

colour juxtapositions are rich but conventional and show none of the daring variety seen in Ugolino's paintings. Ultramarine is the sole blue pigment: there is no azurite used in the picture. The Virgin's robe is constructed simply with an ultramarine glaze over an opaque ultramarine and white underlayer, and the blue cloud at the top edge consists of several layers of ultramarine and white. Her dress is painted in a simple mixture of white and red lake glazed with further lake. The lilac of the Angel's robe (Plate 70) contains ultramarine, red lake and lead white in various proportions.

Earth pigments are used frequently. The predominant colour of the architecture is red earth with white (Plate 71) and there are red and yellow earths mixed with black for the dark tones of the floor (Plate 72) and the doorway behind the Virgin. Green earth is used for the Angel's wing tips and provides the underpaint of the flesh tones.

Plate 71 *The Annunciation*. Pink architecture: red earth in a matrix of lead white. Top surface of an unmounted fragment, 130×

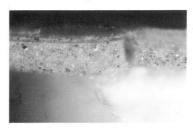

Plate 72 *The Annunciation*. Dark brown paint of floor in two layers: red and yellow earths combined with black and white pigment. Cross-section, 195×

3b Jesus opens the Eyes of a Man born Blind; 3c The Transfiguration

The first scene (Plate 73) shows the incident described in the Gospel of St John (IX, 1 ff.) where Jesus smeared a blind man's eyes with a mixture of mud and spittle; the man washed his eyes in the pool of Siloam and his sight was restored. The two stages of the miracle are subtly linked by the diagonal staff of the blind man, which he has laid down since he will no longer need it to tap his way.

In the second scene (Plate 74) Jesus appears to three of the disciples, with Moses and Elijah, in a glorified state, indicated by his gold striated robes. The subject is described in three of the Gospels (Matthew XVII, 1–8; Mark IX, 2–8; Luke IX, 28–36).

Technical Description

Jesus opens the Eyes of a Man born Blind and the *Transfiguration* were adjacent scenes immediately preceding the *Raising of Lazarus* at the right-hand end of the back predella. The blind man whose sight has been restored looks up in gratitude at the

figure of Christ in the next scene. The continuous panel on which the scenes were painted consisted of a broad central plank with narrow original additions at top and bottom, attached with glue and nails. They can be seen both in X-radiographs and on the panels themselves and confirm the fact that the now separated panels were originally continuous. Additional confirmation is provided by the wood grain, visible in the X-radiographs, which shows a continuous knot pattern just above the centre of the plank (Fig. 49).

The *Transfiguration* still retains most of its original frame. The moulding at either side was sawn down the centre at its highest point to separate it from the adjacent panels (Fig. 48). It seems that the moulding at top and bottom has been trimmed, since no trace of the outer rebate, observed on the front predella panels in Siena (see above) and assumed to have fitted into an overall predella frame, now remains. The frame quite clearly shows the linen and gesso applied over both panel

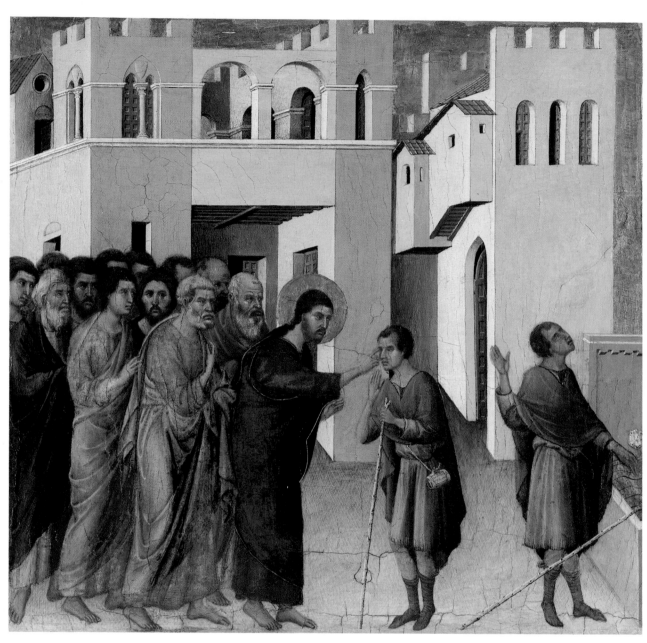

Plate 73 Duccio: *Jesus opens the Eyes of a Man born Blind.* Painted surface 43·5 × 45 cm

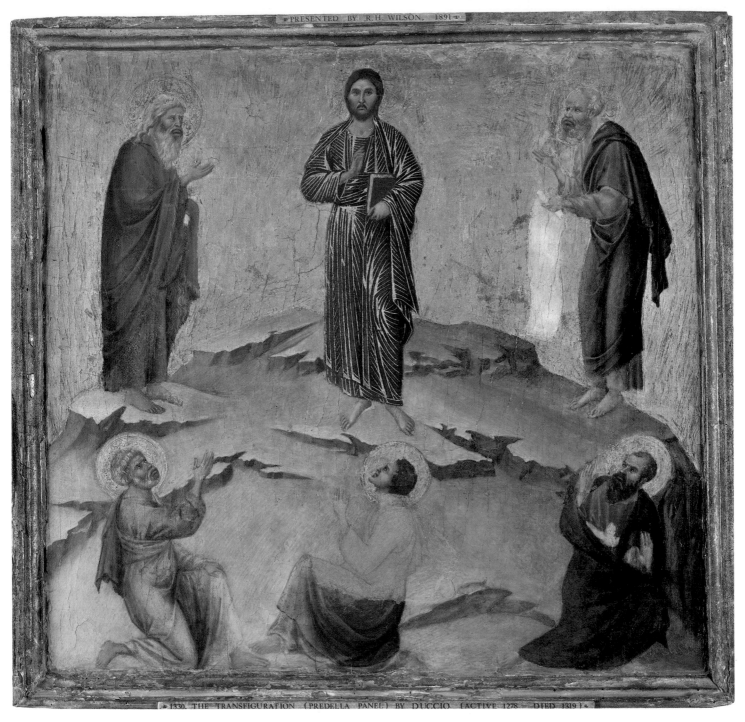

Plate 74 Duccio: *The Transfiguration*. Painted surface 44 × 46 cm

and frame before they were gilded.

The *Man born Blind* has not only had its frame removed, but the bare wood border which would have been exposed by the removal of the frame has been trimmed away also. The panel is therefore some 6 cm smaller in both horizontal and vertical dimensions than that of the *Transfiguration*.

The possible construction of the predella box of the *Maestà* has been discussed above. It might be expected that there should be nail holes and batten marks corresponding to those observed for the front predella, where the structural cross-pieces of the box attached to the rear of the back predella panel. However, measurements suggest that the position of one of the cross-pieces might have coincided with the framing at the left of the *Man born Blind* where the panel has been cut away and that this evidence has been lost. In addition, the fixing into the ends of the rear predella, corresponding to the three fixing points at either end of the front predella, cannot be confirmed: the end left-hand scene has not been identified, and the panel of the *Raising of Lazarus*, the end right-hand scene, is no longer visible, as a result of treatment carried out in the 1930s.

Underdrawing may be seen in both *Jesus opens the Eyes of a Man born Blind* and the *Transfiguration*. In the latter, Duccio's characteristic scratchy quill drawing can be observed by infra-red reflectography under the draperies (Fig. 47), particularly those of Elijah (upper right) and John (lower centre). This corresponds so well with the type of drawing seen on the *Annunciation* and on the triptych (Cat. no. 4) that there can be little doubt that they were done by the same hand.

On the *Man born Blind* the situation is more complex: there are clearly at least two hands at work here, and Duccio may have been responsible only for the more important figures. The architecture is certainly by another hand: comparison with the architecture of the *Annunciation* – generally accepted as wholly by Duccio – makes the contrast clear. On the *Annunciation*, the paint is more freely handled, less precisely applied; on the *Man born Blind* the architecture is painted with crispness of detail and firm hard outlines. In the lighter areas the paint has been blended to produce an enamel-like finish, and the shadows are

painted with a cross-hatched technique not seen on the *Annunciation*.

The contrast between the scenes is also marked in the underdrawing of the architecture. On the *Annunciation* the drawing is broad, rudimentary and freehand and few lines are incised: on the *Man born Blind* almost all the architectural drawing is meticulously ruled with a straight edge and incised (Fig. 50). However, there is evidence that Duccio himself embellished the drawing with a few characteristic flourishes, which the painter of the architecture subsequently chose to ignore. On the *Man born Blind* it is possible to see the sequence of the different stages, and learn something of the nature of the methods of Duccio's workshop and the way in which the artists collaborated. The design and the painting appear to have proceeded in an essentially empirical way, controlled, altered and refined by Duccio as the work progressed.

After the panel had been gessoed, the position of Christ's halo was established in the exact centre of the composition by an incised circle. The figure of Christ (and possibly the Apostles Peter and Paul behind him) and also the two figures of the blind man (showing the two separate episodes of the story) were sketched in. To the left of the blind man at the fountain a thick dark stroke was made, probably with a quill pen, about level with his hips, to show roughly where the base of the architecture was to be (Plate 75). The general area of the figure group to the left was indicated, but not drawn in any detail.

The first three steps in fixing the design were probably carried out by Duccio. The design then appears to have been taken over by the second artist, whose meticulous approach to the complex architecture was so different from Duccio's.

Fig. 47 *The Transfiguration.* Infra-red reflectogram showing underdrawing in the draperies of Elijah

Fig. 48 *The Transfiguration.* Left edge of the panel showing the frame moulding

Plate 75 Macro detail showing the sketched line indicating the base of the architecture to the left of the blind man at the fountain

The straight outlines of the architecture, including the vertical which fixed the relationship to the figures, were drawn and incised with a ruler. Often the horizontals and verticals were extended further than necessary across or down the composition. For example, the prominent horizontal moulding, which forms the capitals of the arcade and windows of the upper floor, is marked out by three continuous ruled lines which can be seen to run across the open arches (Fig. 51 and Plate 76). But, just below this a horizontal line has been ruled across the entire width of the composition: its only apparent function is to delineate the lower edge of the little roof to the left of the three windows at the right (Plate 77). A vertical line outlining part of the building also extends down to the top of the blind man's shoulder as he faces Christ – and was finally painted out. Most of these lines are visible to the naked eye.

Duccio himself then sketched in extra details on the buildings, for example adding a lunette to the door above Christ's head and capitals to the door between the two positions of the blind man (Fig. 52). Although they were later ignored by the painter of the architecture, they have now become visible due to the increased transparency of the paint. The group of Apostles at the left was drawn in, but one cannot be sure who was responsible for this: the drawing is faint and the articulation weak, and the grouping of figures lacks coherence and definition.

The architecture was then painted as meticulously as it had been drawn. Blocks of colour were carefully painted up to each other, sometimes even not quite touching in the effort to achieve clarity and crispness, stopping well short of the figures. The main architectural lines were then ruled on top of the partly dry paint with a metal stylus: the paint is clearly indented and metallic particles can be seen in the grooves (Plate 78). Analysis shows that the metallic lines contain lead and tin: this corresponds exactly with the composition of the lead point drawing styluses in common use at this period which were alloys of lead and tin. It was clearly important to the painter of the architecture to reinforce its linear quality continually throughout the drawing and painting processes: first by ruled drawing and incising,

Fig. 49 *Jesus opens the Eyes of a Man born Blind.* X-radiograph

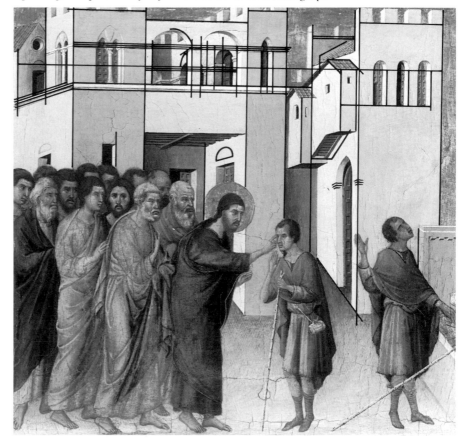

Fig. 50 *Jesus opens the Eyes of a Man born Blind.* The incised and sketched lines of the architecture are indicated by the black lines

87

then by painting in straight-edged blocks and finally by further emphatic incising with the metal stylus.

The figures were then painted. The green earth underpaint for the heads of the secondary figures clearly overlaps the paint of the architecture. The foreground was painted with the same distinctive cross-hatched technique noted in the shadows of the architecture, in some cases not quite reaching the outline of the figures (for example to the right of the blind man facing Christ). It was certainly painted around the figures, but some outlines were afterwards adjusted. Tiny areas which had been overlooked were then filled in, for example the brown area just below the chin of the blind man facing Christ, the white patch just below Christ's halo above his shoulder, and the thin brown strip to the left of the narrow pink vertical structure.

At the right of the composition there is some evidence that the pose of the blind man at the fountain went through several stages. Very faint tentative lines visible in infra-red reflectography (Fig. 53) show that Duccio initially intended to show him bending over to wash his eyes in the water of the fountain. Before he had even got as far as sketching in the head he abandoned this idea and decided to show him upright, gazing up. At this stage, the shoulders of the blind man were drawn more broadly (this drawing is also visible to the naked eye) and his left arm was higher. The right arm was not raised, but probably hung down, contained within the main outline of the body. At some stage, after the architecture had been painted, the decision was taken to change the position of the right arm: it is not drawn, but only painted, and goes over the pale grey paint of the building behind. It may be that Duccio, having by then sketched in the adjacent scene, the *Transfiguration* (Cat. no. 3c), saw the possibility of extending the link already made with the blind man gazing up at the figure of the transfigured Christ by raising the blind man's hand. It may also be that there were structural problems with the plank. A round area of raised gesso at the base of the blind man's elbow suggests there was a fault in the wood, although no knot is visible in the X-radiograph. Perhaps Duccio decided to disguise the fault by incorporating it into a

gesture and making it the very place where the elbow would be rounded if the blind man's hand were raised.

Infra-red photography and reflectography show that the blind man at the fountain was first drawn with bare feet (Fig. 54). While still at the drawing stage the stockings were added. In order to conceal the feet, two layers of orange paint were painted over, although the bare toes still remain visible beneath. A cross-section showed no flesh paint beneath the orange, thereby confirming that the alteration was made before the painting stage had begun.

The paint layers of these panels show many of the same characteristics observed

Fig. 51 Infra-red reflectogram showing ruled lines across the architecture of the loggia

Plate 76 Macro detail in raking light showing ruled and incised lines across a capital from the loggia

Plate 77 Macro detail of the roof to the left of the row of windows on the right, showing ruled lines extended further than necessary

Fig. 52 Infra-red reflectogram showing capitals sketched in, but never painted

Plate 78 Macro detail of lines incised with a metal stylus

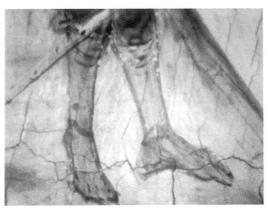

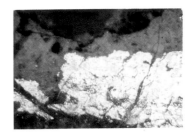

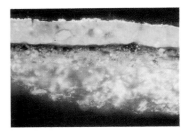

Plate 79 *The Transfiguration.* Fragment of mordant gilding from Christ's drapery showing the yellow-brown of the mordant where the thin gold leaf is abraded. Top surface, 85×

on the *Annunciation*. The striking raised mordant gilding, seen especially in Christ's striated robes on the *Transfiguration* (Plates 79 and 80), is identical to that observed on the *Annunciation*.

The backgrounds and haloes are water-gilded over red bole. The hole of the compass point can be seen at the centre of each incised halo, and the halo designs are incised rather than punched (Plate 81).

Very few paint samples have been examined from these back predella panels. The green draperies in both pictures are composed of green earth, mixed with lead white for the highlights (Plate 83). The flesh tints consist of a layer of green earth and white under a hatched pink of white, red earth and a little vermilion. The architecture in the *Man born Blind* is the same simple mixture of red earth and white as that in the *Annunciation*. Unlike the *Annunciation*, the *Transfiguration* contains some azurite, mixed with red lake to make the brown-mauve drapery worn by Isaiah.

Condition

Some comment should be made about the condition of all three of these pictures. Each has one substantial area of paint loss. As well as losing its original frame and the bottom 2.5 cm of the panel, the *Annunciation* has lost most of the paint in a narrow band along the bottom edge, and some of the gilding along the left edge. There is also a flake loss from the Virgin's head-dress and halo. On the *Transfiguration*, the whole upper body of St John (lower centre) is missing and has been reconstructed by drawing on a neutral colour the presumed shape of the lost part. The level of the filling has been left slightly lower so that there is no ambiguity about what is original paint.

Perhaps because of a fault in the panel, the *Man born Blind* suffered an unfortunate loss: not only has the top of the fountain flaked away, but also the focus of the story, the evidence of Christ's miracle, the face of the cured man with his now-seeing eyes. Anything less than complete reconstruction would have destroyed the point of the narrative and so the restorer has painted back the missing areas. However, he has not imitated the craquelure of the original so, on close inspection, the slightly smoother inpainting can be identified (Plate 82).

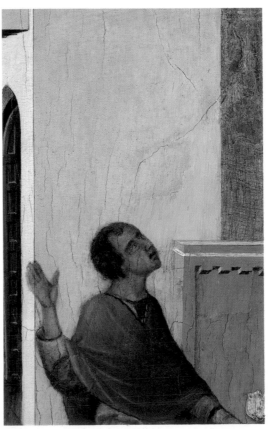

Plate 82 Detail of the blind man at the fountain after restoration

Plate 80 *The Transfiguration.* Cross-section of mordant gilding over Christ's ultramarine drapery. Magnification, 130×

Plate 81 Macro detail of the head of the standing figure of Moses on the left

Plate 83 *The Transfiguration.* Drapery of kneeling figure, bottom left, consisting of green earth and lead white. Some black particles of underdrawing are visible between the paint and the gesso. Cross-section, 380×

DUCCIO

4. The Virgin and Child with Saints

This small triptych is generally accepted as being by Duccio (see biography on p. 72). The intimate iconography of the Virgin and Child, with the Child tugging gently at her veil, and the iridescent transparency of the Child's cloak and of St Aurea's veil, all suggest that the triptych was painted late in Duccio's career. Small portable altarpieces like this were probably commissioned by individuals for their private devotion. The presence of St Dominic and St Aurea has led to the suggestion that it might have been commissioned by Cardinal Niccolò da Prato (d. 1321), a high-ranking Dominican, who was cardinal of Ostia and who would therefore have had good reason to venerate St Aurea of Ostia.

The triptych, which survives intact and in extremely good condition, is a fascinating example of the methods of a medieval workshop. John White has shown that its measurements are identical to those of a triptych in Boston (Plates 87 and 88), which is also, although more controversially, attributed to Duccio and his workshop. Moreover, he shows that both triptychs were designed according to the same proportional system based on the side of a square and its diagonal (see Cat. nos. 5 and 8), which Duccio also used in the *Maestà* (see Cat. no. 3). This type of system would have been a useful means of communication between the artist who designed the altarpiece and the artisan who constructed it.

The triptychs in the National Gallery and Boston also share common patterns in the tooling of the gold, and identical geometric designs on the outside of the shutters. It is interesting that the patterns on the two shutters are not symmetrical: in both triptychs the left-hand shutter is painted with interlocking squares and the right-hand shutter is painted with the squares separate or unlocked. When the triptychs are closed the left-hand shutter is closed first and the right-hand shutter lies over it. The design acted as a prompt to anyone opening the shutters: the right wing with the design left unlocked was the shutter to be lifted first to open the altarpiece.

This type of small-scale altarpiece was intended to be portable. The shutters have an inner dark stripe carefully painted in light and shade to create the impression of an architectural niche, almost like a small chapel in which the worshipper could open the altarpiece for devotion.

Technical Description

The triptych is constructed in relatively simple layers. For the centre panel, the basis of the structure is a flat backboard with a pointed top: the main piece of wood available was fractionally too narrow and narrow strips were added at either side, and attached with glue and nails, to make up the desired width. The backboard was the main structural element of the triptych and also, on its front face, the principal painted and gilded surface.

To the backboard was attached the overhanging gable, a single piece of wood which fitted the precise shape of the top of the backboard and was cut away to make the rounded arch on its underside. At the bottom, the projecting sill was attached directly to the front of the panel: this has at some point been lost and the sill now present is a relatively modern replacement. It may originally have borne an inscription. Finally, the straight mouldings around the edges of the panel and gable were nailed and glued in place. All the mouldings are of wood, carved from a solid strip, except for the curved mouldings around the gable arch and the tops of the wings: these are made entirely of gesso, built up and shaped to resemble the wood

Plate 84 Duccio: *The Virgin and Child with Saints* (Triptych). Central panel including framing 61·5 × 39 cm. Left wing 45 × 20·5 cm, right wing 45 × 18 cm

90

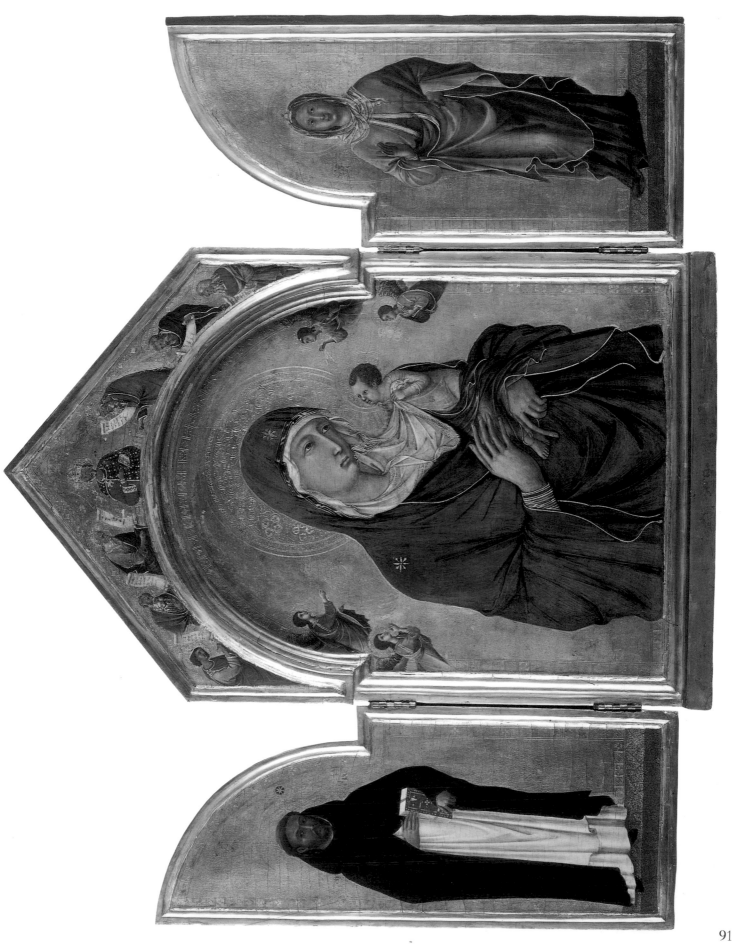

mouldings elsewhere (see also Cat. no. 5). The difference can be seen immediately in the X-radiograph (Fig. 55): the wood mouldings are relatively transparent, but the curved gesso mouldings register as dense white.

To construct a curved frame of solid gesso in this way was obviously simpler than carving wood to the precise shape of the arch, but it was by no means always done. Several altarpieces and polyptychs associated with Duccio and his followers have curved wooden mouldings. What is significant, however, is that the Boston triptych has exactly the same combination of wood and solid gesso frame elements as seen here – another confirmation that the manufacture of these two tabernacles was carried out at the same time by the same craftsman.

The shutters of the London triptych consist of single shaped pieces of poplar

with similar mouldings attached around their front edges. The narrow fillet of wood on the right wing, which overlaps the rebate on the left wing when the triptych is closed, appears to be a separate strip let into the outer edge of the wing. The wings were originally attached to the central panel with simple interlocked ring hinges – which still appear to be present on the Boston triptych. There are now modern hinges on the London triptych. Both the London and Boston triptychs have two bands of wood running across the outside of each wing, let into grooves in the panel below the paint surface: they register as slightly darker strips in the X-radiograph. Their function seems to have been to fasten the wings together in the closed position by means of rings or fastenings on their ends which would link when the wings were shut. On the London triptych, there is a considerable amount of filling and

Plate 85 *The Virgin and Child with Saints*. Reverse with shutters open

Plate 86 *The Virgin and Child with Saints*. Shutters closed

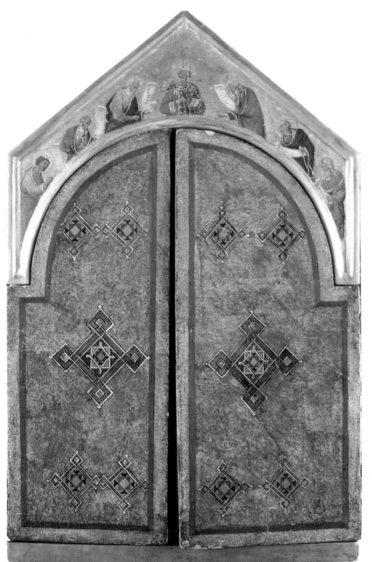

retouching along these strips.

The carpentry and construction of these two tabernacles would have been carried out by a specialist craftsman, directed by Duccio; gessoing and gilding would then have followed. The triptychs have been gessoed on their fronts, backs and sides, with fine linen placed under the gesso at the back in order to make the structure more robust. It is not clear whether there is also linen over the panel and mouldings at the front. The outermost mouldings on both the centre panel and wings of the London triptych have been regilded and the edges regessoed and painted dark red, so it is difficult to glean any information here about the finer details of the construction.

The gilding is over orange-red bole and is decorated with incised borders and haloes (Plate 89). The outlines of all the figures have been incised, but the final painted outlines do not always precisely coincide with the incisions. As usual, the gold passes under the paint of the figures for some little way and some of the outlines (especially those of St Dominic on the left wing) have flaked away where the egg tempera has become detached from the smooth gold beneath.

The initial working out of the composition would have preceded the gilding. Recent examination by infra-red reflectography of the plum-coloured drapery across the Child's legs (Fig. 57) has revealed a highly characteristic underdrawing, which is also present quite recognisably on both front and back predella panels from the *Maestà* (Cat. no. 3) and which can convincingly be attributed to Duccio himself. The drawing is somewhat abrupt, the lines sketched in an emphatic manner and evidently done with a slightly scratchy quill: the double line of the split nib shows

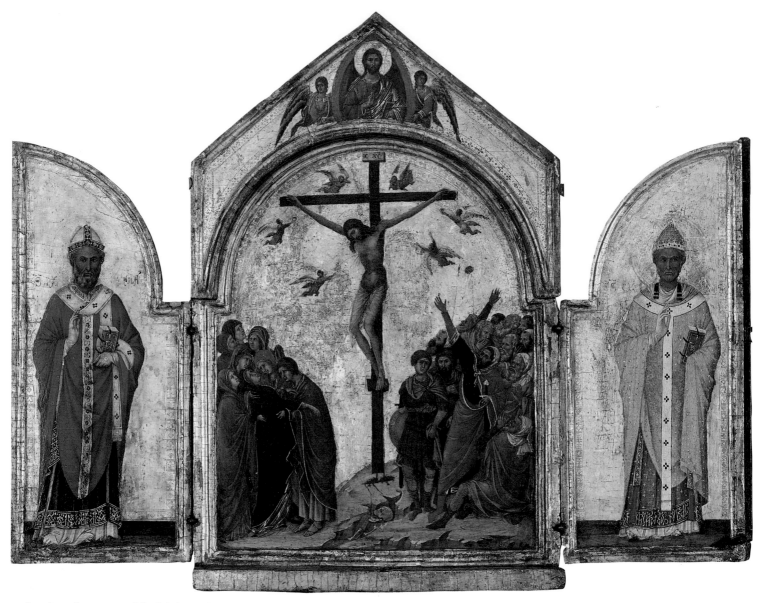

clearly when magnified (Fig. 58).

The discovery of this readily identifiable style of drawing and its presence additionally on the *Maestà* panels (Fig. 59) examined here is obviously of significance in attributing works from the Duccio circle. Its absence from a particular work would not, of course, exclude an attribution to Duccio: it should, for example, be borne in mind that *two* distinct styles of underdrawing seem to be present on the *Annunciation* (Cat. no. 3a) and that Duccio sometimes also sketched with a fine brush. However, where this particular type of quill drawing is found, links with Duccio should be considered.

The paint layers of the London triptych are in such fine condition generally that very few samples to identify pigments or structure have been taken. Neverthe-

less, it is possible to assume that the usual range of pigments is present by comparison with other works by Duccio and by studying technical photographs.

The Virgin's brilliant blue robe is ultramarine of the highest quality (Plate 90): this is made clear by the infra-red photograph in which it appears almost white, due to the very high infra-red reflectance associated with pure ultramarine. Azurite would give a much darker image because it absorbs infra-red radiation to a much greater degree. The ultramarine is mixed with some lead white – hence its light image in the X-radiograph. The shadows have been hatched over the ultramarine with pure carbon black. This absorbs very strongly in the infra-red photograph (Fig. 56). The use of black modelling over ultramarine is unusual.

Plate 87 Duccio: *Crucifixion* with *Sts Nicholas and Gregory* (Triptych). Boston, Museum of Fine Arts

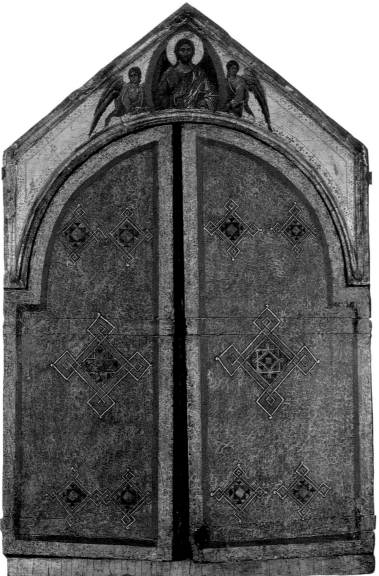

Plate 88 *Crucifixion* with *Sts Nicholas and Gregory*. Shutters closed

Plate 89 Macro detail showing incised decoration of the gilding

Fig. 55 *The Virgin and Child with Saints*. X-radiograph

Under the blue robe at the lower edge of the picture is a mysterious band of red paint about 1 cm deep. This was considered at first to be red bole associated with the adjacent gilded frame moulding, but examination shows it to be a red lake pigment. Its function is not clear, but it is present only at the bottom and is not any form of underpaint for the blue robe.

The painting of the faces and other flesh tones conforms to the standard practice described in Cennino's treatise, but over the years increased transparency and wearing of the paint layers have made the terre verte underpaint considerably more prominent than originally intended.

The use of green underpaint was a sophisticated optical device exploited by the Trecento painters in order to suggest the cool mid-tones of human skin. In the

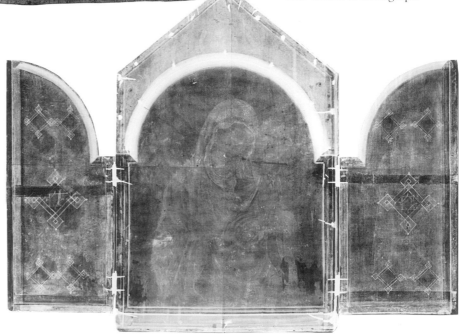

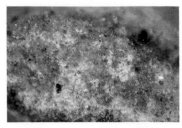

Plate 90 The Virgin's blue mantle showing the use of high-quality ultramarine. Unmounted fragment, 130×

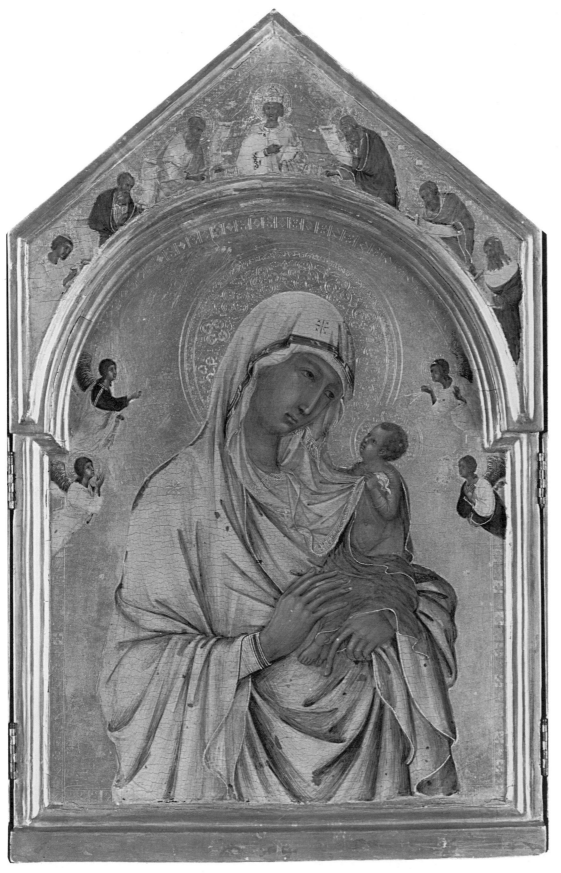

Fig. 56 Infra-red photograph of the central panel

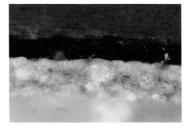

Plate 91 Background to pink marbling on reverse of shutter showing red lake glaze over a mixture of red earth and white. Cross-section, 300×

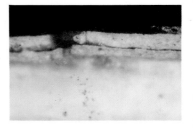

Plate 92 Lead white pattern of marbling on reverse of shutter. Cross-section, 145×

Fig. 57 Infra-red reflectogram showing underdrawing in the Child's drapery

Fig. 58 Infra-red reflectogram of the same area at a higher magnification, showing the double line of the split nib of the quill pen

Fig. 59 Duccio: *The Annunciation*. Infra-red reflectogram from the Angel's drapery for comparison with that on the Child

lights and highlights, the hatched pink and white upper layers (which follow the form in a characteristically linear pattern) would completely conceal the green and would simply reflect their own colour. In the shadows, the green would be glazed over with the olive-brown mixture called *verdaccio* which would convincingly recede into the darkest parts where a little black might be used. Only in the half-tones was the green underpaint supposed to shine through a sparse scattering of pink hatched brushstrokes in order to suggest a neutral cool grey where flesh colours pass from light to shade. Duccio presumably understood the optics of this technique perfectly: but time and change have altered the balance of colour to the over-emphatic green tone that we see today.

The gold outlines and stars on the draperies are done with mordant gilding, and repeat almost exactly the technique Duccio used for gold decoration on the *Maestà* (see Cat. no. 3). Like that on the *Maestà* the mordant is thick and raised, a glossy yellow-brown paint containing significant quantities of lead white both for colour and to act as a drier. This relief decoration with the raised mordant lines was intended to catch the light and give a sense of actual depth. Even if the gold wore away, or if a piece of gilding was missed, the glistening yellow mordant would imitate the gold line (Plate 93).

The imitation marbling on the outside of the triptych appears identical to that seen on the Boston triptych. The white detailing is thickly painted with lead white and the red tones are a combination of earth pigment and a red lake glaze (Plates 91 and 92).

Plate 93 Macro detail of the mordant-gilded star on the Virgin's mantle

UGOLINO DI NERIO

active 1317–27, died 1339(?)

Comparatively little is known about Ugolino di Nerio. His only surviving signed work is the altarpiece (Fig. 60) painted for Santa Croce, Florence, which once bore an inscription naming Ugolino da Siena as its painter. Other important attributed works include polyptychs now in the Sterling and Francine Art Institute, Williamstown, Massachusetts, and in the Cleveland Museum of Art, Ohio, which contain the design and iconography of the Santa Croce Altarpiece in embryo.

Ugolino seems to have been working for Florence in the 1320s, perhaps because the major Sienese commissions were going to Simone Martini. Vasari says that Ugolino died in Siena: in the first edition of his Vite *he gives the date as 1339, in the second edition as 1349.*

It is interesting that although Ugolino, like his Sienese contemporaries the Lorenzetti brothers, carried out Florentine commissions, unlike them he remained relatively unaffected by the monumental style of Giotto. Vasari said of him that he remained constant to the Byzantine style of painting: 'tenne sempre in gran parte la maniera greca,' and he may well have been a pupil of Duccio.

5. Fragments from the Santa Croce Altarpiece

Ugolino painted at least two altarpieces for Florentine churches, one for Santa Maria Novella, the main Dominican church, and the one for the high altar in the Franciscan church of Santa Croce (Fig. 61), from which these fragments originate. The latter is thought to have been painted in about 1324–5.

The Santa Croce Altarpiece was removed from the high altar in 1569 to make way for a ciborium designed by Vasari. In the eighteenth century it was seen in the Upper Dormitory in Santa Croce, and in the nineteenth century most, if not all, surviving fragments were in the Ottley Collection in England, remaining there until the sales of that collection in 1847 and 1850. They are now scattered in collections throughout the world, a substantial part of the main tier being in the Gemäldegalerie in Berlin (for the location of the extant fragments see Fig. 60).

Technical Description

The altarpiece can be reconstructed according to a drawing made in the eighteenth century when it was in the Upper Dormitory at Santa Croce (Fig. 62). The reliability of the drawing has been questioned, not only because the altarpiece must have been at least partially dismantled to remove it from its original setting, but also because it exhibits some rather odd features, for example the shape of the panel above the central Virgin and Child and the spacing of the predella panels so that they do not all line up with the upper tiers. However, the examination of X-radiographs of all the surviving panels has confirmed that the arrangement shown in the drawing is essentially correct. In addition, the X-radiographs have supplied much information on the construction and manufacture of the altarpiece.

Fig. 60 Ugolino di Nerio. Reconstruction of the Santa Croce Altarpiece showing the original positions of the surviving fragments. Those belonging to the National Gallery appear in colour. The remaining panels are as follows: predella, from left to right, *The Last Supper* (New York, Metropolitan Museum of Art, Lehman Collection); *The Flagellation* and *The Entombment* (both Berlin, Gemäldegalerie); main tier, *St John the Baptist, St Paul* and *St Peter* (all Berlin, Gemäldegalerie); second tier, *Sts Matthew and James Minor, Sts James Major and Philip*, and *Sts Mathias and Elizabeth of Hungary* (all Berlin, Gemäldegalerie); pinnacle, *Daniel* (Philadelphia Museum of Art, Johnson Collection)

99

The principal tiers

The main part of the altarpiece originally consisted of seven separate vertical units. The predella formed an eighth, horizontal unit. When the X-radiographs of the dismembered tiers are placed in their correct positions, as illustrated in the eighteenth-century drawing, the pattern of the wood grain can be seen to run continuously from the topmost pinnacle panels right down to the bases of the three-quarter-length saints in the main tier (Figs. 63 and 64). It is clear that each of the vertical units was painted on a single plank of poplar, approximately 5 cm thick and shaped at the top to form the pinnacles.

Each vertical unit has been subdivided with arches, spandrels and mouldings. The spandrels painted with angels above the main tier and the double-arched spandrels in the second tier have been cut from thin pieces of poplar (1 cm thick) and nailed to the front of the panel (Fig. 65). The nails with their irregularly shaped heads can be identified in the X-radiographs (Figs. 64 and 66). Between seven and ten nails have been used to attach the double-arched spandrels and six or seven for the spandrel angels. One of the National Gallery's pairs of angels was removed from, and subsequently reunited with, its section of main panel. Therefore only the pointed tips of the nails can be seen in the X-radiograph. The heads of the cut nails are still attached to the spandrel and a typical rectangular-shaped head can be seen in the bare wood of the arch below the left-hand angel.

Certain framing elements were also carved from poplar and nailed to the panels. These include the two pieces of moulding which form the gabled tops of the pinnacles (surviving on the *Daniel* in Philadelphia, and *David* and *Moses*, but not *Isaiah*, in the National Gallery); most, if not all, of the horizontal mouldings which separate the tiers from one another; and the projecting ledges or sills which divide the saints of the second tier from the rows of quatrefoils beneath. The sill of *Sts Bartholomew and Andrew* is either new or has been much repaired. The only vertical framing elements to have been attached to the altarpiece while it was still in its separate units were the carved half-columns and the dividing columns around the pairs of saints in the second tier. These

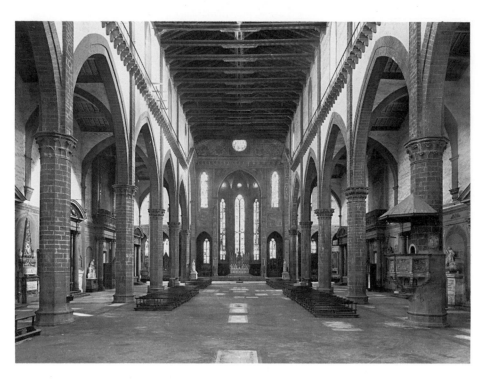

Fig. 61 Interior of the church of Santa Croce, Florence, showing the present high altar

were each pinned in place with two or three small nails (Fig. 67). The outer frames on the panels from this tier are not original.

The architecture of the spandrels on both the second and main tiers was then completed with arched mouldings, not of carved wood, but built up and modelled using a plaster consisting of anhydrite (burnt gypsum) reinforced with flax fibres and presumably bound with animal glue (Fig. 65). These plaster mouldings can easily be distinguished in the X-radiographs as they are dense and X-ray opaque due to the thickness of the calcium sulphate. A similar use of plaster mouldings can be seen on the X-radiograph of the triptych by Duccio (Cat. no. 4). While it may have been easier to make the smaller mouldings out of plaster, its use for the relatively large arches of the main tier of the Santa Croce Altarpiece is rather surprising. On other Sienese altarpieces where the ends of the mouldings are visible, for example Polyptychs 28 and 47 by Duccio and his workshop and Polyptych 39 attributed to Ugolino himself (all Siena, Pinacoteca), all the arches appear to have been carved from wood. The opacity to X-rays of the *pastiglia* trefoils between the arches of the second tier and the rows of quatrefoils on the cornice beneath suggests that they too have been built up using some sort of calcium sulphate plaster, but

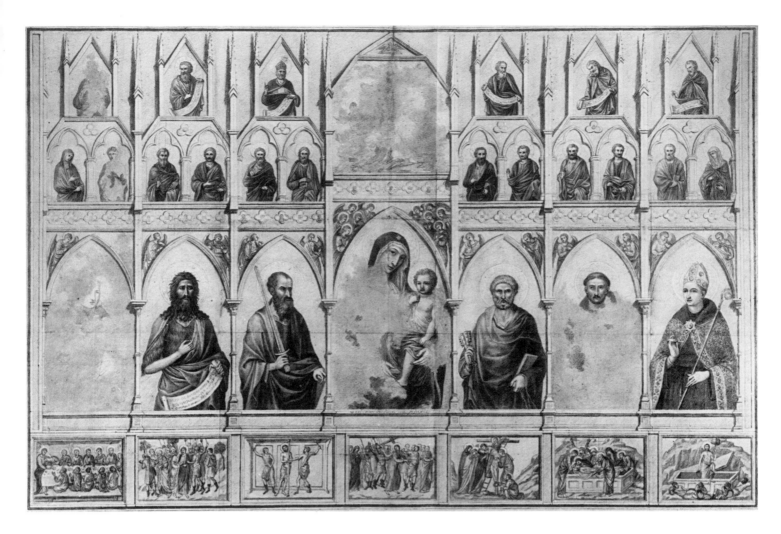

Fig. 62 Eighteenth-century drawing of the altarpiece. Rome, Biblioteca Vaticana, Vat.Lat.,9847, f.92ʳ

this would have been done only after the whole panel had been prepared with a gesso ground.

Before the application of the gesso, however, all the flat surfaces and some of the mouldings were covered with pieces of linen fabric. This canvas is now exposed on the fragments of panel to which the pairs of spandrel angels are attached (Plates 94 and 95). Originally, of course, it would have been covered by the gesso and gilding belonging to the three-quarter-length saints below. Samples of gesso taken from the interstices of the canvas were found to be of the anhydrite form with only traces of gypsum. This corresponds with a first application of *gesso grosso* to the flat areas as described by Cennino. The gesso in the upper layers, including that applied over the wood and plaster mouldings, consists of a mixture of gypsum and anhydrite and probably represents the use of the finer, smoother *gesso sottile* (perhaps not very thoroughly slaked, hence the presence of some anhydrite).

The predella

Details of the construction and preparation of the predella showing the Passion of Christ can also be established by study of the X-radiographs. Although the scenes now appear as seven separate panel paintings, they were painted on a single long poplar plank (at least 40·5 cm × 403 cm) of similar thickness to the units of the upper tiers. Just as with the upper tiers, when the X-radiographs are placed in the correct narrative order the pattern of the wood grain can be traced from scene to scene (Fig. 68).

Vertical bands of clean wood on the backs of three of the scenes, the *Betrayal of Christ*, the *Way to Calvary* (Fig. 69) and the *Entombment*, may have been left by wooden battens originally nailed to the long narrow plank to prevent it from twisting and warping. In addition the plank was coated with a red lead paint; its absence along the possible batten marks means that they are easily distinguished.

The whole plank (with its mouldings – see below) could have been either inserted into an outer frame or attached to a supporting skeleton of timber. Alternatively, if the predella projected forwards from the main part of the altarpiece (as might have been the case in Duccio's *Maestà* – see Cat. no. 3) it could have been constructed in the form of a hollow box. These marks might then be from sections of wood slotted at intervals into the box to act as reinforcing cross-pieces, almost certainly necessary considering the size and weight of the main altarpiece above it.

Whether they were battens or the cross-pieces of a predella box, the vertical pieces of wood were attached with nails hammered through from the front of the plank. The heads of the nails appear in the X-radiographs of the relevant panels. Despite the artist having taken the precaution of covering them with fabric (although perhaps not with the tin-foil which Cennino recommends), they have tended to erupt through the gesso causing considerable damage to the paint and gilding.

The framing elements now visible on the separated scenes are partly original. Of the panels in the National Gallery only the *Resurrection* has old and presumably original wood for all three levels of the plain carved moulding along the top and bottom edges. On the other three panels the two inner strips or levels are original – the nails used to attach them appear in the X-radiographs – but the outermost ones are new. They can be distinguished by their smooth, machine-cut regularity. Similarly the outer strips on the vertical mouldings which once divided the scenes can be identified as false. Their rounded outer edges would not be consistent with the predella having been a continuous construction. Instead it is likely that the scenes were divided from one another either by simple flat-profiled mouldings like those between the pairs of saints in the second tier or by a more raised moulding like that on the *Maestà* predellas (see Cat. no. 3).

If each predella scene is aligned with the corresponding vertical unit of the main part of the altarpiece, spaces occur on either side of the *Way to Calvary*. This is due to the greater width of the central panel, determined by the dimensions of the spandrel angels now in Los Angeles. The width of the central panel is in fact

Fig. 64 Photomontage of X-radiographs of *Sts Simon and Thaddeus* and the temporarily removed backing panel from the spandrel angels below

103

Fig. 65 The bottom edge of the panel of the spandrel angels from the right end of the altarpiece. At the bottom is the radially sawn backing panel (originally part of the main tier), then the spandrel and finally the moulding

Fig. 66 X-radiograph of the spandrel angels from the right end of the altarpiece

related to the width of the side panels by the same proportional relationship referred to in Cat. no. 4, in that it is just about equal to the diagonal of a square based on the width of the side panels. These side panels are almost exactly one *braccio* wide. Therefore the spacing shown in the eighteenth-century drawing is obviously wrong and when the X-radiographs are placed in the correct positions there is a slight discontinuity in the wood grain across these gaps. They may have accommodated the coats of arms of the Alamanni family mentioned in a description of the altarpiece in 1575.

Assembly and erection of the altarpiece

A surprising amount – given the fragmented state of the work – can be discovered about the assembly of the whole construction on the high altar at Santa Croce. On those panels where the non-original side mouldings have been removed, for example *David* and *Moses*, the gesso and gilding extend well beyond the lines

incised to mark the intended positions of the vertical parts of the frame (Plates 96–98). Identical incised lines occur on other Sienese altarpieces of similarly vertical construction, including Polyptychs 28 and 47 ascribed to Duccio and his workshop and Polyptych 39 attributed to Ugolino (all three in the Pinacoteca, Siena), and in each case they confirm that the painting and gilding were executed before the vertical framing elements were finally pinned in place. However, no. 47 has the remains of an outer containing frame and no. 28 appears to retain its original continuous battens, suggesting that in both instances the panels had already been assembled – and lacked only the vertical framing elements – before they were painted and gilded. Ugolino's polyptychs, on the other hand, may sometimes have been painted and gilded in separate sections and not assembled until the work was actually set up on the altar.

While holes bored into the sides of the planks to take dowels are a relatively common feature of Sienese panel construction, they do seem to occur with particular

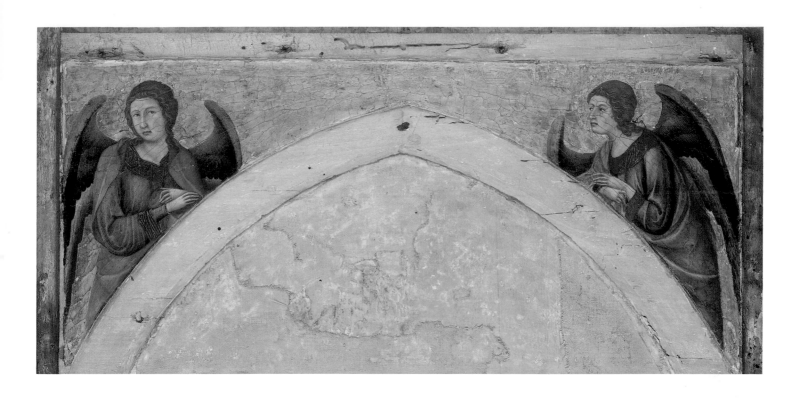

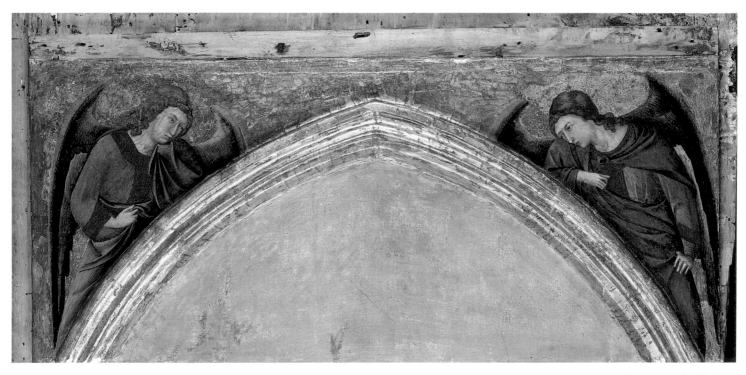

Plates 94 and 95 *Angels.* Upper panel 28·5 × 57·2 cm. Lower panel 27 × 56·5 cm

frequency on panels attributed to Ugolino and his circle. They can be seen along the edges of the panels of the polyptych in Siena (evidently dismantled in the past) and have also been reported on the polyptychs now in the Sterling and Francine Art Institute, Williamstown, Massachusetts, and in Cleveland, and on the fragmented altarpiece of which the *St Catherine* in the Krannert Art Museum, University of Illinois, is part.

Identical holes appear down the sides of those fragments of the Santa Croce Altarpiece which have not acquired modern outer frames (Fig. 70). All the dowel holes on the surviving panels can be detected in the X-radiographs, where they appear as dark shadows and reveal that each vertical unit of the altarpiece was originally linked to the next by three wooden dowels (Fig. 71). The irregular spacing between the dowels confirms the accuracy of the eighteenth-century drawing, as the dowel holes in the X-radiographs match up only if the panels are placed as in the drawing (see Fig. 63). Measurements taken from the X-radiographs and silicone rubber casts of some of the dowel holes in the National Gallery panels show that the dimensions of the cylindrical dowels were standardised to a length of about 20 cm and a diameter of 1.9 cm. Where broken dowels have remained in the panels, it can be seen in the X-radiographs that they did not necessarily have pointed ends so they would not have quite reached the ends of the holes.

Despite their size, these dowels were insufficient to hold together and support such a large free-standing structure. A framework of cross-battens was also needed. The marks left on the backs of the surviving panels by the removal of these battens provide further proof that the altarpiece was planned so that it could be executed in separate sections. Instead of the usual wide strip of clean wood associated with the use of a continuous length of timber, the areas left by the removal of the battens from Ugolino's panels have stepped profiles at either end (Fig. 72). As with the predella panels the marks are made visible by the red lead coating. Their outlines indicate the use of an ingenious system of interlocking battens. Each vertical unit of the altarpiece was fitted with two sections of batten: on the upper tier the

lower part of the left end would have projected so that when the panels were brought together it slotted into the space cut out of the right end of the batten of the next panel. Equally the projecting upper right part of the batten would have dovetailed with the gap in the batten of the panel on the opposite side. The battens across the lower tier worked in the same way but with the zig-zag pattern reversed (Fig. 73). The linked battens must have been nailed together or, more likely, pegged with vertical dowels (Fig. 74).

Two rare examples of panels with intact original interlocking battens are a small altarpiece by Bernardo Daddi dated 1344, exhibited in the Spanish Chapel at Santa Maria Novella, Florence, and a polyptych by Taddeo di Bartolo, dated 1411, once in the Duomo at Volterra and now in the Pinacoteca. They both have a slightly different mortise-and-tenon joint between the battens, but the latter shows the pegging of the joint particularly well as the ends of the dowels have never even been trimmed (Fig. 75). The advantage of this system of interlocking battens is that the potentially damaging operation of nailing the battens to the panels could be carried out before the application of the fragile paint and gold and before the altarpiece was finally assembled. The absence of any heads on the nails embedded in the panels and visible in the X-radiographs shows that the sections of batten were fixed by nailing through from the backs of the panels alone.

Unfortunately, most of the evidence as to the precise method of support for the linked panels once they were raised on the altar has been lost. There are no dowel holes along the outer edges of the surviving panels from the right end of the altarpiece, so if it was framed by pilasters or piers – perhaps supported by buttresses

Fig. 67 *Sts Bartholomew and Andrew*. X-radiograph showing nails attaching the dividing column

Fig. 68 Photomontage of X-radiographs of part of the predella. From left to right: *The Way to Calvary*, *The Deposition*, *The Entombment* and *The Resurrection*

set into the floor on either side of the altarblock – the pilasters can have been attached only to the projecting batten ends. However, along the outer edges of the scenes at each end of the predella, the *Last Supper* and the *Resurrection* (see Fig. 68), no original frame moulding survives and each has a new piece of wood set into the lower outer corner. The damage could have been caused by the removal of a base socle originally let into the picture surface. If that were so, then the altarpiece very probably did have piers and supporting buttresses and was a prototype for many Florentine monumental altarpieces of the fourteenth century. The form of the piers would have depended on whether the predella was in the same plane as the rest of the altarpiece or whether it was of the box type. In the latter case, logically the bases of the piers would also have projected forwards, providing another possible location for the coats of arms referred to above.

Pilasters, topped by finials, would have disguised the joins between the panels and smaller pilasters would have completed the framing of the pinnacles. Shadowy holes in the X-radiographs of the pinnacle panels (Fig. 76) – also visible along the edges of certain panels – show that crockets and other frame ornaments were dowelled into the gables.

The thin protective coating of red lead on the exposed sides and backs of the panels must have been applied before the final assembly of the altarpiece as it follows the outlines of the battens in their unlinked state. It is therefore original. As well as supplying further proof of the care and craftsmanship that went into the making of the altarpiece, by marking the positions of the battens and by exaggerating the patterns of the wood grain in the X-radiographs, the red lead has proved invaluable in working out its method of

construction. This method, with its division into portable and relatively manageable units (Fig. 77), suggests the possibility that Ugolino did not necessarily work on the project in Florence. Indeed it may be that he and his carpenter invented the method of assembly; earlier examples of this method of construction have yet to be reported.

The dismemberment of the altarpiece

The displacement of the predella panels in the eighteenth-century drawing (Fig. 62) demonstrates that the altarpiece had already been partly dismantled. The drawing also shows that many of the panels were in poor condition. Most of the paint on the left-hand unit seems to have been lost and the panel above the very damaged *Virgin and Child* is only just identifiable as the *Crucifixion* – virtually essential to the iconography of the altarpiece given the

Fig. 69 *The Way to Calvary.* Back of panel

107

Plate 96 *Isaiah.* 46 × 32 cm

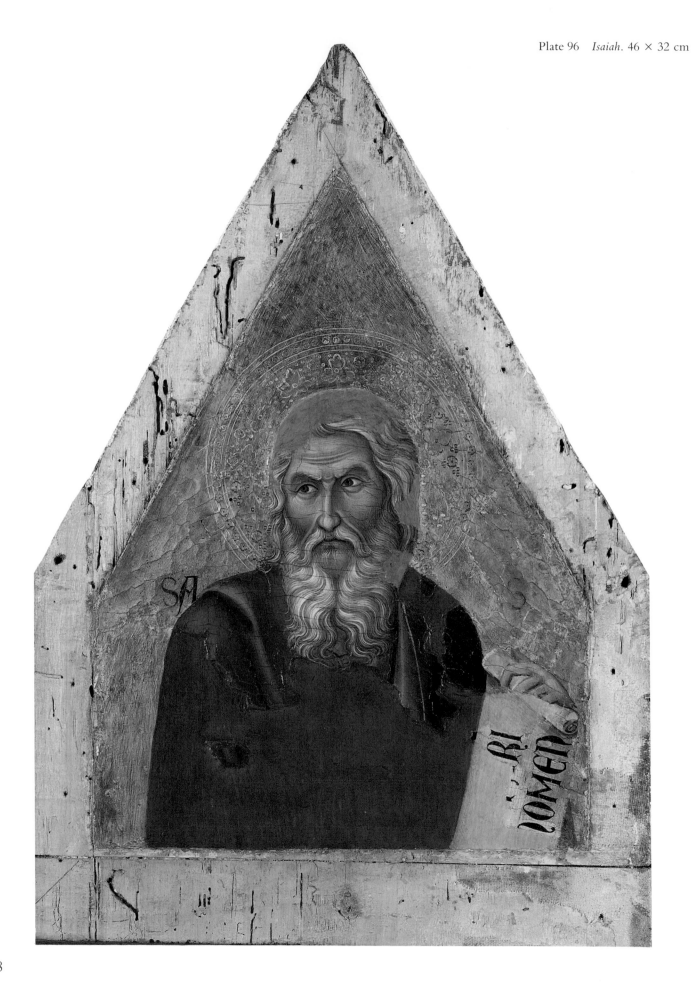

Plate 97 *David*. 55·3 × 31·1 cm

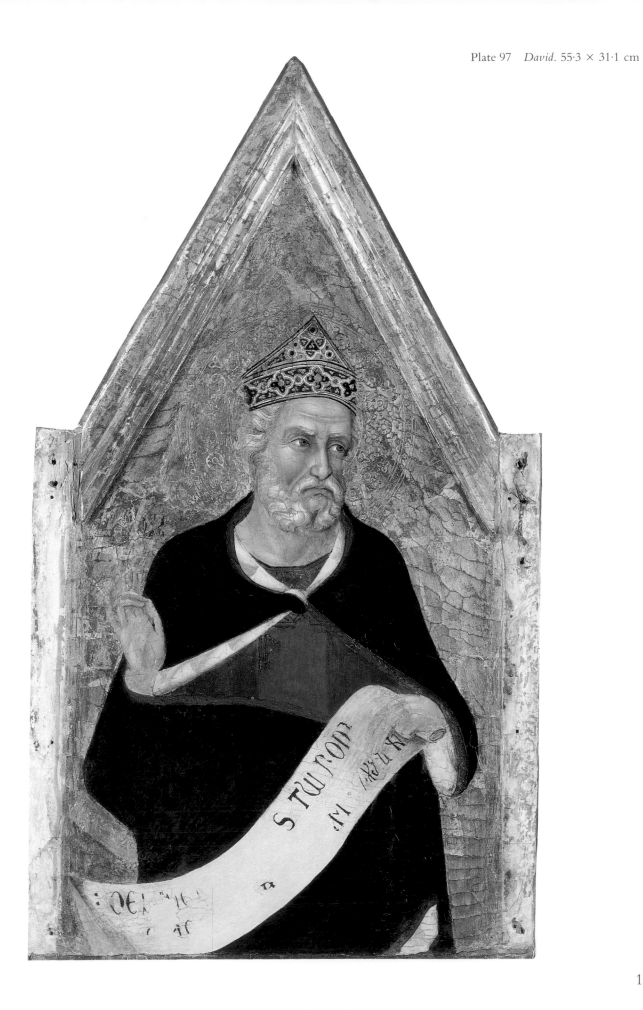

Plate 98 *Moses.* 54·4 × 31·4 cm

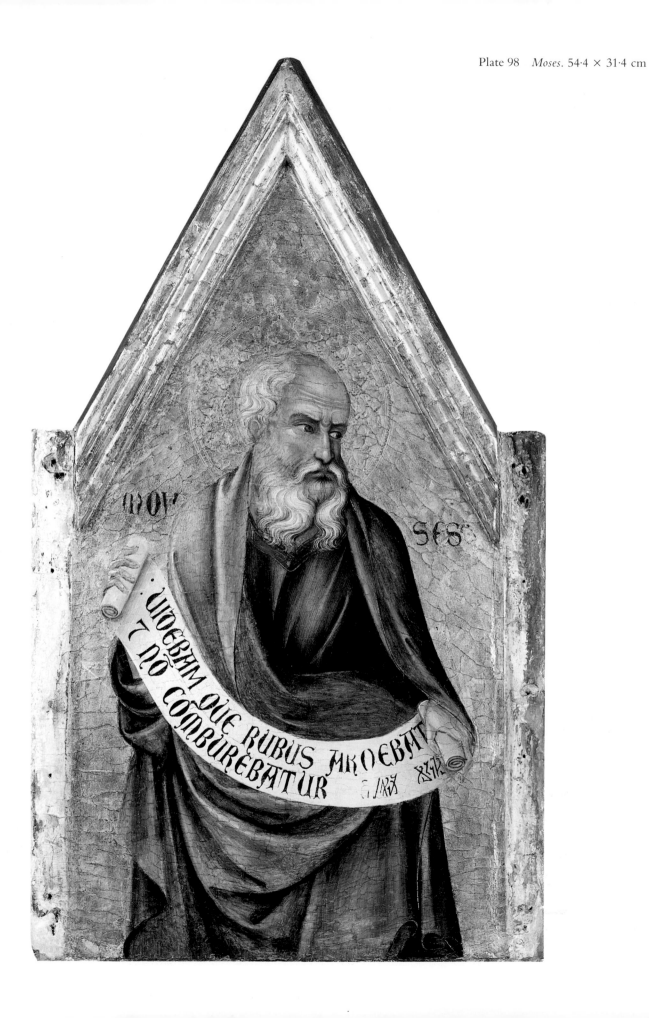

dedication of the church to the Holy Cross. The top of this panel must have been cut and altered, presumably because the original pointed gable made the altarpiece too tall for its new position in the Upper Dormitory – a similar fate may have befallen the panels of the San Pier Maggiore Altarpiece (Cat. no. 8). When the Santa Croce Altarpiece was cut up and dispersed, the most damaged panels appear to have been discarded. As the National Gallery's two pairs of spandrel angels (Plates 94 and 95) are attached to sections of wood which should belong to *St Francis* and *St Louis of Toulouse* it is likely that those figures were sacrificed. On the other hand, the Los Angeles spandrel angels are only on the thin sections of wood originally pinned to the main panel. In addition the spandrels have clearly snapped at the top of the arch and broken into two halves. While they could simply have been removed from a backing panel at some later date it is not impossible that an attempt was made to save the remains of the *Virgin and Child* and that the panel may still survive in a heavily repainted and unrecognisable condition.

Most of the National Gallery's panels from the upper tiers have suffered from large losses of gesso, paint and gilding. In some instances these losses are so large that complete restoration has not been possible. Instead, areas of related but unmodulated colour have been used to reduce the disruption of the images caused by the damage. In places where the missing gesso has at some time in the past been replaced with new fillings a curious pattern of small, V-shaped marks can be seen in the X-radiographs (Figs. 63, 64 and 76). These occur where the wood has been gouged and indented with a chisel to give it 'tooth', improving the adhesion of the replacement gesso. Similar marks, on a much larger scale, can often be seen on frescoes in Italian churches which have been uncovered from beneath later layers of plaster and whitewash. The marks also appear on the X-radiographs of the panels from Berlin and Philadelphia and it is probable that they date from a restoration carried out in Italy, perhaps just before the export of the panels to England at the beginning of the nineteenth century.

The predella panels are better preserved, having suffered mainly from minor scratches and scattered small flake losses. Some of the scratches seem to have occurred before the gesso was painted and gilded. As they are not related to the design, it is most likely that they were made accidentally while scraping down the gesso. The *Resurrection*, the last of the four to be acquired by the National Gallery, may have been overcleaned before it joined the Collection. The paint is worn and the edges of the cracks are badly

Fig. 70 *Two Angels*. Left edge of panel showing the dowel hole

Fig. 71 *Sts Simon and Thaddeus*. Detail (actual size) from the X-radiograph showing a dowel hole

eroded, especially on the figure of Christ and on the tomb. Therefore this panel is not quite such a reliable source for Ugolino's style and technique.

Ugolino and Duccio

Style and technique

Stylistically Ugolino could hardly fail to have been influenced by the work of Duccio and in particular the *Maestà*, on which some think he may have collaborated. The design and iconography of the predella of the Santa Croce Altarpiece derive closely from the equivalent surviving scenes of the *Maestà* and the physiognomy of many of Ugolino's figures can be traced to those of Duccio. However, a close examination of both the style and the technique of the National Gallery's collection of fragments suggests that Ugolino was in fact a strikingly different and original painter.

Compared with their equivalents on the *Maestà*, Ugolino's predella figures (Plates 99–102) exhibit a heightened emotionalism. The expressions of grief in the *Deposition* are of extraordinary intensity. Individual features have often been exaggerated so that some of the heads, particularly that of Judas in the *Betrayal*, have a viciousness and brutality more commonly associated with Northern European painting. This higher emotional pitch is emphasised by his more angular and jagged line. Instead of Duccio's sinuous curves, the folds and lines of Ugolino's draperies are often punctuated by straighter, more direct lines; for example, the hard, taut folds of the drapery of David and Sts Bartholomew and Andrew. Ugolino also differs considerably in his application of paint and choice of palette, to be described below.

Underdrawing

Far less underdrawing can be detected by infra-red examination on the panels by Ugolino than on those by Duccio, although this may be partly due to Ugolino's choice of pigments (see below). The small amount of drawing that can be seen around the feet and hemlines of Christ and the surrounding figures in both the *Betrayal* and the *Way to Calvary*, and in the more transparent red lake draperies of the Virgin and St John the Evangelist in the

Fig. 72 *Sts Bartholomew and Andrew*. Back of panel

Deposition (Figs. 78 and 79), shows the use of a simple, exact outline drawn with a brush. There is no hatching to define the internal modelling of the drapery folds. The drapery folds as drawn on the figure of the Evangelist illustrate Ugolino's inclination towards firm, straight lines. In the painting these folds have relaxed to fall in softer, more fluid curves.

Gilding

The divisions between the areas to be painted and those to be gilded have been marked with the faintest of incised lines. Sometimes these are barely visible. At this stage there seems to have been some confusion on the *Deposition* as to precisely which areas were to be gilded. To the left of the Cross Ugolino has slightly stretched

Fig. 73 Diagram showing the positions of the batten marks on the backs of the surviving panels

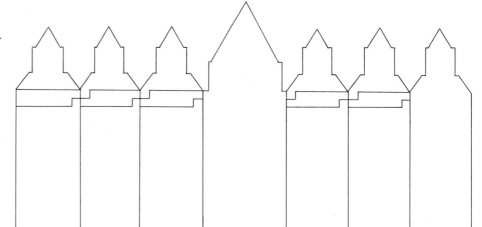

112

Duccio's original figure grouping (Fig. 80) to fit the more elongated format of the predella. He has failed to clarify the somewhat confusing and illogical relationships between the gilded haloes and the painted areas. Furthermore, the adjustment has resulted in a gap between the Magdalen and the Virgin, which does not occur in Duccio's version. This gap is also partly due to the tendency for Ugolino's figures to be more slender than those of Duccio. The decision to fill it by adding an extra figure seems to have been made at a relatively late stage, as the green paint of the cloak covering the head of the figure lies over a layer of red bole, presumably applied on the assumption that this part of the composition was to be gilded. Alternatively, if the gilding was carried out by someone other than the painter, it may be that Ugolino's indications as to the areas to be gilded were not clear and that the design was simply misunderstood by the gilder.

The bole beneath all the gilding on the altarpiece has the unusually bright orange-red colour which has been noted on other Sienese pictures in the National Gallery, including those by Duccio (Cat. nos. 3 and 4) and later panels by Sassetta (Inv. nos. 4757–63).

Once gilded and burnished, the flat areas of the surviving parts of the original frame, notably on the second tier panels, were ornamented with incised, punched and stippled patterns. The gold leaf of the backgrounds of the paintings has been left undecorated, apart from the tooled haloes. In common with other painters of the generation following Duccio, Ugolino has used for these an assortment of composite punches rather than the incised and stippled decoration normally favoured by Duccio. Eleven separate composite punches, not to mention the small ring punches, appear on the haloes of the National Gallery fragments alone (Fig. 81). They have been stamped in various combinations to provide a wide range of patterns. For the frame some extra, larger motifs, which recur on the main tier panels, have also been used.

Some of the punch marks seen on the Santa Croce Altarpiece appear on Polyptych 39 (Siena, Pinacoteca), while one of the most distinctive designs, the diamond-within-a-diamond motif used, for example, on the haloes of the Evangelist and the

third Mary in the *Deposition*, has been identified on a work by Niccolò di Segna. Two more of Ugolino's punches may have found their way, either through borrowing or more probably following his death, to the workshop of the Ovile Master, a painter who seems to have had the use of an unusually large collection of punches.

Although not confirmed by analysis, it is likely that silver leaf as well as gold was applied to parts of the frame of the altarpiece. The background to the inscriptions along the bottom of the frames on the surviving main tier panels has the appearance of silver leaf. Among the panels in this exhibition, the pairs of saints from the second tier may include small touches of silver on the patterns in the *pastiglia* trefoils and quatrefoils on their frames.

The technique of mordant gilding to embellish the completed draperies has been applied with great delicacy and discretion. Although the yoke and neckline of David's red robe were once decorated with an intricate pattern of gold, now mostly lost, mordant gilding has usually been restricted to a single fine line applied along

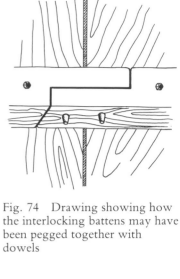

Fig. 74 Drawing showing how the interlocking battens may have been pegged together with dowels

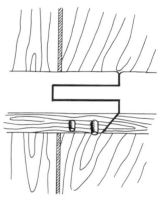

Fig. 75 Drawing showing how the original battens on a polyptych by Taddeo di Bartolo, now in the Pinacoteca, Volterra, are linked

Fig. 76 *Moses*. X-radiograph showing dowel holes for frame ornaments

113

the edges of a few of the draperies. The gilded base for the elaborate decoration of the crown of David (Plate 97) has also been applied over a mordant to distinguish it from the brighter, burnished gold of the water-gilded background. Analysis of a sample of paint which included the mordant confirmed that it is a true oil mordant. Despite the fact that it is not particularly heavily pigmented, containing only some earth pigment, together with red lead, verdigris and lead white, all apparently present as driers rather than to colour the mordant (Plate 103), on the picture surface it appears as a dark chocolate-brown colour. It is often visible because so much of the gold has worn away. The dark colour seems to be due to the darkening of the large amount of oil medium present; this makes it slightly different in composition and appearance from the lighter yellow-brown mordant used by Duccio on the panels from the *Maestà* (Cat. no. 3) and in the triptych (Cat. no. 4). However, dark brown mordants do appear on some of Duccio's earlier works, notably the *Rucellai Madonna*.

The paint layers

In his application of paint, Ugolino is at least the equal of Duccio in refinement and precision. His fine, hatched brushstrokes are meticulously applied, usually following round the form, but where the different planes of the face meet, for instance at the bridge of the nose or across the cheeks, they sometimes become almost cross-hatched. This cross-hatching over the cheeks is particularly evident on *Isaiah* and *David* (see Plates 96 and 97) and is also present in the *Virgin and Child* in the Louvre (Plate 105). Here it is instructive to compare the modelling of the Virgin's face with that of the Virgin in the triptych by Duccio (Cat. no. 4).

The flesh paint in the National Gallery panels is applied over an underlayer of green earth of a similar cold blue-green tint to that seen on the panels by Duccio, but possibly containing a higher proportion of lead white. The flesh colours have been modelled with a mixture of earth pigments, black and lead white in the shadows and lead white and vermilion or red earth in the highlights (Plate 104). Areas of flesh painting on some of the smaller figures, for example the angels and those in the pre-

della scenes, are often outlined with a red-brown colour. Another distinct feature of the predella scenes is a fine hatching of dark coloured paint around the outlines of some of the figures, rather as if they were casting slight shadows (Fig. 82). Despite being so thinly applied that it barely registers on the X-radiographs, the paint has a crisp, almost enamel-like quality where it is well preserved. This is quite unlike the softer, more feathery brushwork associated with Duccio.

However, it is perhaps in his choice of palette and use of colour that Ugolino differs most from Duccio. The *Maestà* panels and the triptych (Cat. nos. 3 and 4) illustrate Duccio's use of the expensive, slightly purple-blue pigment ultramarine, but on Ugolino's panels ultramarine is not to be found. Instead he has used the greener blue azurite. Its characteristic turquoise hue shows best when it is mixed with white as on the robe of the figure on the right of the *Way to Calvary* (Plate 100) and on the sleeves of some of the angels. It also appears with only a little lead white as the dark, inky blue of David's cloak (Plate 108) and even on the deep blue mantles of Christ and the Virgin for which ultramarine was customarily used. For these deep blues it seems to have been applied over a very thin layer of lead white, a layer structure which also occurs on the blue mantle of the Virgin in the Louvre panel. In those areas where it has not been possible to identify the azurite by sampling, it can be recognised by its characteristic darkness in infra-red photographs (see Fig. 79). This is because azurite absorbs light from the infra-red end of the spectrum whereas ultramarine reflects infra-red light, thus appearing light in infra-red images.

While we cannot know whether Ugolino used ultramarine for the Virgin's robe in the central panel of the main tier, it seems unlikely that he abstained from its use on grounds of expense for a work destined for the high altar of one of the most important churches in Florence, so his use of azurite must have been a deliberate choice. It has had a considerable effect on the whole colour range, modifying the green and purple pigment mixtures and subtly altering relationships and colour contrasts.

The light blue-green draperies which

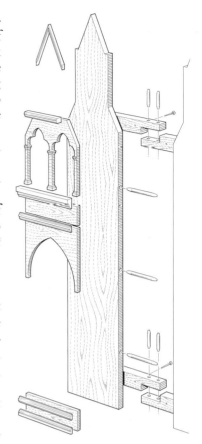

Fig. 77 Drawing (slightly simplified) showing the construction of a vertical unit. The framing elements shown were all attached to the panel before application of the gesso, gilding and paint. When painted, the units were assembled on the altar using the dowels and the interlocking battens. Finally the joins between the panels would have been covered by vertical framing elements

114

Plate 99 *The Betrayal of Christ.*
Painted surface 34·5 × 53 cm

Plate 100 *The Way to Calvary.*
Painted surface 34·5 × 53 cm

116

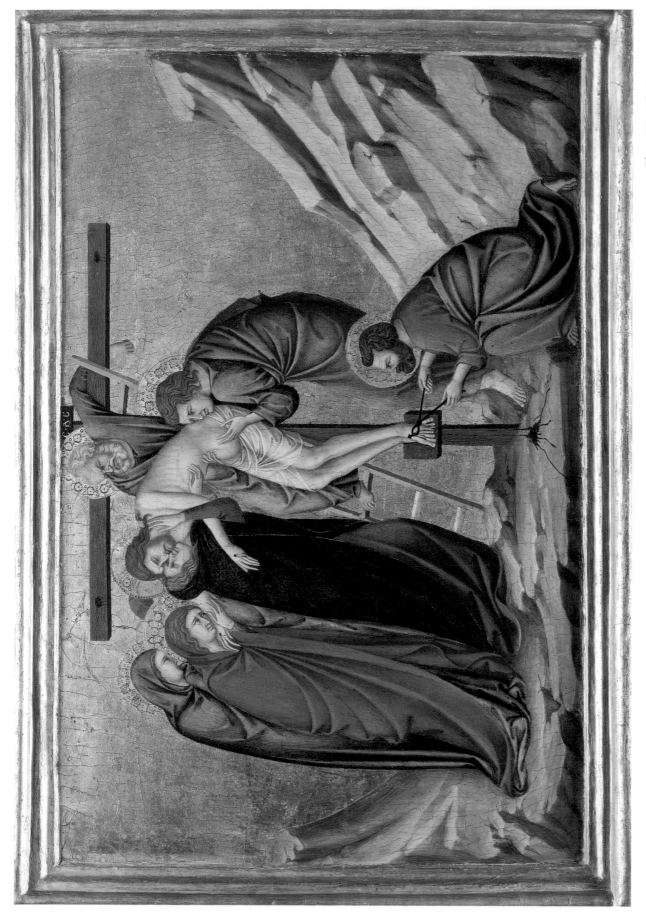

Plate 101 *The Deposition.*
Painted surface 34·5 × 52·5 cm

117

Plate 102 *The Resurrection.*
Painted surface 34·5 × 52 cm

contain azurite are painted with a most unusual technique. A cross-section from the blue-green mantle of Moses (Plate 109) shows that the folds have been modelled using thin, almost transparent scumbles of azurite with a little lead white, and possibly some yellow lake, applied over an undercolour of green earth, exactly like that used in the flesh painting. The green earth has been allowed to show through in the mid-tones and has been left unglazed to supply the slightly warmer, duller green of the turned-back lining. This simple use of green earth mixed only with lead white is a feature of the green draperies on Duccio's panels from the *Maestà* (Cat. no. 3).

However, most of the areas of green on Ugolino's panels exhibit complex and varied layer structures: for example, the dull moss-green mantle of St Andrew (Plate 106) has been modelled with a mixture of yellow lake and earth pigments, again over an underpaint of green earth, whereas the quite different khaki-brown robe of St Simon has been achieved by glazing a mixture of azurite and yellow lake over an underlayer of yellow and red ochres. Due to the increased transparency and probable discoloration of the azurite and yellow lake, the brown undermodelling has become predominant (Plates 107 and 110). The lining of the mantle of St Thaddeus next to Simon has been painted with the same mixture, but on this occasion over a thin layer of lead white so it remains a brighter, truer green (Plate 111).

The areas of dull purple and lilac which occur on St Bartholomew and St Thaddeus and on certain figures in the predella are all based on combinations of azurite, red lake and lead white. Some are straightforward pigment mixtures, but the purple robe of Moses is painted to achieve an optical complexity similar to that of his green mantle. The colour has been achieved by applying a thin scumble of azurite, mixed where appropriate with lead white, over an underpaint principally of red lake (Plate 112). Since this layer structure is also present on the mantle of St Bartholomew, it is unlikely to represent a *pentimento*. Rather it is another example of the sophistication of Ugolino's technique. If the less green pigment, ultramarine, had been chosen for these mixtures a truer, brighter purple would have resulted. Again it seems that the softer, greyer

Fig. 78 *The Deposition*. Infra-red reflectogram detail of the drapery of St John the Evangelist

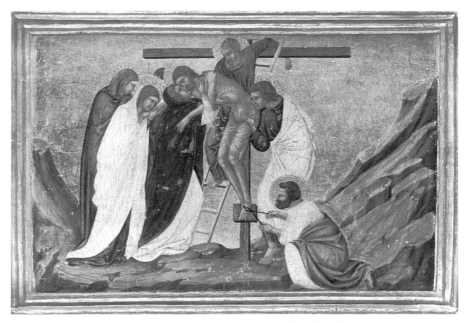

Fig. 79 *The Deposition*. Infra-red photograph

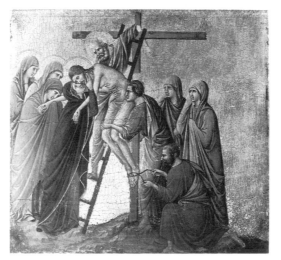

Fig. 80 Duccio: *The Maestà: The Deposition*. Siena, Museo dell'Opera del Duomo

shades caused by the use of the greener blue were considered desirable by the painter. Indeed, for the drapery of the third Mary, who appears on the left of the *Deposition* (Plate 101), some black has been added to the basic mixture of azurite, red

lake and white to produce a dull, yet beautifully subtle slate grey.

Two shades of red are set against these muted colours. The first is a bright orange red based on vermilion. Sometimes it appears mixed with lead white to produce a more salmon-pink colour. The same colour is used by Duccio on the *Maestà* panels, but because his palette tends to be dominated by ultramarine blue, the red does not have quite the same vibrancy as on the Santa Croce fragments. In terms of colour Ugolino's panels seem closer to the earlier *Rucellai Madonna* (Plate 6) than to the *Maestà*. Although modern colour theory with its circles of complementary colours would have been unknown to Ugolino, instinctively he seems to have exploited the contrast between orange reds and their complementary blue greens. The other red is a deep purple red consisting of a particularly saturated red lake, modelled with only the smallest amount of lead white. The colour has often been reserved for important figures like Christ and the Virgin and it contrasts strongly with the greens and blues. This fondness for rich reds set against dark green blues is seen again in the recently cleaned Crucifix (Inv. no. 36) in the Pinacoteca, Siena. Here Christ's blood is represented by vermilion generously glazed with red lake, which must have contrasted dramatically with the lavish azurite and silver decoration, both now sadly blackened.

The brown, orange and yellow colours are as unusual and varied as the rest of Ugolino's palette. The small area that survives of the hot red-brown drapery of the much-damaged panel of *Isaiah* (Plate 96) has been painted essentially with a red earth enriched by the addition of some red lake, but the shadows have been modelled in azurite. If more original paint with shadows and folds had survived, it would probably have appeared as a deep maroon colour. The bright orange which features, for example, on the stockings of the soldier to the right of the Virgin in the *Way to Calvary* (Plate 100) could not be sampled, but is probably a variant of the more yellow orange of his neighbour, or of the tunic of the sleeping soldier on the left in the *Resurrection* (Plate 102). This consists of a yellow earth with some white, but much intensified by the addition of a yellow lake. For the red orange a red earth (with

perhaps a little vermilion) is likely to have been similarly treated.

Ugolino's frequent use of yellow lakes may account for perhaps the most unusual colour of all, the acid, greenish yellow which forms the highlights of the very pale green cloak of the soldier to the right of the Virgin in the *Way to Calvary*, and is also used on its own for the robe worn by Judas in the *Betrayal* (Plate 99). This looks quite unlike lead-tin yellow, the usual bright yellow pigment in use at the time, and analysis of a sample from the soldier's cloak located no elements other than calcium, most probably deriving from the substrate of a pure yellow lake.

Yellow pigments based on dyestuffs are described in *De Arte Illuminandi* (a handbook written by a craftsman apparently from his own experience), in the fifteenth-century Bolognese Manuscript (see Bibliography) and also briefly by Cennino (see p. 39). They occur in pigment mixtures on the two altarpieces in this catalogue attributed to Jacopo di Cione (Cat. nos. 7 and 8). Owing to the small amount of dyestuff present in the samples, it is difficult to identify their sources, especially when they are in mixtures with other pigments. The existence of a number of recipes for their manufacture in treatises of the type of *De Arte*

Fig. 81 Drawings (actual size) showing the composite punch marks found on the haloes in the National Gallery panels

Plate 103 *Sts Bartholomew and Andrew*. Cross-section of mordant gilding on Bartholomew's purple robe. The drapery is painted in two layers containing azurite and red lake; over this is a relatively thick layer of oil mordant. Magnification, 130×

Plate 104 *David*. Flesh of hand where it overlaps gilded background. The underpaint containing green earth is clearly visible. Cross-section, 250×

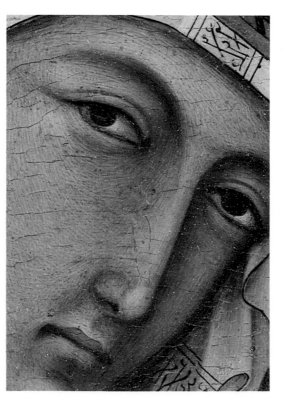

Plate 105 Ugolino di Nerio: *Virgin and Child*. Detail of the Virgin. Paris, Louvre

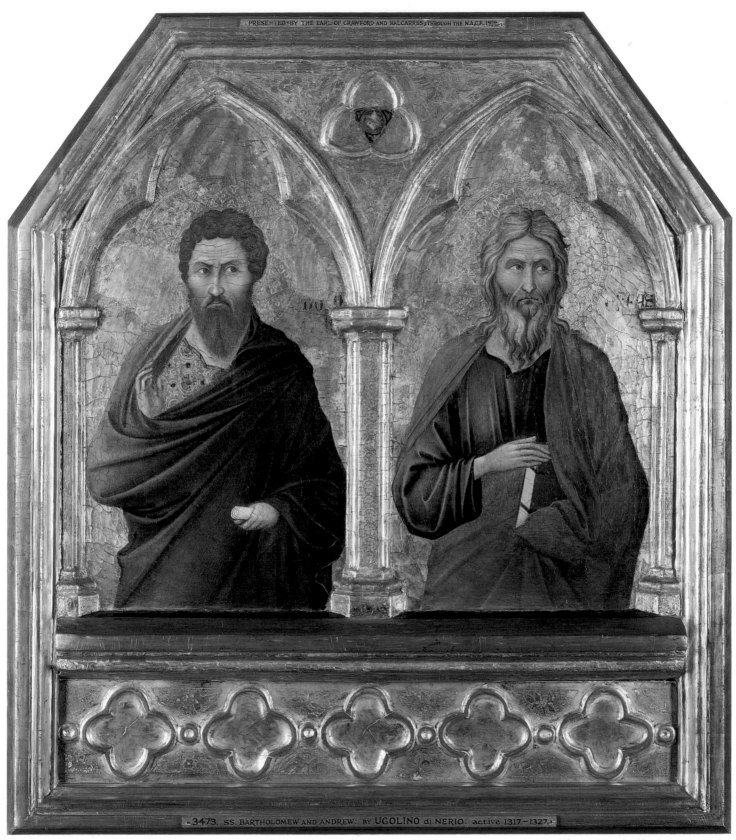

Plate 106 *Sts Bartholomew and Andrew.* 62 × 70 cm (including modern outer frame)

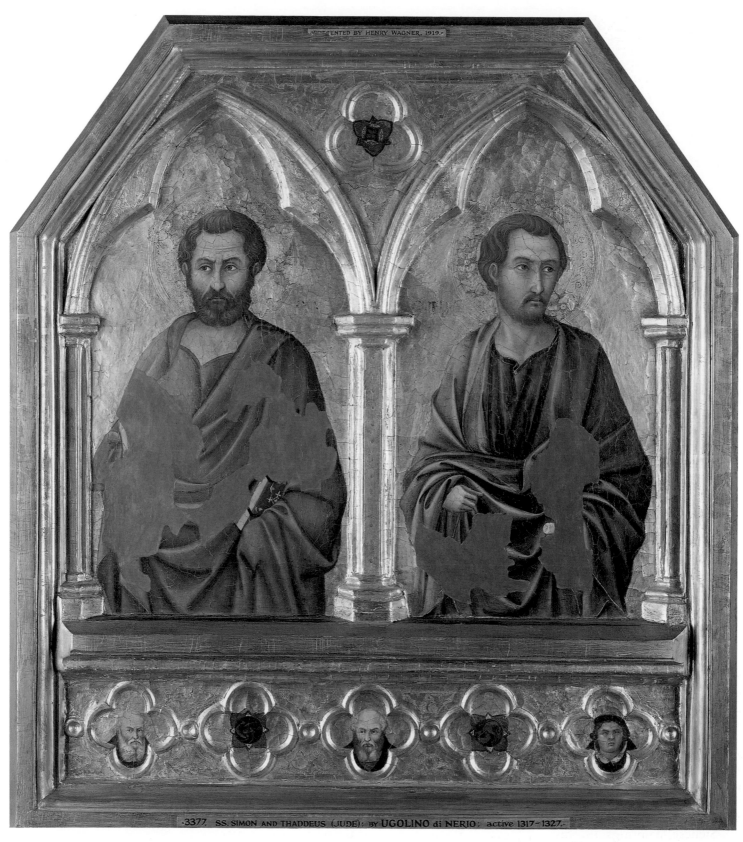

Plate 107 *Sts Simon and Thaddeus.* 62·5 × 70·5 cm (including modern outer frame)

Fig. 82 *The Deposition*. Macro detail of the Magdalen's hem

Plate 108 *David*. Mineral azurite used for the cloak. Top surface of an unmounted fragment, 130×

Plate 109 *Moses*. Azurite scumbled over an undercolour of green earth for the blue-green drapery. Cross-section, 150×

Plate 110 *Sts Simon and Thaddeus*. Azurite with yellow lake, over ochre for Simon's khaki robe. Cross-section, 325×

Plate 111 *Sts Simon and Thaddeus*. Azurite with yellow lake, over lead white for the lining of the mantle of St Thaddeus. Cross-section, 380×

Plate 112 *Moses*. Purple: azurite over red lake, white and a little azurite. Cross-section, 160×

Illuminandi, suggests the possibility that they were made into pigments by the painter or manuscript illuminator himself using locally occurring dyestuffs supplied by the apothecary. Among the yellow dyestuffs recorded as having been stocked by Sienese apothecaries in the thirteenth and fourteenth centuries are weld (also called *bietola gialla* – literally yellow beet-root), dyers' broom and saffron.

It is interesting that Ugolino used a yellow lake instead of lead-tin yellow: in this period lead-tin yellow seems to have had a peculiarly Florentine usage. It has been identified on the panel by Giotto (Cat. no. 2), but does not occur on any of the Sienese paintings in this catalogue. Ugolino's use of a fugitive yellow lake may also account for the strange, ghostly plants and clumps of grass in the foreground of the *Betrayal*. There is a possibility that they could have been painted with

a dark, transparent green made from yellow lake, black and perhaps a little blue. The yellow lake may then have faded leaving only the faint grey marks now visible.

When assessing Ugolino as a colourist, allowances constantly have to be made for the likely alteration of some of the pigments. Also many of his strange, if not unique, superimpositions of different colours may have changed in their effects due to damage and increased transparency of the upper layers. Nevertheless, these fragments show a beautiful and inventive use of colour with vibrant and striking juxtapositions. While they can be appreciated in an abstract sense alone, it is also necessary to imagine these alternating muted and jewel-like colours distributed across the surface of the complete work to realise the full magnificence of this monumental altarpiece.

123

NARDO AND JACOPO DI CIONE

active 2nd half of the 14th century

Nardo and Jacopo di Cione were, with Matteo, brothers of Andrea di Cione, known as Orcagna, whose workshop dominated Florentine painting during the second half of the fourteenth century. Andrea was pre-eminent as a sculptor, architect and painter. In about 1347, when the Pistoians drew up a list of the best painters in Florence, the list of six included Andrea and Nardo di Cione, and a certain 'Maestro Francesco' working in Andrea's workshop.

Nardo di Cione is documented as a member of the Arte dei Medici e Speziali in Florence in 1343, the same year as Orcagna. According to Ghiberti, Nardo painted the frescoes in the Strozzi Chapel (Fig. 83) in Santa Maria Novella, Florence, for which Andrea painted the Strozzi Altarpiece (Plate 114) in 1357. The small number of works attributed to him are undated and undocumented. Nardo, who was ill in 1365, had probably died by May 1366, two years before Andrea.

The third brother of Andrea, Matteo, was a stonemason, so when Andrea became ill in 1368 it was Jacopo who apparently took over the workshop. Jacopo, who is first mentioned in 1365 in Nardo's will, agreed on 25 August 1368 to complete a panel of St Matthew (Plate 171) which the Arte del Cambio (the guild of the money changers) had commissioned for a pilaster in Orsanmichele in Florence from Andrea in 1367 and which Andrea was too ill to finish. Jacopo matriculated with the Arte dei Medici e Speziali the following year. He often collaborated with other painters, in particular with Niccolò di Pietro Gerini with whom he worked on frescoes for the Guildhall of Judges and Notaries in 1366, on the Coronation of the Virgin (Plate 170) for the Zecca (Mint) in 1372–3, on frescoes in Volterra in 1383 (Plates 173 and 174), and on the San Pier Maggiore Altarpiece (see Cat. no. 8). He probably died between May 1398 and 1400.

The generation of painters after Giotto in Florence reverted to hieratic and archaic forms, particularly in figure composition, and were less interested in the portrayal of human emotion or of naturalistic forms set in a three-dimensional space. Florentine painting of the second half of the fourteenth century is accordingly characterised by an interest in decoration. Painters concentrated more on the rich effects of brilliantly coloured fabrics, sgraffito floors and silks, inventively patterned haloes, and frames ornamented with pastiglia and proliferating in crockets and finials.

In a fourteenth-century novella Francesco Sacchetti related how several of his artist friends went up to San Miniato to see how some paintings were progressing and over dinner with the Abbot they discussed the state of contemporary art. Orcagna raised the question of who was the greatest painter after Giotto; Taddeo Gaddi, one of Giotto's pupils, replied that it was impossible to emulate the painters of Giotto's time in their perfection of the representation of human nature, and that 'this art has become and is becoming less'. It is interesting that they themselves apparently saw art as in decline after Giotto and that, today, we with hindsight see the Renaissance prefigured not in the period immediately preceding the fifteenth century, but much earlier, in the art of Giotto.

Fig. 83 Nardo di Cione and assistants: *Paradise*. Fresco. Left wall of the Strozzi Chapel. Florence, Santa Maria Novella

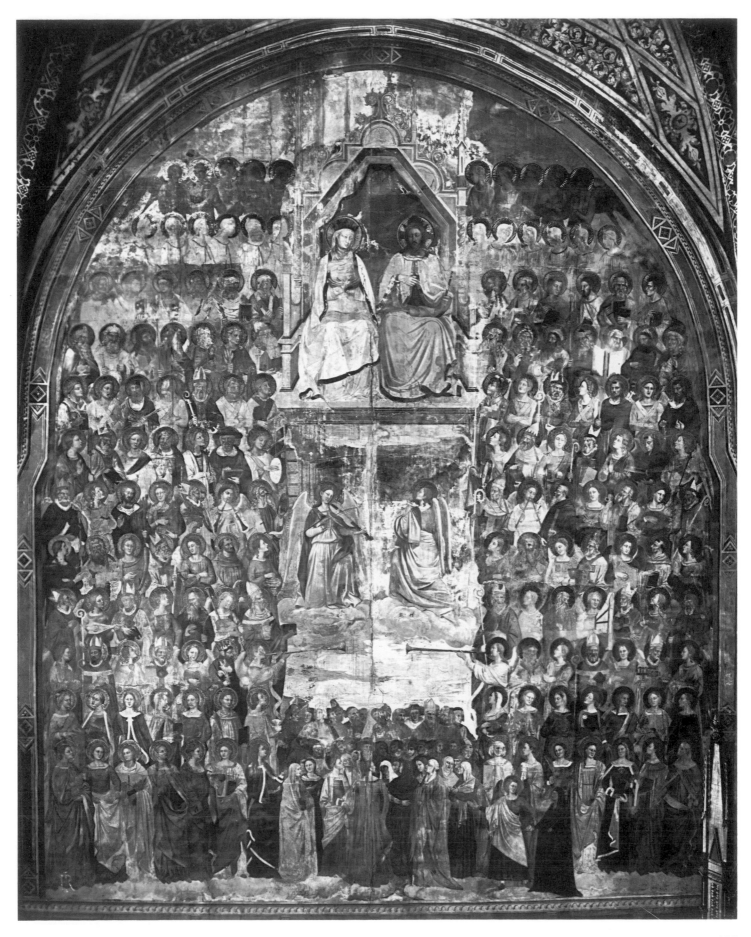

125

NARDO DI CIONE

6. St John the Baptist with St John the Evangelist(?) and St James

This panel probably came from the church of San Giovanni Battista della Calza in Florence, which was originally known as San Giovanni Gerosolomitano, and as early as 1362 belonged to the Knights of Malta (known also as the Knights of St John). The painting was probably commissioned in about 1365 by Bindo di Lapo Benini, whose brother was Prior of the Order of St John in Pisa. The choice of saints is likely to reflect the patron's personal devotions: St John the Baptist may echo the dedication of the church to him and to the Order; James was the name of Bindo's father, Lapo (= Jacopo = James); and John the Evangelist may have been chosen as James's brother.

Technical Description

The panel

The panel is constructed from poplar. The central figure of St John the Baptist and the figure of St James on the right share a single wide plank. A smaller plank has been glued to this to form the left-hand section with St John the Evangelist. Further narrow strips, little more than 2 cm wide, have been added to the left and right edges to make up the full width of the panel. Marks on the gilded surface of the altarpiece show that it was originally divided into three compartments by carved, twisted columns with bases and capitals on either side of each figure. The join between the two main planks coincides with one of the divisions into compartments and would have been hidden by the dividing column; and the additions at the edges would have been covered by the outer frame mouldings. The whole construction of the panel suggests that particular care has been taken to avoid joins, with their potential for splitting open, occur-

ring beneath important parts of the picture.

Almost all the original frame is lost. The only features to have survived are the rebates for the insertion of some form of cusped or traceried decoration around the inner edges of the pointed arches (Fig. 84). These rebates have been formed by glueing and nailing two thin, appropriately shaped pieces of poplar to the front of the panel. Similar rebates – also lacking the tracery – appear on the otherwise relatively intact frame of the Zecca *Coronation* by Jacopo di Cione (Plate 170).

It is not clear whether the top of our panel has always had its present outline of three truncated triangles, a design which reflects that of Andrea di Cione's Strozzi

Fig. 84 Detail showing the rebate for the insertion of frame decorations

126

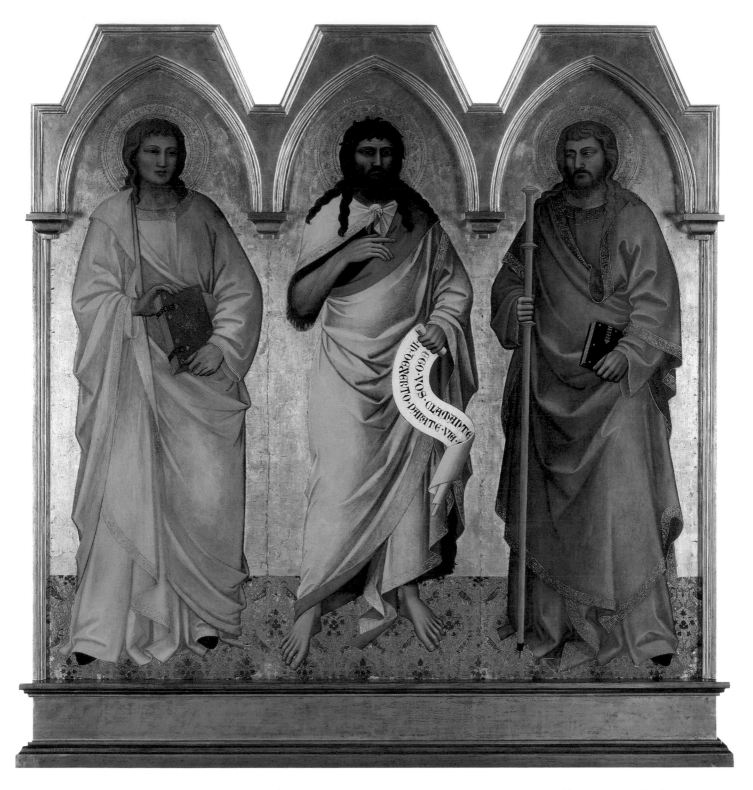

Plate 113 Nardo di Cione: *St John the Baptist with St John the Evangelist(?)* (left) *and St James* (right) 159·5 × 148 cm

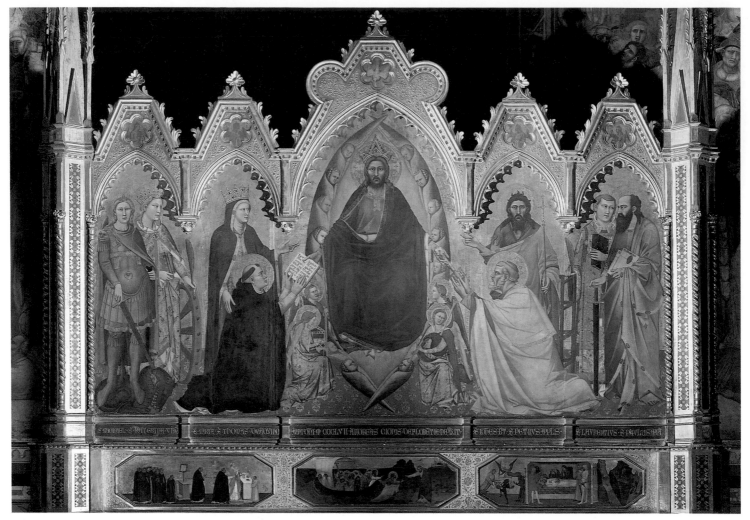

Altarpiece in Santa Maria Novella (Plate 114). The Strozzi Altarpiece was reframed in the nineteenth century, but supposedly in accordance with the original design. Drawings made just before this reframing (Figs. 85 and 86) show it as a single-tiered construction with the tops of the panels terminating as now in truncated triangles, but it may have been altered earlier while retaining some of the apparently original frame details shown in the drawing. Whether the shape of the upper part of the Strozzi Altarpiece is original or not, the side panels of the San Pier Maggiore Altarpiece (Cat. no. 8) were evidently cut to this shape when the panels were reframed in the nineteenth century, probably while in the Lombardi–Baldi Collection. As Nardo's panel was in the same collection, it may well have been similarly altered. When the nineteenth-century frame was removed, exposed worm channels (filled with later gesso) could be seen along the edges of the truncated triangles (Figs. 87 and 88), confirming that

the edges have been trimmed to some extent.

At the base of the National Gallery panel a strip 14.5 cm deep has been left bare. The gesso covering the main part of the panel ends in a raised lip or 'barbe' indicating that a moulding was originally present. This may have framed some form of decorative frieze, perhaps with inscriptions like those on Nardo's *Trinity with Sts Romuald and John the Evangelist* (Florence, Accademia; Fig. 89), and below this there could have been a narrative predella, painted as usual on a separate horizontal piece of poplar. Alternatively, the altarpiece may have had only a narrow predella with some form of gilded decoration, perhaps of *pastiglia* with inset roundels like the *Crucifixion* (Cat. no. 7). If this is so then Nardo's panel is virtually a complete altarpiece, and the only painted parts which are likely to have been lost are those small decorations which may have been set into the original frame.

The surface of the panel has been

Plate 114 Andrea di Cione (Orcagna): The Strozzi Altarpiece. 1357. Florence, Santa Maria Novella, Strozzi Chapel

128

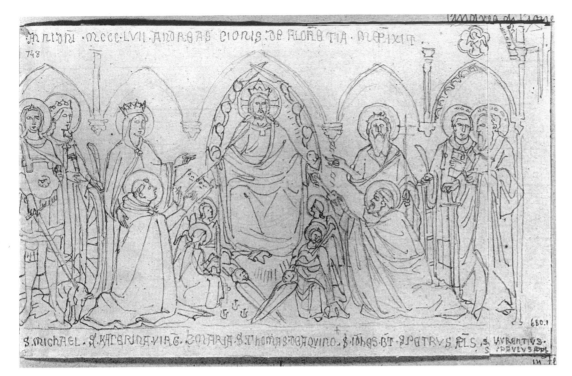

Figs. 85 and 86 Drawings made in the nineteenth century of the Strozzi Altarpiece and its frame before the construction of the present frame. Frankfurt, Städelsches Kunstinstitut

covered with linen and prepared with gesso in the usual way. In the cross-sections the gesso appears homogeneous and very white, with no sign of the many successive applications advised by Cennino. However, it occurs in both the anhydrite and the gypsum forms, so separate layers of *gesso grosso* and *gesso sottile* must have been applied.

Underdrawing

More preliminary underdrawing can be seen on Nardo's panel than on most other Italian paintings of this period. The increase in transparency of St John the Baptist's pink robe renders much of the drawing visible to the naked eye. In addition underdrawing can be detected beneath the other colours by infra-red

129

photography and reflectography (Figs. 90–94). Unlike the other panels examined for this catalogue, the drawing has been used not only to outline the forms and to delineate the drapery folds, but also to establish the main areas of shadow. Although Cennino describes the shading of folds and the modelling of the faces, in practice underdrawing often seems to have been omitted. Its use by Nardo demonstrates his evident concern to suggest the bulk and three-dimensionality of the figures. When the underdrawing features in cross-sections it occurs as small glistening rounded black particles, close in appearance to lampblack. In infra-red the drawn lines can be seen to lack the smooth fluency typical of a brush drawing. Instead they have an uneven, almost scratchy, character which suggests the use of a broad-tipped quill pen. The technique for shading the folds of St John the Baptist's robe is notably calligraphic in pattern, the hatching taking the form of a series of long U-shaped loops, seemingly made without lifting the quill from the surface of the gesso.

Gilding

The outlines of the areas to be left ungilded have been deeply incised into the ground (Plate 120) and the remaining areas coated with bole to provide a base for the gold leaf. Where the bole has been exposed by wearing of the gold leaf, it can be seen to be noticeably darker and duller in colour than the very bright orange bole visible on the Sienese pictures discussed here. The dark reflective surface of the gilding and the difficulty in distinguishing the joins between the individual sheets of gold leaf indicate that it has been well burnished.

Certainly it was essential to burnish the gold leaf when it was to provide the base for decorative textiles executed by the technique of *sgraffito*. The instructions given by Cennino for the execution of these cloths of gold are very precise, and the examination and analysis of the floor coverings and wall hangings of both Nardo's altarpiece (Plate 115) and the panels of the main tier of the San Pier Maggiore Altarpiece (Cat. no. 8) confirm that the technique – perhaps with some slight variations – was in common use in Tuscan workshops of the second half of the fourteenth century. First the area to be

Fig. 87 Detail showing the truncated top before the removal of nineteenth-century framing elements

Fig. 88 Detail during removal of the nineteenth-century frame showing the worm channels along the cut edge

represented as the cloth of gold was gilded; next a layer of the predominant colour of the textile, in this instance the orange pigment, red lead, was painted in the usual egg tempera medium over the whole area of gold leaf to be patterned (Plate 116). If Nardo followed the method described by

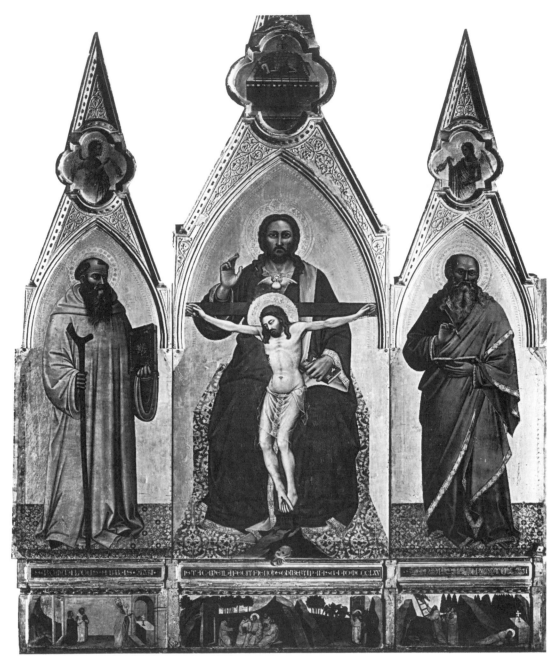

Fig. 89 Nardo di Cione: *The Trinity with Sts Romuald and John the Evangelist*. Florence, Galleria dell'Accademia

Cennino, the design of the textile would then have been transferred to the paint surface by dusting powdered pigment through the pricked outlines of a paper or parchment cartoon. On lifting the cartoon the pattern would appear as lines of dots on the paint surface. Cennino makes the helpful, if somewhat hazardous, suggestion that if the main colour of the brocade is dark, the design should be pounced in this way with lead white; if light, then powdered charcoal should be used.

However, Nardo may have used a slightly different method for transferring his designs. In the bottom right corner of the panel showing St John the Evangelist in his *Trinity* triptych (Fig. 89) a column-base present in the photograph has since been removed, revealing an incomplete area of *sgraffito* pattern. Instead of being pounced, the lines to be covered by the base and therefore never scraped out have been lightly indented into the paint. They now show particularly well as this is the shadowed front edge of the step; the pigment is the darker red vermilion rather than red lead, and the pressure from the stylus has caused the vermilion to blacken along the lines. It may be that Nardo just used a stylus for the less complicated parts of the patterns and still pounced the main motifs, but it is equally possible that he

Fig. 90 Infra-red photograph.
Detail of St John the Evangelist

Fig. 91 Infra-red photograph.
Detail of St John the Baptist

also transferred the whole design from the cartoon by laying it over the paint and indenting around the outlines.

Whichever method was used for its transfer, the bird and flower motif on the National Gallery altarpiece is quite in-

132

genious in design. By turning over the cartoon and pouncing or indenting through both sides, it was possible to achieve a complex pattern using a very simple repeat of a single bird together with the appropriate segments of the floral ornament (Plate 117). The need for precise registration of the repeats is emphasised by Cennino. Nardo's cloth-of-gold pattern is more complicated than those of Cennino in that it introduces a second colour, the ultramarine on the heads and wings of the birds and in the centres of the flowers. These parts of the design show as white in the X-radiographs, confirming that the ultramarine (a pigment transparent to X-rays) was applied over the red lead. As red lead absorbs X-rays strongly, it gives a light image in the radiograph (Fig. 95).

The gold parts of the design were then exposed by scraping away the appropriate areas of superimposed paint (Plate 118), hence the need for the gold leaf to be firmly attached and well burnished. The egg tempera paint above, although technically dry, should not have hardened completely, but should remain slightly soft and still flexible and cheese-like in texture. To avoid scratching the gold, Cennino recommends the use of a wooden stylus with a point at one end and a scraping edge at the other. Larger areas of paint were scraped away and smaller details, for example the wing feathers of the birds, were scored through the paint with the wooden point. The final stage was the tooling of the exposed gold with small stipple punches to make the cloth of gold shimmer and sparkle in flickering candlelight (Plate 115). Fine lines were indented with a single blunt needle punch, but to save time on larger areas, rosette composite punches, made of clusters of points rather like vaccination needles, were probably used. Furthermore, the punching was omitted on any part of the textile which was to be covered by framing elements such as the bases of the columns.

Rosettes may also have been employed for the stippled decoration on the widest bands of the tooled haloes. Here a cusped-arch punch and floral and quatrefoil motifs in two sizes have been combined with simpler ring and indenting punches to supply each saint with a different pattern of halo (Fig. 96). The punches have sometimes been rather erratically placed, not

Fig. 92 Infra-red photograph. Detail of St James

always following precisely the incised arcs of the haloes, but the stamping is generally skilful, executed without breaking and damaging the delicate skin of gold leaf. It has been suggested that these haloes were decorated using a set of punches brought to Florence from Siena by the itinerant painter Giovanni da Milano in 1363. If the large five-petalled flower used for the halo of St John the Evangelist is the same as that on Giovanni da Milano's *Pietà*, dated 1365 (Florence, Accademia) then its centre must have become worn down through use: on Nardo's altarpiece the faint ring has had to be reinforced by a further stamping, often slightly off-centre, with a small indenting punch. While punches do seem to have been shared and transferred between different painters' workshops, punches may

have been more widely circulated among other crafts as well (see p. 25). In addition it is not yet clear to what extent the tooling and stamping were executed by the painter or whether in large workshops greater use was made of specialist craftsmen. Some evidence for the latter practice is given in the entry for Cat. no. 8.

Paint layers

Even if the painter did not always carry out the gilding and tooling himself, the importance attached to the subject by Cennino suggests that the techniques were part of the training of the painter for his profession. Certainly the gilded decoration on Nardo's altarpiece has been executed using methods described by Cennino, and the painting of the draperies also seems to have proceeded almost exactly according to the method described in his treatise. When describing the system of modelling the folds by working from dark to light using pre-mixed shades of colour, each applied to the appropriate part of the relief, he takes a red lake drapery as his example:

Fig. 93 Infra-red reflectogram. Detail of St John the Baptist

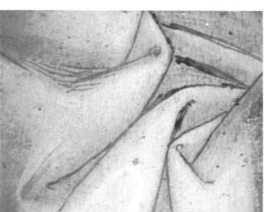

Fig. 94 Infra-red reflectogram. Detail of St James

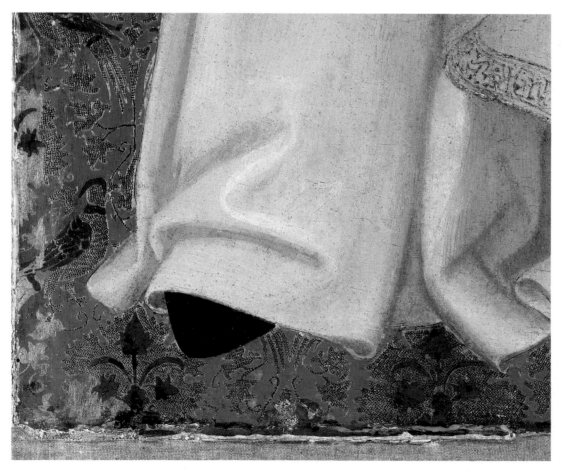

Plate 115 Detail of the *sgraffito* floor covering

Always start by doing draperies with lac by the same system which I showed you for fresco; that is, leave the first value in its own colour; and take two parts of lac colour, the third of white lead; and when this is tempered, step up three values from it, which vary slightly from each other: tempered well, as I have told you, and always made lighter with white lead well worked up . . . Then take a rather large blunt minever brush, and start to apply the dark colour, shaping up the folds where the dark part of the figure is to come. And in the usual way take the middle colour and lay in the backs and the reliefs of the dark folds, and begin with this colour to shape up the folds of the relief . . . Then take the light colour and lay in the reliefs and the backs of the light part of the figure. And in this way go back once again to the first dark folds of the figure with the dark colour. And carry on as you began, with these colours, over and over again, first one and then the other, laying them in afresh and blending them skilfully, softening delicately.

Finally the 'strongest reliefs' were to be highlighted with pure lead white and the 'strongest darks' reinforced with pure lac. Inevitably this technique of modelling by carefully blended juxtaposed tones leads to some overlapping of the shades, and by chance a sample taken from St John the Baptist's pink robe includes three gradated shades of pink (Plate 119). The lowest layer over the underdrawing is a thin application of pure red lake, the 'first value in its own colour'. The next layer consists of a mixture of red lake and lead white and represents one of the mid-tones, while the final layer contains yet more lead white so that it is virtually a highlight. Examination of the surface of the picture suggests that rather than finishing the sequence of application with the highlights, Nardo has returned to the deepest shadows to apply final touches of pure red lake. Analysis of a very small sample of the dyestuff suggests that it might derive from an insect of the Polish cochineal type. With time the paint of this drapery has become very transparent, rendering visible not

Plate 116 Cross-section showing the red lead applied over gold leaf for the *sgraffito* textile. Cross-section, 340×

Plate 117 Transferring the repeats of the *sgraffito* design using the method described by Cennino

Plate 118 The ultramarine blue details have been applied and the outlines of the design scratched through the paint, following the pounced dots. In the top left section the gold parts of the pattern have been exposed by scraping

135

only the underdrawing but also the free laying in of the white background of the scroll held by the Baptist (Plate 120).

A cross-section from the ultramarine blue robe of St James on the right (Plate 121) also has a multi-layer structure. In this instance the darker shade lies over the lighter, not because the colours have been applied in the reverse order, but because egg tempera paint has insufficient hiding power, particularly when using the semi-transparent ultramarine, for the white ground to be covered evenly in a single application. The colours have been applied 'over and over again, first one and then the

other', so that in this case a stroke of the darker shade happens to appear above a paler one.

Nardo's (and Cennino's) modelling system becomes even clearer on examination of the light green drapery of St John the Evangelist on the left (Plate 124). This has been painted to imitate the effect of *cangiante* or shot silk, in which different coloured threads are used for the warp and the weft so that depending on the angle of light some of the fabric will appear one colour and some another. Cennino describes several possible colour variations in his section on fresco painting (perhaps

Fig. 95 X-radiograph. Detail of the *sgraffito* floor covering

inspired by the many *cangiante* draperies used by his master Agnolo Gaddi in, for example, his Santa Croce frescoes). However, they seem to appear less often on earlier fourteenth-century panel paintings. Apart from similar areas of green in the *Crucifixion* (Cat. no. 7) and some rather crude examples on a few of the saints in the San Pier Maggiore Altarpiece (Cat. no. 8), they do not feature on any other panels in this catalogue. Nardo's *cangiante* drapery has been constructed so that it is blue in the deepest shadows but pale yellow in the highlights. The mid-tones, not surprisingly, appear as gradated shades of light green. The yellow end of the colour scale is provided by lead-tin yellow with some lead white, but the blue pigment in the shadows and in the green intermediate tones is ultramarine rather than the azurite which occurs in most of the mixed greens on the other paintings examined for the catalogue (Plates 122 and 123). Although the precious ultramarine was often used in mixtures with red lake and white to make purple, it is unusual to find it mixed with a yellow pigment. It also occurs in a similar context on the figure of St Paul in the *Baptism* by Niccolò di Pietro Gerini (Plate 172). Its use in Nardo's panel could have been justified by the fact that it appears in an almost pure form in the blue shadows.

The principal areas of colour on each of the saints' mantles are complemented by the turned-back linings which are painted with a different colour, usually one worn by another figure: St John the Baptist's pink robe has an ultramarine blue lining and the green *cangiante* drapery a pale pink lining. The blue robe is lined with a bright vermilion red, a colour also picked up on the cover of the book carried by the saint on the left. Unfortunately, some of the red paint has been disfigured by the photochemical change of the originally red mercuric sulphide to its black form (Plate 124). It is not clear why the vermilion should have blackened on this panel and, indeed, also on the two altarpieces attributed to Nardo's brother Jacopo (Cat. nos. 7 and 8), but not on the paintings by the Master of St Francis, Giotto, Duccio and Ugolino. Possibly the di Cione brothers' pigment was inadequately bound in the egg medium and therefore not properly protected. Certainly vermilion is a notoriously difficult pigment to grind and mix

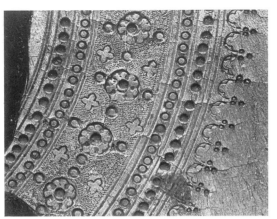

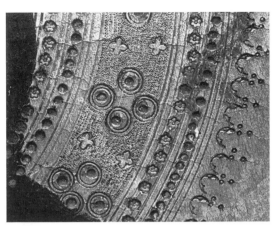

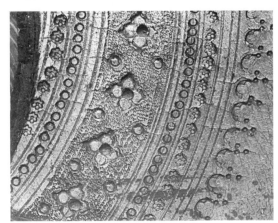

Fig. 96 Actual size details of the punch marks on the three tooled haloes

with a water-based medium like egg tempera. It tends to separate and the pigment rises to the surface even as the paint is brushed on to the panel.

The edges and hems of the draperies have been embellished with some form of mordant gilding. Under magnification the gold can be seen to have been applied as pieces of leaf (rather than powdered to make a gold paint) but the mordant is rather curious. It is visible in many places where the gold has been worn away, appearing as a fairly dark brown colour, but lacking the pronounced raised profile of the mordant on, for example, the panels

Plate 119 St John the Baptist's pink drapery comprising red lake and lead white in three layers. Black particles of the underdrawing are also visible. Cross-section, 150×

Plate 120 Detail of St John the Baptist

Plate 121 Cross-section in two layers from the robe of St James painted in high-quality ultramarine. Cross-section, 150×

by Duccio. A small scraping showed it to be pigmented with red and yellow earths mixed with bone black and lead white (Plate 125). When viewed in cross-section Nardo's mordant shares certain features with the known oil mordants (see p. 43) and is most likely to be of this type. It may owe its flatness to the fact that it contains a relatively low proportion of lead white, one of the pigments often added to accelerate the drying of a mordant, giving it the stiff consistency necessary for achieving raised lines.

Problems in obtaining a suitable sample also made it impossible to confirm whether the areas of flesh paint have been underpainted with green earth or with the mixture of black, ochre and lead white which produces the green-brown colour known as *verdaccio*. In most places the undermodelling has been almost concealed by the flesh colours above, but where it has been exposed by abrasion of the upper paint layers, for example on the face and hands of St John the Evangelist, it inclines towards the cooler blue tint characteristic of green earth, but not as blue as that seen on the paintings by Duccio and Ugolino

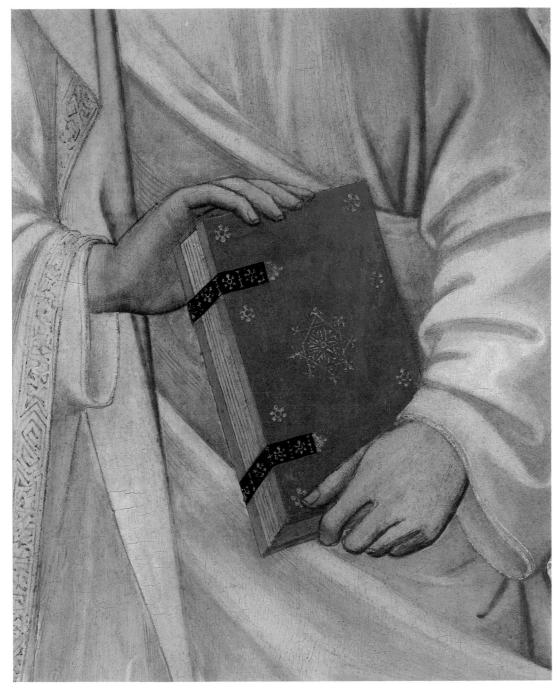

Plate 124 Detail of St John the Evangelist

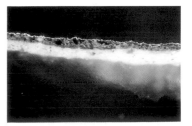

(Cat. nos. 3, 4, 5). Perhaps Nardo altered the colour of the green earth by the addition of black and yellow pigments in the same way as did Jacopo di Cione (Cat. nos. 7 and 8).

The damaged condition of the face and hands of the figure of St John the Evangelist may be one of the reasons why its execution has sometimes been attributed to a member of Nardo's workshop. However, the uniform style of underdrawing revealed by infra-red reflectography on all three figures suggests that the design at least is by a single hand. Rather than assigning complete figures to members of the workshop, Nardo is more likely to have employed workshop assistance in laying in the colours for the *sgraffito* textile and perhaps for the earlier stages of the systematic modelling of the drapery folds. The wide square faces and broad strong hands of all three saints are typical of Nardo's frontally posed figures. So too is the painting of the draperies. They have a weightiness which remains impressive, however much it may be contradicted by the flatness and lack of recession in the patterned cloth of gold on which the figures stand.

139

JACOPO DI CIONE

7. The Crucifixion

Christ hangs on the Cross while angels receive the blood from his wounds in basins. On the left is the Good Thief: two angels carry his soul up to heaven. On the right is the Bad Thief: two devils hold a brazier of burning coals above his head; his legs are being broken. In the foreground the Virgin is supported by the Magdalen and the other Maries. St John the Evangelist stands near her. On the left soldiers are casting lots for Christ's robe. Several soldiers and shields bear the Roman insignia S.P.Q.R., standing for *Senatus Populus Que Romanus*. In the compartments on the left are St John the Baptist and St Paul, and on the right St James with a pilgrim staff and St Bartholomew with the knife with which he was flayed.

In the roundels in the predella below are the Virgin and Child flanked by a female saint and St Bernard on the left and by Sts Anthony Abbot and Catherine of Alexandria on the right. It is not certain what the original location of the altarpiece might have been, probably a small chapel.

Attributions of works, including the *Crucifixion* and the San Pier Maggiore Altarpiece (Cat. no. 8), to Jacopo di Cione have always been made with some caution. This is because of his well-documented tendency to collaborate with other painters and craftsmen, often apparently on an equal basis rather than as the dominant master in charge of the project. Therefore one of the aims of the technical examination of these two altarpieces has been to try to identify Jacopo's likely role in their production and consequently to obtain a better understanding of his style and technique.

Technical Description

Structure

In a catalogue devoted mainly to fragments of dismembered altarpieces, the *Crucifixion* (Plate 126) is a remarkable object in that it is a rare example of a fixed altarpiece, albeit a small one, which has retained much of its original structure, together with many of the original framing elements, although much of the fragile canopy has in the past been restored. Recent accidental damage to the altarpiece revealed the extent of the earlier restoration and that the canopy was even more fragile than had previously been suspected. Consolidation of the worm-eaten wood and of the panel has now been effected.

Virtually every detail of the construction of the altarpiece can now be identified and described. Until the final assembly of the work, the two pilasters on either side remained separate, but the central panel, predella and canopy were treated as a single unit. The central panel is constructed from three planks of poplar, 3 cm thick and with a vertical grain. The narrow predella has been formed by glueing and nailing a plank of poplar, 21.7 cm wide and 2 cm thick, across the base of the main panel (Fig. 97). The large evenly spaced nails (visible in the X-radiographs – Fig. 100) have been hammered through from the front of the predella. Simple carved

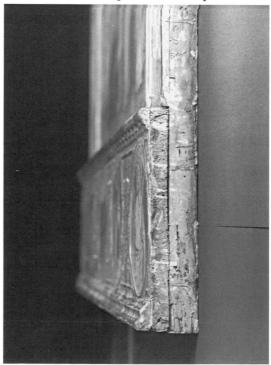

Fig. 97 Detail of the right edge showing the predella attached to the main plank

140

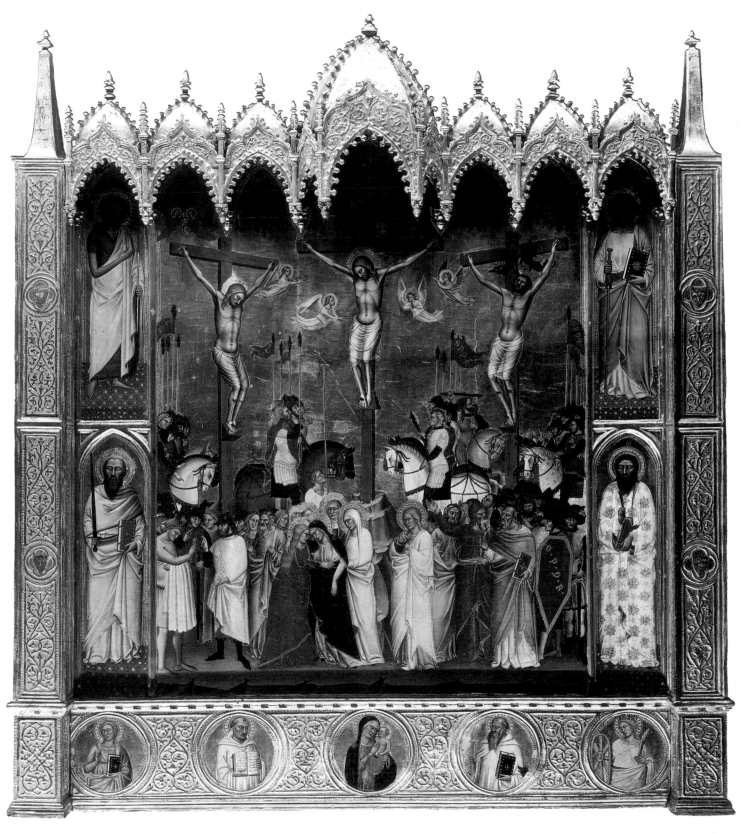

Plate 126 Jacopo di Cione and
his workshop: *The Crucifixion*
154 × 138·5 cm (including the
frame)

wooden mouldings have then been attached, using smaller nails, to the top and bottom edges of the predella. Similarly, the mouldings which form the compartments for the full-length saints flanking the Crucifixion scene have been glued and pinned to the surface of the panel. Small bumps in the gesso and gilding indicate the positions of the nails or panel pins (Figs. 98 and 99).

Each of the seven domes of the canopy is composed of a separate block of wood, almost certainly poplar, glued and nailed to the front of the main panel (Plate 127). The solid block of each dome has been slightly hollowed out to form the vaulting, but the only decoration integral to the blocks are the carved crockets along the ridges of the faceted domes. The cusps and the ogival arches on the front faces of the domes have been carved separately and then fixed in place with glue and small nails or panel pins. Similarly, small sections of tracery have been attached to the sides of the outer edges of the canopy (Fig. 101). The last pieces to be applied would have been the miniature pilasters and finials to cover the joins between the arches. Most, if not all, of the finials now present appear to be later replacements. So too are many of the drop capitals, much of the decoration along the edges of the ogival arches, and probably all the finials surmounting the domes. Some of these replacement details have been cast in plaster rather than carved from wood and therefore they produce solid white images in the X-radiographs (Fig. 102).

The backs of the domes and the back of the panel have been painted a dark grey colour, but as the paint runs into worm channels it must have been applied at a later date. Originally, any part of the construction not visible when the work was positioned on an altar, and therefore seen from a fairly low viewpoint, was left in a surprisingly rough and unfinished condition.

The pilasters have been carved independently, also from solid blocks of wood. The authenticity of their curious pyramidal tops has sometimes been questioned, but each is shaped from the same continuous piece of timber as the rest of the pilaster (Figs. 103 and 104). Only the finials on the tops (possibly not original), and the mouldings which run down the sides and

Fig. 98 X-radiograph. Detail showing where the moulding has been pinned to the panel to form the compartment for St James

Fig. 99 Infra-red detail of the same area showing the bump in the gesso caused by the panel pin

Plate 127 Detail showing one of the domes of the canopy

form the horizontal divisions corresponding to those on the main panel, have been made from separate pieces of wood.

The altarpiece seems to have been held together by two horizontal wooden battens nailed across the back of the panel, almost certainly before any gilding and painting began. On completion of the work on the main panel, the projecting ends of the battens would have been used to attach the pilasters on either side – these were definitely gilded separately from the main panel since on the inner faces the bole

142

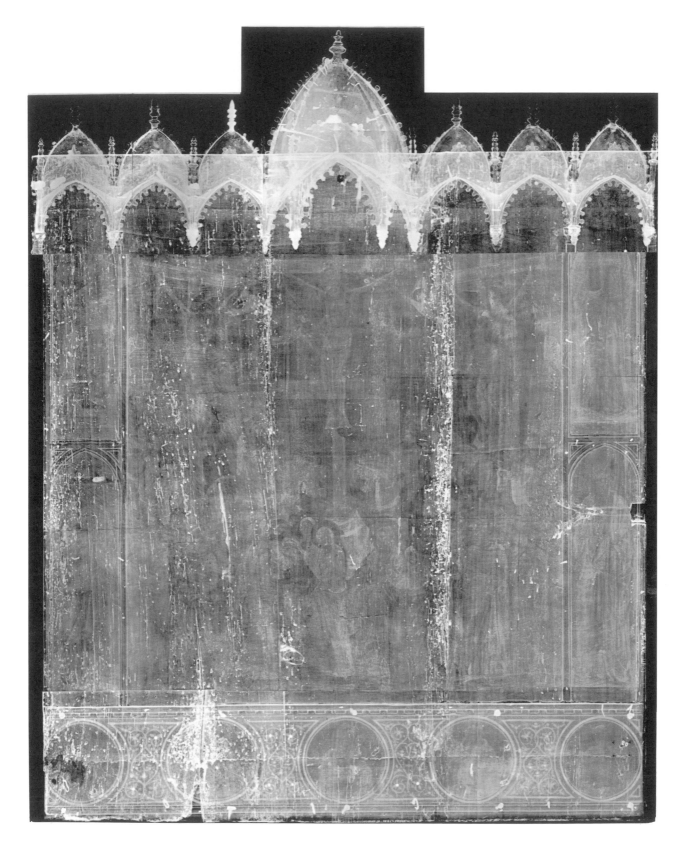

and gold leaf extend beyond the areas which would have been visible when the structure was assembled (Fig. 105). Unfortunately, many years ago the back of the panel was coated with wax to reduce its sensitivity to changes in humidity, so no batten marks can be seen; nor are there any traces of the nails in the X-radiographs. However, large square-headed nails and lighter marks indicating the probable

Fig. 100 X-radiograph of the altarpiece without the pilasters

143

positions of the original battens still remain on the pilasters. At the base of each pilaster a cube-shaped section has been cut away at the back edge (Fig. 104). The cuts appear to be very old and it is possible that some sort of block was inserted for the installation of the work on an altar. The dimensions of the altarpiece mean that the altar itself must have been small, perhaps that of a sacristy or private oratory. A fresco by Benozzo Gozzoli in the church of Sant'Agostino, San Gimignano (Plate 128), shows the figure of St Monica praying at a side-altar on which can be glimpsed an altarpiece very much like the *Crucifixion*.

Gesso and *pastiglia*

Before the setting up of the work on the altar all the gilding and painting would have been complete. As a base for this, gesso has been applied to the flat surfaces and carved framing elements alike, but first the flat part of the main panel, but not, it seems, the predella, was covered with linen canvas. The X-radiographs show that the canvas does not quite extend to the tops of the arches beneath the canopy and that the fabric has been cut and shaped so as not to cover the drop capitals glued to the surface of the panel.

Samples of gesso taken from the flat areas of the main panel and the predella were found to consist primarily of the pure gypsum which may be identifiable as Cennino's *gesso sottile*. Also detected were traces of the anhydrite form, so the samples may have included a little *gesso grosso* from the lower layers. Calcium sulphate, in the form of pure gypsum, has also been used in most of the lavishly applied raised gesso decoration on the predella, the pilasters and the canopy (Plate 129). This technique of raised gesso decoration, commonly called *pastiglia*, is described by Cennino. The gesso is applied in a liquid form, dribbled from a brush on to the flat gesso ground. With successive applications a ridge is formed. If necessary this could be scraped smooth or rubbed down with a damp linen rag in the same way as the frame mouldings. In the X-radiographs of the *Crucifixion* the *pastiglia* appears flecked with particles of a more X-ray opaque material (Fig. 106). This may be due to the presence of lead white, perhaps added to make a slightly harder,

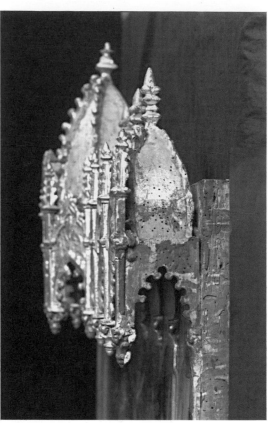

Fig. 101 Detail of the right end of the canopy

tougher modelling material.

On the predella small pieces of glass, coloured to imitate precious stones, have been embedded in the *pastiglia*, again exactly as described by Cennino (Plate 129). The shields on the pilasters also form raised cushions of gesso (Fig. 103). The coats of arms which must have been on these shields have been scraped off, leaving only islands of the original ultramarine background. At some later date they have then been repainted with azurite which has in turn been partially removed.

Underdrawing

Only a small amount of preliminary drawing on the white ground can be detected by infra-red photography and reflectography, and most of this can also be seen with the naked eye. A few faint lines appear in the draperies of the saints and the foreground figures and occasionally the line of a fold (Fig. 107), but there is no sign of any hatching like that on the altarpiece by Nardo (Cat. no. 6). Moreover, the softer, fluid lines suggest that the drawing on the *Crucifixion* has been executed with a brush rather than a quill. Although no drawing can be detected in the groups of horsemen (probably because of the greater thickness of the paint layers), the final design must

144

have been fixed at this early stage since the complicated outline of the areas to be left ungilded has been lightly but precisely scored into the gesso ground.

Gilding

A bright red-brown bole appears beneath the gold on the original gilded parts of the altarpiece. Wherever a darker, chocolate-coloured bole can be seen, this indicates later repairs to the gilding, particularly on the arches and domes of the canopy, which has inevitably suffered damage. Sometimes the new gold leaf can be seen to have been applied over lumps of dust and dirt. In addition, there are repairs to the gilding on some of the roundels of the predella, to the lower parts of the pyramids crowning the pilasters and on the main panel, particularly along the joins between the planks. For the most part, however, the gilding is very well preserved, especially on the main Crucifixion scene where its burnished surface is marred only by slight abrasion and occasional scratches.

At least eight separate punches have been used in the tooling of the gold leaf. The haloes are quite simple in design: for example, the bands within the incised circles of Christ's halo have been decorated using only a large ring punch, a small indenting punch and a stippling needle. The areas to be stippled are too small for the use of rosette. The same punches also feature on the haloes of the Virgin, the Magdalen, St John the Evangelist and the half-length figures on the predella (Plate 129). For the very small haloes of the Infant Christ and the angels around the crosses an appropriately reduced ring punch was used, while for the polygonal halo of the Good Thief on the left a fairly large five-petalled floral motif has been introduced. The full-length saints on either side of the Crucifixion have haloes of the same pattern as the figures in the central scene, but the ring punch in the widest band of decoration has an indented centre. This probably represents the use of a composite punch as opposed to first stamping the ring and then indenting its centre.

The same punch appears in the lines of tooling around the *pastiglia* on the outer faces of the pilasters, but for some reason a slightly smaller version appears on the front faces and on the predella. The edges of the Crucifixion scene, the roundels on

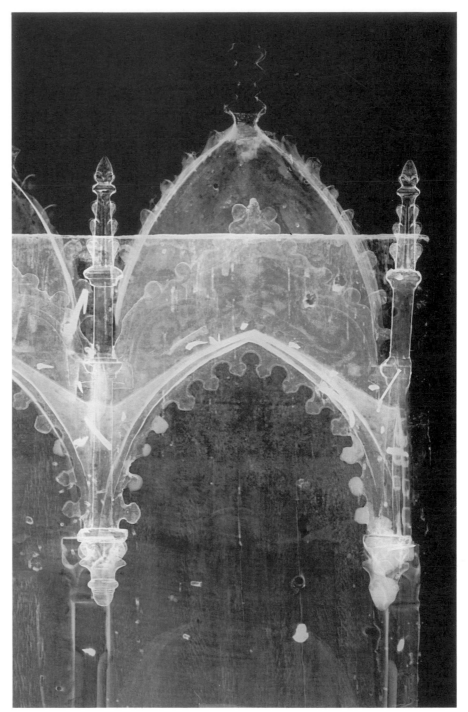

Fig. 102 X-radiograph. Detail of the dome on the far right

the predella and the compartments containing the full-length saints have been decorated with a scaled-down version of the floral motif, sometimes with the addition of a row of simple indentations. Where the arched tops of the main panel meet the vaulting of the six smaller domes of the canopy (Fig. 108), the pattern changes to the large ring with an indented centre seen on the outer faces of the pilasters and on the haloes of the full-length saints.

The edge of the central arch, however,

145

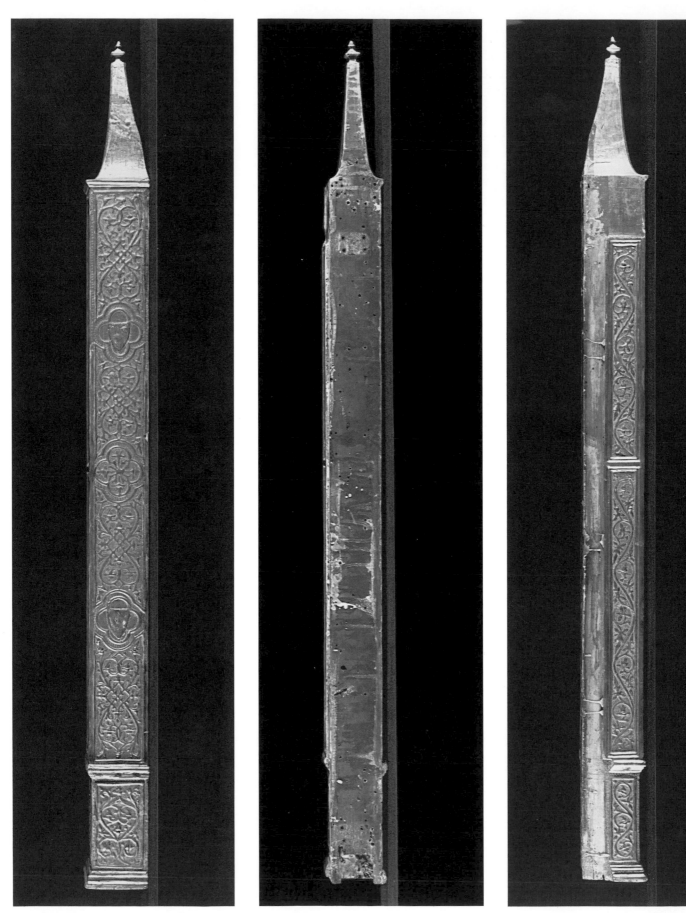

Figs. 103, 104, 105 The outer, back and inner faces of a pilaster

has been left unadorned. The discovery, at the lower right edge of the arch (Fig. 109), of a few faint marks made with the large floral punch used for the halo of the Good Thief, provided an explanation. Evidently the craftsman responsible for the tooling was hampered by the overhanging canopy and was unable to draw back his hammer to strike the metal punch sufficiently hard to indent the gold and gesso. Therefore the tooling of the arch had to be abandoned. The gilding of the other arches is more accessible, but even there the stamping is uneven: as a result of having to strike the punches at an angle, one half of the ring is deeply indented and the other half barely marks the gold.

Pigments and colour

Despite the evident problems for the artist in getting at the areas beneath the canopy, the vaulting has been painted a deep dark blue and decorated with gold stars and a daisy motif (Plate 130). The blue consists of a layer of azurite applied over a black underpaint. Even if the azurite has discoloured to some extent, the black undercolour suggests that the vault was intended to

represent a dark, night sky. Any form of mordant gilding would have been almost impossible in the confined space, so the stars must have been applied using a gold paint ('shell gold'), probably made by grinding gold leaf with egg white as directed by Cennino.

The crowded and busy design of the Crucifixion scene has been controlled by clever management of tone and colour so that the important narrative never becomes confused or obscured. Just as the grey and chestnut horses in the groups beneath the Cross are paired with darker-coloured animals, so the predominantly pale and pastel draperies are distributed

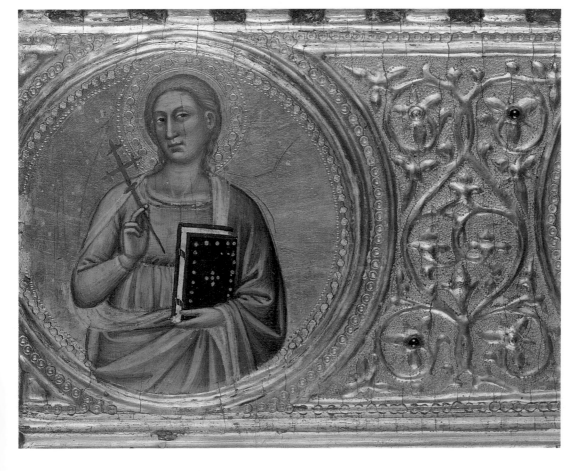

evenly across the surface of the design, always carefully interspersed with areas of a richer, darker tonality. On the predella and the full-length saints the same range of colours reappears and successfully unites the various elements of the altarpiece.

The pale blue draperies have all been painted with a simple combination of ultramarine and lead white. Sometimes the ultramarine has a particularly violet tint: for example, in the shadows of the robe of St John the Evangelist the folds have been reinforced with a very thin glaze of ultramarine over the paler blue modelling (Plate 131). Scattered between the blue pigment particles are a few fine grains of red iron oxide. Iron oxide particles are frequently observed in layers containing ultramarine but seem not to be impurities from the mineral. However, in some instances it is possible that the red colour has been introduced deliberately to give the pigment the richer more purple hue admired in the finest grades of natural ultramarine.

The very pale pink of the Evangelist's mantle consists of lead white with only a little red lake. This pastel colour appears in several places on the altarpiece and it was suspected that extensive fading of the red lake pigment had occurred. A sample taken from the patterned robe of St Bartholomew in the lower right compartment included a layer of the superimposed ultramarine decoration. This should have protected any red lake beneath. However, the colour underneath was found to be just as pale as that in areas which have been exposed to light, therefore the pastel tonality must have been intended. When describing the painting of robes for the Virgin, Cennino states that the drapery should be made 'white, shaded with a little violet so very light that it is just off white'. 'Just off white' is an apposite description of some of the colours in the *Crucifixion*.

The areas of yellow paint are carefully balanced and arranged symmetrically across the design. A few of the mantles are turned back to show yellow linings and the same yellow appears on the armour of certain soldiers. The details of the cuirass and skirt of the dismounted soldier on the left have been defined with a mixture of lead-tin yellow 'type II' (*giallorino*), ochre and yellow lake over a paler base colour of lead-tin yellow and lead white (Plate 132).

Fig. 106 X-radiograph. Detail of the *pastiglia* on the predella

Fig. 107 Infra-red photograph. Detail of St John the Evangelist

148

This has itself been modelled with the darker mixture so that in the sample illustrated the paler brushstroke overlies the darker yellow. Lead-tin yellow also occurs in the bright apple green of some of the costumes. They have been painted to achieve a slightly *cangiante* effect, similar to that on the altarpiece by Nardo di Cione (Cat. no. 6). In this instance the blue pigment in the mixture is azurite, whereas Nardo used ultramarine.

A darker, more turquoise green, also based on azurite, can be seen on some of the horsemen beneath the crosses. Similarly, the ultramarine and white mixtures tend to be rather deeper in tone and sometimes have a distinct greyish cast. A cross-section from the blue crupper of the chestnut horse to the left of the Cross (Plates 133 and 134) shows that the harness has been painted over the mixture of charcoal black, red and yellow iron oxides, with lead white, which constitutes the brown of the horse. The blue layer is unusually thick for a tempera painting and the harness has a slightly raised profile on the surface of the picture. The grey tinge can be attributed to the use of the poorer quality lapis lazuli now known as ultramarine ash. Although the sample does include one large particle of a dazzlingly intense blue, much of the pigment appears grey or even colourless.

The only truly saturated blue has, predictably, been reserved for the ultramarine mantle of the Virgin, both on the main panel and on the predella. The ultramarine is of high quality and seems to have been glazed over a grey undermodelling. As this underlayer contains some black pigment, the mantle registers in infra-red as unusually dark for an area painted with ultramarine. A similar technique has been used for the many representations of the Virgin in the San Pier Maggiore Altarpiece (Cat. no. 8). In both her appearances on the *Crucifixion* Altarpiece, her robe beneath is a brownish pink achieved by a now rather streaky and uneven application of red lake. Since the sample from her blue mantle coincides with a point where its edge overlaps the pink robe, a layer of this pink forms the lowest layer of the paint structure. The same colour appears on the tunic and stockings of the soldier on the far right (Plate 140): a sample from this suggests

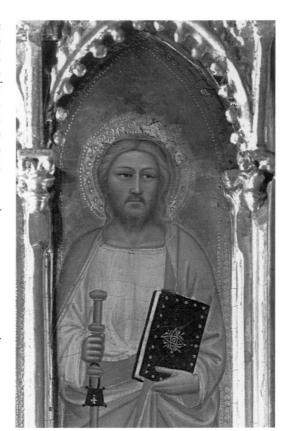

Fig. 108 Detail of St James showing the punched decoration around the top of the arch

Fig. 109 Detail showing the punch marks at the lower right edge of the central arch

that the lake has been applied directly over the gesso ground. The lake has been used with little or no white pigment: some fading may have occurred, thus accounting for its patchy appearance. Again, this distinctive use of translucent colours reappears on draperies in the San Pier Maggiore Altarpiece and with exactly the same consequences.

149

Changes to the pigment have also affected the areas painted with the bright red vermilion. Patches of brown-black discoloration can be seen almost everywhere that the pigment has been used, but they are most disturbing on the draperies of the Magdalen and the priest in the group to the right of St John the Evangelist (Plate 140). The blackening tends to be related to the hatched brushstrokes made in applying the paint. It may be that the final touches of colour, particularly those in the shadows of the folds, lacked sufficient medium to protect the vulnerable particles of red pigment.

The vermilion is slightly better preserved where it occurs in the floor coverings beneath the lateral saints. On the shadowed vertical planes of the steps it has been mixed with a little red lake and then patterned with ultramarine and gold. On the lighter horizontal planes it has been replaced by the orange pigment, red lead. Red lead is also found in the drapery of the Christ Child on the predella. The pigment is briefly mentioned by Cennino, but judging by the frequent occurrence of red lead in Nardo's work (Cat. no. 6) and on the San Pier Maggiore Altarpiece, this pigment was popular with Andrea di Cione, his family and his followers.

Nardo and Jacopo di Cione's works also have in common the employment of more black paint than is usual. Unless its use is demanded by the iconography, as in the habits of certain religious orders – and even then, Duccio, for example, sometimes preferred to use a dark brown (see Cat. no. 4) – large areas of solid black seldom feature on fourteenth-century paintings. In the *Crucifixion* there are suitably black devils, but also black horses and many touches of black on the saddles and boots and shoes. Even the hog at St Anthony Abbot's elbow has been painted with pure black pigment. It has been suggested that the hog is a later addition, but the crack which has opened up along the incised outline of the saint's arm runs through the black paint and has not been filled in by any later overpaint.

Other parts of the altarpiece now appear black or dark brown but were once gleaming silver. These include the helmets and chainmail of many of the soldiers (Plate 132), the tips of the lances, the sword and the knife carried as attributes by St

Plate 130 Detail showing the decoration of the vaulting beneath the canopy

Paul and St Bartholomew respectively, and the spikes on St Catherine's wheel. A sample from the armour (Plate 135) shows that the silver was applied not as silver leaf, but in a powdered form over a layer of lead white. The instructions given by Cennino for the grinding of gold leaf to make a paint were equally applicable for silver. Although the upper part of the cross-section is quite black through tarnishing, the metallic sparkle of silver can still be seen lower down in the sample. Its original effect must have been spectacular.

Another area of decorative gilding which has discoloured badly is the lining of the Virgin's mantle on the main panel (Plate 136). This too looks almost black but a circular pattern can just be made out. A sample revealed gold leaf followed by a layer of malachite (presumably connected with the circular motifs) and finally a thin layer of what appears to be verdigris or 'copper resinate'. This is completely discoloured to a blackish brown. The occurrence of the malachite is of interest as, apart from the San Pier Maggiore Altarpiece where it is also used over gold, it is the only identification of the pigment among the paintings examined here. The presumed 'copper resinate' is also interesting. Among Cennino's suggestions for different cloths of gold is one patterned with verdigris in an oil medium. A textile fitting this description has been identified on fifteenth-century panels by Sassetta in the National Gallery (nos. 4757, 4758 and 4763). The green lining of the Virgin's robe in the *Virgin and Child* by Ugolino in the Louvre (see p. 114) also features a green glaze, based on verdigris and again applied over gold leaf. In the latter case no analysis was carried out to establish the medium; nor was any analysis possible, given the very small area concerned, on the *Crucifixion* Altarpiece and, for different reasons,

Plate 131 Robe of St John the Evangelist: glaze of ultramarine over two layers of ultramarine with lead white. Traces of old restoration are present at the surface of the sample. Cross-section, 380×

Plate 132 Yellow-brown detailing on soldier's armour: lead-tin yellow, ochre and yellow lake, applied over the basic modelling which makes use of the same pigments in differing proportions. Cross-section, 150×

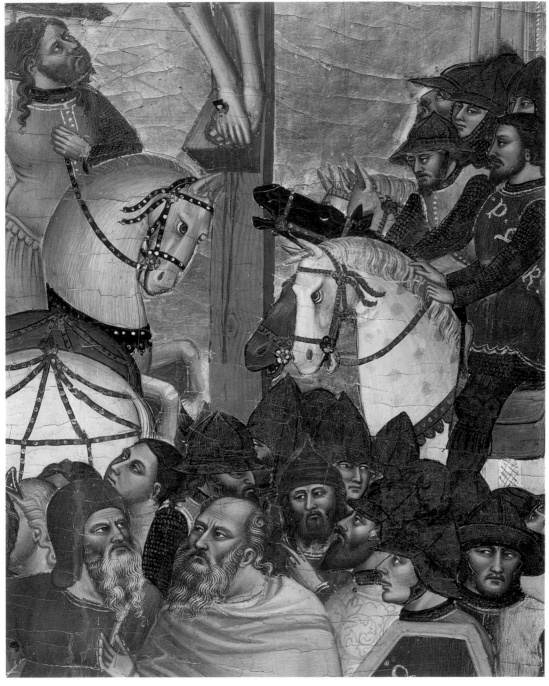

Plate 133 Detail showing the figures at the foot of the Bad Thief's cross

Plate 134 Cross-section of the harness of the chestnut horse to the left of the Cross, showing a thick layer of ultramarine ash applied over the brown paint of the horse. Magnification, 200×

Plate 135 Cross-section from the armour showing silver applied in powder form over a layer of lead white. The top surface of the silver has tarnished. Magnification, 380×

Plate 136 Discoloured copper-green glaze over gold leaf on the lining of the Virgin's robe. Top surface of an unmounted fragment, 130×

on the green glazes, now discoloured or obscured by overpaint, which occur on parts of the Crucifix attributed to the Master of St Francis (Cat. no. 1).

Yet more gold has been applied to the picture surface by mordant gilding. Some powdered 'shell gold' may have been used as well. The lattice pattern on Christ's loin-cloth (Plate 137) seems impossibly fine and delicate to be mordant gilding, and where it is rubbed and worn there is no trace of any mordant beneath. On the other hand, the worn sections of the parallel gold lines which decorate the edges

and hems of many of the draperies reveal faint greyish marks which probably represent the remains of this unpigmented mordant. The lines are not raised like those of the unpigmented oil mordant on the panel attributed to Giotto (Cat. no. 2), so they would appear to be an example of a quick-drying mordant like the garlic mordant described by Cennino (see p. 46). The letters SPQR on the red breastplate and shield in the lower right part of the composition were also gilded on to a mordant, although they have since been extensively retouched with gold paint.

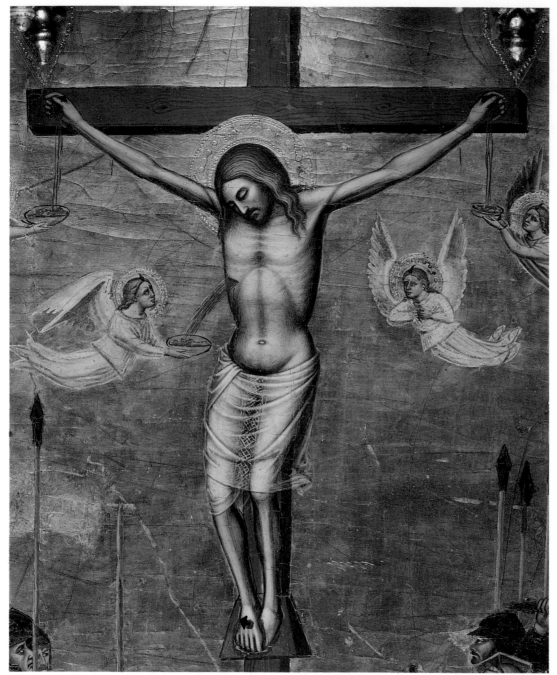

Plate 137 Detail of Christ on the Cross

They can be compared with the lettering above the Cross and on the Roman banners which has been scraped through the vermilion paint to reveal the burnished gold leaf beneath, a simple application of the technique of *sgraffito*.

The faces and hands of the many figures have been underpainted with green earth but in an unusual combination with other pigments. In a cross-section from the flesh of the Bad Thief on the right (Plate 138) the underlayer looks almost translucent and seems to include a little vegetable black, lead white and yellow ochre, but also a relatively high proportion of a yellow lake. Consequently in the few places on the surface of the picture where the underpaint is visible, it appears as a transparent golden brown, and not really green at all. The areas of flesh on the San Pier Maggiore Altarpiece (Cat. no. 8) have been similarly underpainted. As the Bad Thief is still alive, his pink flesh consists of a mixture of lead white and vermilion modelled in the shadows with a mixture of black, lead white and red and yellow earth pigments. To distinguish the figures of Christ and the Good Thief the vermilion has been omitted because, as Cennino points out, 'a dead person has no colour'.

Plate 138 The Bad Thief's arm: over the green earth, modified with a little black and yellow pigment, is a thin layer of *verdaccio*, and then a pink highlight consisting of lead white and vermilion. At the left end of the sample some gold leaf from the background can be seen. Cross-section, 325×

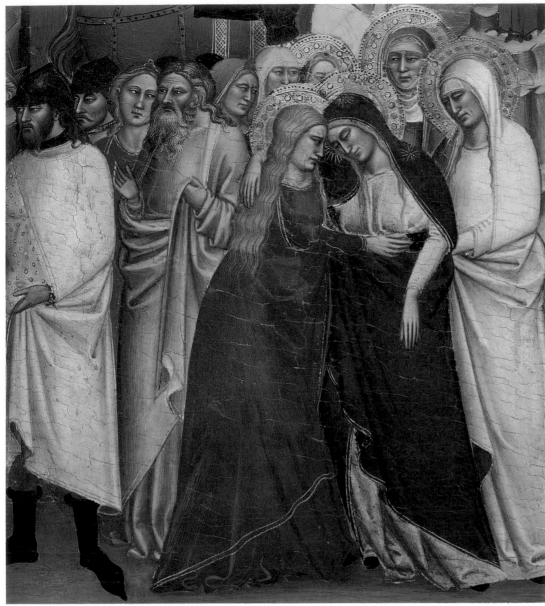

The division of labour

There is another division which can be made between the areas of flesh painting on this altarpiece. Differences in the handling and application of the tempera suggest that two separate painters were involved. The first hand seems to have been responsible for the group of mourners under the Cross (including the figure with the vinegar-soaked sponge), all three crucified figures, the full-length saints and the half-length figures in the roundels on the predella. On these faces an attempt has been made to differentiate between expressions: for example the serenity of Christ, the agony of the Bad Thief, the grief of the Virgin and St John the Evangelist, the concern of the Magdalen and the puzzlement of the man with the sponge (Plates 139 and 140). The brushwork is unfocused and soft. Although there is some minor damage, particularly in the central group, this softness cannot be attributed to a difference in condition. The hair of the bare-headed figures has been painted with relatively broad brushstrokes and tends to hang in loose undulating waves (Fig. 110). The hands have long elegant fingers, but they are not articulated at the joints and knuckles so they appear quite boneless. As all these features reappear on the small-scale figures in the narrative panels of the San Pier Maggiore Altarpiece, it is reasonable to identify this painter as Jacopo di Cione.

The second painter, who was responsible for most, if not all, of the remaining faces, is characterised by a much crisper,

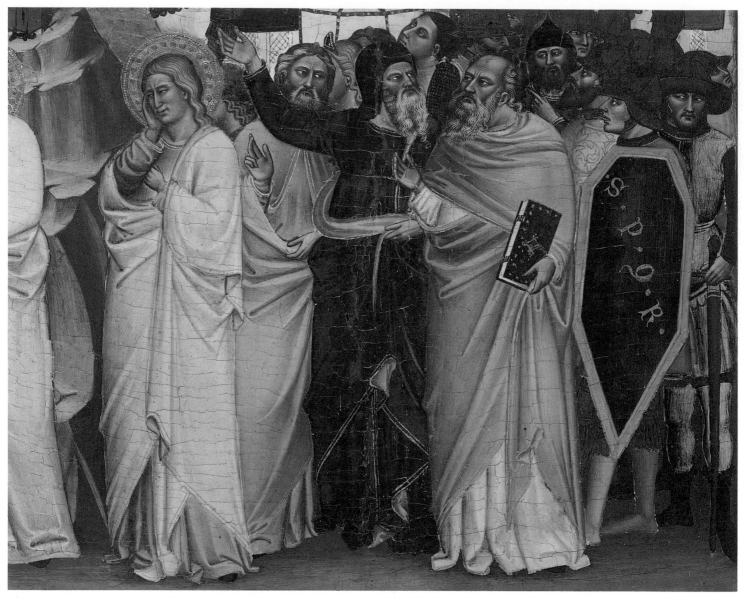

almost enamel-like application of the paint. The strokes seem to have been made with an exceptionally fine pointed brush and the paint built up to a greater density so that the greenish underlayer is almost completely obscured. Although some of the faces are beautifully painted, especially those in profile, they tend to have more generalised expressions. The hands are realistically articulated: the difference is very apparent when the hands of the two priests to the right of St John the Evangelist are compared with those of the central mourners. The hair and beards are rendered with great precision, often with tight curls and ringlets. A particular quirk is the representation of the bushy eyebrows of the old men by a series of short vertical strokes of white paint (Fig. 111).

The presence of these two distinctive styles on the *Crucifixion* Altarpiece has been noted before, while the participation of yet another member of the workshop in some of the minor details, for example the angels, has also been suggested. Previous attempts to distinguish between the different hands have hitherto assigned complete figures to one painter or the other. However, this does not necessarily accord with the processes entailed in the production of a tempera painting. The making of the paint was an extremely laborious procedure, involving both the grinding of the colours and then the pre-mixing of the range of tones to be used in the modelling. In terms of workshop practice it made more sense to divide the execution of the drapery painting by colour. Once a painter had prepared a sufficient quantity of a particular pigment mixture – which would

not keep once combined with the egg – he would then have proceeded to paint all the draperies which were to be that colour.

On this basis it is possible to attribute most of the drapery painting to the hand identified as Jacopo di Cione. The folds are softly modelled, often with quite thin and transparent paint. In many areas the reflective properties of the white gesso ground have been retained, although this is an effect which may be exaggerated by an increase in the transparency of the paint with age. Conversely, the paint of the horses and riders at the foot of the Cross has generally been applied more thickly, so that it is relatively opaque and rather deeper in tone. The fine hatching and crisp detail are particularly evident on the horses (Plate 133) and can be compared with that on the heads assigned to the second hand. Of the colours in the foreground, only the vermilion draperies emerge as being noticeably different from those around them. Inevitably they are solid and opaque, due to the nature of the pigment, but there are other indications that the application of the red paint was deputed to the second painter. The precise, hatched strokes of the modelling have been conveniently emphasised by the blackening of the vermilion with time, as has the schematic depiction of the crumpled folds of the sleeve of the priest to the right of the Evangelist. This painting of the highlights as a chain of contiguous ovals seems to be another of this painter's idiosyncrasies. Furthermore, the man who applied the final touches of mordant gilding to the red draperies of this figure and the Magdalen is unlikely to be the same man who had previously painted them. In both cases the diagonal sweep of the lines of gold intended to mark the hems of the mantles totally contradicts the construction of the folds as they have been painted.

If, as has been postulated, two distinct painters were employed on the *Crucifixion*, a problem arises as to which of the two was responsible for the design of the work. Undoubtedly the painter here identified as Jacopo di Cione was the principal master in the project, since he has painted the most important areas, including all the leading figures in the drama. The supporting cast has been left to the second painter. The small amount of detectable underdrawing does not supply many clues, but it is uniform in style and not unlike that on the San Pier Maggiore Altarpiece (Cat. no. 8). The exact nature of Jacopo di Cione's well-documented collaboration with other painters and the question of whether he was necessarily responsible for the design and drawing of the works he painted are discussed further on pages 185–9.

As for the second painter, he seems such a marked and individual artistic personality that it ought to be possible to identify further works by his hand. Some of his mannerisms (including the peculiar eyebrows) appear on the prophet in the left-hand spandrel of the Zecca *Coronation* (that on the right is too damaged for any attribution) (Plate 170). He might therefore be the painter Simone, mentioned in the documents for that altarpiece (see p. 185). In that case he would appear to have worked on the *Crucifixion* not as a talented workshop assistant or journeyman painter, but rather as an independent collaborator and probably a master in his own right.

Fig. 110 Detail of St John the Evangelist

Fig. 111 Detail of the old man on the right

JACOPO DI CIONE

8. The San Pier Maggiore Altarpiece

This altarpiece was among the largest to have been painted in Florence in the second half of the fourteenth century. It was almost as big as Duccio's *Maestà* (Cat. no. 3). The twelve panels (Fig. 112) which make up the greater part of the altarpiece are all in the National Gallery. The main tier shows the *Coronation of the Virgin, with Adoring Saints*, most of whom can be identified by their attributes (see Fig. 114) The second tier consists of six scenes from the Life of Christ: the *Nativity, with the Annunciation to the Shepherds and the Adoration of the Shepherds,* the *Adoration of the Magi,* the *Resurrection,* the *Maries at the Sepulchre,* the *Ascension,* and the *Pentecost.* Above these were three pinnacle panels: in the centre the *Trinity* and on either side *Seraphim, Cherubim* and *Adoring Angels.* The theme of the central panel with the *Coronation of the Virgin* was an extremely common one in Florence. A large number of altarpieces stem from the altarpiece of that subject, which was signed by Giotto, but possibly executed by his workshop, made for the chapel of the Baroncelli family in Santa Croce. Cat. no. 8 was painted in 1370–1 for the church of San Pier Maggiore in Florence: a model of the actual church, which was destroyed in the eighteenth century, is held by St Peter (recent cleaning has revealed the crossed keys of St Peter in gold over the entrance; Plate 141). The predella, which is now dispersed in other collections, also gave prominence to St Peter. It consisted of six paired scenes devoted to a Petrine cycle.

The altarpiece was probably commissioned by the Albizzi family, who dominated the patronagè of the church of San Pier Maggiore (Fig. 113). The family made a payment of twenty-five gold florins to the church in 1383 for 'aiuto alla tavola dell'altare maggiore', which was probably a final contribution, completing payments for the high altarpiece.

The altarpiece was begun in 1370. That year there is a record of a payment to a 'Niccolaio dipintore', almost certainly Niccolò di Pietro Gerini (see below), for designing the altarpiece ('per disegnare la tavola dell'altare di San Piero'). In 1371 a *colmo* (main tier panel) was removed from the house of Matteo di Pacino; also in 1371 there are payments for various materials and for transporting the altarpiece and predella to Santa Maria Nuova for varnishing, and payments to a certain Tuccio for colours, eggs, silver, and so on (see Appendix III).

Technical Description

Reconstruction of the altarpiece

The twelve panels have been cut and altered in shape more than once in the five hundred or so years between being set up on the high altar of the church of San Pier Maggiore and their arrival at the National Gallery in 1857. Two reconstructions of the altarpiece made by Gronau and Offner respectively have been published. The second successfully identifies all but one of the panels from the fragmented predella (see above) and also proposes some possible candidates for the decoration of the side pilasters. While there can be little disagreement over the correct order of the panels, the two reconstructions diverge over the details of the architecture of the altarpiece and the precise relationships of the panels to one another. Since neither reconstruction was based on technical examination of the panels, depending instead on the iconography and on comparisons with less mutilated contemporary altarpieces, it is now possible to present new evidence which should result in a better understanding of the original appearance of the work.

Main tier

The three large panels showing the *Coronation of the Virgin, with Adoring Saints* (Plate 142) are now framed as though they belonged to a single-tiered altarpiece (Fig. 114), the inspiration for the frame being

Fig. 112 A photomontage reconstruction by Jill Dunkerton of the San Pier Maggiore Altarpiece based on evidence obtained from the examination of the twelve panels in the National Gallery. Main tier: *The Coronation of the Virgin, with Adoring Saints*; Second tier: *The Nativity, The Adoration of the Magi, The Resurrection, The Maries at the Sepulchre, The Ascension,* and *The Pentecost*; Pinnacles: *The Trinity* with on either side *Seraphim, Cherubim* and *Adoring Angels*; Predella panels: from left to right, missing, but probably *The Calling of St Peter, The Taking of St Peter* (Providence, Rhode Island School of Design, Museum of Art), *St Peter in Prison and The Liberation of St Peter* (Philadelphia, Johnson Collection), *St Peter raising the Son of Theophilus* and *The Chairing of St Peter at Antioch* (both Rome, Pinacoteca Vaticana), *The Last Meeting of Sts Peter and Paul in Rome* (only a fragment, formerly Lugano-Castagnola, Schloss Rohoncz Collection), *The Crucifixion of St Peter* (Rome, Pinacoteca Vaticana), and at the base of the pilaster, *The Beheading of St Paul* (Milan, Galleria Edmondo Sacerdoti). Most of the suggested framing elements are derived from the Impruneta Altarpiece (see Fig. 121) and other contemporary works

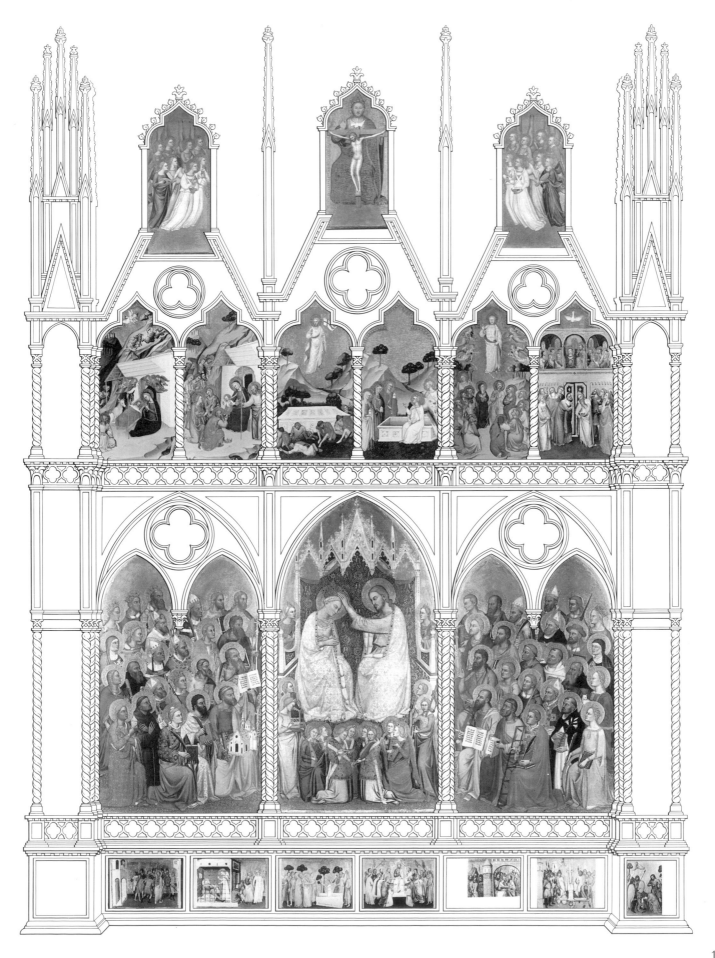

157

that on the Strozzi Altarpiece by Andrea di Cione (see p. 128 and Plate 114). This reframing, which took place in the mid-nineteenth century when the panels were still in the Lombardi–Baldi collection, resulted in a complete reshaping of the tops of the panels to a trapezium-shaped outline. The edges are suspiciously clean and the cuts often run across and along wood-worm channels, but the most valuable evidence for the original shape is found on the exposed wood at the top of the main right-hand panel (Fig. 115). Incised into the wood are faint lines marking the positions of the framing elements which were to be pinned to the front of the panel and gessoed and gilded with the rest of the picture surface. The incisions indicate that not only were mouldings applied to the present double arch, but that a wide single arch (of the same proportions as that on the centre panel) sprang from the left and right edges of the main side panels, meeting at a point just above the section which has been cut away. In the space enclosed by the arch was a roundel, which in turn contained a large quatrefoil. The quatrefoil may well have been painted, probably with a half-length prophet, saint or angel. Curiously, the design is very close to that proposed in the reconstruction of the altarpiece by Gronau, apparently made without the benefit of an examination of the panels.

No incised lines appear on the centre and left-hand panels. This could be because the wood has been scraped and planed to remove the gesso and gilding, and perhaps *pastiglia*, left on their surfaces when the carved mouldings were removed prior to the reframing of the altarpiece. However, the application of the mouldings directly on to the surface of the panels would be most unusual. More often the mouldings were attached to a thin piece of wood shaped to form the arches and nailed to the surface of the panel as in, for example, the fragments from the altarpiece by Ugolino (Cat. no. 5). These shaped spandrels could have been omitted from the San Pier Maggiore Altarpiece, perhaps in an attempt to reduce the weight of the panels, but it is more likely that the incisions at the top of the right panel represent a trial placing of the mouldings by the designer and the carpenter and that they were later covered by the spandrels.

At the base of each panel is an un-

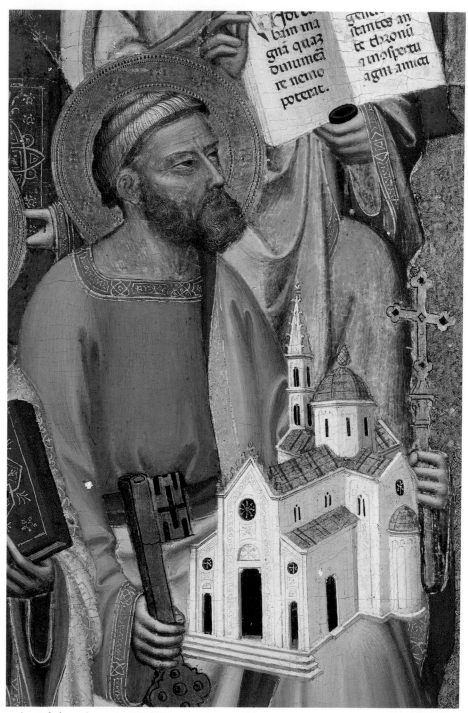

painted border about 2.3 cm deep. This suggests that the bottom edges have only been slightly cut, if at all. The left and right edges of each panel have definitely been trimmed. Saw marks are visible on the relatively clean and newly cut wood, and the gesso and gilding extend to the very edges of the two side panels. In the case of the centre panel, thin slivers of new wood have been glued to either side, so these are covered with non-original ground and paint. On all three panels the edge of the original gesso follows the outline of the

Plate 141 Detail of St Peter from the left panel of the main tier, after cleaning, before restoration

bases and capitals of the columns which would once have partitioned the composition. Although the bases and capitals may have been attached to the panels before the application of the gesso, the columns, probably of the barley-sugar twisted type, can have been put in place only when the painting and gilding were complete. The accounts associated with the installation of the altarpiece specifically list nails for the fixing of 'the columns and foliate ornaments' (literally 'leaves': *colonelli e folgle* [sic]). Using the outline of the original gesso as an indicator, it is possible to estimate how much of each base and capital is missing and consequently by how much the panels are likely to have been cut. Since Gothic bases and capitals are usually quite slender, it can be assumed that the sides have been trimmed by no more than 1.5 cm on each side, and probably by rather less in the case of the centre panel.

On turning to the backs of the main panels (Fig. 117), more evidence as to their construction becomes apparent. Each panel appears to be composed essentially of two wide planks of poplar, not quite as wide as that which constitutes two-thirds of the width of the altarpiece by Nardo di Cione (Cat. no. 6), but still of considerable width. The joins, which run approximately down the centres of the panels, have remained secure and very well glued, so that they are difficult to detect on the panels themselves. However, in X-radiographs they are easily distinguished because the adhesive produces an unusually dense X-ray image (Fig. 118). Inevitably, planks of this width are not without flaws. There are many areas of rough and knotty grain, and at the bottom right corner of the centre panel there is a weakness in the wood which has been reinforced with small wooden butterflies, which have been chiselled and gouged together with the rest of the panel and must therefore be original. Most butterfly keys seen on Italian panels (including the larger ones on this panel and those on some of the other panels from the altarpiece) are later restorers' additions, but original ones are occasionally found; judging from the cracking and damage along the joins in the Zecca *Coronation* (Plate 170), reinforcing butterflies were used by the carpenter of that panel. Despite the great width of the planks used for the

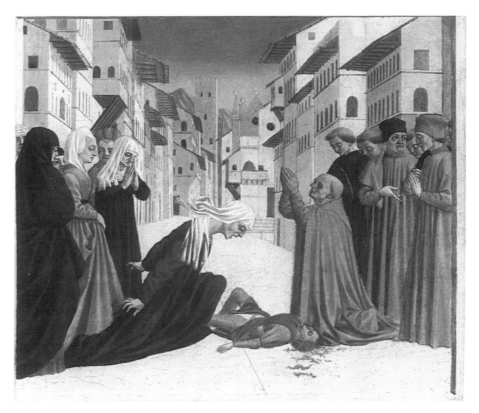

tier of the San Pier Maggiore Altarpiece it was still sometimes necessary to enlarge them slightly by adding narrow strips of wood. These strips have, of course, been reduced in width by the trimming of the panels. This use of wide planks extended only where the joins were to be masked by the frame demonstrates a concern – also noted on Nardo's altarpiece – to avoid as far as possible the danger of splits occurring beneath important parts of the design.

In fact, these may not have been the only joins covered by the columns of the frame as there are indications that the panels were not treated as three separate units, but that they could have been glued together to form a single enormous panel. Across the centre and right panels (on the left when seen from behind) are runs and dribbles of adhesive which appear to have been squeezed out of the joins as the planks were glued, tipped up on end so that the weight of each plank could be exploited to ensure a strong and tight join (Fig. 117). Analysis of scrapings of the glue identified an animal skin glue rather than casein, but the proteins were relatively denatured, indicating that the glue was of some considerable age. In addition, a little lead white and a mercury compound appear to have been added to the glue, presumably as fillers to give it more bulk. This makes the

Fig. 113 Domenico Veneziano: *A Miracle of St Zenobius*. 1445. Cambridge, Fitzwilliam Museum. The miracle, in which St Zenobius raised a young boy from the dead, took place in Borgo degli Albizzi which leads to the church of San Pier Maggiore. Domenico Veneziano's representation of the church shows some features in common with that on the National Gallery altarpiece

dribbles of adhesive clearly visible in the X-radiographs (Fig. 118) and suggests the possibility that the glue which produces such an opaque X-ray image in the joins might be of the same composition. The fact that these glue dribbles have survived, whereas the other joins have tool marks across them, showing that the wood was reworked after they were glued, suggests that, if the glue is indeed original, the panels are more likely to have been painted separately and then assembled as the documents suggest (see Appendix III). Often when the main tier of an altarpiece is divided into three compartments the panels remain detached, held together only by linked battens at the back and the open joins disguised by the framing columns. However, because of the massive structure to be raised above the main tier of the San Pier Maggiore Altarpiece, it would have made sense for the panel to be a solid, continuous construction. Although its dimensions must have been approximately 210 cm by 348 cm, its size is not unprecedented: the single panel constructed of several planks for Orcagna's Strozzi Altarpiece, where the figures are united in a continuous space without any dividing columns, is very nearly as wide.

Surprisingly, given its size, the main tier of the San Pier Maggiore Altarpiece was reinforced by only a single horizontal batten, its position now marked by a band of cleaner, lighter wood. X-radiographs show that as with the Santa Croce Altarpiece by Ugolino (Cat. no. 5) the heads of the nails are missing – the slight thickening at the wider end of some of the nail remnants is probably due to bending and compression of the metal during later attempts to chisel them out. Therefore the batten may not have been attached until the setting up of the altarpiece. Often the points of the nails were hammered in dangerously near to the picture surface, resulting in some disruption of the gesso ground.

Second tier

The six panels showing scenes from the Life of Christ which make up the second tier have been altered to an even greater extent than the main tier. They now appear as individual panels, their tops shaped as simple pointed arches (Fig. 119, Plates 143 to 148). Although they look as though they are gessoed right up to the edges, some of this is later restoration. The outline of the original gesso and gilding with its tooled pattern indicates that the area enclosed by the framing elements was topped by a more complicated inflected arch. The top 5–6 cm of gesso and gilding is not actually original; in the past, for reasons to be discussed below, the tops of the panels were cut and reshaped to give them some form of rounded arch. They were restored to what is almost certainly their correct shape only in the nineteenth century. The replacement timber has been glued to the panels using stepped or half-lap joins, so more new wood (stained to disguise the repair) appears at the back of the panels than at the front.

The marks left by the removal of the battens from the panels show that they were arranged in a long horizontal row. This would confirm, even if there were no clues like the incisions for the frame mouldings, that the three compartments of the principal tier were of equal height and the whole tier was rectangular in shape. Some of the nails are still embedded in the wood but those from the lower batten have mostly been pulled out, often causing considerable damage to the paint and ground above. On the front faces of the panels small plates of wood have had to be inserted at the points most damaged by the removal of the nails. The absence of heads on the surviving nails means that, as before, the battens were probably attached only at the time of the erection of the altarpiece. On each panel, placed either to the right or to the left, is a square of clean wood perpendicular to the lower batten mark. Extra reinforcing blocks could have been used, the other halves secured to the back of the main tier, although here no corresponding marks are present owing to the cutting of the tops of the main tier panels. Alternatively, such a tall and heavy altarpiece might have needed bracing by struts running diagonally down to the floor behind the altar. If supported only by a framework of cross-battens and side buttresses, a construction of this size could have lacked stability. The accounts for the altarpiece include payments to a stone-mason or paver (*lastraiuolo*) 'for one of his workmen who helped us make holes', presumably in the floor. These may just have been for the side buttresses, but

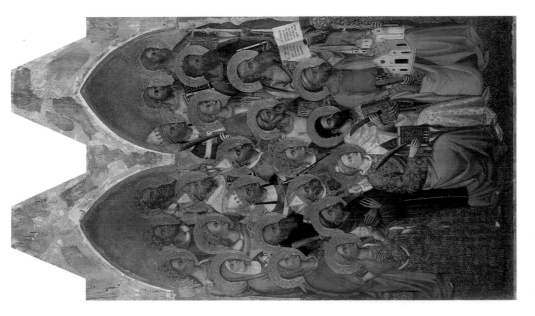

Plate 142 *The Coronation of the Virgin, with Adoring Saints.* Left panel 200 × 113 cm, painted surface 169 × 113 cm. Centre panel 209 × 113·5 cm, painted surface 206·5 × 113·5 cm. Right panel 119 × 113 cm, painted surface 169 × 113 cm. All three are shown before cleaning, although the panel on the left (with a cleaning test) has since been cleaned

161

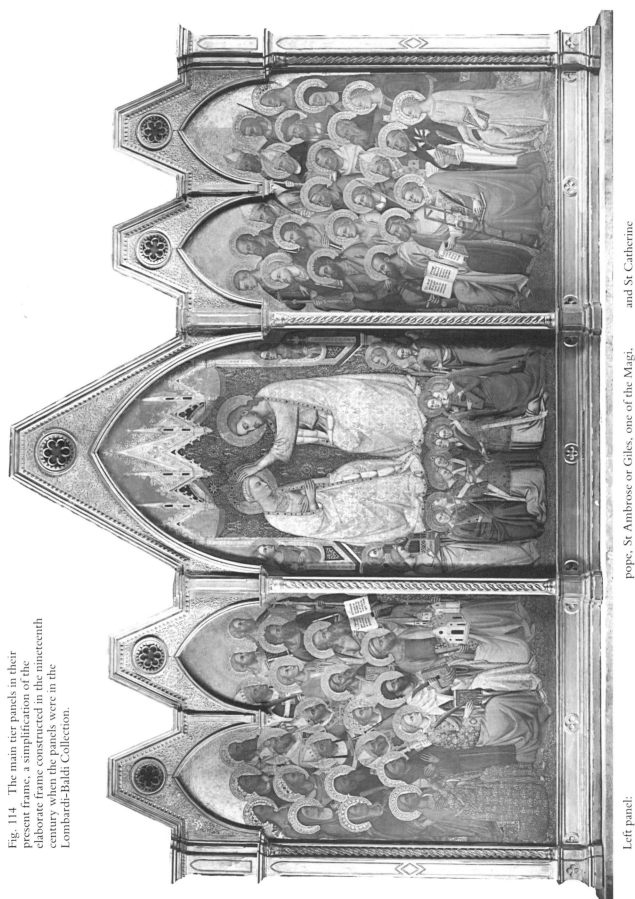

Fig. 114 The main tier panels in their present frame, a simplification of the elaborate frame constructed in the nineteenth century when the panels were in the Lombardi-Baldi Collection.

Left panel:
Front row, from right to left: St Peter, St Bartholomew, St Stephen
Second row: St John the Evangelist, St Philip(?), St Miniato(?), St Zenobius, St Francis and St Mary Magdalene
Third Row: St Andrew, a youthful saint, St Blaise, St Gregory, St Benedict and St Lucy
Fourth row: an apostle, St Luke(?), a martyr

pope, St Ambrose or Giles, one of the Magi, Caspar(?) and St Clare
Back row: Melchior(?), Balthasar(?) and St Reparata(?)

Right panel:
Front row, from left to right: St Paul, St Matthew, St Lawrence
Second row: St John the Baptist, a youthful saint, St Julian(?), St Nicholas, St Dominic

and St Catherine
Third Row: St James the Greater, an apostle, St John Gualberto(?), St Bernard(?), St Anthony Abbot and St Agnes
Fourth row: an apostle, St Mark(?), a holy martyr pope, St Augustine(?), St Jerome and St Scholastica
Back row: St Ambrose(?), a young saint with a sword (Julian?) and St Ursula

162

additional bracing could also have been involved.

The fact that the battens ran across the backs of all six panels suggests that, partly for reasons of structural strength, they too were joined to form a unified horizontal structure. This supposition is confirmed by an examination of the planks, their grain and the positions of the joins. The two outer panels (see Fig. 112) are single planks of poplar with a vertical grain, but the remaining panels are each composed of a main plank plus an additional slice of wood. In every case the grain and texture of the extra piece are the same as that belonging to the adjoining scene in the series. The only panels which could not be linked in this way are the *Adoration of the Magi* and the *Resurrection*, either because they shared a single, wider plank or more probably because the division coincided with the join between them. However, here, and indeed on all six panels, the marks from the wood-working tools cross from panel to panel, so they must once have been joined to form one large panel. Yet again, it can be seen that the panel was constructed to ensure that the joins did not fall beneath the important areas of the design. The splits which have developed in two of the panels (the *Maries at the Sepulchre* and the *Pentecost*) are probably the result of the restriction of the wood by the fixed cross-battens.

The sum of the widths of the six panels in their present state adds up to only 294 cm, whereas that of the main tier, allowing for the loss of a few centimetres in the cutting, was about 348 cm. The difference has to be accounted for by estimating the likely widths of the framing elements used to divide the panel of the second tier into its six scenes. The first clue is provided by the backs of the two central panels. On each panel is one half of a large circle incised into the timber (Fig. 120). The possible significance of this circle is discussed below, but for the present it serves a useful function: if the two panels are brought together to the point where the circle is complete and perfectly round, the gap between them is no more than one centimetre. When they are seen from the front with this spacing (Plates 143 to 148), it immediately becomes apparent that the foreground and mountain landscapes of the *Resurrection* and the *Maries at the*

Fig. 115 Detail of the top of the right-hand panel

Sepulchre run continuously across the two scenes, even though they represent consecutive episodes taking place in the same setting. Indeed, some of the plants in the foreground have been bisected so that half appear on one panel and half on the other. For the two scenes to have been painted in this way only the capital and base of the dividing column could have been attached to the panel at the time. The column itself – and there is space only for a single column – must have been pinned in place at a later stage.

When the first two panels, the *Nativity* and the *Adoration of the Magi*, are separated by the same distance, a similar, although less obvious, continuity can be observed. Here, again despite the setting being repeated, the rock formation in the lower right corner of the *Nativity* continues across into the left side of the *Adoration of the Magi*. Inevitably, the attempt to unify each pair of scenes breaks down with the *Ascension* and the *Pentecost* because their iconography demands very different settings.

The close single-column spacing between these three pairs of scenes means that for the widths of the two tiers to tally, the pairs of scenes must have been separated from one another by a much wider space, and very probably with double or even triple twisted columns like those on the large altarpiece in the Collegiata at Impruneta (Fig. 121) which is thought to

reflect the original design of the San Pier Maggiore Altarpiece. In a sense this articulation of the panel by alternate multiple and single columns has its origins in the subdivisions which occur in the upper tiers of vertically constructed altarpieces such as Ugolino's Santa Croce Altarpiece (Cat. no. 5) or, as a less-mutilated example, Taddeo Gaddi's Pistoia Polyptych (Fig. 12). In both instances the pairs of saints on each panel are separated from one another by single columns, but when two pairs are placed side by side inevitably a doubling of the columns occurs. While the San Pier Maggiore Altarpiece has been constructed on a horizontal format, the arrangement of the columns still works logically with both the division of the main panel into three sections and with the crowning of each pair of scenes by one of the three pinnacle panels.

Pinnacle panels

The pinnacle panels (Plate 149) have been altered in much the same fashion as those of the second tier. Originally they are likely to have had either steep gabled tops, or decorated ogival arches as shown in the reconstruction, but they too have been first cut down and then reconstructed as pointed arches. The central panel also has some new wood at the bottom. Its gesso and gilding appear to have been so damaged by the repeated alterations that they were completely replaced during the nineteenth-century restoration. The tooled decoration around the edges imitates that on the better-preserved panels of angels. Here the tooling shows that the arches enclosed by the framing elements were almost certainly of the same shape as those on the second tier. The pattern continues down the sides but towards the bottom it turns inwards, forming a triangular indentation. There is no pattern along the bottom edges, which suggests that they have been trimmed. To accommodate the side frame mouldings the panels must have once been wider; if this extra width is allowed for and the sides are projected down to meet the diagonal lines of tooled decoration, some idea is obtained of the amount likely to have been cut from the bottom of the panels.

The triangular indentations must mark the angle of the moulding which would have been applied to the sloping edges of

Fig. 116 Detail of the edge of the left-hand panel, after cleaning and before restoration, showing the nineteenth-century gilding over the area once covered by the capital of the dividing column and therefore not originally gilded

the framing elements belonging to the second tier. The steep angle implies that this part of the frame extended well above the painted scenes, so it would probably have been decorated with roundels containing quatrefoils, or perhaps trefoils, and *pastiglia*, and the pinnacle panels set into it with their bases resting on the tier below. The upwardly inclined heads of the angels suggest that the *Trinity* panel was set slightly higher. Small patches of clean wood on the inner edges of the arches of each pair of second tier panels (Fig. 119) could be from the corners of battens or blocks used to secure the pinnacle panels. Because they have been cut there are no corresponding marks on the pinnacles. Nor are there any vertical batten marks, so they cannot have been attached using a system sometimes seen on large Tuscan altarpieces whereby a vertical batten on the back of the pinnacle is slotted into a specially shaped wooden loop nailed to the top of the panel of the tier below.

Geometry and proportions of the altarpiece

The exact positioning of the various framing elements which mark the edges of the painted scenes in both the upper tiers would have been a complex operation. To assist in this, lines and arcs were scored

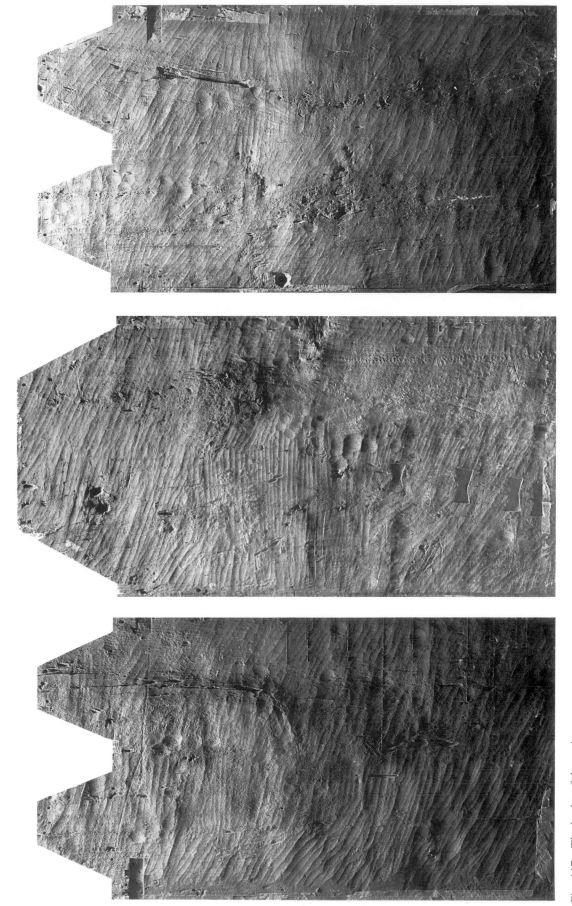

Fig. 117 The backs of the main
tier panels in raking light

into the timber in much the same way as the arches, roundels and quatrefoils on the right-hand compartment of the main panel. On one panel, the *Adoration of the Magi*, the nineteenth-century gesso around the edges of the arch was scraped away to reveal some of the lines incised in the wood (Fig. 122). On the other panels the lines can easily be detected in the X-radiographs (Fig. 123). Down the middle of each scene a vertical line has been scored, presumably to locate the central point of the arch. A faint line, probably made for the same purpose, can just be detected below the arch of one of the pairs of spandrel angels from Ugolino's Santa Croce Altarpiece (Cat. no. 5) and similar vertical divisions are visible on the bare wood exposed by

Fig. 118 X-radiograph detail from the right panel of the main tier. The area shown covers the heads of St John the Baptist (in the second row) and the two saints to the right of him. Towards the right end is the main join in the panel, at the left the runs of adhesive. In the centre is a particularly bad flaw in the timber

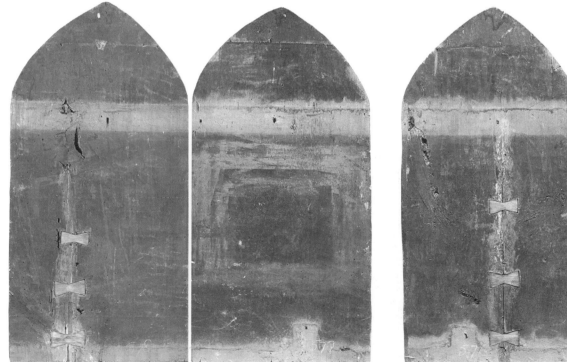

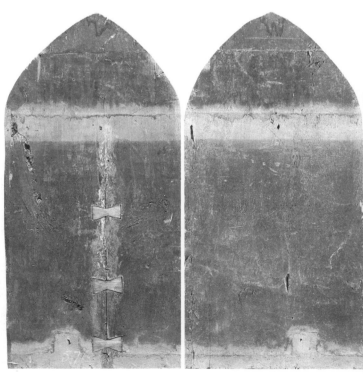

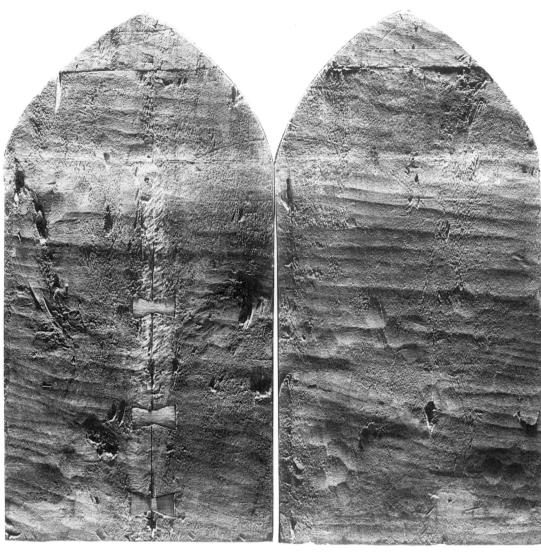

Fig. 120 The backs of *The Maries at the Sepulchre* and *The Resurrection* in raking light (photomontage)

Fig. 119 The backs of the six panels from the second tier of the altarpiece (photomontage). From left to right: *The Pentecost, The Ascension, The Maries at the Sepulchre, The Resurrection, The Adoration of the Magi* and *The Nativity*

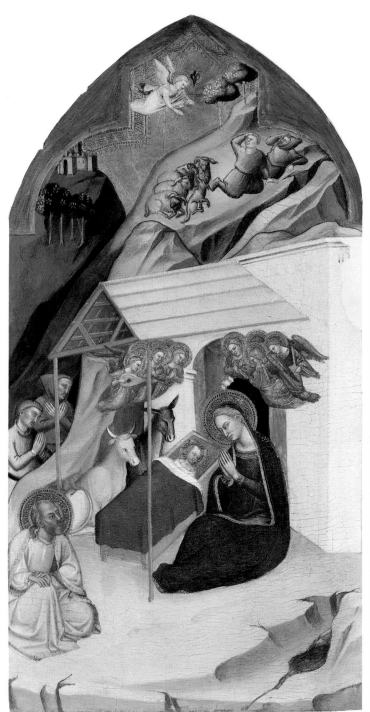
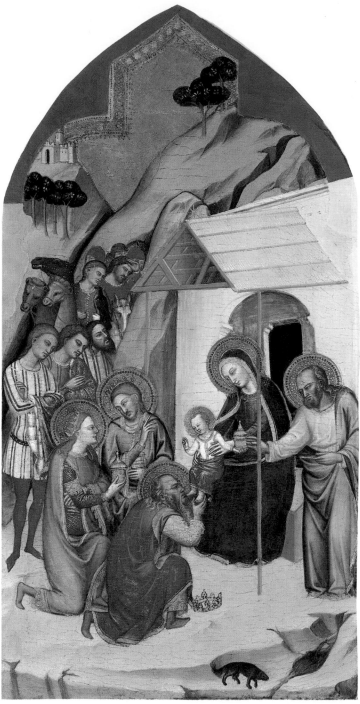

Plates 143 and 144 *The Nativity* and *The Adoration of the Magi.* After cleaning. Each 95 × 49 cm

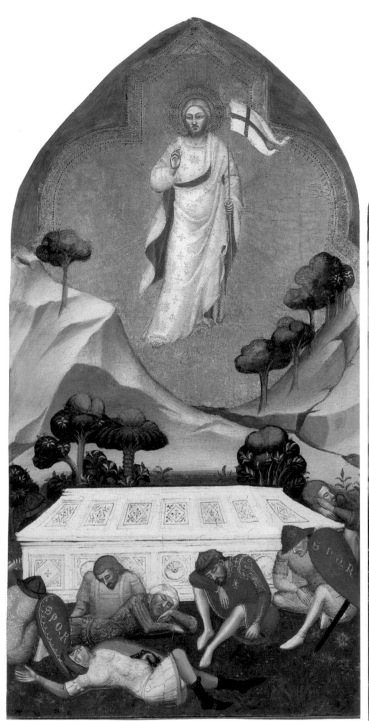
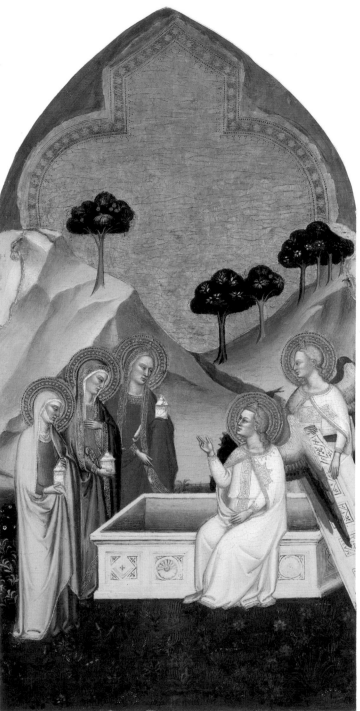

Plates 145 and 146 *The Resurrection* and *The Maries at the Sepulchre*. After cleaning. Each 95 × 49 cm

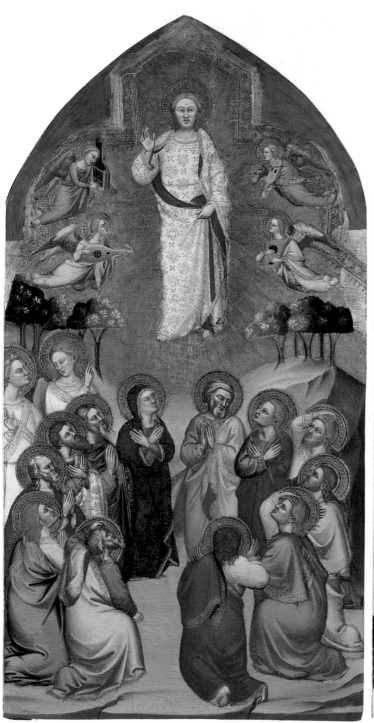

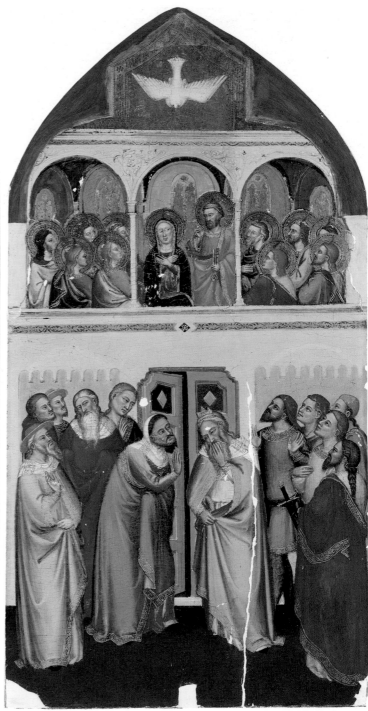

Plates 147 and 148
The Ascension and *The
Pentecost. The Ascension*
is shown after cleaning
and *The Pentecost* after
cleaning but before
restoration. Each
95 × 49 cm

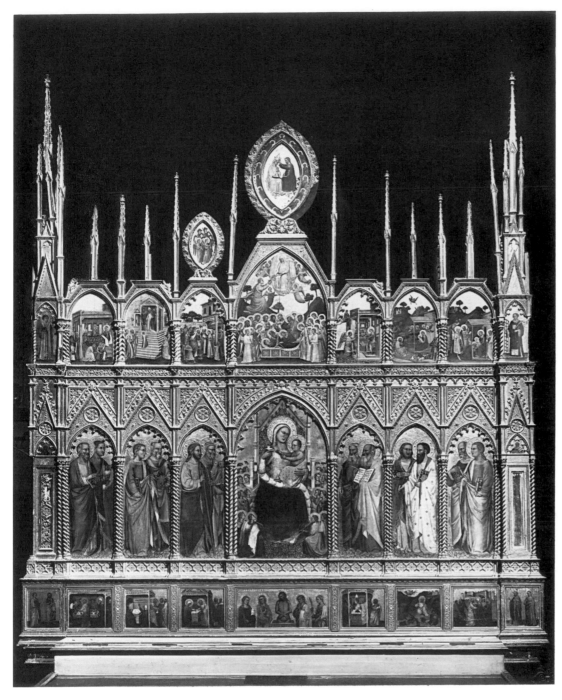

Fig. 121 Pietro Nelli and
Tommaso del Mazza(?): *The
Virgin and Child Enthroned with
Saints and Angels and Scenes from
the Lives of the Virgin and Joseph.*
1375. Impruneta, Collegiata di
Santa Maria

the removal of the frame of a polyptych attributed to him in the Pinacoteca, Siena.

The panels from the upper tiers of the San Pier Maggiore Altarpiece have also been marked out horizontally with two parallel lines at the bases of the arches. The lower line may be connected with the placing of the capitals of the columns, but the purpose of the upper line is quite clear: on every panel the holes made by the fixed point of the dividers when inscribing the arcs of the curved segments of the arches occur along this line. At the top of the arcs are diagonal incisions indicating the point at which the outline of the arch becomes vertical. These diagonal incisions also appear to fall along the radii of the two arcs forming the simple arches which nominally contain the more complex outlines of the actual arches (Fig. 124). In addition, on one panel, the *Maries at the Sepulchre*, there appear four concentric arcs with the compass point centred on the main vertical division. For the present at least, it is difficult to account for these and for the equally mysterious circle inscribed across the back of this panel and the adjoining *Resurrection*. They may just represent the

172

Plate 149 The three pinnacle panels: in the centre,
The Trinity, and on either side, *Seraphim, Cherubim
and Adoring Angels*. Before cleaning. Centre panel
87 × 40 cm, side panels 87 × 37·5 cm

carpenter experimenting with the size of the radii of the roundels, which were probably placed above each pair of second tier scenes, or they could be connected in some way with the working out of the design of the altarpiece.

In fact, to a considerable extent the working out of the design and dimensions of the complete altarpiece, including the predella fragments and the lost framing elements, can be reconstructed, partly by reference to other altarpieces of the period, but also by using a proportional system suggested by the dimensions of the surviving panels. If allowances are made for their trimmed edges, the widths of each of the three compartments of the main tier with their framing columns must have been approximately 116 cm. This dimension is almost exactly twice the standard Florentine unit of measurement, the *braccio da panno* (just over 58 cm). The arrangement of the predella panels – with the exception of the scene at the base of the left-hand pilaster, all have been identified – is dictated by the sequence of the narrative and by their dimensional relationship with the divisions of the main panel. The surviving panel from the base of the right-hand pilaster has been cut at the right edge, but its width was evidently half that of the main predella panels, setting the width of the side pilasters at ½ *braccio* and giving a total width for the altarpiece of 7 *braccia*.

However, the *braccio* does not work as the unit of measurement for the vertical dimensions. This can be found by estimating the height of the predella panels together with their frame mouldings as about 42 cm. Multiplied by five this equals the height of the main tier panel. The vertical division of the panel into five also coincides neatly with the dimensions of the single and double arches on the two side compartments (Fig. 125). The relationship between these two units of measurement is very nearly that of the two sides of the rectangle, in which the dimension of the longer side is equal to the diagonal of the square formed on the shorter side, that is a relationship of one to root two. This system of proportion (see also Cat. nos. 4 and 5) is thought to have been widely used by medieval masons and carpenters as the measurements could be calculated using little more than a set square, a pair of

Fig. 122 Detail of *The Adoration of the Magi* after cleaning, before restoration

dividers and a piece of string. By halving and quartering the basic rectangle it is possible to incorporate the panels of the upper tiers into the design system without contradicting any of the evidence obtained from examination of their structure. Even the diagonal marks in the angles of the shaped arches appear to fit the system. Although they are not very precisely angled, when projected they fall approximately along the diagonals of the rectangular grid.

The design system can also be used to work out suitable proportions for elements of the frame such as the bands of decoration which would have separated the principal tier from the upper tiers and from the predella. The subdivisions of the side pilasters are likely to have echoed those of the central part of the altarpiece and they almost certainly contained painted figures of saints. These have probably not survived. For reasons to be given below, they cannot be identified with a group of appropriately shaped panels proposed in an earlier reconstruction of the work. Judging from other surviving altarpieces, the spires and finials of the pilasters would have risen to a considerable height, perhaps as high as the tops of the pinnacle panels. Therefore it is possible to arrive at

an approximate height and width for the whole construction of 550 cm by 410 cm, making it one of the largest and most ambitious altarpieces of the second half of the fourteenth century.

Dismemberment of the altarpiece

The great height of the altarpiece suggests a credible reason and a possible date for the first cutting and reshaping of the two upper tiers of panels. Rather than being removed from the high altar of San Pier Maggiore in *c*. 1450–60 to make way for a ciborium by Desiderio da Settignano as had previously been thought, it appears not to have been moved until it was transferred to the della Rena family chapel, probably in 1611–15. In 1667 it was recorded as being in a chapel in the right transept of the church, under the nuns' choir: it may simply have been too tall for its new position. By cutting out or replacing sections of the frame and by reshaping the tops of the panels of the upper tiers to rounded arches, or perhaps squat trefoil arches, a considerable reduction could have been made. In addition, the second tier scenes may have been divided at this date to fit into a more convenient system of polyptych construction whereby individual panels are inserted into a ready-assembled, self-supporting frame, as opposed to the earlier method of building most of the frame on to the panels so that they are themselves the main means of support for the altarpiece. If this were the case, then the horizontal battens must have been sawn through and retained on the backs of the panels: the marks left by their removal are too clean for them to have been removed at this early date. Although the framing of the altarpiece is not remarked upon by early commentators, its overall appearance would have been distinctly odd, especially as the lower sections may have escaped alteration until their radical reframing in the nineteenth century.

Cleaning and restoration

When the panels of the dismembered altarpiece were acquired by the National Gallery they were reported as having been 'repaired while in the possession of Signori Lombardi and Baldi before 1857'. As well as the various alterations to the panels these 'repairs' are likely to have included some

Fig. 123 X-radiograph of *The Maries at the Sepulchre*

174

restoration of lost and damaged paint. The paintings may also have been cleaned. A light surface cleaning was recorded in 1887, but as the panels were also described as having been revarnished and no modern varnish is now present, it is possible that this treatment was entered mistakenly. Certainly the panels received no further treatment (except for the securing of a few minor blisters and a 'polishing' of the surface with a wax paste) until the project to clean and restore the complete altarpiece was begun in 1985.

To date, all six panels of the second tier and the left-hand section of the main tier have been cleaned. In general this has involved the removal of a great deal of greyish-yellow surface dirt together with most of the discoloured old restoration (Plate 150). The damaged areas have then been retouched using pigments in a stable and easily reversible synthetic resin and the paint surfaces protected by a thin application of varnish. By exhibiting the altarpiece in a partially cleaned state it is possible to demonstrate the extent to which the colours are obscured and distorted by the surface dirt. For this reason observations on the materials and techniques used in the paint layers are based principally on examination and sampling of those panels which have been cleaned.

Gesso

Before the application of the gesso ground, the front faces of the panels were covered with canvas in the usual way. The canvas, which is visible in the X-radiographs and along the cut and damaged edges, is of medium weight and with a fairly tight weave. The frayed edges can mostly be detected, showing that large pieces were used rather than the patchwork of assorted scraps sometimes seen in X-radiographs of early Italian panels. Where there are particularly bad flaws in the timber, for example beneath the head of St John the Evangelist in the main tier, strips of canvas have first been pasted over the flaws, and then covered by larger pieces. Because there is less gesso above them they appear darker in the X-radiographs.

Both forms of gesso occur. It was from the edges of this altarpiece that it was possible to take separate samples of gesso from immediately above the canvas and from the upper layers of the ground to

Fig. 124 Drawing showing the geometrical construction of the arch. The lines incised in the wood are indicated by a solid line. R_1 and R_2 are of equal length and are the radii of the outer arch; r_1 and r_2 are the radii of the quarter-circles which comprise part of the inner ogival arch

Fig. 125 Drawing showing the division of the main tier panels into rectangles with the dimensional relationships of $1:\sqrt{2}$

Plate 150 Detail of the left panel of the main tier during cleaning

175

confirm that the calcium sulphate, identified by X-ray diffraction as being of the anhydrite form, is indeed the equivalent of Cennino's first application of *gesso grosso*. The samples from the upper layers are of the gypsum form, because the calcium sulphate has taken up molecules of water during the slaking to make *gesso sottile* (see p. 17). In some of the cross-sections it is possible to see the coarser, more granular texture of the *gesso grosso* in the lowest ground layers.

Underdrawing

As in the *Crucifixion* (Cat. no. 7), the underdrawing is difficult to detect by infra-red photography and reflectography. In fact most of the preliminary drawing is seen just as easily with the naked eye. This suggests that the drawing may have been executed using a material containing little or no carbon, either because the ink was very dilute or because something like an iron-gall ink was used. Only one paint cross-section includes a few black particles which may represent a line drawn with a dilute ink or paint. Where underdrawing is visible, mainly in the more transparent areas of pale pink, for example the robe of St Stephen (Fig. 126), it is broadly and freely sketched in with soft, fluid lines indicative of drawing with a brush. Again like the *Crucifixion*, the drawing has been used primarily to establish the outlines and to define a few of the drapery folds. Occasionally a few long parallel strokes of hatching can be seen, for instance on the hands of St Francis and in the folds beneath the book carried by St Stephen. The drawn lines are not always followed in the painting of the figures: the sketched folds of St Stephen's mantle bear little relation to those which have been painted. Slightly more careful, but still sketchy, drawing occurs on the church held by St Peter, and details such as the lunettes often fail to coincide with the final painted versions (Fig. 127).

In the complex architecture of the canopy of the throne, however, a different drawing style is revealed, suggesting the possibility of a second hand (Fig. 128). The lines are crisp and precise and have been executed with a much blacker drawing material, producing clear images in infra-red. They have been carefully followed in the painting of the canopy and often the

Fig. 126 Infra-red photograph. Detail of St Stephen from the left panel of the main tier

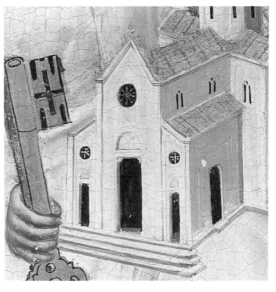

Fig. 127 Infra-red photograph. Detail of the model of a church held by St Peter

176

lead white paint has deliberately been applied thinly to allow the black underdrawing to show through and supply most of the architectural detail. Only occasionally was it necessary for the painter to reinforce the foliate decoration with touches of black paint.

Gilding

The lines to demarcate the areas to be gilded have been incised lightly but confidently into the gesso. There are no signs of hesitancy to suggest that the compositions had not been fully worked out, so there must have been more preliminary drawing than can now be detected. Often the incised lines have been used only as a very approximate guide for the painted forms, especially around some of the hem lines on the main tier. The tiara of the martyr pope in the back row of the left-hand compartment was to have been decorated differently and the head of the angel seated on the tomb in the *Maries at the Sepulchre* was originally in profile. On the right-hand pinnacle panel departures from the incised outlines occur in the robes of both the foremost angels. Some of the architectural detail, particularly on the *Pentecost*, has also been incised. Here dividers have been used to inscribe the arches of the raised loggia and also the tops of the windows in the back wall, even though they were eventually painted as pointed arches (Fig. 129).

The gold leaf has been laid over a fairly bright orange-brown bole and has the appearance of being well burnished. Overlaps between the pieces of gold leaf can be seen in just a few places, mostly on the main tier panels. The sheets are rather smaller than usual, only about 6 cm square, and to fit the spaces enclosed by the arches they have been laid diagonally rather than in horizontal rows. On two panels, the *Trinity* and the *Maries at the Sepulchre* (Plates 149 and 146), nearly all the original gilding and the gesso beneath have been scraped away and replaced, almost certainly during the nineteenth-century restoration. The division between original and later gilding is very obvious around the trees of the latter panel (Fig. 123).

Compasses or dividers were employed again to incise the circles of the haloes as a guide for the punched decoration. The

Fig. 128 Infra-red photograph. Detail of the canopy of the throne in the centre panel

holes made by the fixed point are occasionally visible, both on the picture surface (Fig. 129) and in the X-radiographs. The haloes of the saints in the main tier all follow a basic pattern: an outer band of three rings of simple indented punches, followed by a wide decorated band, and finally an inner ring of indentations. The tooling of the decorated bands afforded an opportunity for a remarkable display of technical virtuosity. Using only five or possibly six plain ring and indenting punches of assorted sizes, together with a stylus for the incised lines, every single saint has been given a halo of a slightly different pattern. Appropriately, the most elaborate designs have been reserved for the haloes of Christ, the Virgin and St Peter (Plate 141), while those of the angels in the foreground of the *Coronation* are virtually uniform in design. On many of the haloes parts of the pattern appear to have been stippled, but have in fact been executed with a very small ring punch.

The tooling on the upper tier panels has been achieved using even fewer punches. Just two ring punches and an indenting punch appear on the haloes, with the spaces in between stippled with a needle (Fig. 129). The stippled marks tend to

form rows rather than clumps, suggesting the use of a single needle as opposed to a rosette. The edges of the gilded backgrounds are ornamented with a design based on an indenting punch and a single ring punch stamped in clusters to form a daisy motif. The decoration of the false gilding associated with nineteenth-century repairs can easily be distinguished because a composite punch has been used instead. Identical patterns of tooling feature on the dismembered predella panels, and it is this consistent application of punched motifs throughout the altarpiece that makes it improbable that the panels of individual saints which have been proposed as pilaster panels could have originated from the same work. These are decorated using quite different punches, including a small composite floral motif very like one used on the *Crucifixion* (Cat. no. 7). In addition, the hems and borders of their draperies have stippled decoration (like that on the Zecca *Coronation*; Plate 170) as opposed to the mordant gilding used on the San Pier Maggiore figures.

The paint film

Although the accounts (see Appendix III) for the altarpiece are incomplete, they record expenses for some of the materials used. These include eggs for making the tempera and fifty small pots, presumably to hold the pre-mixed shades of each colour. As the eggs cost 10 *soldi* 2 *denari* and the pots only 8 *soldi*, a fair quantity of eggs must have been purchased. Analysis of paint samples from the left-hand compartment of the main tier confirms the exclusive use of egg tempera as the paint medium, even in the thickly applied blobs of decoration on the crowns (Plate 151).

Of the pigments listed in the accounts, lapis lazuli or natural ultramarine was inevitably the most expensive. Three grades are recorded. The purest (*azzurro d'oltre mare*) cost 1 *lira* 13 *soldi* for a quarter (*quo.*) of a pound, that is, 3 ounces, as there were 12 ounces to the Tuscan pound (see Appendix IV). The next grade, despite being described as ultramarine ash (*biodetto d'oltremare*), was only a little cheaper at 1 *lira* 5 *soldi* a quarter, so it must still have been of reasonably good quality. The cheapest grade costing 2 *soldi* per ounce (there were 20 *soldi* to 1 *lira*) is listed simply as pale blue (*biodetto*). While these amounts

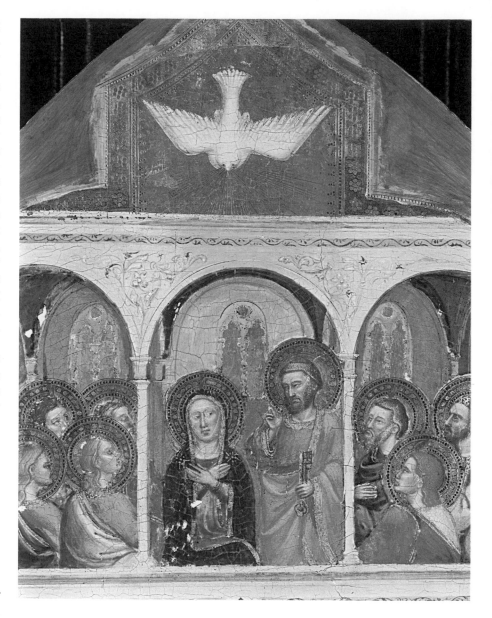

may not represent all the ultramarine used on the altarpiece, by reference to paint samples it is possible to project how the different grades were applied. The finest quality and most intensely coloured blue occurs in a pure form, unmixed with white, on the mantle of the Virgin in her several appearances in the scenes of the second tier. It has been glazed over a layer of lead white, a technique similar to that used on the Virgin's mantle in the *Crucifixion* (Cat. no. 7), but without the grey undermodelling. High-quality ultramarine also appears on many of the mid-blue draperies, particularly in the shadows of the folds, where it has been used as a glaze over lighter and more opaque mixtures of ultramarine (perhaps of slightly lesser quality) and lead white (Plate 152). This

Fig. 129 Detail of *The Pentecost* after cleaning, before restoration. Many incised arcs can be seen and also the holes made by the compass points; for example, that for the Virgin's halo appears at the inner corner of her left eye

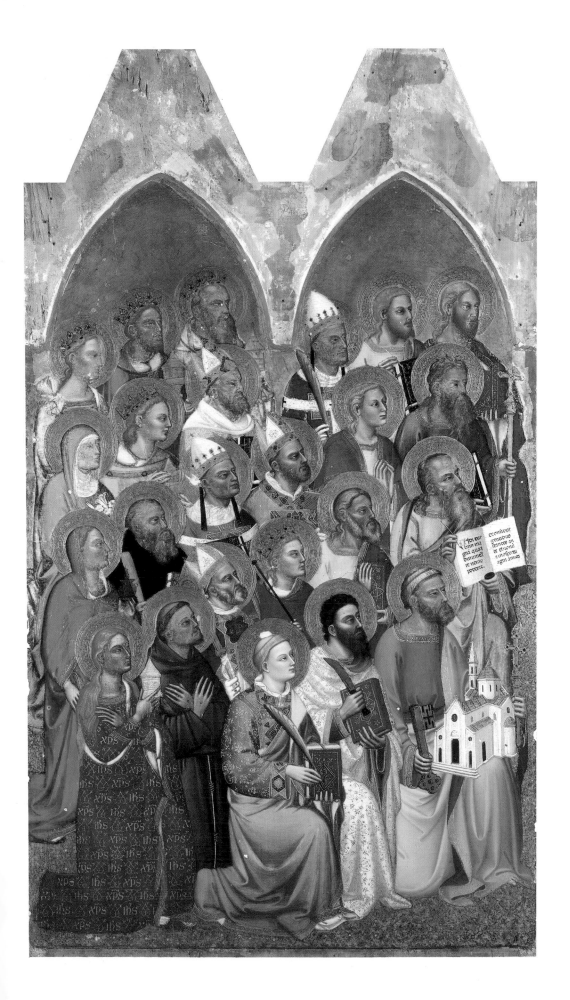

Plate 151 *Adoring Saints*, left panel of the main tier, after cleaning, before restoration. Most of the paint cross-sections discussed come from this panel

179

tendency to complete the modelling of the folds with a final application of pure saturated colour in the shadows is typical of much of the drapery painting on this altarpiece.

Rather than being used on their own, as on the harnesses in the *Crucifixion* (Cat. no. 7), the cheaper grades of ultramarine ash (*biodetto d'oltremare*) occur mainly in mixtures with red lake and lead white to produce shades of lilac and purple. Under magnification the varying amounts of the three pigments needed to obtain gradated tones of lilac for the habit of St Clare can be seen (Plates 153 and 154). A higher proportion of red lake has been added for the shadows, and in the deepest folds of the icy blue-white mantle of St Bartholomew a final glaze of what appears to be red lake has been applied. This has almost completely faded, surviving only where it was protected by flyspots and patches of old dirt and perhaps varnish. While most areas of purple have been achieved with the same combination of pigments, the robe of St Joseph in the *Adoration of the Magi* is a softer, more muted colour due to the replacement of the ultramarine by the greenish-blue azurite.

Red lake pigments do not appear in the surviving documents for the altarpiece but have been widely used. Both in mixtures to make purple, and when modelled with lead white alone, the red lake appears in two quite distinct hues, suggesting the presence of more than one dyestuff. In a few places, notably the robe of St John the Evangelist, the red lake is a cold purple pink, and when analysed the dyestuff showed characteristics of those obtained from lac. More often the red lake is a warm, slightly brown colour and when mixed with lead white it tends to stain the white matrix. Analysis of a sample of this brownish-red lake showed none of the characteristics expected of a dyestuff derived from a scale insect such as kermes or lac, nor of the chemically related dyestuff extracted from madder (*Rubia tinctorum* L.). Therefore it is possible that the dyestuff was derived from brasilwood. When newly prepared, brasilwood lakes are a brilliant scarlet red, so if this was indeed the dyestuff used, the lake may have been chosen as much for its particular colour as for its relative cheapness when compared with the costly insect-derived dyestuffs

like lac. It has been generously applied, especially in the shadows of the paler pink draperies, and on the draperies of Melchior and St Reparata in the back row, which have been modelled entirely with red lake glazes over a lead white underlayer (Plate 155). Abrasion to the upper layers and almost certainly some fading have resulted in the uneven, streaky effect seen on the similarly painted drapery in the *Crucifixion* (Cat. no. 7).

Translucent red glazes, used to intensify the shadows on the opaque vermilion draperies, have protected the pigment from the blackening which has disfigured much of the unglazed paint. The discoloration occurs only in the uppermost application of colour, often in a patchy or spotty form, which suggests that the vermilion may have shown its propensity to wet poorly, causing aggregates of pigment to separate out from the medium. The pigment would then be insufficiently bound for protection from the photo-chemical changes which produce the blackening. It would also be vulnerable to abrasion by cleaning: these draperies are probably the most damaged parts of the altarpiece.

On the upper tier panels some of the vermilion robes have been highlighted with touches of red lead (Plate 148), a pigment listed in the accounts, but only for the decoration of the protective curtain. Red lead also appears with a creamy white to produce unusual *cangiante* effects, for example on the cope of St Ambrose (or Giles) and on the lining of St Stephen's mantle (Plate 165). Other obvious occurrences of red lead on the uncleaned panels are the shoulder of St Julian in the right-hand compartment and the *sgraffito* patterns on the bagpipes and tunics of the central angels. A duller, more yellowish-orange features on the robe of St Peter in the *Pentecost* and in several places on the altarpiece, including the stable roof in the *Nativity* and the *Adoration of the Magi* (Plates 143 and 144) and the borders of many of the draperies. Essentially this consists of an orange-yellow earth pigment but with the colour intensified by the addition of a translucent yellow lake. On the stable roof a further thin glaze of black and red earth has been applied to deepen the colour (Plate 156). The same combination of yellow and red earths with yellow lake has also been used to model the

Plate 152 The blue robe of St Peter (main panel): two layers of ultramarine and lead white glazed with pure ultramarine. Cross-section, 130×

Plate 153 Pale lilac of St Clare's habit showing a mixture of red lake with ultramarine and lead white. Top surface of an unmounted fragment, 90×

Plate 154 Deeper shade of lilac in the shadows of St Clare's habit showing the same pigment mixture but with a higher proportion of red lake. Top surface of an unmounted fragment, 130×

Plate 155 St Reparata's pink drapery: pure red lake glazed over lead white. Cross-section, 125×

shadows of the bright, opaque yellow draperies, for example the mantle of St Peter in the main tier (Plate 157). Here the principal pigment is lead-tin yellow (type II), recorded in the accounts as 'giallolino' and costing one soldo per ounce.

In his section on the yellow lake pigment which he calls arzica, Cennino, after warnings about its impermanence, says: 'it makes a lovely green if you mix in a little azurite and giallorino.' A similar mixture, but with lead white replacing the lead-tin yellow, has been employed for most of the greens on the altarpiece (Plate 158). These range from the pale pistachio green of the architecture in the Pentecost – not to the taste of the nineteenth-century restorer who toned it down with an opaque orange-brown stain (Plate 167) – to the deep blue greens of Sts Andrew, Gregory and Stephen on the main tier (Plate 151). In some samples, including those from the architecture of the Pentecost, the azurite and yellow lake lie over an underpaint of green earth and lead white. Occasionally a little ultramarine was added, suggesting that a cool, blue green was intended, but in other samples there are signs that some fading of the yellow lake has occurred in the upper paint layers (Plate 159).

The only large area of green not based on this pigment mixture is the bright, apple green of the sgraffito textile on which the saints stand (Plate 160). This consists of malachite with a little lead white: only where the paint is thickly applied is it possible to see the pigment's characteristic cold blue tinge. Generally the paint is thin enough to allow the yellow of the gold to show through, producing a rich brilliant green. The unequal spacing of the horizontal trellis pattern suggests that it has been drawn freehand rather than with a pounced cartoon or stencil. The centres of the flowers have been picked out alternately with touches of vermilion and a pale blue-grey, probably ultramarine ash mixed with white. The repeats are more precisely registered in the complex design of the ultramarine blue cloth of gold on the Coronation throne, so here a cartoon may have been used. A simpler use of sgraffito occurs on the angels' wings, where the feathers have been scratched into the paint to expose the gold beneath. As the colours of the sgraffito textiles tend

to overlap those of the draperies, they must have been executed at a fairly late stage and probably just before the application of the flesh paint.

The underlayer for the areas of flesh is the same translucent greenish-golden colour seen on the Crucifixion (Cat. no. 7). Again it consists of a dull olive shade of green earth mixed with lead white and some yellow lake and ochre pigment. On certain figures, for example St Lucy, it is quite densely applied and consequently looks more like the green earth underpainting seen on the other panels in this catalogue. A great effort has been made to characterise each saint individually and this extends to their flesh tones, which vary considerably. In general the faces of the female saints (plate 161) and some of the younger male saints like St Stephen have been modelled using lead white with vermilion, whereas the older male saints are painted with lead white and red and brown earth colours. In the mid-tones some of the faces have developed a distinct greyish cast, mainly owing to an optical effect caused by laying pale colours, which with time have probably become increasingly transparent, over a darker undermodelling of ochre, black and white (Plate 162). This combination of pigments, traditionally called verdaccio, has also been used to reinforce the shadows and outlines of the faces and hands.

Verdaccio appears again in the landscapes of the second tier. Here it has been applied over a solid black underlayer (Plate 163) to provide a dull green base colour for the trees and flowered meadow in the Resurrection and the Maries at the Sepulchre (Plates 145 and 146). The leaves and plants have been picked out with lighter shades of verdaccio and perhaps malachite, and the flowers with touches of lead white, vermilion and ultramarine. A similar technique of painting foliage over black is described by Cennino in his section on fresco painting, and it has also been discovered on a panel by the Master of the Lehman Crucifixion in the National Gallery (no. 3894). In the case of the San Pier Maggiore Altarpiece, the black pigment used both as an underpaint for the foliage and as a colour in its own right, for example on the habit of St Benedict, is some form of vegetable black, but seemingly not charcoal.

Plate 156 *The Adoration of the Magi.* Shadow of the stable roof comprising a scumble of black and red earth, over a layer of yellow earth intensified with yellow lake. Top surface of an unmounted fragment, 130×

Plate 157 Shadow of the yellow mantle of St Peter (main panel): lead-tin yellow modelled with yellow lake combined with a little earth pigment. Top surface of an unmounted fragment, 130×

Plate 158 Green tunic of bearded figure to the right in *The Pentecost*, painted with azurite, yellow lake and lead white. Top surface of an unmounted fragment, 130×

Plate 159 Green cope of St Gregory consisting of the standard mixture of azurite, yellow lake and lead white, but containing in addition a little ultramarine. Towards the upper part of the paint layer, some fading of the lake pigment seems to have occurred. Cross-section, 380×

In common with the *Crucifixion* (Cat. no. 7), some areas which now appear dark brown or black were originally shiny metallic silver. These again include weapons and armour (Plate 164), but also parts of the musical instruments like the organ pipes, and several attributes such as St Lawrence's metal grid, the prongs of St Blaise's curry comb and the spikes on St Catherine's wheel. On this occasion the silver was applied in a leaf form rather than as a powder, and usually over a deep red-brown bole. For some unexplained reason the bole applied beneath areas to be silvered is often a darker, redder colour than that to be seen beneath gold. This darker colour is especially marked where the silver has been rubbed on the fastening of St Zenobius' cope (Plate 151). In one instance, the lamp carried by St Lucy, no bole is present, so the application of the silver leaf must have been an afterthought.

Mordant and 'shell gold'

A payment for silver (*ariento*), together with more eggs, appears in the accounts for the altarpiece but probably only in connection with the decoration of the arch of the chapel, presumably that behind the high altar. However, on three separate dates in August and September 1371, payments of one gold florin were made, each for '100 pieces of gold for the fringes and draperies of the figures' ('cento pezzi d'oro per li fregi e drappi delle figure'). The last payment was specifically for the 'half or middle panel'(?) ('colmo di mezzo'), presumably the middle tier. It is interesting that whole pieces of gold leaf were bought especially for the mordant gilding, rather than making use of scraps and trimmings left over from the water-gilding. Cennino points out the importance of using 'the most thoroughly beaten gold, and the most fragile', because if the gold is too thick and inflexible it will not conform and adhere to the lines of mordant.

Mordant gilding has been widely used on the altarpiece. Examples include the armour of the soldiers in the *Resurrection* (Plate 164); patterned textiles such as the mantles of Christ and the Virgin in the central *Coronation*, and the robes of Sts Stephen (Plate 165), Bartholomew and Catherine on the side panels; the hems and borders of most of the draperies; and the

roof and cupola of the model church held by St Peter. Here it provides a useful contrast with his keys, which have been water-gilded in gold and silver (Plate 141). The mordant – which is barely raised on the surface of the panels – is a red-brown colour, consisting principally of a red iron oxide, and in cross-section at the junction with the paint layers it has the thin, medium-rich layer observed in most other examples of presumed oil mordant (Plate 166).

In some instances, notably the pattern on the Magdalen's draperies (Plate 151), this coloured mordant is absent. The lettering, at least, has the appearance of mordant gilding, so it may be that a quick-drying mordant was employed (see p. 46). As the drapery is red there was no need for the red-brown colour to enrich the gold. Some of the finer lines around the letters may well have been applied with the gold in a powdered form; gold paint also seems to have been used on the bindings of the books carried by the saints and to add final touches to some of the embroidered borders. The difference between powdered or 'shell gold' and true mordant gilding becomes apparent when comparing the decoration of St Stephen's book with that on his sleeve (Plate 165). The occurrence of 'shell gold' on this altarpiece and on the *Crucifixion* (Cat. no. 7) is of some interest since it was previously believed not to have been introduced to Florence until the early fifteenth century (see p. 46).

Varnishing

Only nine days after the last payment for gold leaf the accounts list expenses amounting to a mere 4 *soldi* for the transport of a panel to Santa Maria Nuova, where it was to be varnished ('per portare e rechare la tavola a Santa Maria Nuova, quando si vernichò'). A little later it was followed by the predella. It is not clear why the panels were taken to Santa Maria Nuova (see Appendix III). The extent to which early tempera paintings were varnished and the type of varnish used is a much-debated subject among both restorers and art historians. At the end of his section on panel painting Cennino gives relatively brief instructions on how and when to varnish a panel painting with '*vernice liquida*'. Although he does not

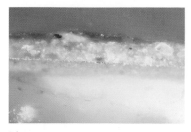

Plate 160 Bright green of *sgraffito* textile painted as a layer of malachite with white over gold leaf and bole. Cross-section, 380×

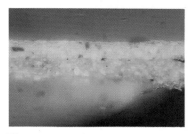

Plate 161 Pink paint of St Reparata's neck: lead white tinted with vermilion, over green earth mixed with lead white and a little yellow lake and ochre. Cross-section, 300×

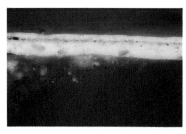

Plate 162 Greyish-pink paint of St Lucy's hand: here a thin layer of shading with *verdaccio* lies between the green underlayer and the pale pink flesh colour. Cross-section, 160×

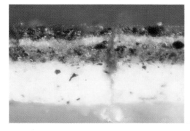

Plate 163 Greenish black of the tree above the tomb in *The Resurrection*: three layers of *verdaccio*, the lowest layer containing a high proportion of black pigment. The tree has been painted over a layer of lead white with a little black, which constitutes the grey of the rocky landscape. Cross-section, 380×

describe the making of this 'vernice liquida' (which implies that it may have been available ready-made), recipes in the slightly later Bolognese Manuscript show that basically it consisted of semi-hard resins such as sandarac dissolved and boiled in linseed oil. Spirit varnishes in which soft resins like mastic are dissolved in volatile solvents, for example distilled turpentine, only evolved in the sixteenth century and are still in use today. As 'vernice liquida' was an oleo-resinous varnish it would have been viscous and difficult to apply. This is confirmed by Cennino's account: the varnish had to be rubbed on to the surface of the painting, either with the palm of the hand or with a sponge, and ideally, to improve the flow of the varnish the painting should first have been warmed by leaving it in the sun. As it would dry rather slowly and therefore be prone to picking up dust, he warns against varnishing on a windy day. He also advises against varnishing too soon after completion of the painting, recommending a delay of at least a year. This makes the varnishing of the San Pier Maggiore panels seem somewhat precipitate if 'vernice liquida' were used.

As an alternative to 'vernice liquida', particularly if time was short, Cennino suggests a varnish made from glair, the white of egg whisked into a foam and then left to stand until it becomes liquid again. In 1985 when the first panels from the altarpiece were being cleaned, an egg-white varnish was reported to have survived on an unusually well-preserved fourteenth-century tempera painting by Jacopo del Casentino. Descriptions of its silvery grey surface accorded well with a thin grey layer discovered beneath the wax polish and superficial grime on the tomb in the *Resurrection*. Samples were therefore taken to try to establish whether the varnishing referred to in the documents could have simply been done with egg white. The layer was too thin for the use of precise analytical methods such as gas-chromatography; it failed to stain when tested with a reagent used to locate the presence of gelatine and egg proteins, while the proteins in the ground and paint layers produced a strong positive result. When seen in cross-section black and brown particulate matter was clearly visible, so it was concluded that the grey layer

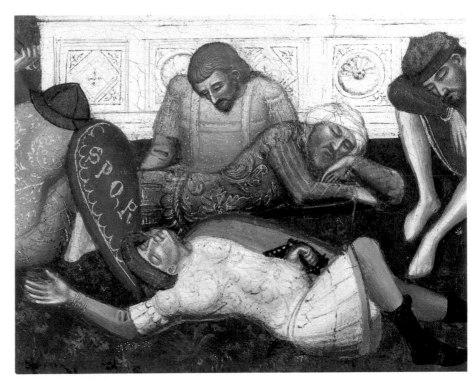

Plate 164 Detail from *The Resurrection*

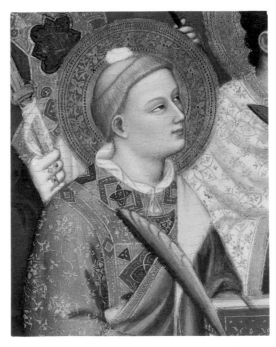

Plate 165 Detail of St Stephen from the left panel, after cleaning, before restoration

Plate 166 Mordant gilding from St Stephen's green sleeve. Cross-section, 130×

was merely surface dirt. Even if it had been identified as egg white, it would have been difficult to prove that it was original, since the use of egg-white varnishes is often recorded in eighteenth- and nineteenth-century manuals on the restoration of paintings.

However, when the *Pentecost* was cleaned, small patches of a transparent, hot orange substance, insoluble in normal cleaning solvents and reagents and very well-bonded to the paint surface, were

uncovered along the left and right edges beneath the surface dirt and inauthentic toning (Plates 167 and 168). Analysis of a sample of the transparent orange-coloured substance identified it as the remains of an oleo-resinous varnish, consisting of linseed oil, heat-bodied as a consequence of boiling, together with some resin, probably of *Cupressaceae* origin, that is, a sandarac-type resin as cited in fourteenth- and fifteenth-century varnish recipes. Under high magnification the orange patches can be seen to contain a very few particles of red lead (Plate 169). Too little pigment is present to have had any appreciable effect on the colour of the material, so the red lead must have been added to act as a drier; it is listed in this capacity as an ingredient of one of the three recipes for '*vernice liquida*' given in the Bolognese Manuscript. Finally, a cross-section confirmed that the orange layer lies directly over the paint surface without any intermediate layers of dirt or residues of other, later restorers' varnishes. Therefore it seems likely that it represents the remains of an original oleo-resinous varnish. The varnish could have survived around the edges if the panels had received their first cleaning while still in their frames; moreover, traces are visible on the other panels along those edges not so extensively cut in the dismemberment of the altarpiece.

There is some evidence that the altarpiece may have been cleaned relatively early in its history. As they age, oleo-resinous varnishes become increasingly insoluble, demanding ever-stronger cleaning methods. Of the cleaning methods described in old treatises, only caustic alkalis and abrasives like sand, pumice or powdered glass are likely to have been effective on an aged, polymerised varnish film. While there is some damage on the San Pier Maggiore Altarpiece which could be attributed to harsh cleaning methods, other areas, for example the head of St Stephen, are strikingly well-preserved. Furthermore, if the varnish had been removed at a fairly early date and the panels then left unvarnished, this could account for the presence of small circular losses from the upper paint layers on several of the heads in the left compartment of the main tier. This type of damage is characteristic of an outbreak of mould, a

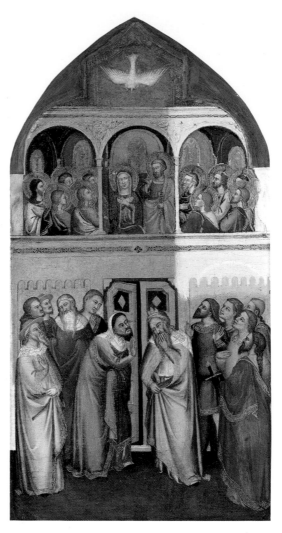

Plate 167 *The Pentecost* during removal of the surface dirt and inauthentic brown toning

not uncommon occurrence on tempera paintings, given the amount of protein in the paint and ground layers, but less likely if the paint surface is protected by a substantial varnish layer. In 1677 the altarpiece is recorded as having been badly neglected and much injured by dust and grime. On the removal of the dirt from an area of the picture 'it became very beautiful again' ('è ritornata bellissima'). No varnish is mentioned and it would certainly have become extremely discoloured by this date.

Regardless of when the varnish was removed, the fact that the altarpiece does appear to have been varnished with an oleo-resinous varnish is of great interest. Our view of the original surface appearance of early Italian tempera paintings should perhaps be reconsidered. When newly applied, an oleo-resinous varnish would have been quite clear, but with a glossy finish which is alien to the idea current among most restorers as to how

184

these paintings were intended to look. As yet it is not known how widespread the practice may have been. Few, if any, convincing identifications of original varnishes have been made on works as early as these, and without the documentary references to the varnishing it is unlikely that we would have been alerted to the possibility of any having survived on the San Pier Maggiore Altarpiece.

The division of labour

By using the documents in conjunction with stylistic and technical analysis of the altarpiece and other related works, some conclusions can be drawn about the nature and extent of the collaboration between the painters and craftsmen responsible for its design and its execution. As Jacopo di Cione himself is not mentioned in the surviving documents (see Appendix III), his participation has been established only by associating the figure painting style seen in the altarpiece with that in the slightly later Zecca *Coronation* (Plate 170), in the execution of which he is documented as having played the major part, and with that in the earlier *St Matthew Triptych* (Plate 171) which he is recorded as having completed because of the illness of his elder brother Andrea di Cione. In the *St Matthew Triptych* the stylistic connection is less obvious and there are some technical differences, for example the incising of all the lines of the drapery folds, which do not appear on his later works, but certain passages of painting, notably the robes of the central figure of St Matthew, are very close to the San Pier Maggiore Altarpiece.

Documents for other works show Jacopo di Cione collaborating with Niccolò di Pietro Gerini. The latter is probably the 'Niccholao' working with Jacopo in the Guildhall of Judges and Notaries in Florence in 1366, and also the 'Niccolaio' working with him on the *Coronation of the Virgin* for the Zecca in 1372–3. He is certainly the 'Nicolao Pieri' paid with Jacopo di Cione for the fresco of the *Annunciation with Standing Saints* in the Palazzo dei Priori in Volterra in 1383. It is therefore extremely likely that he is the 'Niccolaio' who designed the San Pier Maggiore Altarpiece. His accomplished, but somewhat unappealing figure painting style, with its crisp, hard modelling as exemplified by the *Baptism of Christ* in the

National Gallery (no. 579; Plate 172) does not feature on the San Pier Maggiore Altarpiece, so he seems to have been involved solely in the capacity of designer. Other evidence tends to bear this out.

In the documents of payment for the Zecca *Coronation* his name occurs at an early stage in October 1372; together with a certain Simone he is paid for the stipend and working expenses on a painting in which they are to paint the Virgin Mary ('pro eorum salario et labore picture unius tabule in qua pingere debent imaginem gloriose Virginis Marie . . .'). A year later, in October 1373, Jacopo di Cione is paid a wage for completing the painting ('pro eius pretio et labore pro complemento picture tabule gloriose Virginis Marie . . .'). It was probably therefore begun by Niccolò and Simone, and perhaps even taken as far as having been gilded and punched, and then left for Jacopo to complete the actual painting: the painting style is identical to that in the San Pier Maggiore Altarpiece.

Further evidence for this type of

Plate 169 The orange-coloured, oleo-resinous varnish which survives around the edges of *The Pentecost*. A few particles of red lead, added as a drier, can be seen. Top surface of an unmounted fragment, 115×

185

division of labour occurs in the fresco of the *Annunciation* in Volterra (Plate 173). There the payments to Niccolò and Jacopo together indicate that they collaborated at the same time and on an equal basis. The precise division of labour is suggested by the fragments of the *sinopia* (Plate 174), detached some time after 1959. This shows that one hand was clearly responsible for the design of all the architectural detail and some of the figures, while another hand designed only some of the figures. The architecture has been drawn with fine lines of a bright red ochre over a preliminary rough sketch made with a black material; the wings and swirling drapery of the angel (the only part of the main composition to have survived in the *sinopia*) have also been drawn with the same precise lines of red. However, the figures of the saints at the sides have been drawn quite differently: a much darker brown 'sinoper' has been used and the lines are broadly and freely applied, mainly to establish the outlines and a few of the simple columnar drapery folds. Allowing for the translation to a different medium and scale it is possible to link this style of figure drawing with that detected on the San Pier Maggiore Altarpiece.

If the drawing of the two side saints in the *sinopia* is assigned to Jacopo – the frescoed figures are so repainted that any firm attribution is out of the question – then the angel must have been drawn by Niccolò (the participation of an unnamed member of the workshop is unlikely on one of the key figures in the composition). The painting of the angel's drapery, on the other hand, differs slightly from the *sinopia* in a way which suggests that the design was not fully understood by the man who painted it – the style now visible bears no relation to that of Jacopo di Cione, but the condition of this part of the fresco is also extremely suspect. Since the angel and the architectural setting have been drawn in a similar style and using the same materials, it can be assumed that Niccolò was responsible for the design of both. The fine precise drawing style of the angel does not appear on any of the figures in the San Pier Maggiore Altarpiece, but drawing of a similar precision has been detected by infra-red reflectography on his *Baptism*.

It can therefore be concluded that Niccolò had no part in either the drawing or the painting of the figures of the San Pier Maggiore Altarpiece, but that he was in charge of the design of the altarpiece in an architectural sense. As has been demons-

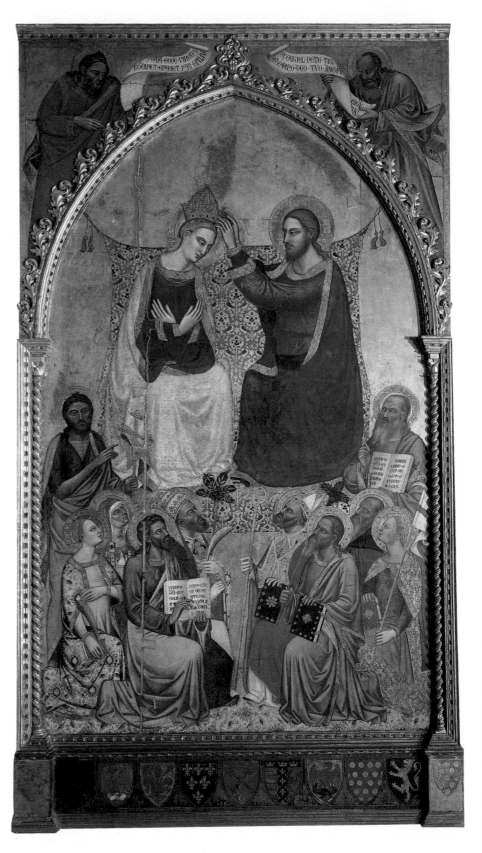

Plate 170 Jacopo di Cione and collaborators: The Zecca *Coronation*. 1373. Florence, Galleria dell'Accademia

186

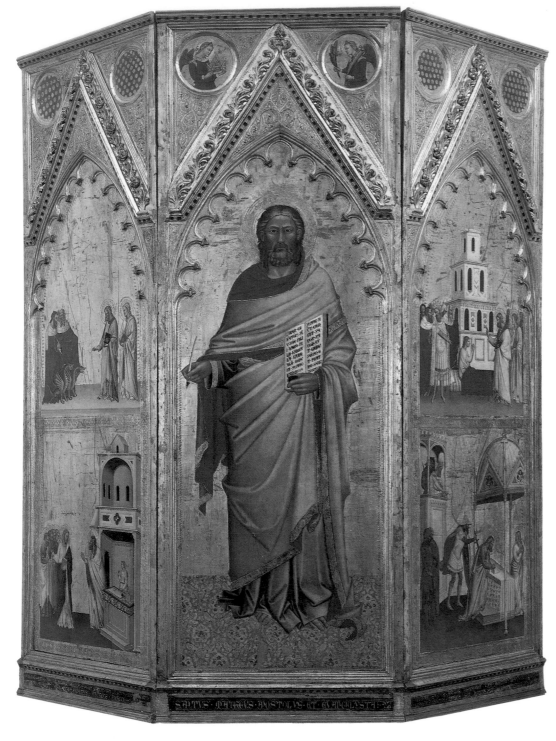

Plate 171 Andrea (Orcagna) and Jacopo di Cione: *St Matthew and Scenes from his Life*. 1367–8. Florence, Uffizi

trated, the architecture and construction of large altarpieces had become very elaborate and complex by the second half of the fourteenth century. Niccolò almost certainly collaborated in this capacity with Jacopo on other occasions, including the Zecca *Coronation* and perhaps the *Crucifixion* in this catalogue, and he is recorded as having worked with other painters as well. Elements of the design of the San Pier Maggiore Altarpiece reappear in other

works associated with his circle, for example a *Coronation of the Virgin* of 1402 attributed to his son Lorenzo di Niccolò in San Domenico, Cortona.

The only two-dimensional part of the San Pier Maggiore Altarpiece which may have been drawn by Niccolò, and was almost certainly designed by him, is the Coronation throne and canopy. Its similarity to the carved canopy on the *Crucifixion* has often been noted, but the preci-

sion of the architectural detail and the convincing sense of perspective recession also occur in a frescoed tabernacle and *sinopia* at Rovezzano attributed to Niccolò and his workshop. Compared with the throne and canopy the other pieces of architecture on the altarpiece seem inept in their design. The perspective and construction of the supposedly identical stables in the *Nativity* and the *Adoration of the Magi* appear to have been adapted and rearranged to suit the different figure groupings, while the tomb has been shortened, losing some of its decorated panelling between the *Resurrection* and the *Maries at the Sepulchre*. Further illogicalities appear on the *Pentecost*, particularly in the lower part where X-radiographs show that the strange walls with their recessed niches decorated with pendant arches have been superimposed over large single arches (also visible on the surface of the picture: see Plate 148). If these less important architectural details are by Jacopo, then it confirms that architecture and perspective were not his strong points, and that he needed to collaborate with a specialist designer.

However, if Jacopo was left to struggle with the minor architectural details, it is not unreasonable to assume that he was also responsible for the general layout of the compositions and figure groupings. It has often been suggested otherwise, but there has perhaps been a tendency to underestimate his design skills, particularly in the clear organisation of narrative through careful distribution and juxtaposition of colours. His rendering of light effects is imaginative and original, notably in the second tier panels; and in small details, such as the Child handing the gift to St Joseph, he may have been iconographically inventive. The role of drawings in the composition of works like these is not known as so few works on paper from this period have survived. Painters probably owned collections or pattern-books of stock designs and may sometimes have shared or borrowed from one another. The use of borrowed drawings (perhaps from Niccolò) might account for the atypical fluttering draperies of the outermost angels in the pinnacle panels and of Christ in the *Resurrection* (Plate 145). Nevertheless, Jacopo seems to have been the dominant figure in both the

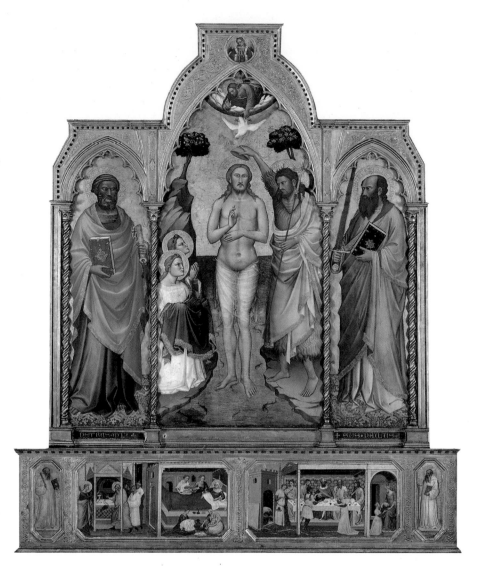

Plate 172 Ascribed to Niccolò di Pietro Gerini: *The Baptism of Christ, with Sts Peter and Paul*. 1387. London, National Gallery

drawing and the painting of the altarpiece.

The other painters named in the documents, Matteo di Pacino and Tuccio di Vanni, can have played only secondary roles in its execution; the possible role of the former is discussed below, and the latter is in fact named only in connection with the decoration of the arch of the chapel behind the altar rather than the altarpiece itself. There are evident signs of workshop assistance in the painting of some of the figures, but generally in a clumsier version of Jacopo's own style as opposed to the distinctive and different style and technique of his collaborator on the *Crucifixion* (Cat. no. 7). As the rows of saints recede there is a tendency for the technique to become increasingly careless and for the drapery tones to be more crudely blended, for example the three young male saints towards the right in the two back rows of the left-hand compart-

ment (Plate 151). This could be explained as workshop participation, or it may just be that Jacopo paid less attention to these background figures. On the smaller figures, the faces vary considerably in their physiognomy and complexion, but the same can be said of the saints in the front rows of the main tier which are accepted as having been painted by Jacopo himself. Until all the panels have been cleaned it is unwise to attempt too rigid a division between master and workshop.

The only other area in which specialist collaboration may have taken place is in the gilding of the altarpiece and in particular the tooling of the haloes. Elaborate tooling using very simple punches appears on other works by Jacopo, including the Zecca *Coronation* and the small *Madonna dell'Umiltà* in the Accademia, Florence (Fig. 1), but similar patterns also occur on works associated with Niccolò di Pietro Gerini. It seems that after the *St Matthew Triptych* Jacopo may not have had access to the stock of complex and beautiful punches which had belonged to his brother. They have not as yet been traced to the workshop of another painter: it could be that they were not used because both Jacopo and Niccolò preferred to make use of a specialist craftsman who supplied his own set of tools. There are indications that the stamping and tooling on the San Pier Maggiore Altarpiece were not carried out by the painter: on the halo of St Peter the punched decoration continues round underneath his beard as if the person responsible had misunderstood the faint incised line and assumed that this was to be a youthful, short-bearded or even beardless figure (Plate 141). A clue as to the possible identity of this specialist craftsman appears in the accounts for the altarpiece. Included is a small payment 'for collecting one panel of the altarpiece from the house of Matteo di Pacino'. The timing of this entry, after the expenses for pigments, but before the purchase of gold leaf for the final mordant gilding, suggests the possibility that the panel had been with Matteo for the tooling and stippling of the gold parts of the *sgraffito* patterns – that they were executed at a late stage has been demonstrated.

If this is the case it would support the belief that the San Pier Maggiore Altarpiece and other related works are not the products of a single controlling master; rather they represent the labours of a loose association of painters and craftsmen, who grouped and re-grouped according to the needs of the commission. They were thus able to manufacture and execute very large works like the San Pier Maggiore and Zecca *Coronations* in a relatively short space of time. Due to the modern tendency to give primacy to the painter, these works now appear in books and catalogues under the name of Jacopo di Cione, but they ought really to be viewed and admired as the products of the collaborative skills of a whole group of specialist craftsmen.

Plates 173 and 174 Jacopo di Cione and Niccolò di Pietro Gerini: *The Annunciation* with *Saints*. 1383. Fresco. Volterra, Palazzo dei Priori, Sala del Consiglio. Details of the central part and of the left-hand fragment of the *sinopia*

Appendix I

The present location of the surviving fragments from Duccio's *Maestà* (Cat. no. 3)

The surviving fragments in Siena (Museo dell'Opera del Duomo) are as follows:

Main Front Panel: Showing the Virgin and Child enthroned with various saints, including the patron saints of Siena – Ansanus, Sabinus, Crescentius, Victor – and bearing the signature: MATER SCA DEI SIS CAUSA SENIS REQUIEI SIS DUCCIO VITA TE QUIA PINXIT ITA, and an upper tier with half-length figures of ten Apostles;

Front Predella: Infancy of Christ:
Adoration of the Magi; *Presentation in the Temple* with *David* and *Malachi*; *Massacre of the Innocents*; *Flight into Egypt* with *Jeremiah* and *Hosea*; *Teaching in the Temple*.

Front Pinnacles: Scenes from the Life of the Virgin:
Annunciation of the Death of the Virgin; *Arrival of St John*; *Gathering of the Apostles*; *Death of the Virgin*; *Funeral Procession of the Virgin*; *Burial of the Virgin*.

Main Back of Altarpiece: Passion of Christ:
Entry into Jerusalem; *Last Supper* with *Washing of the Feet*; *Judas taking the Bribe* with *Christ taking Leave of the Apostles*; *Betrayal* with *Agony in the Garden*; *Christ before Annas* with the *First Denial*; *Second Denial* with the *Third Denial*; *Christ accused by the Pharisees* with *Christ before Pilate*; *Christ before Herod* with *Christ in the Robe before Pilate*; *Flagellation* with *Crowning with Thorns*; *Pilate washing his Hands* with *Carrying of the Cross*; *Crucifixion*; *Deposition* with *Entombment*; *Maries at the Tomb* with *Harrowing of Hell*; *Noli me Tangere* with *Apparition on the Road to Emmaus*.

Back Predella: Ministry of Christ:
Temptation on the Temple; *Feast at Cana*.

Back Pinnacles: post-Resurrection scenes:
Apparition behind Closed Doors; *Incredulity of St Thomas*; *Apparition on the Sea of Tiberius*; *Apparition in Galilee*; *Apparition at Supper*; *Pentecost*.

Fragments no longer in Siena are as follows:
Front Predella Scenes: *Annunciation* (Cat. no. 3a) and *Nativity* with *Isaiah* and *Ezekiel* (Washington, National Gallery of Art).

Back Predella Scenes: *Temptation on the Mountain* (New York, Frick Collection); *Calling of Peter and Andrew* (Washington, National Gallery of Art); *Christ and the Woman of Samaria* (Lugano, Thyssen Collection); *Jesus opens the Eyes of a Man born Blind* (Cat. no. 3b); *Transfiguration* (Cat. no. 3c); *Raising of Lazarus* (Fort Worth, Kimbell Art Museum). Possibly associated with the *Maestà* are four angel pinnacles in the John G. Johnson Collection, Philadelphia; Mount Holyoke College, South Hadley, Mass.; J. W. van Heek Collection, Castle Bergh, the Netherlands; formerly Stoclet Collection, Brussels.

Appendix II

Surviving documents relating to Duccio's *Maestà*
(Cat. no. 3)

Reproduced from John White, *Duccio. Tuscan Art and the Medieval Workshop*, London, 1979, pp. 192–6; and here reproduced by kind permission of the author

1308, 9 October

Siena, State Archive, Diplomatico, Opera della Metropolitana, Parchment 603. 1308, 9 October.

On the verso of the parchment:

Carta di pacti fatti col maestro Duccio per cagione dela tavola Scte Marie.

On the recto:

Anno domini MCCCVIII, indictione VII, die VIIII mensis octubris. Appareat omnibus evidenter quod dominus Jacobus quondam domini Giliberti de Mariscottis de Senis, operarius operis sancte Marie civitatis Senarum, nomine et vice dicti operis et pro ipso opere ex una parte et Duccius pictor olim Boninsegne civis senensis ex altera parte – Cum ipse Duccius accepisset a dicto operario ad pigendum (sic) quandam tabulam ponendam supra maiori altari maioris ecclesie sancte Marie de Senis – communiter et concorditer fecerunt inter se pacta et conventiones infrascripta et infrascriptas et pepigerunt et promiserunt sibi invicem inter se, occasione laborerii dicte tabule faciende et complendi, pro ut inferius continetur; in primis videlicet quod dictus Duccius promisit et convenit dicto domino Jacoppo, operario, recipienti et stipulanti pro dicto opere sancte Marie et eius nomine, pingere et facere dictam tabulam quam melius poterit et sciverit et Dominus sibi largietur – et laborare continue in dicta tabula temporibus quibus laborari poterit in eadem – et non accipere vel recipere aliquod aliud laborerium ad faciendum donec dicta tabula completa et facta fuerit. Dictus autem dominus Jacoppus operarius, nomine dicti operis et pro eo, dare et solvere promisit dicto Duccio, pro suo salario dicti operis et laborerii, sedecim sol.den.sen. pro quolibet die quo dictus Duccius laborabit suis manibus in dicta tabula – salvo quod si perderet aliquam doctam diei debeat exconputari de dicto salario pro rata docte sive temporis perditi; quod quidem salarium idem operarius, nomine quo supra, dare teneatur et promisit dicto Duccio hoc modo, videlicet quolibet mense quo dictus Duccius laborabit in dicta tabula dare eidem Duccio decem libras denariorum in pecunia numerata et residuum dicti salarii exconputare in denariis quos idem Duccius dare tenetur operi sancte Marie supradicto. Item promisit dictus operarius, nomine supradicto, furnire et dare omnia que necesse erunt pro dicta tabula laboranda, ita quod dictus Duccius nihil in ea mictere teneatur nisi suam personam et suum laborem, et predicta omnia et singula sibi ad invicem inter se actendere et observare et facere et adimplere promiserunt, dictus dominus Jacoppus, nomine dicti operis et dictus Duccius pro se ipso et suo nomine, et unus eorum alteri promisit, nominibus supradictis, sub pena et ad penam XXV librarum den. sen. quam penam sibi ad invicem inter se antedictis nominibus, dare et solvere promiserunt, et unus eorum alteri promisit in quolibet et pro quolibet articulo predictorum, si conmissa fuerit et ea data commissa soluta vel non, predicta firma perdurent et in predictis omnibus et singulis et pro eis servandis obligaverunt sibi ad invicem, et unus eorum alteri obligavit, scilicet dictus dominus Jacoppus, tamquam operarius, se et successores suos et dictum opus et bona eius presentia et futura, et dictus Duccius se et suos heredes et bona omnia presentia et futura pignori, et renunctiaverunt exceptioni non factorum pactorum dictorum et non factarum promissionum et obligationum rei dicto modo non geste, fori privilegio et omni jurium et legum auxilio. Insuper dictus Duccius ad maiorem cautelam juravit sponte ad sancta Dei evangelia, corporaliter tacto libro, predicta omnia et singula observare et adimplere bone fide sine fraude in omnibus et per omnia sicut superius continetur – quibus domino Jacoppo et Duccio supradictis volentibus et predicta confitentibus, precepi ego notarius infrascriptus, nomine juramenti guarentigiam secundum formam capituli constituti senensis, quod hoc instrumentum observent per singula ut supra continetur.

Actum Senis coram domino Ugone de Fabris judice, Nerio domini Gabrielli et Tura Bartalomei testibus presentibus et rogatis.

Ego Paghenellus notarius, filius Dietifecis notarii, predictis interfui et ea rogatus scripsi.

On the verso:

Document of agreements made with Master Duccio by reason of the panel of S. Maria.

On the recto:

AD 1308, indiction 7, day 9 of the month of October. Let it appear manifestly to all that Lord Jacopo, son of the late Giliberto de Mariscotti of Siena, clerk of works of the Opera of S. Maria of the city of Siena, in the name of and for the said Opera and for this work, on the one part, and Duccio di Buoninsegna, the painter, citizen of Siena, on the other part – whereas the same Duccio accepted from the said clerk of works the task of painting a certain panel to be placed on the high altar of the church of S. Maria of Siena, they jointly and amicably made between them the contract and agreements written below and covenanted and promised between them, each to the other, on account of the work of making and completing the said panel as is contained below; to wit, in the first place, that the said Duccio promised and agreed with the said Lord Jacopo, clerk of works, engaging and covenanting on behalf of the said Opera of S. Maria and in its name, to make the said panel, as well as ever he was able and knew how to and the Lord bestowed upon him – and to work continuously upon the said panel at such times as he was able to work on it – and not to accept or receive any other work to be carried out until the said panel shall have been made and completed. Moreover, the said Lord Jacopo, clerk of works, in the name of and for the said Opera, promised to give and pay the said Duccio, as his salary for the said works and labour, sixteen soldi of Sienese money for each day that the said Duccio shall work with his own hands on the said panel, except that if he should lose any part of the day there should be a deduction from the said salary, established in proportion to the part, or of the time, lost; which salary, the same clerk

of works, as named above, is bound and promises to give to the said Duccio in this way, namely, for any month that the said Duccio shall work on the said panel, to give to the same Duccio ten lire of denari in cash and to deduct in denari those parts of the said salary which the said Duccio binds himself to give to the aforesaid Opera of S. Maria. In like manner, the said clerk of works, named above, promises to supply and to give all those things which shall be needed for the working of the said panel, so that the said Duccio shall be bound to put nothing into it except his person and his work, and the said Lord Jacopo, in the name of the said Opera, and the said Duccio for himself and in his name, promised each other reciprocally to carry out and observe and to do and to fulfil each and all of the aforesaid, and each one promised the other, in the names of the aforesaid, under penalty and for a penalty of 25 lire of Sienese denari, which penalty they promised reciprocally, each to the other, in the aforesaid names, to give and to pay, and each promised this to the other in every and for every article of the aforesaid, if it [the fine] shall have been contracted, and whether it has been given, contracted, paid, or not, the aforementioned agreements shall continue binding. And they pledged themselves each to the other, in respect of each and all of the aforesaid and for their maintenance, and each of them bound himself to the other, namely the said Lord Jacopo, as clerk of works, binding himself and his successors and the said Opera and its present and future goods, and the said Duccio binding himself and his heirs and all present and future goods as pledges, and they renounced the objection of non-completion of contracts and non-fulfilment of promises and obligations, if the matter is not performed in the said way, with the privileges and every assistance of law and right. Moreover, the said Duccio, for greater precaution, swore voluntarily on the Holy Gospels of God, physically touching the book, that he would observe and implement each and everything in good faith and without fraud, in respect of all things and for all things as contained above – the which Lord Jacopo and Duccio, abovementioned, desiring and agreeing to the aforesaid, I the undersigned notary, admonished them by way of oath

and guarantee, according to the form of the established Chapter of Siena, to observe this contract in every respect, as is entered above.

Transacted in Siena, in the presence of Lord Ugone de' Fabri, judge, Neri di domini Gabrielli and Tura Bartolomei, who were present and called as witnesses.

I Paganello, notary, son of Dietifeci, the notary, was present with the aforesaid and wrote and published these things, as requested.

1308, 20 December
Siena, State Archive, Diplomatico, Opera della Metropolitana, 1308, 20 December.

On the verso of the parchment:
Maestro Duccio dipegnitore – L. – fiorino d'oro.

On the recto:

Anno Domini MCCCVIII^O, indictione VII^A, die XX^O mensis decembris. Ego magister Duccius pictor olim Boninsegne, civis senensis, pro me ipso facio et constituo me principalem debitorem et pagatorem vobis domino Iacoppo quondam domini Giliberti de Mariscottis, operario operis Sancte Marie de Senis recipienti et stipulanti pro dicto opere et eius nomine, in quinquaginta florenis de bono et puro auro et recto pondere, quos a vobis dante et numerante pro dicto opere et de ipsius pecunia mutuo numeratos de vero et puro capitali, non spe future numerationis, habiusse et recepisse confiteor, et dictos L florenos auri vobis recipienti ut supra dictum est, reddere et solvere promicto hinc ad kalendas ianuarii proxime venturi in civitate Senarum vel alibicumque locorum et terrarum me inveneritis pro dicto opere et volueritis convenire, et reficere et restituere promicto vobis recipienti ut dictum est, omnia et singula dampna expensas et interesse que et quas in curia et extra feceritis et substinueritis pro dictis florenis rehabendis vel eorum occasione, ut vestro simplici verbo sine alia probatione dixeritis vos fecisse, et in hiis omnibus et singulis et pro eis me et meos heredes et bona mea omnia presentia et futura vobis, dicto modo recipienti, pignore obligo, quorum liceat vobis, recipienti ut dictum est, propria auctoritate, sine iudicis vel curie inquisitione seu alterius contradictione, possessionem et tenutam ingredi et accipere corporalem, et ea et ex eis vendere distrahere et alienare et interim dicta bona pro

vobis et dicto opere et vestro et eius nomine predictis me constituo possidere, renuntians exceptioni non habite et non recepte et non numerate dicte quantitatis florenorum mutuo, ut dictum est, et non factarum promissionum et obligationum dictarum, rei dicto modo non geste, fori privilegio et omni Iuris et legum auxilio. Cui Duccio debitori predicto volenti et predicta confitenti, precepi ego notarius infrascriptus, nomine iuramenti guarantigiam secundum formam capituli constituti Senarum, quod dictos florenos reddat et solvat dicto creditori recipienti ut dictum est, in termino supradicto et hoc instrumentum observet per singula ut superius continetur.

Actum Senis, corum Andrea magistro lapidum olim Venture et Naldo ser Pagni testibus presentibus et rogatis.

Ego Paghanellus notarius, filius Dietifecis notarii, predictis omnibus interfui et ea rogatus scripsi et publicavi.

AD MCCCVIII, the seventh indiction, the twentieth day of the month of December. I, Master Duccio di Buoninsegna, the painter, a citizen of Siena, on my own behalf, make and constitute myself principal debtor and payer to you Lord Jacopo son of the late Lord Giliberto de Mariscotti, clerk of works of the Opera of S. Maria of Siena, receiver and stipulator for and in the name of the said Opera, in the sum of 50 florins of good and pure gold of true weight, which I acknowledge that I have had and received from you as giver and lender for the said Opera, which money having been mutually counted with true and honest addition with no expectation of future counting. And I promise to return and pay the said 50 florins of gold to you, the receiver as aforesaid on behalf of the said Opera, on the next forthcoming first of January hence, in the city of Siena or elsewhere, in whatsoever place or territory you shall find me and shall wish me to meet you, and I promise to return and restore to you as the aforesaid receiver, each and all losses, expenses and interest which and whichsoever you shall have made and sustained, in court or out of court, for the repossession of the said florins or on account of them, as you shall say you have made, by your simple word, without other proof. And in each and all these things and for them, I bind myself

and my heirs and all my present and future goods as pledge to you, the receiver, in the said manner. It shall be lawful for you the receiver of which things, as has been said, to enter into and to take over physical possession and ownership without investigation by judge or court or other objection, and to sell, distrain and alienate them or part of them, and in the meantime I agree that I possess the said goods on behalf of you and of the said Opera, in your name and in its name as aforesaid, renouncing the objection that the said quantity of florins has not been had, received or counted out between ourselves and that the aforementioned promises and obligations have not been carried out by reason of the affair not being executed in the aforementioned way; this to be with privilege and with every assistance of law and right. I, the undersigned notary, by way of oath and guarantee according to the form of the established Chapter of Siena, admonished the aforesaid Duccio, who as debtor desired and agreed the aforesaid, that he should return and pay the said florins to the said creditor and receiver, as is said, within the aforesaid limit and that he observe this contract in every respect, as is contained above.

Transacted in Siena, in the presence of Andrea di Ventura, master mason, and Naldo di Ser Pagno, who were called and present as witnesses.

I Paganello, notary, son of Dietifeci, the notary, was present for all the aforesaid and have written and published these things as requested.

1308–09

In nomine Domini Amen.

Questa e la concordia, che Buonaventura Bartalomei, et Parigiotto ebero insieme, del fatto de la tavola de' lavorio de la parte dietro.

Conoscono ce sono trenta quatro storie principalmente, le quali stimano per la magiorezza d'alcuna d'esse storie, a le comunale: et per li angieletti di sopra, et per alcun' altra opera, se ve si richiedesse di penello, che le dette storie sieno trenta otto: per trenta otto sia pagato, et abia et aver debia di ciasceduna (sic) storia, due fiorino d'oro et mezzo; fornendo esso maestro

Duccio tutto ciò che fa mestiero di penello: et l'operaio dell' opera, debia fornire de colore et d'altro che bisognasse: del quale pagamento, debia avere el mastro Duccio, ora contiati cinquanta fiorini d'oro et l'altri debia avere, scontati questi, sicome servira, per storia.

In the name of the Lord, amen.

This is the agreement, which Bonaventura Bartolomei and Parigiotto shall have together for the making of the panel for the work on the rear part.

They understand that there are thirty-four histories principally, which they estimate, for the majority of any of the same histories, at the common figure, and for the little angels above, and for any other works, if they should be required of the brush, that the said histories shall be thirty-eight. He shall be paid for thirty-eight and he shall have and must have for each history two and a half gold florins, the same Master Duccio furnishing all that which pertains to the craft of the brush, and the master of works must furnish colours and whatever else may be needed; of which payment, Master Duccio shall have in immediate reckoning 50 gold florins and the others he shall have, discounting these, as it shall serve, per history.

1310, 28 November
Siena, State Archive, Diplomatico, Opera della Metropolitana, Parchment 614, 1310, 28 November.

In nomine Domini amen. Omnibus appareat evidenter quod cum ad officium dominorum Novem gubernatorum et defensorum comunis et populi Senensis et ad ipsos dominos Novem pro Comuni Senensis pertineat et expectet habere curam et sollicitudinem et amorem circa operam beate Marie semper Virginis et circa conservationem dicti operis sue opere et circa cessandas expensas inutiles que incumbunt opere supradicte et ad expensas utiles acceptandas et volendas pro ipsa opera conservanda, consilio dominorum Novem gubernatorum et defensorum comunis et populi Senensis choadunato in eorum consistorio novi palatii dicti comunis, in quo dicti domini Novem morantur ad eorum officium exercendum, dictum consilium dictorum dominorum Novem, nemine discordante, audita et diligenter inspecta provisione facta per

discretos et sapientes viros de civitate Senensi, electos et deputatos specialiter super providenda utilitate et commodo dicte opere et super necessariis et opportunis operibus faciendis in opere supradicto, et habita supra predictis deliberatione plenaria invocato nomine Jesu Christe et beate Marie Virginis matris sue, et habito tractatu solempni de predictis, voluit, firmavit atque decrevit, consideratis redditibus et facultatibus et expensis dicte opere, facto diligenti partito secundum formam statuti, quod in operando et faciendo et fieri faciendo opera seu opus musaicum quod est inceptum, et etiam in laborerio nove et magne tabule beate Marie semper Virginis gloriose, solicite et cum omni diligentia procedatur, ita quod quam citius fieri poterit compleantur ad laudem et reverentiam Salvatoris et Beate Virginis matris sue et omnium sanctorum et sanctarum Dei, et quod in laboreriis omnibus faciendis et super eis complendis stent et remaneant solum decem magistri de melioribus et utilioribus dicte Opere, tantum et non plures, consideratis facultatibus redditibus et proventibus dicte Opere; aliis vero magistris omnibus dent commiatum et quod removeantur a laboreriis opere supradicte, cum ipsius opere redditus facultates et proventus non sint sufficientes ad tales et tantas et sic intollerabiles substinendum. Quorum decem magistrorum nomina hec sunt:

Item Magister
 Chamainus
 Crescentini

Item Magister
 Vannes Palmerii

Item Magister
 Andreas Venture

Item Magister Tura
 Paghaniscii

Item Magister
 Vannes
 Bentivegnie

Item Magister
 Corsinus Guidonis

Item Magister
 Tofanus Manni

Item Magister Ciolus
 Maffei

Item Magister Cieffus Item Magister
 Venture Tuccius de la fava

Ego Ioannes Paganelli, notarius et nunc scriba dictorum dominorum Novem, supradicte reformationis et concordie dicti consilii interfui et ut supra continetur de mandato discreti et sapientis viri Antonii magistri Pacis prioris dictorum dominorum Novem in palatio senensi in dicto consistorio coram ser Pasquali Fedis notarii et Ventura Guitonis testibus presentibus in anno Domini MCCCX, indictione VIIII, die XXVIII novembris scripsi et publicavi rogatus.

In the name of the Lord, amen. Let it appear manifestly to all that, since it is expected of and pertains to the office of the Lords Nine, the governors and defenders of the Commune and people of Siena and to the same Lords Nine, for the Commune of Siena to have care and solicitude and love concerning the Opera of the Blessed Mary ever Virgin and concerning the maintenance of the said work or works and concerning the cessation of useless expenses, which weigh upon the aforesaid works, and for the accepting and determining of useful expenses for the maintenance of the same Opera, with the counsel of the Lords Nine, the governors and defenders of the Commune and people of Siena, gathered together in their council chamber in the new palace of the said Commune, in which the said Lords Nine remain for the purpose of exercising their office, the said council of the said Lords Nine, with no one in disagreement, having heard and diligently inspected the provision made by the distinguished and judicious men of the city of Siena, specially elected and deputed to provide for the said works with utility and profit and for the doing of necessary and appropriate works in the aforesaid Opera, and having had a full deliberation on the aforesaid, the name of Jesus Christ and of the Blessed Virgin His mother having been invoked, and having treated solemnly of the aforesaid, wished, confirmed and decreed, having considered the income and means and expenses of the said Opera and made a careful allocation according to the form of the statute, that, as regards the carrying out and doing and causing to be done of the works or work in mosaic, which is begun, and also as regards the work on the new and great panel of the blessed and glorious Mary ever Virgin, it should be carried out carefully and with all diligence, so that they should be completed as speedily as it can be done for the praise and reverence of the Saviour and of the Blessed Virgin His mother and of all the men and women saints of God, and that for the doing of all these works and for their completion, there shall stay and remain only ten of the best and most useful masters of the said Opera, so many and no more, the means, income and provision for the said works being considered; to all the other masters, indeed, they give leave of absence and

[decree] that they be removed from the undertakings of the aforesaid Opera, since the income of the same Opera and its means and provision are not sufficient to sustain such and so great and so intolerable burdens.

Of which ten masters these are the names:

Item Master Camaino di Crescentino

Item Master Vanni di Palmerio

Item Master Andrea di Ventura

Item Master Tura di Paganiscio

Item Master Vanni de Bentivegna

Item Master Corsino di Guido

Item Master Tofano Manni

Item Master Ciolo Maffei

Item Master Ceffo di Ventura

Item Master Tuccio de la fava

I, Giovanni de Paganello, the notary, and now the scribe of the said Lords Nine was present at the above-mentioned decisions and agreements of the said council and, as is contained above, at the command of the distinguished and judicious man, Antonio di Maestro Pace, Prior of the said Lords Nine, in the palace of Siena in the said council chamber, in the presence of Ser Pasquale Fedi, the notary, and of Ventura di Guido, present as witnesses, in the year of the Lord 1310, the 9th indiction, on the 28th day of November, I wrote and published this as requested.

1311, June

Siena, State Archive, Biccherna 125, Entrata e uscita, 1311, Jan.–June, f.117r (in old ink f.261r).

Ancho – VIII – sol. a Malfarsetto Buoninsegnie
a Pericciuolo Salvucci
a Ciertiere Guida
a Marcho Cierreti
trombatori et ciaremella et nacchare del chomune di Siena per una rinchontrata che feciero de la tavola de la Vergine Maria a ragione di due soldi per uno sechondo la forma de patti chene tra'l chomune di Siena e loro.

Also, VIII soldi to Malfarsetto Buoninsegna
to Pericciuolo Salvucci
to Certiere Guida
to Marco Cerreti
trumpeters and pipers and castanet players of the Commune of Siena for a meeting with the panel of the Virgin Mary, at the rate of two soldi for each, according to the form of the agreements which were made between them and the Commune of Siena.

Appendix III

The surviving accounts for the San Pier Maggiore Altarpiece (Cat. no. 8)

1370 FLORENCE, ARCHIVIO DI STATO. S. PIER MAGGIORE, vol. 50, f. 6ᵛ

1370. Niccolaio dipintore dee avere per disegnare la tavola dell'altare di San Piero:
lavorò la prima settimana dì 5.
lavorò dì 4.
lavorò dì 5.
Anne avuto a dì 10 di novembre, ebe da me ser Taddeo, fior. IV d'oro.
Anne avuto a dì 17 di novembre fior. IV d'oro.
Anne avuto a dì 24 di novembre fior. IV d'oro.

1371 FLORENCE, ARCHIVIO DI STATO. S. PIER MAGGIORE, Vol. 50, ff. 8ᵛ, 9

1371. L'opera di San Piero Maggiore dee dare, paghai per lei: Per 50 vaselli, s. VIII—per lb. 1 di biaccha, s. IV—per oncie 6 di cinabro, s. VI—per oncie 2 di giallolino, s. II—per oncie 1 di biodetto, s. II—per q̄ro 1 di biodetto d'oltremare, l. I s. V—per q̄ro 1 d'azurro d'oltre mare, l. I s. XIII—per rechatura 1 colmo della tavola da casa Matteo di Pacino, s. I d. VI—per lb. 1 di biaccha, s. IV—per huova s. X d. II—per cento pezzi d'oro per li fregi e drappi delle fighure, d'agosto, fior. I d'oro—per cento pezzi d'oro per li fregi e drappi delle fighure, a dì 2 di settembre, fior. I d'oro—Per cento pezzi d'oro per drappare il colmo di mezzo a dì 10 di settembre fior. I d'oro—Per portare e rechare la tavola a Santa Maria Nuova, quando si vernichò, a dì 19 di settembre, s. VI—per huova e ariento a Tuccio a dì 31 d'ottobre, s. XII d. VIIII—a dì 29 di novembre diedi a Tuccio per colori per l'archo della cappella, l. I s. X—a dì 17 di dicembre per IIc (duegento) pezzi d'oro per li compassi dell'arco della cappella, l. VI s. X—decto dì per 18 pezzi d'oro, s.XII—e per rechare e portare la predella a Santa Maria Nuova a vernichare, s. III—e per lb. 1 di biaccha per fare cenerognolo per mettere i civori dentro d'azurro, s. IV—per 100 bullette per la tavola, s. III d. IV—per 1 pezzo di stagno per la tavola, s. II d. II—portare a seghare 1 legno alla bottegha di Bartolo Lana s. I—per 24 anellini per la cortina, a d. VI l'uno, s. XII—per bollette e chiovi per chiavare i colonelli e folgle, s. V—per riportare e achattatura uno paio di tagle, s. III d. IIII—per spagho rinforzato per la cortina, s. V d. VI—per orpimento con minio per la cortina s. VI—a Niccolò, lastraiuolo, per uno suo lavorante checci aiutò a fare buche, s. X

Reproduced from R. Offner and K. Steinweg, *A Critical and Historical Corpus of Florentine Painting*, New York, 1965, Section IV, Vol. III, *Jacopo di Cione*, pp. 41–2.

1370

Niccolaio painter is owed for designing the altarpiece of St Peter.[1]

> he worked the first week for 5 days
> ,, ,, [the second week] for 4 days
> ,, ,, [the third week] for 5 days

He has had on 10 November from me Ser Taddeo 4 gold florins.
He has had on 17 November 4 gold florins.
He has had on 24 November 4 gold florins.[2]

[Archivio di Stato di Firenze, Conventi Soppressi, San Pier Maggiore, vol. 50, Ricordanze 1369–1380, f. 6.]

1371

The committee of works for San Pier Maggiore, must pay
For 50 small pots[3] 8 *soldi*
for 1 pound of lead white 4 *soldi*
for 6 ounces of vermilion 6 *soldi*
for 2 ounces of lead tin yellow 2 *soldi*
for 1 ounce of pale blue[4] 2 *soldi*
for 1 quarter of pale blue ultramarine (ultramarine ash) 1 *lira* 5 *soldi*
for 1 quarter of ultramarine blue 1 *lira* 8 *soldi*
for fetching back one *colmo*[5] of the altarpiece from the house of Matteo di Pacino[6] 1 *soldo* 6 *denari*
for 1 pound of lead white 4 *soldi*
for eggs[7] 10 *soldi* 2 *denari*
for 100 pieces of gold [leaf] for the fringes and draperies of the figures[8] in August 1 gold florin
for 100 pieces of gold for the fringes and draperies of the figures on 2 September 1 gold florin
for 100 pieces of gold for the draperies of the *colmo di mezzo* [middle/upper tier][9] on 10 September 1 gold florin

for taking and fetching the altarpiece to and from Santa Maria Nuova when it has been varnished[10] on 19 September 6 *soldi*

for eggs and silver to Tuccio[11] on 31 October 12 *soldi* 9 *denari*

on 29 November given to Tuccio for pigments for the arched vault of the chapel 1 *lira* 10 *soldi*

on 17 December for 200 [*duegento*] pieces of gold for the ribs of the vault of the chapel 6 *lire* 10 *soldi*

on the same day for 18 pieces of gold 12 *soldi*[12]

for fetching and taking the predella to Santa Maria Nuova to be varnished[13] 3 *soldi*

and for 1 pound of lead white for making an ash-grey colour for putting blue into the vaults[14] 4 *soldi*

for 100 small nails for the altarpiece 3 *soldi* 4 *denari*

for a piece of tin for the altarpiece[15] 2 *soldi* 2 *denari*

for taking for sawing one plank of wood[16] to the workshop of Bartolo Lana 1 *soldo*

for 24 little rings for the curtain[17] at 6 *denari* each 12 *soldi*

for small and large nails for nailing the columns[18] and foliate ornament 5 *soldi*

for returning and borrowing 2 sets [a pair] of block and tackle 3 *soldi* 4 *denari*

for a piece of cord(?) for the curtain 5 *soldi* 6 *denari*

for orpiment with red lead (*minium*) for the curtain 6 *soldi*

to Niccolò, paver,[19] for one of his workers who helped make holes 10 *soldi*

Notes on the translation

The surviving documents for the San Pier Maggiore Altarpiece are fragmentary. Apart from the payments of 1370 which must relate to an early stage in the production of the altarpiece, the sequence of payments appears more or less to follow the chronological progress of the later stages of its manufacture and its installation on the altar.

1. This is almost certainly Niccolò di Pietro Gerini (see p. 185). Niccolò, according to Offner (*Corpus of Florentine Painting*, *Jacopo di Cione*, Section IV, Vol. III, p. 2),

lived in the parish of San Pier Maggiore. His connection with the church, and indirectly with the Albizzi, continued: in 1392 he was commissioned to restore a panel showing the Deposition of Christ which had hung above the door to the cemetery in San Pier Maggiore, and which had been commissioned from Maso di Banco by Drea, daughter of Albizo del Riccho degli Albizzi (see David Wilkins, *Maso di Banco: a Florentine artist of the early Trecento*, New York and London, Garland Publishing Inc., 1985, p. 117). This may well be the *Pietà* in the Uffizi, Florence (Inv. no. 1890–454), which has been attributed to Maso (see W. R. Valentiner; 'Orcagna and the Black Death of 1348', *Art Quarterly*, 1949, pp. 48–68).

2. In the second week Niccolò was paid the same amount as in the first and third weeks, although he worked one day less. It may be worth noting that 18 November is the feast day of the Dedication of the Churches of Sts Peter and Paul in Rome. As this feast day is likely to have been honoured at San Pier Maggiore, Niccolò may have had to be paid for a day of enforced idleness.

3. The small pots were probably for keeping the ground pigments and also for the pre-mixed shades of colour used in the systematic modelling of draperies (see p. 29 and pp. 134ff.).

4. This first payment for 'pale blue' (*biodetto*) could, strictly speaking, refer to a number of possible pale blue pigments, not necessarily ultramarine (see p. 178). However, as it is immediately followed by a payment specifically for pale blue ultramarine (*biodetto d'oltremare*), now called ultramarine ash, it is reasonable to assume that this first reference is to a cheaper and still paler grade of ultramarine ash. In addition none of the artificial copper blues which were also known as *bio(a)detto* was identified in samples from the altarpiece.

5. As the literal translation of the word *colmo* is top or summit, it is often taken to refer to the crowning pinnacles of an altarpiece. However, the way the term is used in documents of the period indicates that its meaning was not so specific: for example, in the contract of 12 April 1372

for an altarpiece for the Monastery of Passignano (see G. Milanesi, *Documenti per la Storia dell'Arte Senese*, I, 1854, p. 269) the altarpiece is described as being 'cum tribus colmis' and the contract makes it clear that these are main tier panels and that they are to show the Pentecost in the centre and Sts Catherine and Anthony Abbot on either side. However, as the scenes above are also described using the same word – 'in aliis vero colmis' – it seems that the term was somewhat loosely used in the same way that we use the word panel. Possibly it first came into use when altarpieces were constructed from linked vertical units with the uppermost pinnacle panels integral to the units (see Cat. no. 5), the term referring to the whole vertical unit. With the evolution of the horizontal form of construction with detached pinnacles, fitted only on assembly of the altarpiece, the application of the term may have become correspondingly less specific. Therefore in this instance the reference is most probably to a main tier panel.

6. Matteo di Pacino is documented from 1359 to 1394. His only surviving autograph work is a triptych signed and dated 1360, ex-Stroganoff Collection, Rome (see A. Munõz, *Pièces de choix de la collection du Comte Grégoire Stroganoff*, Rome, 1912, Part 2, Plate 6). The four panels attributed to him in the Gemäldegalerie in Berlin (see M. Boskovits, *Frühe Italienische Malerei, Katalog der Gemälde*, Berlin, 1987, pp. 112ff. and Abb.168–173) are neatly and accurately punched in a similar way to the smaller panels of the San Pier Maggiore Altarpiece, using the simple punches which seem to have been standard in the circle of Jacopo di Cione and Niccolò di Pietro Gerini. This could be taken to support the tentative speculation that the panel may have been fetched from his house after punching of the *sgraffito* textiles, and that he may have been responsible for the gilding and punching of the altarpiece.

7. The fact that the eggs cost more than the fifty small pots suggests that this payment was for a fairly large number. For obvious reasons, all the eggs to be used in painting the altarpiece would not be purchased at once so this may represent a cumulative retrospective payment.

8. This gold leaf was evidently of the special grade needed for mordant gilding (see p. 182).

9. If the previous two purchases of gold leaf were for the mordant gilding of the main tier, it is possible that this third payment refers to the gold for the second or middle tier (that is, the Scenes from the Life of Christ) and therefore in this instance *colmo di mezzo* means the middle, or even perhaps half-length, tier rather than the middle panel of the main, full-length tier.

10. This entry can be interpreted in more than one way. One possible reading is that the panel made its journey to Santa Maria Nuova and back only after it had been varnished, but by analogy with the second payment concerning the varnishing of the predella, it seems more likely that the use of the past tense, 'when it has been varnished' (*si vernichò*) is connected with the fetching back of the panel. Similarly, in the second payment the use of the purposive 'to be varnished' (*a vernichare*) belongs to the taking, rather than the fetching, of the predella. Therefore in both entries the tense of the verb 'to varnish' is related to the second of the two movements recorded. Nevertheless, it is not clear why the altarpiece should have been taken to Santa Maria Nuova for varnishing. The chapel of Sant'Egidio (formerly dedicated to St Luke) in that church was the meeting-place of the Compagnia di San Luca (see Ottavio Andreucci, *Della biblioteca e pinacoteca dell'ospedale di S. Maria Nuova* [etc.], Florence, 1871, pp. 27–9, and W. and E. Paatz, *Die Kirchen von Florenz*, Frankfurt-am-Main, IV, pp. 1–7; 15; 23; p. 49, note 95), so one can speculate whether it was taken there for assessment and then literally given the seal of approval by the very final process of being varnished. Another possibility is that some part of the church provided a suitably large and dust-free area for laying out the panels for the difficult application of the varnish (see p. 183). However, as far as is known, the Compagnia di San Luca was primarily a religious organisation and not concerned with practice (see Carlo Fiorilli, 'I dipintori a Firenze nell'arte dei medici, speziali e merciai', *Archivio Storico Italiano,* LXXVIII, 1920, Vol. II, pp. 35ff.). The *compagnie* met once

a month for religious purposes and to honour the dead. Officials met on the first Sunday of October and the first Sunday of April to elect new officers for the next six-month period, and on the first Sunday of each month to inscribe new members (Fiorilli, loc. cit., pp. 51–4, 63). Whatever the reason for taking the panels to Santa Maria Nuova, the distance they were carried is likely to have been relatively short. Although Jacopo di Cione is recorded as living in the parish of Santa Maria Novella from 1368 up to at least 1390 (Offner, op. cit., pp. 7–12), Niccolò di Pietro Gerini, on the other hand, was a resident of the parish of San Pier Maggiore at the time when the altarpiece was painted. As the project may well have been arranged through him, the work was probably executed in his workshop or even in the church of San Pier Maggiore itself, perhaps in a temporary workshop like that set up in San Giovanni Fuorcivitas for the altarpiece eventually painted by Taddeo Gaddi (see p. 11). The distance between Santa Maria Nuova and San Pier Maggiore is no more than about 250 metres.

11. According to Offner he is identifiable with Tuccio di Vanni who is referred to in other documents for San Pier Maggiore in 1371. He was working there from 9 June to 27 October and from 3 to 24 November in 1371. He designed a dossal for a certain Madonna Lucia in 1374, and carried out a number of manuscript illuminations in antiphonaries in 1377 and 1378 (see Mirelli Levi d'Ancona, *Miniature e miniatori a Firenze dal XIV al XVI secolo*, Florence, 1962, pp. 253ff.). He is documented with the Arte dei Medici e Speziali in 1379 and 1382 (see R. Ciasca, *L'Arte dei Medici e Speziali nella storia e nel commercio fiorentino del secolo XII al XV*, Florence, 1927, pp. 705, 709). He entered the Compagnia of St Luke in 1380. No surviving work has been identified as by him and the accounts suggest that he was employed solely on the decoration of the chapel, although he might have been a member of Jacopo's workshop and assisted on the altarpiece as well.

12. Although this gold may have been less thinly beaten than that bought for the mordant gilding, it seems to have been more or less the same price (see Appendix IV, Table (i)).

13. See Note 10.

14. This refers to the decoration of the vaults of the chapel, hence the large quantity required.

15. See p. 16. Alternatively, it might have been used for covering the heads of the nails used to attach the battens and the various frame fittings. However, such precautions seem somewhat superfluous when the nail heads would have been only in the battens and on the back of the panel, rather than beneath the gesso and the gilding as in the situation described by Cennino (see p. 13).

16. This would have helped to support the altarpiece and may even have been one of the battens nailed to the back of the panels since these appear to have been attached at a relatively late stage (see p. 160).

17. See pp. 16–17 and Cat. no. 3, p. 80.

18. These are the carved twisted columns and ornaments which would have been gessoed and gilded separately and only nailed in place once the main part of the construction had been assembled. For holes which were evidently made for the pegging in of carved foliate ornaments see Cat. no. 5, p. 107.

19. Presumably in the paved stone floor of the church for the insertion of buttresses on either side of the altar to support the outer piers or pilasters of the altarpiece. See p. 160.

Appendix IV

(i) Table of Pigment Prices

Pigment	Brief details of purchase, commission, etc.	Date	Quantity	Price	Price/pound (or appropriate unit)	Source[1]	Comments
Gold leaf	For Bonaccorso di Cini and Alesso di Andrea for the Chapel of San Jacopo, Pistoia Cathedral	24.2.1347	400 leaves	11 *l*.8*s*.0*d*.	2 *l*.17*s*./100 leaves	Ciampi, 1810, doc. XXIX, p. 146	[2]
Gold leaf	As above	19.4.1347	1700 leaves	47 *l*.12*s*.0*d*.	2 *l*.16*s*./100 leaves	As above, p. 147	From Bartolo Ciani *speziario*; 1 of 6 purchases at this unit price.
Gold leaf	As above	4.9.1347	1000 leaves	42 *l*.0*s*.0*d*.	4 *l*.4*s*./100 leaves	As above, p. 149	Much dearer.[2]
Gold leaf	For repair of fresco of Virgin and Child above central portal, façade, Siena Cathedral, by Luca di Tommè and Cristofano di Stefano	August 1358	500 *pezzi*	6 *fl*.36*s*./22 *l*.10*s*[3]	4 *l*.10*s*./100 leaves	Fehm, 1986, doc. 3a, p. 195	Unit price stated in accounts; 1 of 3 purchases. Paid to Magio di Ceccho, *battelloro*.
Gold leaf	As above	September 1358	117 *pezzi*	4 *l*.14*s*.	4 *l*.0*s*.4*d*/100 leaves	As above, doc. 3e	Rather cheaper: a different quality?
Gold leaf	For vault of guild hall of Judges and Notaries, Florence, by Jacopo di Cione	19.9.1366	1000 leaves	10 *fl*.	1 *fl*./100 leaves [≈3 *l*.7*s*.]	Borsook, 1982, doc. III, p. 87	1 of 2 entries. 1 *fl*.≈±67*s*.[3]
Gold leaf	San Pier Maggiore Altarpiece, attrib. to Jacopo di Cione and others	August 1371	100 *pezzi*	1 *fl*.	1 *fl*./100 leaves [≈3 *l*.5*s*.2*d*.]	Offner, 1965, p. 42	1 *fl*.≈±65*s*.2*d*. only rate quoted, month unknown.
Gold leaf	As above	17.12.1371	200 *pezzi*	6 *l*.10*s*.	3 *l*.5*s*./100 leaves	As above	
Gold leaf	San Pier Maggiore Altarpiece, attrib. to Jacopo di Cione and others	17.12.1371	18 *pezzi*	12*s*.0*d*.	3 *l*.6*s*.8*d*./100 leaves	Offner, 1965, p. 42	
Gold leaf	Sold by Luca di Tommè for the use of Ugolino Ilario for the choir of Orvieto Cathedral	4.2.1374	934 leaves	10 *fl*.	1 *fl*.6*s*.3*d*./100 leaves [≈3 *l*.19*s*.7*d*.]	Fehm, 1986, doc. 17, p. 198	1 *fl*.≈73*s*.4*d*. in Florence; only rate quoted. Unit price quoted in accounts.
Gold leaf	Chapel of the Sacra Cintola, Prato Cathedral, frescoes by Agnolo Gaddi	26.8.1394	1100 *pezzi*	33 *l*.11*s*.0*d*.	3 *l*.1*s*.0*d*./100 leaves	Poggi, 1932, doc. 58, p. 367	[4]
Gold leaf	As above	6.11.1394	500 *pezzi*	16 *l*.0*s*.0*d*.	3 *l*.4*s*.0*d*./100 leaves	As above	[4]
Silver leaf	For Bonaccorso di Cini and Alesso di Andrea for the Chapel of San Jacopo, Pistoia Cathedral	22.2.1347	12 leaves	1*s*.4*d*.	11*s*.1*d*./100 leaves	Ciampi, 1810, doc. XXIX, p. 147	About one-fifth the price of the gold leaf used for this commission.
Silver	Altarpiece for San Giovanni Fuorcivitas, Pistoia, by Taddeo Gaddi and others; paid to Jacopo Ciani	c.1348?	1 *libra*	10*s*.0*d*.	10*s*.0*d*.	Ladis, 1982, doc. 44, p. 257	
Gilded tin	For vault of guild hall of Judges and Notaries, Florence, by Jacopo di Cione	19.9.1366	20 leaves	1 *fl*.	c.3*s*.4*d*./1 leaf	Borsook, 1982, doc. III, p. 87	1 *fl*.≈±67*s*. About 5 times the price of the gold leaf (see above).[5]
Gilded tin	As above	24.11.1366	12 leaves	1 *l*.16*s*.0*d*.	c.3*s*.0*d*./1 leaf	As above, doc. IV, p. 87	[5]
Gilded tin	Letter to Francesco di Marco Datini from Francesco e Stoldo listing pigments	10.4.1395	2 'pesi'	1 *l*.14*s*.	17*s*. each	Piattoli, 1929, p. 433	It is not clear how much 2 *pesi* is, but it still seems expensive.[5]
Gilded tin	To Arrigo di Niccolò from Francesco di Marco Datini	13.9.1408	300 *pezzi*	14*s*.7*d*.	4*s*.10*d*./100 leaves	Mazzei 1880, Vol. II, p. 411	Very much cheaper than gold leaf.[5]

Pigment	Brief details of purchase, commission, etc.	Date	Quantity	Price	Price/pound (or appropriate unit)	Source[1]	Comments
Ultramarine	For Bonaccorso di Cini and Alesso di Andrea for the Chapel of San Jacopo, Pistoia Cathedral	23.2.1347	3 oz.	12 *l*.0*s*.0*d*.	4 *l*.0*s*.0*d*./oz	Ciampi, 1810, doc. XXIX, p. 147	Ultramarine was the dearest item in the accounts: a servant was paid 10*s*. to fetch it from Florence.[6]
Ultramarine	As above	9.4.1347	3½ oz.	11 *l*.7*s*.6*d*.	3 *l*.5*s*.0*d*./oz	As above	Unit price quoted in accounts.[6]
Ultramarine	As above	16.7.1347	7¼ oz.	22 *l*.16*s*.9*d*.	1 *fl*./oz. [3 *l*.3*s*.0*d*.]	As above, p. 149	Unit price quoted in accounts; rates of exchange quoted as 1 *fl*.≈±61–62*s*.
Ultramarine	San Pier Maggiore Altarpiece, attrib. to Jacopo di Cione and others	1371	¼ lb [3 oz]	1 *l*.13*s*.0*d*.	11*s*.0*d*./oz.	Offner, 1965, p. 42	[7]
'Biodetto d' oltremare'	As above	1371	¼ lb. [3 oz.]	1 *l*.5*s*.0*d*.	8*s*.4*d*./oz.	As above	Probably a lighter blue, lower grade ultramarine.[7]
'Biodetto'	As above	1371	1 oz.	2*s*.0*d*.	2*s*.0*d*./oz.	As above	Very low grade ultramarine?[7]
Ultramarine	Chapel of the Sacra Cintola, Prato Cathedral, frescoes by Agnolo Gaddi; bought from Donato di Bonifazio, *speziale*, of Florence	1392/3	2 lb. 7½ oz.	98 *l*.8*s*.9*d*.	10 *fl*./lb. [37 *l*.10*s*.; 3 *l*.2*s*.6*d*./oz.]	Poggi, 1932, doc. 37, p. 363	1 *fl*. = 3*l*.15*s*.; rate given in accounts.
Ultramarine	As above	27.10.1394	6 oz. 3 grains	45 *l*.0*s*.0*d*.	80 *l*.0*s*.0*d*./lb. [≈6 *l*.13*s*.4d./oz.]	As above, doc. 58, p. 367	
Ultramarine	As above	As above	6 oz.	27 *l*.1*s*.0*d*.	14 *fl*./lb. [≈1 *fl*.12*s*.11*d*.– 4 *l*.10*s*.3*d*.-/ oz.]	As above	1 *fl*. = 77*s*.4*d*.; rate given in accounts.[8]
'Azurro fine'	As above	20.4.1395	8 oz.	9 *fl*.9*s*.8*d*.	14 *fl*./lb. [≈1 *fl*.12*s*.10*d*.– 4 *l*.9*s*.7*d*.-/ oz.]	As above, doc. 58, p. 368	1*fl*. = 76*s*.10*d*.; rate given in accounts.[9]
'Azurro'	As above	As above	6 oz.	2 *fl*.1 *l*.1*s*.9*d*.	5½ *fl*./lb. [≈1 *l*.15*s*.2*d*./ oz.]	As above	[10]
Azurite[11]	For Bonaccorso di Cini and Alesso di Andrea for the Chapel of San Jacopo, Pistoia Cathedral	23.2.1347	1 lb.	3 *l*.6*s*.0*d*.	3 *l*.6*s*.0*d*. [5*s*.6*d*./oz.]	Ciampi, 1810, doc. XXIX, p. 146	From Matteo Pagni, *speziario*; *c*. ¹⁄₁₂ the price of ultramarine.[12]
Azurite	As above	17.6.1347	½ lb. [6 oz.]	1 *l*.10*s*.0*d*.	3 *l*.0*s*.0*d*. [5*s*.0*d*./oz.]	As above, p. 149	[12]
Azurite	As above	24.11.1347	3⅝ oz.	14*s*.4*d*.	≈2 *l*.7*s*.5*d*. [≈4*s*.0*d*./oz.]	As above, pp. 149–50	[12]
Azurite	*Crucifixion*, above cemetery entrance, San Pier Maggiore, Florence, restored by Niccolò di Pietro Gerini	1392	1½ lb.	3 *fl*.2 *l*.16*s*.	2½ *fl* [≈15*s*.5*d*./oz]	Wilkins, 1985, doc. 5, pp. 119–20	Unit price quoted in accounts; 1 *fl*.≈±74–75*s*. Originally painted by Maso di Banco.
Azurite	To Master Ambrogio, *orafo*, from Francesco di Marco Datini	16.9.1394	5 lb. 1 oz.	13 *fl*.25*s*.7*d*. picc. ('a oro 13 *fl*.6*s*.9*d*.')	≈2 *fl*.47*s*.2*d*. [≈16*s*.6*d*./oz.]	Mazzei, 1880, Vol. II, p. 409	1 *fl*.≈ 75*s*.7*d*. (9.1394). Price given in 2 accounting systems.
Azurite	Letter to Francesco di Marco Datini from Francesco e Stoldo listing pigments	10.4.1395	4 lb.	4 *fl*.	1 *fl*.	Piattoli, 1929, p. 433	'1/1 fior. della lib'. [sic]
Indigo	For Bonaccorso di Cini and Alesso di Andrea for the Chapel of San Jacopo, Pistoia Cathedral	24.2.1347	1 oz.	3*s*.10*d*.	2 *l*.6*s*.0*d*. [3*s*.10*d*./oz.]	Ciampi, 1810, doc. XXIX, p. 146	Cheaper than azurite.
Indigo	Letter to Francesco di Marco Datini, cited above	10.4.1395	1 lb.	2 *l*.4*s*.0*d*.	2 *l*.4*s*.0*d*. [3*s*.8*d*./oz.]	Piattoli, 1929, p. 433	
'Azzurrum'	For vault of guild hall of Judges and Notaries, Florence, by Jacopo di Cione	19.9.1366	10 lbs.	30 *l*.0*s*.0*d*.	3 *l*.0*s*.0*d*. [5*s*.0*d*./oz.]	Borsook, 1982, doc. III, p. 87	[13]

Pigment; Sundries	Brief details of purchase, commission, etc.	Date	Quantity	Price	Price/pound (or appropriate unit)	Source[1]	Comments
'*Azurro da macinare*'	Chapel of the Sacra Cintola, Prato Cathedral, frescoes by Agnolo Gaddi	27.7.1394	1 lb.	2 *l*.8*s*.0*d*.	2 *l*.8*s*.0*d*. [4*s*.0*d*./oz.]	Poggi, 1932, doc. 58, p. 367	'per libre una d'azurro da macinare reghò da Firenze'[13]
Verdigris	To Tommaso del Mazza from Francesco di Marco Datini	16.12.1384	4 oz.	[6*s*.8*d*.]	[1 *l*.0*s*.0*d*.]	Mazzei, 1880, Vol. II, p. 383	(Unclear from accounts if 6*s*.8*d*. is price or price/pound.)
Vermilion	For Bonaccorso di Cini and Alesso di Andrea for the Chapel of San Jacopo, Pistoia Cathedral	24.2.1347	½ lb. [6 oz.]	5*s*.0*d*.	10*s*.0*d*.	Ciampi, 1810, doc. XXIX, p. 146	Ready ground: 'uncinabri macinati' [sic].
Vermilion	San Pier Maggiore Altarpiece, attrib. to Jacopo di Cione and others	1371	6 oz.	6*s*.0*d*.	12*s*.0*d*.	Offner, 1965, p. 42	
Vermilion	Letter to Francesco di Marco Datini from Francesco e Stoldo listing pigments	10.4.1395	1 lb.	1 *l*.4*s*.0*d*.	1 *l*.4*s*.0*d*.	Piattoli, 1929, p. 433	
Vermilion – pale	As above	As above	6 oz.	4*s*.0*d*.	8*s*.0*d*.	As above	'Cinabrese chiara'; one-third the price of the 'cinabro' above.[14]
'*Giallolino*' [Lead-tin yellow]	For Bonaccorso di Cini and Alesso di Andrea, cited above	24.2.1347	½ lb. [6 oz.]	9*s*.0*d*.	18*s*.0*d*.	Ciampi, as above	Compare entry below.
'*Giallolino*'	As above	As above	1 lb.	9*s*.0*d*.	9*s*.0*d*.	As above	A different quality or an error in accounting or transcription?[15]
'*Giallolino*'	San Pier Maggiore Altarpiece, cited above	1371	2 oz.	2*s*.0*d*.	12*s*.0*d*.	Offner, as above	
Lead white	For Bonaccorso di Cini and Alesso di Andrea, cited above	24.2.1347	1 lb.	2*s*.0*d*.	2*s*.0*d*.	Ciampi, as above	
Lead white	San Pier Maggiore Altarpiece, cited above	1371	1 lb.	4*s*.0*d*.	4*s*.0*d*.	Offner, as above	
Lead white	Tommaso del Mazza, from Francesco di Marco Datini	16.12.1384	1 lb. 11 oz.	6*s*.8*d*.	3*s*.6*d*.	Mazzei, 1880, Vol. II, p. 383	
Grinding stone	For Bonaccorso di Cini and Alesso di Andrea for the Chapel of San Jacopo, Pistoia Cathedral	30.1.1347		1*s*.4*d*.		Ciampi, 1810, doc. XXIX, p. 146	Payment to 'Andree clerico de cappella'.
Eggs	As above	8.2.1347	Unspecified	1*s*.4*d*.	Unspecified	As above	
Linseed oil	As above	24.2.1347	11 oz.	1*s*.8*d*.	1*s*.10*d*.	As above	1 or 2 entries.
Glue ['*Colla di Bologna*']	As above	As above	1 lb.	2*s*.0*d*.	2*s*.0*d*.	As above	'colle bononiensis' [sic]
'*Varnish*'	As above	21.2.1347	1 lb.	6*s*.0*d*.	6*s*.0*d*.	As above, p. 147	
Payment to Alesso or Bonaccorso	As above	1347			12*s*./day	As above	Several entries at this rate.
Payment to assistant in painting	As above	As above			8*s*./day	As above	Several assistants paid at this rate; several entries.
Payment to assistant for grinding	As above	As above			2*s*./day	As above	One assistant paid for grinding only; several entries.
Small pots	San Pier Maggiore Altarpiece, attrib. to Jacopo di Cione and others	1371	50	8*s*.0*d*.	*c*. 2*d*. each	Offner, 1965, p. 42	Presumably for storage of pigments, etc.
Eggs	As above	As above	Unspecified	10*s*.2*d*.	Unspecified	As above	
Nails	As above	As above	100	3*s*.4*d*.	3*s*.4*d*./100	As above	'per la tavola'
Fetching and carrying panels	As above	As above		1*s*.6*d*.; 3*s*.; 6*s*.		As above	Panels carried to and from Santa Maria Nuova: see Cat. no. 8 and Appendix III, Note 10, p. 199.

Notes

The Table lists a representative selection of entries from a number of published accounts: not all the entries for gold leaf from the 1347 accounts for the Chapel of San Jacopo, Pistoia Cathedral, for example, were included; nor were all those for the blue and gold from the accounts of the Sacra Cintola Chapel, Prato Cathedral, 1392–5. A great many accounts include payments for unspecified pigments, or for pigments, some of which are named but not priced individually: such entries have been excluded. It is, however, interesting, and perhaps not surprising, that the pigments named seem to be the more expensive ones: the accounts for the work on the façade of Siena Cathedral in 1358 (for which payments for gold leaf are listed in the Table) include payments for 'blue, lake and other colours' and 'ultramarine and other colours' (Fehm, 1986, docs. 3b, 3f, p. 195).

1. Full details of sources are given in the Bibliography.

2. The difference in price between the last entry for gold leaf, of 4*l*.4*s*. for 100 leaves, and the earlier entries, of about 2*l*.16*s*. for 100 leaves, may indicate an increase in the price of gold; the supplier in the last case was an associate of Bartolo Ciani, who supplied the gold previously. The more expensive gold leaf may, however, have been of better quality. Other examples of similar price differences occur elsewhere in the Table.

3. Unless stated otherwise, the exchange rates used to convert the Florentine florin into *soldi* and *denari* are those published by Peter Spufford [and others], *Handbook of Medieval Exchange*, London, 1986, pp. 1–58; see also the introduction for an explanation of the accounting systems and the various sources for the exchange rates used. Some accounts give the exchange rate being used. Because of fluctuations in the exchange rates over the period of time taken to execute a commission, some slight variation in prices, particularly perhaps in those of gold leaf, is not surprising and need not reflect a difference in the quality of the pigment.

4. There are small differences – ±3 *soldi* or so – in the prices for gold leaf in this commission. Apart from the possibilities noted above (notes 2 and 3) there is an added factor in this case: the gold appears to have been obtained from different suppliers over a period of a few months.

5. See notes on 'golden tin' in Cennino, pp. 60–3. Prices for tin have been excluded from the Table as it was not always clear what form the tin was in or whether *pezzi* of tin were comparable in size with those of gold leaf; the tin was not necessarily used for laying gold (in fresco: this use is referred to in the 1347 Chapel of San Jacopo accounts), but could also have been used for covering nail heads, for example. Allowing for the fact that the precise size and thickness of the pieces of tin is unknown, one wonders whether it was all that cheap: in the San Jacopo accounts one piece of tin 'leaf' cost about 1*s*.3*d*., much the same price as the grinding stone, while one, undoubtedly thinner, leaf of gold cost *c*.7*d*. The cost of the tin, as well as that of the gold, and the labour involved in applying the gold leaf to the tin, may partly explain the high cost of the material in these accounts. The much later reference to Arrigo di Niccolò's gilded tin, described as '300 pezi d'oro posto in su lo stangnio' [sic], is included for comparison.

6. All the ultramarine was brought in from Florence, from different suppliers, over a period of five or six months; the differences in price may be due as much to this as to genuine differences in quality. The supply of ultramarine was, in any case, variable, so that the pigment was sometimes hard to obtain. It was always expensive.

7. See Appendix III for the San Pier Maggiore documents, particularly note 4, p. 198; also the section 'Colour and Pigments' in the Introduction, pp. 35–6. The price difference between 'biodetto d'oltremare' and 'biodetto' is very marked and must indicate a great difference in quality. No artificial, copper-containing, blue pigment was detected as having been used on the altarpiece, otherwise one might suspect that 'biodetto' was such a pigment.

8. The price for 1 oz. obtained by calculation from the price paid is not quite the same as that obtained using the stated exchange rate for the florin; perhaps a handling charge was included in the payment made.

9. Several entries appear for this grade of pigment.

10. Several entries appear for this grade of pigment. The pigment is described as 'azurro' in the accounts, but it still appears to be more expensive than azurite at the same date and is probably a lower grade of ultramarine. 'Azurro fine' appears to be the same price as one of the entries for ultramarine in the accounts, at about 4*l*. 9 or 10*s*. an ounce, and represents a better grade of the pigment.

11. Azurite: 'Azzurrum de Alamania', 'Azurro della Mangna' [sic] and similar entries in the accounts.

12. As with the ultramarine, the different prices may reflect the different suppliers in Florence as much as the quality.

13. Unfortunately no price for azurite is available for the period around 1366. Borsook (1982) comments on the cheapness of this unidentified blue pigment: it could be an artificial copper-containing blue (for which there is no known entry in any of the accounts consulted) or a low grade mineral pigment, or even indigo. Without more evidence no conclusion can be reached. The other unidentified blue, from the Prato accounts of 1395, appears to be much cheaper than either ultramarine or azurite: it, too, could be an artificial copper blue, or indigo (although in other cases indigo, where used, has been specified).

14. A lower quality, paler vermilion, or a mixture, containing other pigment(s) as well, such as red lead or lead white?

15. Depending upon the proportions of lead and tin and the amount of heating the pigment receives during preparation, the colour is more or less deep; this could, perhaps, be reflected in the price.

(ii) Table of Weights and Measures

There was no common system of measurement in fourteenth-century Italy; each major centre, such as Bologna, Florence, Pisa and Milan, had its own system of weights and measures. A large part of Francesco Balducci Pegolotti's handbook for merchants, *La pratica della Mercatura* (c. 1339–40), is taken up with the comparison of the weights and measures used in one place – Florence, for example – with those in use in other major trading centres. Of Tuscan cities, he includes Pisa, but hardly mentions Siena, which was not, by this time, a major economic centre: Siena had been the second city in Tuscany, after Pisa, in the early part of the thirteenth century, but by the end of the century Florence had surpassed both. There are some slight differences in the systems of measurement in use in Florence and in Siena.

Length

The principal unit of length was the *braccio*. In Florence there were two such measures, the *braccio a terra*, originally an agricultural measurement, and the *braccio a panno*, primarily a cloth measure which became one of the official standard units of measurement for other trades also: the Statutes of the Podestà of 1325 required its use by the city brickmakers, for example (Finiello Zervas, 1979, p. 6). The *braccio a terra* corresponded to the Pisan *braccio* (from which it was probably derived) of about 55·12 cm. It was probably introduced into Florence before the thirteenth century (Finiello Zervas, 1975, note 24, pp. 491–2). Like the *braccio a panno* (below) it was subdivided into 20 *soldi* or 12 *crazie*. The *braccio a terra* was abolished in 1782 and from this time the *braccio a panno* was known as the *braccio fiorentino*. The subdivisions of the *braccio a panno* are as follows:

1 *braccio a panno* = 20 *soldi* ≡ 58·36 cm (for practical purposes, 58·4 cm)
 1 *soldo* = 12 *denari* ≡ 2·92 cm
 1 *denaro* ≡ 0·24 cm or 2·4 mm
or
 1 *braccio a panno* = 12 *crazie*
 1 *crazia* ≡ 4·86 cm

Larger multiples of the *braccio a panno*:

4 *braccia a panno* = 1 *canna*, the official unit of measurement of the cloth guild, the Arte della Calimala (see above) ≡ 233·44 cm
3 *braccia a panno* = 1 *passo (di legno)* ≡ 175·1 cm
2 *braccia a panno* = 1 *passetto* ≡ 116·72 cm

The Sienese *braccio* appears to have measured 60·105 cm, divided into 24 *oncie* of 2·50 cm (White, 1979, note 26, p. 177, taken from the *Tavole di ragguaglio per la riduzione dei pesi e misure che si usano in diversi luoghi del Granducato di Toscana*, Florence, 1782, a source unavailable to the present author). (Alexander, 1850, gives two measurements for the Sienese *braccio*, one, for measuring linen, of c.0·6565 yds and the other, for wool, of c.0·413 yds; these convert to approximately 60·03 and 37·76 cm respectively.)

For practical purposes the values for the *braccio a terra* and the Sienese *braccio* are taken as 55·1 cm and 60·1 cm respectively.

Weight

The Italian pound was divided into 12 ounces. The weights listed below are those of Florence. The subdivisions vary depending on the nature of the material being weighed: the first set of subdivisions apply to goods other than medicines; the second set are for medicines (see Martini, 1883, pp. 207–8 for other weights):

1 *libbra* = 12 *once* ≡ 339·542g
1 *oncia* = 24 *denari* ≡ 28·295g
1 *denaro* = 24 *grani* ≡ 1·179g
1 *grano* ≡ 0·0491g
or
1 *oncia* = 8 *dramme* ≡ 28·295g
1 *dramma* = 3 *scrupoli* ≡ 3·537g
1 *scrupolo* = 24 *grani* ≡ 1·179g
1 *grano* ≡ 0·0491g

According to Alexander, the Sienese pound was rather smaller than that of the Florentine (0·709 lbs, that is, c. 321·57g, as opposed to 0·7485 lbs). This would give a value for the Sienese ounce of about 26·8g.

Volume

Measures of volume varied according to the type of material: whether it was dry or liquid, and, if liquid, alcohol or oil. As an example, some values for wine are given

(see Martini, 1883, p. 207, for other values):

For Florence:

1 *barile* = 20 *fiaschi* or 40 *boccali* ≡ 45·584 litres
1 *fiasco* = 2 *boccali* or *metadelle* ≡ 2·279 litres
1 *boccale* or *metadella* = 2 *mezzette* ≡ 1·14 litres (or ≈2 English pints)
1 *mezzetta* = 2 *quartucci* ≡ 0·57 litres (or ≈1 English pint)
1 *quartuccio* ≡ 0·285 litres (≈½ pint)

for Siena:

1 *barile* = 32 *boccali* ≡ 43·761 litres
1 *boccale* = 2 mezzette ≡ 1·368 litres (or ≈2·4 pints)
1 *mezzetta* = 2 *quartucci* ≡ 0·684 litres (or ≈1·2 pints)
1 *quartuccio* ≡ 0·342 litres (≈0·6, or rather less than ⅔ pint)

Coinage and accounting

The system commonly used for ordinary accounts, including many of the documents referred to throughout this catalogue, was based on the silver penny coin or *denaro* (*denaro piccolo*). It derived from the early medieval *librae*, *solidi* and *denarii* – pounds, shillings and pence – a system of counting coins such that 12 *denarii* (*denari*) equalled 1 *solidus* (*soldo*), and 20 *solidi* (*soldi*) equalled 1 *libra* (*lira*). It supplied a standard of reference for the wide variety of *denarii* in circulation, very necessary as more trading centres came into existence, and also later supplied a means of expressing the varying values of gold, silver and debased silver (also containing copper) coins. The *lira* and *soldo* were thus accounting units, not actual coins. In an attempt to counteract the inflationary effects of the debasement of the silver penny a number of Tuscan cities, including Siena and Pisa (in the 1220s) and Florence (in 1234), first introduced a larger silver coin, initially worth 12 *denari*, and equivalent to 1 *soldo*, the *grosso* (in Florence, the *fiorino* or *fiorino piccolo*). Subsequently, Florence introduced a gold coin, the *fiorino d'oro*, worth 240 *denari piccoli* and thus initially equivalent to the *lira* (the *grosso* was no longer minted after 1279 and was withdrawn from circulation in 1296). As a result of inflation, however, the gold florin increased rapidly in value relative to the *denaro piccolo*. Other Tuscan, and, indeed, other Italian, cities also minted gold coins later (Lucca, for example, by 1275, Siena not until 1333), but the Florentine coin, following the trade routes, became the principal money of account throughout Western Europe. From 1332, the smallest coin commonly minted in Florence, and the basis of the accounting system, was the 4*d*. piece or *quattrino*.

Glossary

The terms listed below have been defined in the context of fourteenth-century panel painting.

altarblock Consecrated table at which Mass was said and on which the altarpiece was placed.

ancona Panel or altarpiece.

azurite Mineral basic copper carbonate, blue or blue-green in colour according to its source; used as a pigment, but a less pure blue than ultramarine (q.v.).

anhydrite Burnt gypsum (q.v.); composed of dehydrated calcium sulphate and used for the lower *gesso grosso* (q.v.) ground layer on a wooden panel.

bambagia Textile waste, of cotton or wool. The present-day equivalent is cotton wool.

barbe A raised lip of gesso (q.v.) left when frame mouldings originally attached to the panel and therefore gessoed at the same time have been removed. The lip is caused by the accumulation of gesso in the angle between the flat surface and the moulding.

batten A length of wood attached to the back of a panel, partly to keep it flat, but, more important in an altarpiece, to function as part of the supporting framework.

black earth A bluish-black clay coloured by carbon in the form of graphite.

bole An iron-oxide-containing clay, usually of a strong reddish-brown colour, used as the underlayer for gold leaf in water-gilding (q.v.). Sometimes called Armenian bole or red bole.

bone black A black pigment prepared from carbonised bone, composed principally of calcium phosphate and carbon, giving a warmer tone than does wood charcoal.

braccio, braccio da panno Units of length. The dimensions of the *braccio* varied in different cities of Tuscany and also, sometimes, according to what was to be measured. The Florentine *braccio da panno* was originally a cloth measure, of approximately 58.4 cm (see Appendix IV, Table (ii)).

butterfly Also called butterfly key. A butterfly-shaped piece of wood set into a panel, usually across a join between planks, for the purpose of reinforcing the join.

butt join A simple join between planks where the edges of the planks are brought together without interlocking overlaps as in a half-lap join (q.v.).

buttress Supporting side columns or piers (q.v.).

cangiante Literally, changing. A shot silk which varies in colour according to the angle of the light, made by weaving the textile using different coloured threads for the warp and the weft. In painting, these silks are represented by using one colour for the shadow and another quite different colour for the highlight.

capital Shaped decorative top of column.

charcoal Carbon made by burning wood, usually willow or beech. Sticks of charcoal were used for drawing. Wood charcoal, powdered and used as a pigment, has a bluish-black colour.

ciborium Canopy, usually of stone, over altar, supported on columns.

cochineal, Polish cochineal See scale insect dyestuffs.

copper resinate A general term for translucent green pigments based on a preparation of verdigris (q.v.), or another copper salt, with a natural resin and the addition of other materials such as drying oils. Used as a deep green glaze, sometimes over gilding.

craquelure The network of cracks in the paint and ground which is an inevitable and unavoidable consequence of age in a painting.

crocket Carved decorative feature applied to sloping edges of altarpieces, usually leaf-shaped and placed at regular intervals.

cross-section By examining minute samples of paint in cross-section under the microscope, the layer structure of the painting, including the ground layers, can be determined for that sample point. Many pigments can be identified by their colour and optical properties in a cross-section, and analysis by LMA (q.v.) or EDX (q.v.) can be carried out on individual layers. Samples are mounted in a block of cold-setting resin, then ground and polished to reveal the edge of the sample for examination in reflected (incident) light under the optical microscope. The usual magnification range is 60–800×.

cusping Decoration around inside of an arch, formed of linked semi-circles.

dossal Simple altarpiece, usually rectangular.

dowel A cylindrical length of wood, sometimes tapered at each end, inserted into pre-drilled holes across a join between pieces of timber to reinforce that join.

dragonsblood The red resinous exudation from *Dracaena* species, used to colour an orange-red glaze for the decoration of small areas of gilding.

Duecento/Dugento Thirteenth century (literally, two hundred).

earth pigment One of a range of natural pigments found in various parts of the world. They consist of a mixture of clay and various oxides of iron in different proportions, and other substances, and are yellow, red, orange, brown or even black in colour. See also green earth; ochre.

energy-dispersive X-ray microanalysis: EDX A method of elemental analysis carried out in the scanning electron microscope (q.v.). Small areas of a sample which has been imaged in the SEM can be selected and analysed for their component elements. For example, a single paint layer in a cross-section, or a single pigment particle, may be selectively analysed. The electron beam which falls on the specimen in the SEM generates X-rays which are characteristic in their energies of the elements in the sample which produce them. The instrument measures the energies of these X-rays and assigns them on a visual display to the elements present. For the purposes of pigment identification, the results show whether the sample contains lead, copper, iron, tin and so on, but not what the actual component pigments are. These analytical data must then be interpreted in conjunction with the examination of paint samples by optical

microscopy in order to specify the pigments involved. See also LMA.

finial Decorative top of a gable, dome or pilaster (q.v.).

fresco A wall painting, usually executed using colours applied to fresh (fresco) and still-wet plaster.

gable A triangular pointed top.

Gas-liquid chromatography: GLC An analytical separation technique for complex mixtures of organic materials, for example paint media (q.v.), based on the partition of components of a vaporised sample between a moving inert gas stream and a stationary liquid phase. The use of sensitive detectors enables the identification of minute amounts of materials.

gesso The Italian word for gypsum (q.v.); the material used for grounds (q.v.) on panel.

gesso grosso The coarse lower applications to a panel making up the gesso ground; generally composed of anhydrite (q.v.) mixed with animal glue.

gesso sottile The fine upper layers of a gesso ground; composed of gypsum (q.v.) formed by rehydrating burnt gypsum (anhydrite) and bound in animal glue. See also gesso; anhydrite; ground.

giallorino, giallolino Literally, pale yellow. A manufactured bright yellow pigment prepared in a furnace from lead, tin and sand (silica). The modern name is lead-tin yellow 'type II'. The material has its origin in coloured glass manufacture, and is the most important opaque yellow in fourteenth-century painting.

glair Egg white which has been whipped to a froth and then left to stand until the froth has subsided; used as an adhesive and as a paint medium.

glaze Paint which is transparent because the pigment and the medium have similar or identical refractive indices (q.v.).

ground The layer used to prepare a support for painting. Fourteenth-century Italian panel paintings always carry white gesso (q.v.), grounds generally applied as several coats of coarse *gesso grosso* (q.v.) finished with a series of thin layers of *gesso sottile* (q.v.).

green earth A naturally occurring dull sage-green pigment commonly used as the underpaint for flesh in tempera painting on panel. The colouring matter is one of two minerals, glauconite or celadonite, in a clay-like matrix. Often called terre verte.

gypsum A white mineral composed of calcium sulphate dihydrate; used in the preparation of gesso (q.v.) grounds.

haematite A very hard crystalline mineral form of iron oxide of a dark brownish-purple tone; occasionally used as a pigment and to shape instruments to burnish gold leaf.

half-lap join A join between pieces of wood where the edges have stepped profiles cut so that they interlock with one another.

half-tone The transitional tones which lie between the shadows and the highlights in a passage of painting.

hatching In painting, the application of paint

with long thin brushstrokes. In drawing, the use of a series of lines, usually parallel, to suggest volume and the distribution of light and shade. If the strokes are in more than one direction and cross one another this is known as cross hatching.

Infra-red photography/photograph Infra-red is similar to visible light, but slightly too long in wavelength for the eye to see: however, it can be photographed. In conventional infra-red photography, an image is recorded using film sensitive to infra-red radiation in an ordinary camera. An infra-red photograph shows layers just below the visible surface of a painting; *pentimenti* (q.v.) and underdrawings (q.v.) done in carbon black on a white ground show up particularly well.

Infra-red reflectography/reflectogram A technique related to infra-red photography in which a television camera adapted to receive infra-red radiation is connected to a television monitor. The image is seen instantaneously, but recording of the image is slightly blurred since it is photographed from the screen. An infra-red reflectogram, like an infra-red photograph, shows layers below the visible surface of a painting, especially carbon black underdrawings. The two techniques are complementary: infra-red photography produces a sharper image, but infra-red reflectography can achieve greater penetration of the upper paint layers because the detector used is sensitive to a greater range of wavelengths than infra-red film.

inpainting The restoration or retouching of missing areas of a damaged painting.

kermes See scale insect dyestuffs.

lac See scale insect dystuffs.

lake A pigment made by precipitation on to a base from a dye solution – that is, causing solid particles to form, which are coloured by the dye. Lakes may be red, yellow, reddish brown or yellowish brown and are generally translucent pigments when mixed with the paint medium. Often used as glazes.

lampblack A very fine-grained carbon black pigment formed by condensing a smoky flame on to a cold surface. Used principally for inks employed in underdrawing (q.v.).

laser microspectral analysis: LMA A method for elemental analysis of minute samples, yielding similar information to EDX analysis (q.v.). An area of a sample is selected for analysis under a specialised microscope, and a laser pulse fired at this spot, causing part of the specimen to be vaporised. The specimen vapour passes between a pair of electrodes across which an electrical spark is induced. This heats the vapour to a high temperature very rapidly, causing it to emit light of wavelengths which are characteristic of the composition of the sample. The emitted light is analysed by a spectrograph and recorded on a photographic plate as a spectrum of lines related to the elements present in the sample. In the same way as in EDX analysis, the pigment composition of a paint layer can be determined by referring its elemental composition to examination of the sample by optical microscopy. LMA may be used on paint cross-sections (q.v.) for a layer-by-layer analysis, or on minute unmounted flakes.

lead white Basic lead carbonate, synthetically prepared for use as an opaque white pigment.

lead-tin yellow See *giallorino*.

ley An alkaline solution of potassium carbonate, prepared by extracting wood ashes with water; used in the purification of certain pigments.

malachite Mineral basic copper carbonate of a strong light green colour. Occurs in deposits with azurite (q.v.) and used as a pigment.

medium The binding agent for pigments in a painting; see also tempera.

minium An artificial opaque orange-red pigment composed of lead tetroxide; also called red lead.

mordant The adhesive used to apply gold leaf to linear designs on to paint; often used to decorate draperies. Where a drying oil such as linseed is incorporated, with or without pigment, the layer is called an oil mordant. See also mordant gilding.

mordant gilding The application of gold leaf with an adhesive to decorate the painted surface of a picture; distinct from water-gilding (q.v.) and shell gold (q.v.).

Naples yellow From the seventeenth century, a misnomer applied to *giallorino* (q.v.) or lead-tin yellow. The modern name for a yellow lead-based artists' pigment containing antimony.

ochre An earth pigment (q.v.) of a dull red, orange, yellow or brown colour.

ogive A pointed-top arch with a concave profile at the top.

orpiment Natural or synthetic arsenic trisulphide, used as a yellow pigment, but of a very poisonous nature.

palette The range of colours selected by the artist.

panel A rigid painting support, usually made from planks of wood.

pastiglia Raised patterns made from gesso (q.v.).

pentimento (plural **pentimenti**) Literally, repentance, that is, an alteration made by the artist to an area already painted.

pier See pilaster

pigment The colouring matter in paint.

pigment identification/analysis Many pigment identifications in minute samples of paint may be accomplished by optical microscopy of mounted cross-sections (q.v.), thin cross-sections and pigment dispersions, by classical methods of optical mineralogy. Supplementary chemical identification is often required to confirm the results of optical examination, and in the present study included laser microspectral analysis (q.v.), energy-dispersive X-ray microanalysis (q.v.), X-ray diffraction analysis (q.v.) and chemical microscopy (wet chemical tests carried out under the microscope). Certain pigment samples and cross-sections were investigated further by imaging in the scanning electron microscope (q.v.). All the pigment and media examples for the painting materials quoted in the catalogue are the result of some positive method of identification or analysis, whether by optical microscopy in some form, or by instrumental means. In many cases confirmation of the identity of a material was obtained by several different techniques.

pinnacle Topmost panel of a multi-tiered altarpiece.

pilaster Vertical framing column, usually square or rectangular in section.

polyptych An altarpiece consisting of several panels.

pounce To transfer a design by dusting a coloured powder through holes pricked along the outlines of a drawing on paper or parchment.

predella The long horizontal structure supporting the main panels of an altarpiece (literally, altarstep or dais).

punch A roughly cylindrical metal tool with a decorative motif cut into one end. This motif is imprinted into gilded gesso by punching, that is, placing the punch perpendicular to the gilded surface and striking the other end with a hammer.

quatrefoil Decorative motif consisting of four semi-circular lobes. See also trefoil.

raking light A technique for revealing the surface conformation of a painting by casting light across it at a low angle.

refractive index The degree to which any material transmits or scatters light.

rosette A type of punch (q.v.) cut so that the motif is formed of a cluster of small points; used to speed up the process of stippling (q.v.) gilded decoration.

scale insects dyestuffs Dyestuffs extracted from the bodies of the wingless females of certain species of scale insect, so called from the hard or waxy protective coating they secrete. Those most likely to have been used include lac, *Kerria lacca*, and kermes, *Kermes vermilio* Planchon. Kermes was generally known under the name of '*grana*'; a number of varieties of which seem to have been in use, possibly including other species of insect such as Polish cochineal, *Porphyrophora polonica* L. True cochineal, an American insect, was unknown in fourteenth-century Italy.

scanning electron microscopy: SEM A technique capable of revealing the fine details of objects at far higher magnifications than is possible with the optical (light) microscope. The scanning electron microscope uses a beam of electrons to scan the sample under examination, and the electrons scattered by the surface are collected and used to generate a video image. The SEM will show surface topography and three-dimensional structure at magnifications up to $100,000\times$, but the image can only be in monochrome. Equipment for microanalysis of very small areas of a specimen can be attached to the SEM. See EDX analysis.

scumble To apply a thin layer of semi-opaque paint over a colour to modify it; layer of paint used in this way.

sgraffito Literally, scratched. A technique in which paint is applied over gold leaf and then scraped away from specific areas to reveal the gold beneath; particularly used to represent cloth-of-gold textiles.

shell gold Powdered gold used as a paint; so-called because traditionally it was contained in a mussel or similar shell.

silica Silicon dioxide; occurring as quartz, sand and as an impurity in many earth pigments (q.v.).

sinoper Red ochre pigment; see ochre.

sinopia Preliminary underdrawing for a fresco usually executed in sinoper (q.v.).

size An adhesive used to make gesso and in gilding; made from animal skin and waste. The finest size was made from parchment clippings.

socle Base of a column or pilaster.

spandrel The triangular space between the outer curve of an arch and the rectangle formed by the mouldings enclosing it.

spezie Literally, 'spices': term used for a wide range of materials – not only spices but also, for example, alum, dyestuffs, gums, resins and sugar – imported from the area around the Mediterranean, parts of Africa and the Far East. Many were used for preparing medicines: *speziali* in this context means apothecaries, or pharmacists, as in the Arte dei Medici e Speziali, the guild of doctors and apothecaries.

stippling In decoration of gilding, very small indentations of the surface made with a needle or clump of needles, rosette (q.v.). In painting, the application of paint in short dabs or spots of colour.

terre verte See green earth.

tempera In its wider sense, as used by Cennino Cennino, any one of several paint media (q.v.), hence the verb to temper, meaning to combine pigments with a paint medium, but it now often refers to egg tempera alone, that is, paint made using egg yolk as a medium.

tracery Openwork decorative pattern, often applied along the curve of an arch.

transfer To convey and reproduce a design from one surface, for example paper, to another, for example a gessoed panel. Alternatively, to remove the original painting support and replace it with a new support.

Trecento Fourteenth century (literally, three hundred). See also Duecento/Dugento.

trefoil Three-lobed decorative motif. See also quatrefoil.

triptych An altarpiece consisting of three panels.

ultramarine A fine quality, costly, pure blue natural pigment extracted from the semi-precious stone lapis lazuli. The pigment itself occurs as the blue mineral lazurite. Artificial equivalents were first made in the nineteenth century.

underdrawing Preliminary drawing on the gessoed panel before the application of paint and gilding.

verdaccio A combination of black, white and yellow pigments which produces a dull greenish brown. Often used to model the shadows in flesh painting.

verdigris A strongly coloured deep green basic acetate of copper, prepared by exposing sheets of metallic copper to vinegar vapours. Used as a pigment and as a drying agent for oil mordants (q.v.).

vermilion A bright scarlet pigment, mercuric sulphide, usually synthetic but sometimes prepared by pulverising the mineral cinnabar.

water-gilding Gilding with thin leaves of gold usually on to a layer of bole (q.v.). The bole is bound with a water-based medium or adhesive, such as glue, gum or white of egg. Often simply referred to as 'gilding', sometimes 'leaf-gilding'.

X-ray A form of radiation which passes through solid objects, but is obstructed to differing degrees by differing materials. The heavier the atoms of which a substance is made, the more opaque it is to X-rays. Lead compounds are particularly opaque, those containing lighter metals less so. Thus in an X-ray image (known as a *radiograph*) of a painting, areas of paint containing lead pigments will appear almost white, while areas containing lighter materials will appear an intermediate grey or dark. In interpreting X-rays, it should be remembered that all layers are superimposed: thus the image of a wood panel, battens and nails may seem to overlie the image of the paint itself.

X-ray diffraction analysis: XRD A technique for the identification of substances in crystalline form (many pigments are crystalline materials). A narrow beam of X-rays (q.v.) is projected through a very small specimen inside a specially designed form of camera. The regular arrangement of atoms in the crystal scatters the X-rays, producing a 'fingerprint' pattern, unique to that crystalline material, on a strip of film. Identification of this pattern allows unambiguous recognition of the material under study. XRD is particularly suitable for the identification of fairly pure samples of crystalline pigments, containing, for example, lead white, lead-tin yellow, vermilion, azurite, calcium sulphate (gesso), the earth pigments and others.

Annotated Bibliography

Cennino Cennini and fourteenth-century technical literature on painting

Cennino Cennini wrote his treatise in the last decade of the fourteenth century or thereabouts, probably in Padua. Other writers (see the bibliography in Schlosser, 1984, pp. 126–32) have commented on aspects of the work which appear to look forward to developments in painting and to the gradually changing status of the artist in the century to come. Cennino's recommendation that the young painter should draw from nature, as well as copy the drawings of the best masters, is one such example: another is the comparison of painting with poetry. The interesting point is not that this comparison was made, for it was by no means new, but that it was made by a craftsman, in a handbook written for the instruction of others in the craft of painting. Cennino himself is not, on the whole, aiming at novelty: he emphasises the traditional nature of his craft. He is proud to lay before the reader a system of rules for painting, apparently unchanged from Giotto's day, and for this reason his work is an invaluable key to fourteenth-century painting practice.

One feature of the treatise is the absence of recipes for the preparation of pigments and other materials: while Cennino discusses how to choose good-quality materials and prepare them for use, their synthesis is not his concern. However, an understanding of the materials and their physical and chemical behaviour is enhanced by a knowledge of how they were likely to have been made. For this information it is necessary to turn to other fourteenth-century sources.

Documentary sources for pigment recipes, of the type circulating in fourteenth-century Italy, may be divided broadly into alchemical and other scientific literature, and collections of recipes on various crafts, some documenting processes of great antiquity. There is a degree of overlap between these categories. In both cases, the recipes may be gathered together in general compilations, or they may be more specific to one branch of knowledge or craft: it is this last category which is closest to Cennino's treatise. It is important to remember that all written information was transmitted in manuscript form. Texts were copied and translated, slowly achieving a remarkably wide circulation. Recipes could, however, be modified during transcription, deliberately or accidentally, if part of the recipe was misread, mistranslated, misunderstood or omitted altogether. Some of the inexplicable omissions and improbable ingredients which sometimes occur in medieval recipes can be attributed to this. Until the advent of printing there was little possibility of regulation or standardisation of written recipes (although the materials they contained could be, and were, strictly regulated, as a study of the statutes of the Florentine Arte dei Medici e Speziali will show).

Individual recipes in a document, ostensibly dating from around the fourteenth century, often derived from very much earlier sources. Those for lead white and verdigris, for example, were likely to be of great antiquity; the method for making lead white from strips of lead suspended in vinegar fumes appears in the writings of Theophrastus, around 300 BC. Earlier sources were copied deliberately: an example of this is given by the manuscript in the Biblioteca Nazionale Centrale, Florence, Ms. Palat. 951, an immense and varied compilation dating mainly from the late fourteenth and fifteenth centuries. The first item, copied in a fourteenth-century handwriting, is part of the first Book (on painting) of *De diversis artibus*, written by the twelfth-century German monk, Theophilus; the second, in the same handwriting, contains recipes from a manuscript in the Biblioteca Capitolare, Lucca (Ms. 490), the *Compositiones variae*, compiled *c.* AD 800, as well as one or two found in the early fifteenth-century compilation published by Mrs Merrifield in 1849 as the Bolognese Manuscript. The relationship between these early sources, and others not discussed here, such as the *Mappae clavicula*, is complex (see the Bibliography for references); their influence and contents, however, were plainly of lasting value.

The alchemical and medical treatises have a rather different lineage to the craft literature, deriving ultimately from ancient Classical Greek, Middle Eastern and Indian writings, which formed the basis to the studies of the great Arabic scholars of the eighth and ninth centuries: the physicians Johannes Mesue (777–837) and Avicenna (980–1037), for example, and the alchemist Jābir ibn Hayyān (fl. *c.* AD 800), known in Western Europe as Geber. Translated into Latin, works by such scholars had a profound influence. Around the end of the thirteenth century, a number of Latin treatises, generally, but erroneously, ascribed to Geber, had a wide circulation. They are much quoted in other alchemical collections of the period, including the *Libellus de alchimia* ascribed to Albertus Magnus (*c.* 1200–80), whose own works were inspired principally by the writings of Aristotle. The group includes the *Liber claritas totius alchimicae artis*, published by Darmstaedter in 1928, which, although by no means the most important of these 'pseudo-Geber' treatises, is particularly noteworthy in the present context as it contains one of the earliest descriptions of the method of purifying ultramarine, as well as recipes for artificial vermilion and a lac lake. Syntheses such as that of vermilion, from mercury and sulphur, thought to be the parents of all metals, or the beguiling mosaic gold, a tin sulphide, were alchemically interesting, and recipes were developed and refined. It is interesting that the method of purifying ultramarine was still, by the 1390s, sufficiently novel and important for Cennino to include a detailed description of it in his treatise, whereas lead white or vermilion were items to be purchased at the *speziario* (apothecary's shop), with hardly a second glance.

Although the medical literature and herbals have not been discussed here, examples of the recipes for medicines, incorporating materials used as pigments, appear in the first Florentine pharmacopoeia, the *Nuovo receptario* of 1498. Even ultramarine had a role: as an ingredient of 'pillole de lapide lazuli' (lapis lazuli pills), in a recipe attributed to Mesue. The ailment against which this, undoubtedly expensive, remedy was supposedly effective is not recorded. In more popular form, as books of 'secrets', collected together with recipes for cosmetics, cookery, dyeing and pigments, these sources had a long life.

The general discussion introducing fourteenth-century craft literature above has already indicated the considerable importance of earlier documents as sources for individual recipes. The fourteenth- and early fifteenth-century compilations, such as the Bolognese Manuscript and the recipes collected by Jehan Alcherius (also published by Mrs Merrifield), are slightly different in character to, and better organised than, the early collections. The Bolognese Manuscript, dating from around the first quarter of the fifteenth century is arranged systematically, in chapters devoted to different groups of pigments or subjects, with space left between chapters for further recipes. Jehan Alcherius travelled in northern Italy and France over a period of thirty years or so, up until *c.* 1410, collecting recipes, principally from painters, appropriate to painting and manuscript illumination. It is not known, however, whether Alcherius himself was a painter, although he had a good understanding of the subject. The recipes themselves are representative of later fourteenth-century practice, but this is a very different type of compilation from those discussed earlier. This is an example of a quite specific compilation, in this case concerned with painting: the three *trattatelli* published by Milanesi under the title *Dell'arte del vetro per musaico* (1864) are also of this type. The first probably dates from the fourteenth century; although many of the recipes are concerned with glass-making and mosaic, others would not be out of place in an alchemical collection.

How, then, does Cennino's treatise compare with sources such as these, typical of fourteenth-century technical literature? His work is closest to another important treatise written at the end of the century, *De arte illuminandi*, on manuscript illumination. Unlike the sources discussed above, both were written by craftsmen, from their own experience, and both are original works, not compilations. The contents of both are organised in a logical order: Cennino starts with drawing, followed by pigments, then instructions for different kinds of painting and, lastly, other crafts. The anonymous author of *De arte illuminandi* states very firmly that his concern is with manuscript illumination only – he is neither scribe nor painter – and he describes the pigments, followed by suitable temperas, colour mixtures and methods of application. They are not quite the first representatives of their type; Theophilus, writing some 250 years earlier, shows something of these features. Cennino, however, goes beyond the author of *De arte illuminandi* in the scope of his handbook. He includes some elements of theory, such as the description of human proportions and some practical perspective, and, while both authors display undoubted individuality of style, the discursive comments and moralisations which enliven Cennino's work give his treatise an entirely different character from the crisp, economical *De arte illuminandi*. Cennino protests his humble status, but it is plain that he was trying to do rather more than write a list of instructions, and, whatever else his intentions were, he has succeeded in giving a picture of the late fourteenth-century craftsman.

Bibliography

The arrangement of the bibliography follows the headings in the catalogue. The items included are those found useful during the writing of the catalogue; the bibliography does not claim to be complete. For further reading reference should be made to the bibliographies under the appropriate entries in Davies, Martin, *National Gallery Catalogues: the Early Italian Schools before 1400*; revised by Dillian Gordon, London, 1988.

Introduction

i) A general introduction to Italy in the 14th century, its history and culture and the position of the artist in society

Larner, John, *Italy in the age of Dante and Petrarch, 1216–1380*, London, 1980 (Longman History of Italy, Vol. 2). A brief general history of the period, with a useful bibliography.

Larner, John, *Culture and society in Italy, 1290–1420*, London, 1971. The relationship between the art and literature of the period and the society and conditions from which they arose.

Pullan, Brian, *A History of early Renaissance Italy from the mid-thirteenth to the mid-fifteenth century*, London, 1973.

Waley, D., *The Italian City Republics*, 3rd edn., London and New York, 1988. A brief account of the rise and history of the city republics, including Florence and Siena.

ii) Painting in the 14th century
See also the references cited below under 'The Artist'

a) Italian art in the 14th century

Cämmerer-George, Monica, *Die Rahmung der toskanischen Altarbilder im Trecento*, Strasburg, 1966.

Eco, Umberto, *Art and beauty in the Middle Ages*, new edn., New Haven and London, 1986 (first published in 1959, this edn. has a revised and enlarged bibliography).

Hills, Paul, *The light of early Italian painting*, New Haven and London, 1987.

White, John, *Art and architecture in Italy, 1250–1400*, 2nd edn., Harmondsworth, 1987.

White, John, *The birth and rebirth of pictorial space*, 3rd edn., Cambridge, Mass., 1987.

b) General Florentine painting

Boskovits, Miklós, *Pittura fiorentina alla vigilia del Rinascimento, 1370–1400*, Florence, 1975.

Fremantle, Richard, *Florentine Gothic painting from Giotto to Masaccio: a guide to painting in and near Florence, 1300–1450*, London, 1975.

Meiss, Millard, *Painting in Florence and Siena after the Black Death*, Princeton, 1951.

c) General Sienese painting

Carli, Enzo, *La pittura senese del Trecento*, Venice, 1981.

Van Os, Henk W., *Marias Demut und Verherrlichung in der sienesischen Malerei, 1300–1450*, The Hague, 1969.

Van Os, Henk, W., *Sienese altarpieces, 1215–1460: form, content, function*; Vol. I. *1215–1344*, Groningen, 1984.

d) Biographies of artists

Ghiberti, Lorenzo [*I commentarii*].
Lorenzo Ghibertis Denkwürdigkeiten (I commentarii): zum ersten Male nach der Handschrift der Biblioteca Nazionale in Florenz vollständig herausgegeben und erläutet von Julius von Schlosser, 2 vols., Berlin, 1912.

Vasari, Giorgio, *Le vite de' più eccellenti pittori, scultori ed architettori*, scritte . . . con nuove annotazione e commenti di Gaetano Milanesi, 7 vols. + index, Florence, 1878–85; particularly Vol. I, 1878.

e) The social background of artists

Antal, Frederick, *Florentine painting and its social background: the bourgeois republic before Cosimo de' Medici's advent to power, XIV and early XV centuries*, London, 1947 (reprinted Cambridge, Mass., and London, 1986).

Larner, J., 1971 (cited in full above), especially Part III, *Italian culture and society in transition (c.1340–1420): the environment of art*, pp. 233–348. See also the article by the same author, 'The artist and the intellectuals in fourteenth-century Italy', *History*, LIV (1969), pp. 13–30; a very brief survey, much expanded in the later book, but with a useful bibliography.

Meiss, Millard, *Painting in Florence and Siena after the Black Death*, Princeton, 1951. The following article should be read in conjunction with this book, as a counterbalance expressing more recent opinion:

Van Os, Henk W., 'The Black Death and Sienese painting: a problem of interpretation', *Art History*, 4, (1981), pp. 237–49.

iii) Culture and society in 14th century Italy

Holmes, George, *Florence, Rome and the origins of the Renaissance*, Oxford, 1986. A discussion of literary and artistic developments, particularly in Florence, *c.1260–c.1320*, set in their historical context.

Hyde, John K., *Society and politics in mediaeval Italy: the evolution of the civil life 1000–1350*, London, 1973.

Larner, J., 1971.

iv) Florence and Siena

Becker, Marvin B., *Florence in transition*, 2 vols.: I. *The decline of the Commune*; II. *Studies in the rise of the territorial state*, Baltimore, Vol. I, 1967, Vol. II, 1968.

Brucker, Gene A., *Florentine politics and society, 1343–1378*, Princeton, 1962.

Davidsohn, Robert, *Forschungen zur Geschichte von Florenz*, 4 vols, Berlin; Vol. I, 1896; Vol. II. *Aus den Stadtbüchern und Urkunden von San Gimignano, 13 und 14 Jahrhundert*, 1900; Vol. III. 1. *Regesten unedirter Urkunden zur Geschichte von Handel, Gewerbe und Zunftwesen*, 2. *Die Schwarzen und die Weissen*, 1901; Vol. IV. *13 und 14 Jahrhundert*, 1908.

Davidsohn, Robert, *Geschichte von Florenz*, 4 vols, Berlin; Vol. I. *Aeltere Geschichte*, 1896; Vol. II. *Guelfen und Ghibellinen*, Bd. 1–2, 1908; Vol. III. *Die letzten Kämpfe gegen die Reichsgewalt*, 1896–1927; Vol. IV. *Die Frühzeit der Florentiner Kultur*, Bd. 1–3 and *Anmerken*, 1–3, 1922–7. Italian

translation: *Storia di Firenze*, 8 vols, Florence, 1956–62.

Florentine studies: politics and society in Renaissance Florence; edited by Nicolai Rubinstein, London, 1968.

Paatz, Walter and Elisabeth, *Die Kirchen von Florenz: ein kunstgeschichtliches Handbuch*, 6 vols, Frankfurt-am-Main, 1940–54.

Bowsky, William M., *A medieval Italian commune: Siena under the Nine, 1287–1355*, Berkeley, 1981.

Hook, Judith, *Siena: a city and its history*, London, 1980.

Riedl, P.A., and Seidel, M., *Die Kirchen von Siena*, Munich, 1985.

v) Economic history, finance and trade

a) Economic history

The Cambridge Economic History of Europe; general editors, M.M. Postan, D.C. Coleman, P. Mathias. The following chapters are of particular interest: Vol. I: *The agrarian life of the Middle Ages*, 2nd edn.; edited by M.M. Postan, Cambridge, 1966. Chapter VII: *Medieval agrarian society in its prime – Italy*, by Philip Jones, pp. 340–431. Vol. II: *Trade and industry in the Middle Ages*, 2nd edn.; edited by M.M. Postan and Edward Miller, Cambridge, 1987. Chapter V: *The trade of medieval Europe – the South*, by Robert S. Lopez, pp. 306–401. Chapter X: *Mining and metallurgy in medieval civilisation*, by John U. Nef, pp. 691–761. Chapter XII: *Coinage and currency*, by Peter Spufford, pp. 788–873. Vol. III: *Economic organization and policies in the Middle ages*; edited by M.M. Postan, E.E. Rich and Edward Miller, Cambridge, 1963. Chapter II: *The organisation of trade*, by R. de Roover, pp. 42–118. Chapter V: *The guilds*, by Sylvia C. Thrupp, pp. 230–80.

b) Finance

Among the most useful documentary sources of the period, for painters and their works and for materials used in painting, are the account books of the various bodies responsible for commissioning works and certain records of indirect taxes – *gabelle*: in this case, tolls levied on the movement of goods into and out of the cities. The following books provide a guide to currency, accounting, exchange and other financial considerations.

Cipolla, Carlo Maria, *The monetary policy of fourteenth-century Florence*, Berkeley [etc.], 1982. (English translation of *Il fiorino e il quattrino: la politica monetaria a Firenze nel 1300*, Bologna, 1982.)

Cipolla, Carlo Maria, *Money, prices and civilisation in the Mediterranean world: fifth to seventeenth century*, New York, 1956 (1967 reprint). A clear introductory text.

Cipolla, Carlo Maria, *Studi di storia della moneta. 1. I movimenti dei cambi in Italia dal secolo XIII al XV*, Pavia, 1948, especially pp. 56–62; 132–214, for exchange rates for the Florentine florin against Florentine and Sienese everyday coinage. See also the publications by Spufford, cited below.

Spufford, Peter, Wilkinson, Wendy, and Tolley, Sarah, *Handbook of medieval exchange*, London, 1986, particularly the introduction and pp. 1–58.

1854; statutes pp. 1–27; register pp. 27–51. In conjunction with this, see:

Fehm, Sherwood A., 'Notes on the statutes of the Sienese painters' guild', *Art Bulletin*, LIV, 1972, pp. 198–200.

Nannizzi, Arturo, *L'Arte degli Speziali in Siena*, Siena, 1939. The 1355 statutes are discussed, but not reproduced. For *spezie* see pp. 30 ff.; the Sienese *Statuti delle Gabelle*, 1301–3, are among the sources quoted.

[1355 statutes: Archivio di Stato, Siena, Corporazioni di Arti e Mestieri, Arte degli Speziali, Ms. N.1: see also Cecchini, Giovanni, and Prunai, Giulio, *Breve degli Speziali (1355–1542)*, Siena, 1942 (the present author was unable to see a copy of this book).]

Senigaglia, Quinto, 'Lo statuto dell'Arte della Mercanzia senese, 1342–1343', *Bullettino Senese di Storia Patria*, 14, 1907; II, pp. 212–71, III, pp. 67–98; 15, 1908, II, pp. 99–140, III, pp. 141–86; 16, 1909, I, pp. 187–216, II, pp. 217–64. A number of the regulations, which are divided into three Books, are concerned with *speziali* and the materials of their trade, e.g. book III, no. 8, on false weights and measures, no. 17, on saffron, and no. 18, on the sale of unsatisfactory merchandise and incorrectly formulated medicines (Vol. 15, II, pp. 128; 132–4).

Contracts

Glasser, Hannelore, 'Artists' contracts of the early Renaissance' (Ph.D. Dissertation, Columbia University, 1965), New York and London, 1977. For a general discussion of artists' contracts.

Milanesi, Gaetano, *Documenti per la storia dell' arte senese*, Vol. I, *Secoli XIII e XIV*, Siena, 1854.

Milanesi, Gaetano, *Nuovi documenti per la storia dell'arte toscana dal XIII al XV secolo*, Florence, 1901.

For Duccio's *Rucellai Madonna*:

Milanesi, G., 1854, doc. 16, pp. 158–60 (see also White, J., 1979, doc. 5, pp. 185–7).

For Pietro Lorenzetti's Polyptych for Santa Maria della Pieve:

Bacci, Pèleo, *Dipinti inediti e sconosciuti di Pietro Lorenzetti, Bernardo Daddi, etc. in Siena e nel contado*, Siena, 1939, doc. II, pp. 76–9 (and also in Milanesi, G., 1901, no. 37, pp. 22–3).

Guerrini, Alessandra, 'Intorno al polittico di Pietro Lorenzetti per la pieve di Arezzo', *Rivista d'Arte*, XL, serie 4, Vol. IV, 1988, pp. 3–29.

For Francesco di Michele's tabernacle:

Milanesi, G., 1901, no. 84, pp. 65–6.

For Andrea di Cione's Strozzi Altarpiece:

Offner, Richard, *A critical and historical corpus of Florentine painting*, Section IV, Vol. I, *Andrea di Cione*, New York, 1962, pp. 8–9.

For an example of a contract specifying lake, 'lacha', as well as gold and ultramarine:

Milanesi, G., 1854, no. 89, pp. 292–3: a contract of 1382 to Bartolo di Fredi for a painting in the Chapel of the Annunciation in the church of San Francesco, Montalcino.

For the provision of food and drink by the patron, see, for example:

Ciampi, Sebastiano, *Notizie inedite della Sagrestia pistoiese de' belli arredi del Campo Santo pisano, e di altre opere di disegno del secolo XII al XV . . .*, Florence, 1810, doc. XXIX, pp. 145–50: a list of accounts for the painting of a fresco, now lost, in the Chapel of San Jacopo in the Cathedral at Pistoia, by Bonaccorso di Cino and Alesso di

Andrea in 1347. A number of payments for wine for the painters are included.

Mazzei, L. (ed. C. Guasti), 1880, Vol. II, Appendix II, pp. 385–6. The painters Dino di Puccio and Jacopo d'Agnolo, who were painting a room for Francesco di Marco Datini, are recorded as having returned to work, eat and sleep in the merchant's house on Tuesday, 14 December 1389, after the Feast of St Lucy on the Monday. See also Origo, I., 1957 (1988 reprint), chap. 4, p. 242, on a dinner given by Francesco to workmen (carpenters, in this case) to celebrate the completion of a piece of work, a custom in Tuscany.

For the payment to Pietro Lorenzetti for materials in 1326:

Bacci, P., 1939, doc, IV, pp. 80–1.

For Jacomo di Mino and Bartolo di Fredi's commission to paint in the chapel of Sant' Ansano in Siena Cathedral:

Milanesi, G., 1854, no. 66, pp. 263–4.

The Artist

Larner, J., 1971, Part III, chap. 12, *The artist in society, II: Workshop and guild*, pp. 285–309. Martindale, Andrew, *The rise of the artist in the Middle Ages and early Renaissance*, London, 1972.

For the selling of saddles:

Fiorilli, C., 1920, doc. 5, p. 57.

For the woman painter:

Ottokar, Nicola, 'Pittori e contratti d'apprendimento presso pittori a Firenze alla fine del dugento', *Rivista d'Arte*, XIX, 1937, pp. 55–7, especially p. 56.

For Jacopo del Casentino's painting for the Confraternity of St Luke:

Vasari, Giorgio, *Le vite de' più eccellenti pittori, scultori ed architettori . . .*, [edited by] Gaetano Milanesi, Vol. I, Florence, 1878, pp. 673–5.

Workshops

For the apprenticeship of painters in Florence:

Ciasca, R., 1927, chap. III, pp. 175 ff. On hierarchy in the guild and the workshop; the master and his apprentices, and related topics.

Statuti dell'Arte dei Medici e Speziali (Ciasca edn.), 1922; Statutes of the painters, 1315–16, no. IX, p. 81 (see also Fiorilli, C., 1920, doc. 2, pp. 47–8), and Statutes of the Medici e Speziali, 1349, no. LXII, pp. 181–2 (Fiorilli, C., 1920, doc. 5, p. 56).

Examples of contracts between painters and apprentices are to be found in:

Borghesi, S., and Banchi, L., *Nuovi documenti per la storia dell'arte senese*, Siena, 1898.

Milanesi, G., 1901; for example, no. 58, p. 36.

For poaching apprentices from another painter's workshop:

Manzoni, L., 1904; statutes of painters in Perugia, no. XIV, pp. 35–6; transliterated p. 160; Italian translation p. 167. See also Florentine painters' statutes, cited above, no. IX.

For examples of collaboration between painters:

Rowley, George, *Ambrogio Lorenzetti*, 2 vols, Princeton, 1958; Vol. 1, Appendix B (documents), p. 135 (for the Lorenzetti brothers working on the façade of Santa Maria della Scala, 1335).

Offner, Richard, *A critical and historical corpus of Florentine painting*, Section IV, Vol. I, *Andrea di Cione*, New York, 1962, p. 23; Vol. II, *Nardo di Cione*, 1960, pp. IV, 47 (for Andrea and Nardo di Cione in the Strozzi Chapel.)

Offner, Richard, *A critical and historical corpus of Florentine painting*, Section IV, Vol. III, *Jacopo di Cione*, New York, 1965 pp. 17–26, and Vol. I, *Andrea di Cione*, p. 23 (for Andrea and Jacopo di Cione on the *St Matthew Triptych*, 1368).

Martindale, Andrew, *Simone Martini*, Oxford, 1988, Cat. no. 12, The *Sant' Ansano Altarpiece*, painted in 1333 by Simone with Lipo Memmi, pp. 187–190; documents published by Pèleo Bacci, *Fonti e commenti per la storia dell'arte senese: dipinti e sculture in Siena, nel suo contado ed altrove*, Siena, 1944, pp. 168–73. See also Frederick, Kavin M., 'The dating of Simone Martini's S. Ansano Altarpiece: a re-examination of two documents', *The Burlington Magazine*, CXXXI, July 1989, pp. 468–9.

On the different rates of pay within a workshop:

Ciampi, S., 1810, doc. XXIX, pp. 145–50.

For painters forming a company:

Milanesi, G., 1901, No. 42, pp. 25–6, for an association between seven painters formed in 1330.

For the joint rental of a workshop by Bartolo di Fredi and Andrea Vanni:

Borghesi, S., and Banchi, L., 1898, doc. 17, p. 27.

On the appearance of workshops:

Egbert, Virginia W., *The medieval artist at work*, Princeton, 1967. Although no illustration is included of a 14th-century painter's shop, the contemporary illustrations of sculptors and other artists at work give some idea of the appearance of workshops in general.

Milanesi, G., 1901, No. 35, pp. 21–2: the contract for the construction of a shop for one Gianotto Baldesi, dated 1318.

On the temporary workshop in San Giovanni Fuorcivitas, Pistoia:

Ladis, Andrew, *Taddeo Gaddi: critical reappraisal and catalogue raisonné*, Columbia and London, 1982; documents 17–69, pp. 255–8, especially nos. 29–31 and 36, p. 256.

Panel Construction

Goodman, W.C., *The history of woodworking tools*, London, 1964 (reprinted 1976). Useful for illustrations of tools.

Marette, Jacqueline, *Connaissance des primitifs par l'étude du bois du XIIe au XVIe siècle*, Paris, 1961.

Walker, Philip, 'The tools available to the mediaeval woodworker', *Woodworking technique before AD1500: Papers presented to a Symposium at Greenwich in September 1980*; edited by Sean McGrail, National Maritime Museum, Greenwich, Archaeological Series, no. 7, London, 1982, pp. 349–56. Other papers presented at this symposium have a limited value in the present context as their concern is primarily with English building practice.

References to the use of dowels in panel construction are listed under Cat. no. 5. For the use of various systems of proportion in the construction of panels see the references listed below under 'Preliminary drawing', and also Cat. nos. 3, 4 and 8.

On poplar species:

Petrus de Crescentiis, in his *Liber ruralium commodorum*, compiled between 1299 and 1305, included poplars in his list of non-fruiting trees, Book V, part ii: *Populus* (the black poplar, *Populus nigra* L.) is distinguished from *Albarus* (the white poplar, *P. alba* L.) by being taller and by having wood that does not take on a polish: *Albarus* is described as having whiter wood, more beautiful

for boards, although the wood does not last for a very long time. The following editions of the work were consulted:

Petri de Crescentiis cuius Bononiensis epistola in librū comodorū ruralium . . ., Augsburg, 1471 (the first printed edition), f. 103;

Trattato della agricoltura di Piero de' Crescenzi, traslato nella favella fiorentina, revisto dallo 'Nferigno Accademia della Crusca [Bastiano de' Rossi], 3 vols., Milan, 1805 (reprint of 1724 edition); Vol. 2, chap. XLVII, pp. 131–2.

The mid-14th century *Gabella delle porti* (Ms. Ricc. 2526), in the *Entrata* and *Uscita* for the Arte dei Legname e Pietre, lists tolls for boards or planks of *albero*, the white poplar, but does not appear to mention the black by name (the full reference to this manuscript is given above under 'Finance': see pp. 71; 113 in edn. cited). (The word *albero*, although used generally to mean 'a tall tree', properly means the white poplar.)

The Lombardy poplar is a native of the Middle East (Iran) which gradually spread, or was introduced, into various parts of Europe: it was in England by 1758, but it is not known when it appeared in Tuscany. The authors of this catalogue would like to thank Dr John Harvey for his assistance with the history of the various species of poplar and the reference to Petrus de Crescentiis.

For deforestation in Italy:

The Cambridge Economic History of Europe; Vol. I. 2nd edn., 1966; chap. VII, *Medieval agrarian society in its prime: Italy*, by Philip Jones, pp. 340–431, especially pp. 356; 366–7.

For the use of casein glue for the main panel of Duccio's *Maestà*:

'Il restauro della "Maestà" di Duccio'; with an introduction by Cesare Brandi, *Bollettino dell'Istituto Centrale del Restauro*, 37–40, 1959, pp. 193–4 (results of analysis).

For the backs of panels, including illustrations:

Marette, J., 1961; eg., p. XVIII, figs. 67–8, pl. XX, fig. 74.

For nails:

An illustration of the sort of nails used in panel construction at this time is included in:

Baldini, Umberto and others, 'Il restauro del Crocifisso di Cimabue', *Atti del Convegno sul restauro delle opere d'arte, Firenze, 2–7 novembre, 1976*, 2 vols., Florence, 1981, Vol. I, pp. 67–94, especially pp. 75–9, Vol. II, pp. 381–407, especially figs. 16–18, pp. 391–2.

For the payment to Paolo Bindi for wood for a predella:

Milanesi, G., 1854, p. 196.

For the San Giovanni Fuorcivitas Altarpiece, Pistoia:

Ladis, A., 1982 (cited in full under 'Workshops'), documents 17–69, pp. 255–8, particularly docs. 18; 22, p. 256 (for the panel and predella); doc. 63, p. 258 (for the lead coating the iron rings or weights).

For the Impruneta Altarpiece:

Milanesi, Gaetano, *La scrittura di artisti italiani (sec. XIV–XVII), riprodotta con le fotografia da Carlo Pini . . .*, Florence, 1876, nos. 9 (Tommaso del Mazza) and 11 (Pietro Nelli).

For a general discussion of the likelihood of carpentry being carried out in the painter's shop:

Gilbert, Creighton, 'Peintres et menuisiers au début de la Renaissance en Italie', *Revue de l'art*, 37, 1977, pp. 9–28.

For Pietro Lorenzetti's Polyptych for Santa Maria della Pieve:

Bacci, P., 1939, doc. II, pp. 76–9 (and also in Milanesi, G., 1901, no. 37, pp. 22–3: both cited in full under 'Contracts').

For Taddeo Gaddi's letter of agreement to Tomaso degli Strozzi, 1342(?):

Ladis, A., 1982, doc. 16, p. 255 (and also no. 1 in Milanesi, G., and Pini, C., 1876, cited above).

For Jacopo di Lazzero's altarpiece for Santa Maria di Grignano, 1372:

Milanese, G., 1901, no. 81, pp. 62–3.

On the sequestration of panels from the workshop of Maso di Banco:

Wilkins, David G., *Maso di Banco: a Florentine artist of the early Trecento*, New York and London, 1985; Appendix 1, Documents 4a–c, pp. 117–19.

On the carving of complex elements for the frame of the Sant' Ansano altarpiece:

Martindale, A., 1988, Cat. no. 12, p. 189, and doc. 18h in Bacci, P., 1944, p. 170. See also Frederick, K. M., 1989, pp. 468–9 (all cited in full under 'Workshops').

The Gesso Ground

For canvas covering the panels of the San Giovanni Fuorcivitas Altarpiece:

Ladis, A., 1982, documents 32–3, p. 256.

For gesso:

Gettens, Rutherford J., and Mrose, Mary E., 'Calcium sulphate minerals in the grounds of Italian paintings', *Studies in Conservation*, 1, 4, 1954, pp. 174–89.

Gettens, Rutherford J., 'A visit to an ancient gypsum quarry in Tuscany', *Studies in Conservation*, 1, 4, 1954, pp. 190–2.

For different forms of calcium sulphate used in North Italy and Tuscany, see the article by Gettens and Mrose cited above and also, for example:

Dunkerton, Jill, Roy, Ashok and Smith, Alistair, 'The unmasking of Tura's "Allegorical Figure": a painting and its concealed image', *National Gallery Technical Bulletin*, 11, 1987, pp. 5–35, especially p. 19 and ref. 20, p. 33.

Gordon, Dillian, Bomford, David, Plesters, Joyce, and Roy, Ashok, 'Nardo di Cione's "Altarpiece: Three Saints" ', *National Gallery Technical Bulletin*, 9, 1985, pp. 21–37, especially pp. 26–7.

For the 1533 additions to the Statutes of the Sienese painters' guild:

Milanesi, G., 1854, pp. 52–4 (cited in full under 'Guilds').

Preliminary Drawing

Degenhart, Bernhard, and Schmitt, Annegrit, *Corpus der italienischen Zeichnungen, 1300–1450*, Teil I: *Süd- und Mittelitalien*, Band 1: Kat. 1–167; Band 3: Tafel 1–195, Berlin, 1968.

For proportional systems and number symbolism in general, and practical mathematics in the 14th century:

Brink, Joel, 'Measure and proportion in the monumental gabled altarpieces of Duccio, Cimabue and Giotto', *Racar – Revue d'art canadienne – Canadian Art Review*, 4, 1977, pp. 69–77.

Brink, Joel, 'Carpentry and symmetry in Cimabue's Santa Croce Crucifix', *The Burlington Magazine*, CXX, 1978, pp. 645–52.

Brink, Joel, 'From carpentry analysis to the discovery of symmetry in Trecento painting', *La pittura nel XIV e XV secolo: il contributo dell'analisi

tecnica alla storia dell'arte . . .*; edited by H.W. van Os and J.R.J. van Asperen de Boer, Bologna, 1983, pp. 345–72.

Finiello Zervas, Diane, 'The *trattato dell'abbaco* and Andrea Pisano's design for the Florentine Baptistry doors', *Renaissance Quarterly*, XXVIII, 1975, pp. 483–503.

Hopper, Vincent F., *Mediaeval number symbolism: its sources, meaning and influence on thought and expression*, New York, 1938.

Kemp, Martin, 'Science, non-science and nonsense: the interpretation of Brunelleschi's perspective', *Art History*, I, 1978, pp. 134–61, especially pp. 143–4.

Roriczer, Mathias, *Des Dombaumeisters und Buchdruckers Matthäus Roriczer 'Büchlein von der Fialen Gerechtigkeit', 1486*; facsimile edition, edited by K. Schottenloher, Regensburg, 1923.

Shelby, Lon R., *Gothic design techniques: the fifteenth-century design booklets of Mathes Roriczer and Hanns Schmuttermayer*, Carbondale and Edwardsville, 1977. Includes the original texts and an English translation.

See also further references under Cat. nos. 3, 4 and 8.

For examples of drawings of altarpieces with their frames see, for example:

Gilbert, Creighton, 'Peintres et menuisiers au début de la Renaissance en Italie', *Revue de l'Art*, 37, 1977, pp. 20–1; 25.

Gilding

Thompson, Daniel V., *The materials of medieval painting*, London, 1936 (Dover reprint, New York and London, 1956), pp. 194–8; 207–8; 211ff.

On making gold leaf:

Theophilus [*De diversis artibus*]
On divers arts: the foremost medieval treatise on painting, glassmaking and metalwork; translated from the Latin with introduction and notes by John G. Hawthorne and Cyril Stanley Smith, Chicago, 1963 (Dover reprint, New York and London, 1979), Book I, chap. 23, pp. 29–31. (See below, under 'Pigments – documentary sources', for another recent edition.)

On the size of medieval gold leaf:

Tintori, Leonetto, ' "Golden tin" in Sienese murals of the early trecento', *The Burlington Magazine*, CXXIV, 1982, pp. 94–5.

On the florin:

Spufford, Peter, Wilkinson, Wendy, and Tolley, Sarah, *Handbook of medieval exchange*, London, 1986; Introduction and Section 1, Tuscany, pp. 1–58.

See also Spufford, Peter, *Money and its use in medieval Europe*, Cambridge, 1988, for gold and silver in general. Methods for assaying and refining gold and silver are described by Francesco Balducci Pegolotti in *La pratica della mercatura*, (Evans edn., 1936), pp. 331–60. The density of gold is 19.31g/cc.

For gold leaf in the Santa Maria della Pieve polyptych, by Pietro Lorenzetti, 1320:

Bacci, P., 1939, doc. II, pp. 76–8 (and also Milanesi, 1901, no. 37, pp. 22–3; both works cited in full under 'Contracts').

Tooling and Punching

On the study of punch marks:

Frinta, Mojmír S., 'A seemingly Florentine yet not really Florentine Altar-piece', *The Burlington Magazine*, CXVII, 1975, pp. 527–35.

Frinta, Mojmír S., 'On the punched decoration in mediaeval panel painting and manuscript illumination', *Conservation and restoration of pictorial art*; edited by Norman Brommelle and Perry Smith, London, 1976, pp. 54–60. [Papers presented at the Congress of the International Institute for Conservation of Historic and Artistic Works, Lisbon, October, 1972.] (Abbreviated below to Frinta, M.S., 1976 (i).)

Frinta, Mojmír S., 'Deletions from the oeuvre of Pietro Lorenzetti and related works by the Master of the Beata Umiltà, Mino Parcis da Siena and Jacopo di Mino del Pellicciaio', *Mitteilungen des Kunsthistorischen Institutes in Florenz*, XX, 1976, pp. 271–300.

Frinta, Mojmír S., 'Unsettling evidence in some panel paintings of Simone Martini', *La pittura nel XIV e XV secolo: il contributo dell' analisi tecnica alla storia dell' arte*; edited by H.W. van Os and J.R.J. van Asperen de Boer, Bologna, 1983, pp. 211–36.

Muller, Norman E., 'Lorenzettian technical influences in a painting of *S. Philip* by the Master of Figline', *La pittura nel XIV e XV secolo . . .*, 1983, pp. 283–95.

Polzer, Joseph, 'A contribution to the early chronology of Lippo Memmi', *La pittura nel XIV e XV secolo . . .*, 1983, pp. 237–51.

Polzer, Joseph, ' "Symon Martini et Lippus Memmi me pinxerunt" ', *Simone Martini – Atti del convegno, Siena 27, 28, 29 marzo, 1985*; a cura di Luciano Bellosi, Florence, c. 1988, pp. 167–73. On the share of work in the Sant' Ansano *Annunciation*.

Skaug, Erling, 'Contributions to Giotto's workshop', *Mitteilungen des Kunsthistorischen Institutes in Florenz*, XV, 1971, pp. 141–60.

Skaug, Erling, 'The "St. Anthony Abbot" ascribed to Nardo di Cione at the Villa I Tatti, Florence', *The Burlington Magazine*, CXVII, 1975, pp. 540–3.

Skaug, Erling, 'The "St. Anthony Abbot" ascribed to Bartolo di Fredi in the National Gallery, London', *Acta ad Archaeologiam et Artium Historiam pertinentia*, 6, 1975, pp. 141–50.

Skaug, Erling, 'Notes on the chronology of Ambrogio Lorenzetti and a new painting from his shop', *Mitteilungen des Kunsthistorischen Institutes in Florenz*, XX, 1976, pp. 301–22. Note discussion of the diffusion of punches.

Skaug, Erling, 'Punch marks – what are they worth? Problems of Tuscan workshop interrelationships in the mid-fourteenth century: the Ovile Master and Giovanni da Milano', *La pittura nel XIV e XV secolo . . .*, 1983, pp. 253–82. This paper, one of the most recent in this particular area, perhaps best sums up progress in the field as a whole.

On punches and their use in general:

Beatson, Elizabeth H., Muller, Norman E., and Steinhoff, Judith B., 'The St. Victor Altarpiece in Siena Cathedral: a reconstruction', *Art Bulletin*, LXVIII, 1986, pp. 610–31, especially pp. 626–8 and note 83.

Frinta, M.S., 1976 (i), pp. 55–6.

Hodson, G.D., 'Some early bindings and binders' tools', *The Library*, new series, XIX, 1938–9, pp. 202–46, especially pp. 243–6 and plate VII.

Skaug, Erling, 'Preliminary report on a collection of punching tools formerly belonging to Icilio Federico Joni', unpublished report, 1983.

Theophilus, *On divers arts*, Hawthorne and Smith edn., 1963 (Dover reprint, 1979), Book III, chap. 13, p. 92.

On separate or specialist gilders:

Ladis, A., 1982, docs. 37; 45, pp. 256–7; doc. 15, p. 255 (cited in full under 'Workshops').

Milanesi, G., 1854, pp. 52–4 (cited in full under 'Contracts').

The Paint Film

Thompson, Daniel V., *The practice of tempera painting*, New Haven, 1936 (Dover reprint, New York and London, 1962). Although intended for the modern painter and referring to current materials and practice, this is a good introduction to and account of painting in egg tempera.

For Luca di Tommè supplying materials:

Fehm, Sherwood A., *Luca di Tommè: a Sienese fourteenth-century painter*, Carbondale and Edwardsville, 1986: doc. 9, p. 196; doc. 17, p. 198.

For the sequestration of Maso di Banco's pigment box and grinding slab:

Poggi, Giovanni, 'Nuovi documenti su Maso di Banco', *Rivista d'Arte*, VII, 1910, pp. 153–5.

Wilkins, D.G., 1985, Appendix 1, doc. 4a, p. 117.

On vermilion:

Ciampi, S., 1810, doc. XXIX, p. 146; there are two entries for the purchase of ground vermilion (cited in full under 'Contracts').

Pigment and Colour

i) General references for pigments and other materials, and for documentary sources

Berthelot, Pierre E.M., *Histoire des sciences: La chimie au moyen âge . . .*, 3 vols., Paris, 1893 (especially Vol. 3, *L'alchimie arab*).

Merrifield, Mary P., *Original treatises dating from the XIIth to the XVIIIth centuries on the arts of painting*, 2 vols, London, 1849 (Dover reprint, New York and London, 1967). Valuable not only for the treatises, but also for the introduction and notes.

Sarton, George, *Introduction to the history of science*, Vol. III, *Science and learning in the 14th century*, Baltimore, 1947.

Singer, Charles, and others, *A history of technology*, Vol. II, *The Mediterranean civilizations and the Middle Ages, c. 700 BC to AD 1500*, Oxford, 1956.

Thompson, Daniel V., *The materials of medieval painting*, London, 1936 (Dover reprint, New York and London, 1956). A useful introduction, not entirely up-to-date.

Thompson, Daniel V., 'Trial index to some unpublished sources for the history of medieval craftsmanship', *Speculum*, X, 1935, pp. 410–31.

ii) Contemporary documentary sources

A brief discussion of the types of 14th-century source relevant to a study of painting materials will be found in 'Cennino Cennini and fourteenth-century technical literature on painting' on p. 210.

a) Accounts, inventories, etc.

The value of such material has been discussed above under 'Finance'. The reader is referred to works cited here, particularly the *Gabella delle porti* (Ms.Ricc.2526), De Robertis edn., 1968; under 'Trade' to the works of Marco Polo, Pegolotti and Heyd; under 'Guilds' to the books by Ciasca and Nannizzi, as well as to the particular guild statutes cited referring to *spezie*. The accounts for a number of paintings survive, which include payments for pigments, and other payments to artists for pigments for unspecified works are documented: see Appendix IV 'Table of pigment prices'. Two of the most complete, from the point of view of pigments used, are the accounts published by Ciampi for the frescoes (now lost) in the Chapel of San Jacopo, Pistoia Cathedral, 1347 (cited in full under 'Contracts') and those for the San Pier Maggiore Altarpiece (see Cat. no. 8 and Appendix III). Inventories of the contents of artists' workshops (see, for example, Milanesi, G., 1901, doc. 59, p. 37) rarely mention the materials of the painter's trade, but, bearing in mind that some materials used as pigments also appeared as ingredients in pharmaceutical preparations, inventories of pharmacies are of some interest, not only for pigments, but also for balances, mortars and pestles, types of storage vessel and so on; for example:

Chiapelli, Luigi, and Corsini, Andrea, 'Un antico inventario dello Spedale di Santa Maria Nuova in Firenze (9. 1376)', *Rivista della biblioteche e degli archivi*, XXXII, 1921, pp. 1–37.

b) Alchemical and other scientific texts

Albertus Magnus (c.1200–80): the standard editions of his works are those edited by A. Borgnet (38 vols., Paris, 1890–99) and B. Geyer (40 vols., Cologne, 1951 – in progress). His works, and works ascribed to him, were in wide circulation in the 14th century. Those listed below are of most interest:

Book of minerals; translated by Dorothy Wyckoff, Oxford, 1967. Probably written after 1248; modelled on Aristotle's works, although not a direct derivation; some concepts are also derived from Avicenna and other writers. Descriptions of minerals, including sources of gold and silver.

[*Suppositious works: De Alchimia*]
Libellus de Alchimia, ascribed to Albertus Magnus; translated from the Borgnet Latin edition, introduction and notes by Sister Virginia Heines SCN . . ., Berkeley and London, 1958. Vol. 37 in the Borgnet edition. Many manuscripts of the text are known, including 13 in Florence (e.g. Biblioteca Riccardiana, Ms. 390) and a number of translations (including Italian) from the 14th century onwards. The work was ascribed to Albert by the 14th century. Includes recipes for verdigris, artificial vermilion, lead white and red lead.

'Geber': a number of works, in Latin, dating from around the 13th century were ascribed erroneously to the Arabic alchemist Jābir ibn Hayyān (fl. late 8th–early 9th century), known in Western Europe as Geber. These influential texts include the *Summa perfectionis magisterii* and the *Liber fornacum*. An example of this group of texts, related to the *Summa perfectionis*, is cited below:

Darmstaedter, Ernst, ' "Liber claritas totius alchimicae artis" dem arabischen Alchemisten Geber zugeschrieben', *Archeion*, IX, 1928, pp. 63–80; 191–208; 462–82. A late 13th- or 14th-century manuscript in Bologna, Cod.Lat. 164(153): the recipes include one of the earliest descriptions of the method of separating ultramarine using a resinous 'pastille', as well as artificial vermilion, a lac lake and other pigments.

Many medical texts were in circulation during the period. At the end of the 15th century, in Florence, this variety was to some extent rationalised by the publication of the first official pharmacopoeia in 1498. As the officially prescribed recipes and ingredients derive from older sources, it is a fairly reliable source for lists of pigments and

other *spezie*, as well as for the smaller weights and measures:

Nuovo receptario composto dal famosissimo chollegio degli eximii doctori della arte et medecina della inclita cipta di Firenze, Florence, 1498; facsimile edition, Biblioteca Nazionale Centrale, Florence, 1968 (from Ms.Pal. E.6.I.27).

c) Collections of recipes for pigments and related materials

Several of the following works have been published in their original language and in translation a number of times. In these cases, the editions cited are the most recent, usually the most readily available: earlier editions are described and listed in those cited.

1) Earlier compilations, still in circulation

Compositiones variae: Lucca, Biblioteca Capitolare, Ms. 490, *c*.800 AD. A compilation, containing a variety of recipes on pigments, glass-making, dyeing, etc.

Burnham, John M., *A classical technology; edited from Codex Lucensis 490*, Boston, 1920. Not well annotated, but the only English edition.

Hedfors, Hjalmar, *Compositiones ad tingenda musiva*; herausgegeben, übersetzt und philologisch erklärt, Uppsala, 1932.

Johnson, Rozelle P., *Compositiones variae from Codex 490, Biblioteca Capitolare, Lucca, Italy: an introductory study*, Urbana, 1939.

This manuscript is closely related to the compilation known as the *Mappae clavicula* (see below): see the articles by Johnson cited below. Of the 14th-century copies of part of the Lucca manuscript, one, in Florence, contains at least 23 of the recipes (Biblioteca Nazionale Centrale, Ms. Palat. 951, cited below).

The *Mappae clavicula*:

This family of manuscripts is a similar compilation to the above, and in fact includes most of the recipes in the Lucca manuscript among its contents. The most extensive manuscripts are those in the library at Selestat (Ms. 17), of the 10th century, and the Corning Museum of Glass, New York (Phillipps Ms. 3715), 12th century.

Smith, Cyril Stanley, and Hawthorne, John G., '*Mappae clavicula*: a little key to the world of medieval techniques . . .', *Transactions of the American Philosophical Society*, new series, 64, part 4, 1974, pp. 3–122.

See below:

Johnson, Rozelle P., 'Notes on some manuscripts of the Mappae Clavicula' and 'Additional notes . . .', *Speculum*, X, 1935, pp. 72–6, 76–81.

Johnson, Rozelle P., 'Some continental manuscripts of the Mappae Clavicula', *Speculum*, XII, 1937, pp. 84–103.

Theophilus [*De diversis artibus*]

This work dates from the 12th century. The manuscripts are discussed in the editions cited below; see also:

Johnson, Rozelle P., 'The manuscripts of the "Schedula" of Theophilus Presbyter', *Speculum*, XIII, 1938, pp. 86–103.

Thompson, Daniel V. 'The *Schedula* of Theophilus Presbyter', *Speculum*, VII, 1932, pp. 199–220.

The 14th-century Ms. Palat. 951, already mentioned, contains part of the first Book of Theophilus (on painting).

De diversis artibus: the various arts; edited and translated by C.R. Dodwell, London, 1961

(reprinted Oxford, 1986). Latin and English translation.

On divers arts: the foremost medieval treatise on painting, glassmaking and metalwork; translated from the Latin with introduction and notes by John G. Hawthorne and Cyril Stanley Smith, Chicago, 1963 (Dover reprint, New York and London, 1979).

2) 14th- and early 15th-century treatises and compilations

Alcherius, Jehan, *De diversis coloribus* [On various colours], 1398, and other writings; collected by Jehan Le Begue, Paris, 1431, in Merrifield, M.P., *Original treatises . . .*, 1849, Vol. I, pp. 280–91; see also pp. 46–71; 90–111: all collected before *c*. 1410. (Referred to below as Alcherius Manuscripts.)

Segreti per colori: the Bolognese Manuscript (Bologna, Biblioteca dell'Università, Ms. 2681, 15th century), in Merrifield, M.P., *Original treatises . . .*, 1849, Vol. II, pp. 325–600; another edition, *Il libro dei colori: segreti del sec. XV*, by O. Guerrini and C. Ricci, Bologna, 1887. (The English edn. is cited throughout, as the Bolognese Manuscript.)

[*De arte illuminandi*] (Naples, Biblioteca Nazionale, Ms.XII.E.27, last quarter of the 14th century). On manuscript illumination:

Brunello, Franco, *De arte illuminandi e altri trattati sulla tecnica della miniatura medievale*, Vicenza, 1975; Latin and Italian, useful notes and bibliography.

Thompson, Daniel V., and Hamilton, George Heard, *An anonymous fourteenth-century treatise – de Arte illuminandi: the technique of manuscript illumination . . .*, New Haven and London, 1933; English only, useful notes.

Milanesi, Gaetano, *Dell' arte del vetro per musaico; tre trattatelli del secolo XIV e XV*, Bologna, 1864. The first treatise, at least, appears to date from around the end of the 14th century, and contains some pigment recipes (e.g. the purification of ultramarine, lead white, etc.) as well as instructions for making glass.

For the treatise of Antonio of Pisa see below under 'Giallorino'.

An example of a 14th-century manuscript compilation from earlier sources is that mentioned above, in the Biblioteca Nazionale Centrale, Florence: Ms. Palat. 951. Parts I–III are of most relevance; part I consists of part of Theophilus, Book I; part II contains recipes from Ms. Luc. 490 and from the Bolognese Manuscript (some of the Latin, and presumably earlier, recipes). The recipes are mostly appropriate for manuscript illumination; some recipes for dyeing leather, for example, are also included. Part III is on minerals, pottery glazes, etc. For details see:

I codici palatini: cataloghi dei manoscritti della R. Biblioteca Nazionale Centrale di Firenze . . . i codici Palatini, descritte del Professore Luigi Gentile, 2 vols, Rome, 1889; Vol. II, pp. 439–45, especially pp. 440–1.

iii) Specific pigments discussed in the text

For colour theory:

Barasch, Moshe, *Light and colour in the Italian Renaissance theory of Art*, New York, 1978, chap. 1, *Cennini and Alberti*, pp. 1–11, especially pp. 6–7, and p. 35, note 18.

Gavel, Jonas, *Colour: a study of its position in the art theory of the quattro- and cinquecento*, Stockholm, 1979, part 1, chap. 1, *Light and Colour*, pp. 14–20;

part 2, chap. 1A, *Colour scales*, p. 47. Part 1 provides a useful introduction to the philosophical background underlying art and, to some extent, science in general.

For the division between natural and artificial colours, see also, for example:

De arte.illuminandi . . .: Brunello edn., 1975, pp. 36–7; Thompson & Hamilton edn., 1933, p. 1.

Pliny [*Naturalis historiae*] *Natural history*, with English translation by H. Rackham, 10 vols, London, 1952 (Loeb Classical Library edn.); Vol. 9, Book XXXV, xii. 30, pp. 282–3.

For gold and silver:

The references cited under 'Gilding' should be consulted; for the general background to and trade in precious metals see, in particular:

Spufford, P., 1988 (cited in full under 'Finance' and 'Gilding').

Vermilion:

Gettens, Rutherford J., Feller, Robert L. and Chase, W.T., 'Vermilion and cinnabar', *Studies in Conservation*, 17, 1972, pp. 45–69.

For its synthesis:

Thompson, Daniel V., 'Artificial vermilion in the middle ages', *Technical Studies in the Field of the Fine Arts*, II, 1933–4, pp. 62–70.

Examples of recipes may be found in, for example:

Libellus de alchimia, Heines edn., 1958, no.25, p.35.

Bolognese Manuscript, Merrifield, M.P., 1849, Vol. II, nos. 179–83, pp. 478–81.

For ground vermilion:

Ciampi, S., 1810, doc. XXIX, p. 146.

Pegolotti (Evans edn., 1936, p. 373) comments on the fragility of vermilion and, for transport, recommends packing it in chests with tow between the 'loaves' of pigment.

On the darkening of vermilion:

Feller, Robert L., 'Studies on the darkening of vermilion by light', *National Gallery of Art, Report and Studies in the History of Art*, Washington, 1967, pp. 99–111.

Red lead:

Fitzhugh, Elizabeth W., 'Red lead and minium', *Artists' pigments: a handbook of their history and characteristics*, Vol. 1; edited by Robert L. Feller, London and Washington, 1986, pp. 109–39. (This handbook is cited below as '*Artists' pigments*, Vol. 1, 1986'.)

Red lake pigments:

Kirby, Jo, 'A spectrophotometric method for the identification of lake pigment dyestuffs', *National Gallery Technical Bulletin*, 1, 1977, pp. 35–45: there is more recent information on insect dyestuffs, much of which is summarised by Taylor, see below.

For lake preparation in general:

Kirby, Jo, 'The preparation of early lake pigments: a survey', *Dyes on Historical and Archaeological Textiles, 6th. Meeting, Leeds, September 1987*, Edinburgh, National Museums of Scotland, 1988, pp. 12–18.

For examples of lake pigment recipes:

Alcherius Manuscripts, Merrifield, M.P., 1849, Vol. I, nos. 11, 13, pp. 50–3 (lakes from shearings); 12, pp. 50–1 (lac lake); 14, pp. 52–3 (brasilwood lake).

Bolognese Manuscript, Merrifield, M.P., 1849, Vol. II, nos. 110, 111, pp. 432–5 (lakes from shearings); nos. 129–31, pp. 446–51 (lac lakes); no. 120, pp. 440–1 (brasilwood lake).

For scale insect dyestuffs:

Cardon, Dominique, 'Mediterranean kermes and kermes-dyeing', *Dyes in History and Archaeology, 7th Meeting, York, 1988*, York, 1989, pp. 5–8.

Schweppe, Helmut, and Roosen-Runge, Heinz, 'Carmine – cochineal carmine and kermes carmine', *Artists' pigments*, Vol. 1, 1986, pp. 255–83; the American cochineal insect was unknown in 14th-century Italy and should be ignored.

Taylor, George W., 'Insect red dyes: an update', *Dyes on Historical and Archaeological Textiles, 4th Meeting, London, 1985*, Edinburgh, National Museums of Scotland, 1986, pp. 21–4.

For brasilwood:

Wallert, Arie, 'Verzino and roseta colours in 15th century Italian manuscripts', *Maltechnik-Restauro*, 92, 3, 1986, pp. 52–68.

Dragonsblood:

Tschirsch, A., and Stock, Erich, *Die Harze . . .*, 2 vols., Berlin, Vol. 1, 1933; Vol. II (3 parts), 1935–6: Vol. II, part I, pp. 140–55 (the chemistry is out-of-date).

Ultramarine:

Plesters, Joyce, 'Ultramarine blue, natural and artificial', *Studies in Conservation*, 11, 1966, pp. 62–81.

On the source of the mineral:

The Travels of Marco Polo, Latham edn., 1958 (1987 reprint), pp. 76; 106 (cited in full under 'Commerce and Trade').

Methods of distinguishing between lapis lazuli and azurite are described by Pegolotti, Evans edn., 1936, p. 372 (using hot coals), and also in the Bolognese Manuscript, no. 1, pp. 340–3, and no. 27, pp. 384–5.

On the method of extraction of the pigment:

Kurella, Annette, and Strauss, Irmgard, 'Lapis lazuli und natürliches ultramarin', *Maltechnik-Restauro*, 89, 1, 1983, pp. 34–54.

One of the earliest descriptions of the method will be found in:

Liber claritas totius alchimicae artis, Darmstaedter edn., 1928, no. 21, p. 78.

On the composition of lazurite, and its colour:

Cotton, F.A., Harmon, J.B., and Hedges, R.M., 'Calculation of the ground state electronic structures and electronic spectra of di- and tri-sulfide radical ions by the scattered wave-SCF-Xα method', *Journal of the American Chemical Society*, 98, 1976, 1417–24.

Hofmann, U. von, Herzenstiel, E., Schönemann, E., and Schwarz, K.-H., 'Ultramarin', *Zeitschrift für anorganische und allgemeine Chemie*, 367, 1969, 125–6.

Biadetto:

There are many recipes for artificial, or chemically prepared, copper blues from early times onwards, including some in the early sources listed above. For examples see:

Bolognese Manuscript, Merrifield, M.P., 1849, Vol. II, no. 29, pp. 384–5; nos. 33–5, pp. 388–91; etc.

Orna, Mary V., Low, Manfred J.D., and Julian, Maureen M., 'Synthetic blue pigments, 9th–16th centuries', part I: 'Literature', *Studies in Conservation*, 25, 1980, pp. 53–63; part II, 'Silver blue', *Studies in Conservation*, 30, 1985, pp. 155–60.

Azurite:

Gettens, Rutherford J., and Fitzhugh, Elizabeth W., 'Azurite and blue verditer', *Studies in Conservation*, 11, 1966, pp. 54–61.

Giallorino – Lead-tin yellow:

Kühn, Hermann, 'Lead-tin yellow', *Studies in Conservation*, 13, 1968, pp. 7–33.

Merrifield, M.P., 1849, vol. I, pp. clvi–clxiii.

For a recent account of the occurrences of lead-tin yellow, Types I and II, in Italian paintings of the 14th and 15th centuries see:

Martin, E., and Duval, A.R., 'Le jaune de plomb et d'étain et ses deux variétés d'utilisation en Italie aux XIV et XV siècles', *2nd. international conference on non-destructive testing, microanalytical methods and environment evaluation for study and conservation of works of art*, Perugia, 17–20 April 1988, Rome, 1988, pp. II.12.1–14.

For the use of lead and tin in the making of yellow glass:

Antonio of Pisa [*Treatise on glass painting*].

This treatise, which was in the archives of the church of San Franceso at Assisi, was first published by Fratini in 1882 and subsequently by Bruck:

Bruck, Robert, 'Der Tractat des Meisters Antonio von Pisa über die Glasmalerei', *Repertorium für Kunstwissenschaft*, XXV, 1902, pp. 240–69, especially pp. 258–9.

Fratini, Giuseppe, *Storia della basilica e del convento di S.Francesco in Assisi*, Prato, 1882, pp. 213–34, especially p. 225.

Milanesi, G., 1864 (cited above under 'Collections of recipes . . . 14th- and early 15th-century treatises'), 3rd treatise (dated 1443), no. XC, 4th recipe, p. 177 (for a yellow, probably golden yellow, for mosaic).

Yellow glass and *giallorino*:

Bolognese Manuscript, Merrifield, M.P., 1849, Vol. II, nos. 272–3, pp. 528–9.

De arte illuminandi: Brunello edn., 1975, pp. 38–9; Thompson & Hamilton edn., 1933, p.1.

Yellow lake pigments:

Stoll, A.M., 'Gelbe Pflanzenlacke, Schüttgelb und Safran', *Maltechnik-Restauro*, 87,2, 1981, pp. 73–110.

For *arzica*:

Bolognese Manuscript, Merrifield, M.P., 1849, Vol. II, no. 194, pp. 482–5. This recipe uses dyer's weld. For a recipe using buckthorn berries see no. 105, pp. 428–9. For the buckthorn berries recipe in the Paduan Manuscript (dating from the 17th century and published by Mrs Merrifield) see:

Paduan Manuscript, Merrifield, M.P., 1849, Vol. II, no. 29, pp. 662–3; no. 133, pp. 708–9.

Some yellow dyestuffs available in Siena at this time are described by Nannizzi, 1939 (cited above under 'Guilds') pp. 46–51; he suggests that buckthorn berries were not known as a dyestuff by the Sienese in the early part of the century at least (p. 41–2); however, the same berries were certainly known in the area of Naples by the writer of the late 14th-century *De arte illuminandi* for the making of sap green (Brunello edn., pp. 42–3, 68–73; Thompson & Hamilton edn., pp. 2, 7). Pegolotti mentions weld (Evans edn., p. 371); see also the *Gabella delle Porti*, De Robertis edn., 1968 (cited above under 'Finance').

For a yellow lake prepared on a lead white substrate:

De arte illuminandi, Brunello edn., 1975, pp. 50–5; Thompson & Hamilton edn., 1933, p. 6.

Green earth:

Grissom, Carol A., 'Green earth', *Artists' pigments*, Vol. 1, 1986, pp. 141–67.

Malachite:

Gettens, Rutherford J., and Fitzhugh, Elizabeth W., 'Malachite and green verditer', *Studies in Conservation*, 19, 1974, pp. 2–23.

Verdigris:

Kühn, Hermann, 'Verdigris and copper resinate', *Studies in Conservation*, 15, 1970, pp. 12–36.

As the pigment was known from antiquity, recipes can be found in most of the sources listed above; see, for example:

Bolognese Manuscript, Merrifield, M.P., 1849, Vol. II, nos. 82–6, pp. 418–21.

Lead white:

Gettens, Rutherford J., Kühn, Hermann, and Chase, W.T., 'Lead white', *Studies in Conservation*, 12, 1967, pp. 125–39.

Again, the pigment was known from antiquity, to the extent that the author of *De arte illuminandi* found it unnecessary to give a recipe for preparing it (Brunello edn., pp. 48–9; Thompson & Hamilton edn., p. 3). For examples of recipes, see:

Bolognese Manuscript, Merrifield, M.P., 1849, Vol. II, no. 195, pp. 484–5.

Libellus de alchimia, Heines edn., 1958, no. 27, p. 38.

Black pigments:

Winter, John, 'The characterization of pigments based on carbon', *Studies in Conservation*, 28, 1983, pp. 49–66.

Mordant Gilding and 'Shell Gold'

For oil mordants see, for example:

Bolognese Manuscript, Merrifield, M.P., 1849, Vol. II, no. 171, pp. 472–3.

For garlic mordants:

Alcherius Manuscripts, Merrifield, M.P., 1849, Vol. I, no. 106, pp. 94–5.

Bolognese Manuscript, Merrifield, M.P., 1849, Vol. II, no. 161, pp. 468–9.

For the comment on moistening a garlic juice mordant by breathing on it:

Marciana Manuscript, Merrifield, M.P., 1849, Vol. II, no. 33, pp. 624–5.

For powdered or 'shell gold':

Methods of making powdered gold, for use as an ink for manuscripts, were well known in early times. The technique of using powdered, rather than leaf, gold in manuscripts appears to have been revived in Northern France during the 13th century, at which time it seems that it was not at all common in Italy:

Alexander, Shirley M., 'Medieval recipes describing the use of metals in manuscripts', *Marsyas*, XII, 1964–5, pp. 34–51; note the observations on p. 51.

Bolognese Manuscript, Merrifield, M.P., 1849, Vol. II, no. 163–5, pp. 468–71 (for gold ink).

For its use in panel painting:

Ames-Lewis, Francis, 'Matteo de' Pasti and the use of powdered gold', *Mitteilungen des Kunsthistorischen Institutes in Florenz*, XXVIII, 1984, pp. 351–61.

Skaug, Erling, 'Contributions to Giovanni Bonsi', *Antichità Viva*, XXVIII, 1, 1989, pp. 11–14.

Varnishing

Statuti dell' Arte dei Medici e Speziali, Ciasca edn., 1922; Statutes of the painters (1315–16), no. III, p. 79 (see also Fiorilli, C., 1920, doc. 2, pp. 45–6; both cited in full under 'Guilds').

Condition, Conservation and Restoration

On the fading of red lake pigments:

Burnstock, Aviva, 'The fading of the Virgin's robe in Lorenzo Monaco's "Coronation of the Virgin" ', *National Gallery Technical Bulletin*, 12, 1988, pp. 58–65.

On the survival of early easel paintings:

Garrison, E.B., 'Note on the survival of thirteenth-century panel paintings in Italy', *Art Bulletin*, LIV, 1972, p. 140.

The Catalogue
The Master of St Francis

For an up-to-date bibliography of the Master of St Francis see P. Scarpellini, *Il Tesoro della Basilica di San Francesco ad Assisi: Saggi e Catalogo*, Assisi, 1980, pp. 45–6.

Brenk, B., 'Das Datum der Franzlegende der Unterkirche zu Assisi', *Roma Anno 1300: Atti della IV Settimana di Studi di Storia dell'Arte Medievale dell'Università di Roma, 'La Sapienza' (19–24 maggio 1980)*, Rome, 1983, pp. 229–34.

Cannon, Joanna, 'Dating the frescoes by the Maestro di San Francesco at Assisi', *The Burlington Magazine*, CXXIV, 1982, pp. 65–9.

Gordon, Dillian, 'A Perugian provenance for the Franciscan double-sided altarpiece by the Maestro di San Francesco', *The Burlington Magazine*, CXXIV, 1982, pp. 70–7.

Poeschke, Joachim, 'Der "Franziskusmeister" und die Anfänge der Ausmalung von S.Francesco in Assisi', *Mitteilungen des Kunsthistorischen Institutes in Florenz*, XXVII, 1983, 2, pp. 125–70.

Romano, Serena, 'Le Storie parallele di Assisi; il Maestro di San Francesco', *Storia dell'Arte*, 44, 1982, pp. 63–81.

Schultze, J., 'Ein Dugento-Altar aus Assisi? Versuch einer Rekonstruktion', *Mitteilungen des Kunsthistorischen Institutes in Florenz*, 10, I–IV, 1961–3, pp. 59–66.

Schultze, J., 'Zur Kunst des "Franziskus-meisters" ', *Wallraf-Richartz-Jahrbuch*, XXV, 1963, pp. 109–50.

See also the relevant sections in:

Poeschke, Joachim, *Die Kirche San Francesco in Assisi und ihre Wandmalereien*, Munich, 1985.

Catalogue no. 1
Crucifix

Davies, Martin, in the *National Gallery Report*, 1965–6, pp.15–16.

Gordon, Dillian, 'Un crucifix du Maître de San Francesco', *Revue du Louvre*, 1984, pp. 253–61.

Giotto

An enormous amount of material has been published on Giotto, which cannot be listed here. For the bibliography up to 1970, see:

Salvini, R., *Giotto bibliografia*, Rome, 1938; and Benedictis, Cristina de, *Giotto: Bibliografia, II (1937–70)*, Rome, 1973.

A useful monograph is Giovanni Previtali, *Giotto e la sua bottega*, Milan, 1967.

Catalogue no. 2
The Pentecost

Bologna, Ferdinando, *I pittori alla Corte Angioina di Napoli, 1266–1414*, Rome, 1969.

Bologna, Ferdinando, *Novità su Giotto*, Turin, 1969, pp. 97–9.

Christiansen, Keith, 'Fourteenth century Italian Altarpieces', *Metropolitan Museum of Art Bulletin*, XL, I, 1982, pp. 50–5.

Fahy, Everett, 'Italian paintings at Fenway Court and elsewhere', *Connoisseur*, 198, May 1978, pp. 28–9.

Gordon, Dillian, 'A dossal by Giotto and his workshop: some problems of attribution, provenance and patronage', *The Burlington Magazine*, CXXXI, August 1989, pp. 524–31.

Hendy, Philip, *European and American paintings in the Isabella Stewart Gardner Museum*, Boston, 1974, pp. 105–6.

Previtali, Giovanni, *Giotto e la sua bottega*, Milan, 1967, p. 143.

Zeri, Federico, and Gardner, Elizabeth E., *Italian Paintings: a catalogue of the Metropolitan Museum of Art, Florentine School*, New York, 1971, pp. 13–16.

Duccio

For Duccio and his followers see the three recent monographs:

Deuchler, Florens, *Duccio*, Milan, 1984.

Stubblebine, James H., *Duccio di Buoninsegna and his School*, 2 vols. [I: text, II: plates], Princeton, 1979.

White, John, *Duccio: Tuscan art and the medieval workshop*, London, 1979.

See also:

Carli, Enzo, *La pittura Senese del Trecento*, Milan, 1981, pp. 29–70.

Catalogue no. 3.
The Maestà. Three panels from the front and back predellas: (a) *The Annunciation*; (b) *Jesus opens the Eyes of a Man born blind*; (c) *The Transfiguration*

Deuchler, Florens, 'Duccio *Doctus*: New readings for the *Maestà*', *Art Bulletin*, LXI, 1979, pp. 541–9.

Deuchler, Florens, 'Le sens de la lecture: à propos du boustrophedon', *Études d'art médiéval offertes à Louis Grodecki*, Paris, 1981, pp. 221–58.

Gardner von Teuffel, Christa, 'The buttressed Altarpiece: a forgotten aspect of Tuscan fourteenth-century altarpiece design', *Jahrbuch der Berliner Museen*, 21, 1979, pp. 21–65, especially pp. 34–45.

'Il restauro della "Maestà" di Duccio'; with an introduction by Cesare Brandi, *Bollettino dell'Istituto Centrale del Restauro*, 37–40, 1959 (entire volume).

Van Os, Henk W., *Sienese Altarpieces 1215–1460*, Groningen, 1984, chap. III, pp. 39–61.

Pope-Hennessy, John, 'A misfit Master', *New York Review of Books*, 20 November 1980, pp. 45ff.

Stubblebine, J.H., 1979, Vol. I, pp. 31–62, Vol. II, figs. 45–127.

White, John, 'Measurement, design and carpentry in Duccio's *Maestà*', *Art Bulletin*, LV, 1973, 334–66; 547–69 (on the system of proportions used in the construction of the altarpiece).

White, J., 1979, chap. VI, pp. 80–135.

3a *The Annunciation*

Plesters, Joyce, Roy, Ashok, and Bomford,

David, 'Interpretation of the magnified image of paint surfaces and samples in terms of condition and appearance of the picture', *Science and Technology in the service of conservation: preprints of the contributions to the IIC Washington Congress, 3–9 September, 1982*; edited by N.S. Brommelle and Garry Thomson, London, 1982, pp. 169–76, especially pp. 171–2 (on the gilding using an oil-based mordant).

Sullivan, Ruth Wilkins, 'Some Old Testament themes on the front predella of Duccio's *Maestà*', *Art Bulletin*, LXVIII, 1986, pp. 597–609.

Sullivan, Ruth Wilkins, 'Duccio's *Raising of Lazarus* re-examined', *Art Bulletin*, LXX, 3, 1988, pp. 375–87.

3b *Jesus opens the Eyes of a Man born Blind*

Ames-Lewis, Francis, and Wright, Joanne, *Drawing in the Italian Renaissance workshop: an exhibition of early Renaissance drawings from collections in Great Britain* [Catalogue of exhibition held at the University Art Gallery, Nottingham, and the Victoria and Albert Museum, London], London, 1983, p. 45 (on lead point drawing).

Stubblebine, J.H., 'Byzantine sources for the iconography of Duccio's *Maestà*', *Art Bulletin*, LVII, 1975, pp. 176–85.

3c *The Transfiguration* (and 3b)

Stubblebine, J.H., 'The back predella of Duccio's *Maestà*', *Studies in late Medieval and Renaissance painting in honour of Millard Meiss*, New York, 1977, pp. 430–6.

Sullivan, Ruth Wilkins, 'The Annointing in Bethany and other affirmations of Christ's divinity on Duccio's back predella', *Art Bulletin*, LXVII, 1, March, 1985, pp. 32–50.

Catalogue no. 4
The Virgin and Child with Saints

Cannon, Joanna, 'Dominican patronage of the Arts in Central Italy: the Provincia Romana c.1220–c.1320'. Unpublished doctoral thesis, Courtauld Institute of Art, University of London, 1980, p. 270; p. 315, note 240.

Stubblebine, J.H., 'The Boston Ducciesque Tabernacle: a collaboration', in *Collaboration in Renaissance art*, edited by W.S. Sheard and J.T. Paoletti, New Haven and London, 1978, pp. 1–20.

Stubblebine, J.H., 1979, pp. 63–4.

White, John, 'Carpentry and design in Duccio's workshop: the London and Boston Triptychs', *Journal of the Warburg and Courtauld Institutes*, XXXVI, 1973, pp. 92–105 (on carpentry and proportional systems).

White, J., 1979, chap. IV, pp. 46–61.

Ugolino di Nerio

Coor-Achenbach, Gertrude, 'Contributions to the study of Ugolino di Nerio's art', *Art Bulletin*, XXXVII, 1955, pp. 153–65.

Francis, H.S., 'An altarpiece by Ugolino da Siena', *The Bulletin of the Cleveland Museum of Art*, 48, 1961, pp. 195–203.

Maginnis, Hayden B.J., 'The Thyssen-Bornemisza Ugolino', *Apollo*, CXVIII, 1983, pp. 16–31.

Pope-Hennessy, John, *Heptaptych: Ugolino da Siena*, Stirling and Francine Clark Art Institute, Williamstown, Mass., 1962.

For other attributions to Ugolino see J.H. Stubblebine, *Duccio di Buoninsegna and his School*, Princeton, 1979, pp. 157–82.

Catalogue no. 5
Fragments from the Santa Croce Altarpiece

Boskovits, Miklós, *Katalog der Gemälde: frühe italienische Malerei*, Gemäldegalerie, Berlin, 1987, pp. 162–76.

Cannon, Joanna, 'Simone Martini, the Dominicans and the early Sienese Polyptych', *Journal of the Warburg and Courtauld Institutes*, XLV, 1982, pp. 69–93.

Delsaux, Nicole, Delteil-Ruffat, Florence, and Ausset, Patrick, 'La restauration d'un primitif italien: Ugolino da Siena "Vierge à l'Enfant" ', *Science et technologie de la conservation et de la restauration*, 1, June, 1988, pp. 69–73.

Gardner von Teuffel, Christa, 'The buttressed altarpiece: a forgotten aspect of Tuscan fourteenth-century altarpiece design', *Jahrbuch der Berliner Museen*, 21, 1979, pp. 21–65, especially pp. 48–57; 65.

Gordon, Dillian, and Reeve, Anthony, 'Three newly-acquired panels from the altarpiece for Santa Croce by Ugolino di Nerio', *National Gallery Technical Bulletin*, 8, 1984, pp. 36–52.

Loyrette, H., 'Une source pour la reconstruction du polyptyque d'Ugolino da Siena à Santa Croce', *Paragone*, 343, September, 1978, pp. 15–23.

For proportional systems:

For a discussion of the proportional systems that could have been used in the design, carpentry and assembly of altarpieces see the references listed under 'Preliminary Drawing'.

For dowels:

Amico, Leonard N., 'Reconstructing an early fourteenth century pentaptych by Ugolino di Nerio: St. Catherine finds her niche', *Bulletin, Krannert Art Museum*, V, 1979, pp. 12–30. (Thanks are due to Kenneth Bé of the Cleveland Museum of Art for his assistance and for sending the authors a copy of this article.)

Beatson, Elizabeth H., Muller, Norman E., and Steinhof, Judith B., 'The St. Victor Altarpiece in Siena Cathedral: a reconstruction', *Art Bulletin*, LXVIII, 1986, pp. 610–31, especially pp. 622–5 (for dowels and battens) and note 74.

Fehm, Sherwood A., 'A pair of panels by the Master of Città di Castello and a reconstruction of their original altarpiece', *Yale University Art Gallery Bulletin*, XXXI, 1967, pp. 16–27, especially pp. 24–5.

Muller, Norman E., 'Lorenzettian technical influences in a painting of S. Philip by the Master of Figline', *La pittura nel XIV e XV secolo: il contributo dell' analisi tecnica alla storia dell' arte . . .*; edited by H.W. van Os and J.R.J. van Asperen de Boer, Bologna, 1983, pp. 283–95, especially pp. 284–5.

For colour theory:

Gavel, Jonas, *Colour: a study of its position in the art theory of the quattro- and cinquecento*, Stockholm, 1979, pp. 14–20.

On yellow lake pigments:

Examples of recipes for such pigments will be found in:

Bolognese Manuscript, Merrifield, M.P., 1849, Vol. II, no. 194, pp. 482–5.

De arte illuminandi, Brunello edn., 1975, pp. 50–5; Thompson & Hamilton edn., 1933, p. 6.

For the dyestuffs see the references cited under 'Yellow lake pigments' above, in the section on 'Pigments and Colour', in particular the discussion in Nannizzi, 1939, pp. 46–51.

Nardo and Jacopo di Cione

Borsook, Eve, 'Jacopo di Cione and the guild hall of the Judges and Notaries in Florence', *The Burlington Magazine*, CXXIV, 1982, pp. 86–8.

Offner, Richard, *A critical and historical corpus of Florentine painting*, Section IV, Vol. I, *Andrea di Cione*, New York, 1962.

Offner, Richard, *A critical and historical corpus of Florentine painting*, Section IV, Vol. II, *Nardo di Cione*, New York, 1960.

Offner, Richard, and Steinweg, Klara, *A critical and historical corpus of Florentine painting*, Section IV, Vol. III, *Jacopo di Cione*, New York, 1965.

Steinweg, Klara, *Andrea Orcagna*, Strasburg, 1929.

Valentiner, W.R., 'Orcagna and the Black Death of 1348', *Art Quarterly*, XII, 1949, pp. 48–68. (Sacchetti's story is on p. 48.)

Catalogue no. 6
Nardo di Cione: *Sts John the Baptist with St John the Evangelist(?) and St James*

Gordon, Dillian, Bomford, David, Plesters, Joyce, and Roy, Ashok, 'Nardo di Cione's *Altarpiece: Three Saints*', *National Gallery Technical Bulletin*, 9, 1985, pp. 21–37 (p. 30 for the analysis of the red lake pigment, pp. 32–3 for the darkening of vermilion).

For the representation of brocade patterns and silks in paintings:

Klesse, Brigitte, *Seidenstoffe in der italienischen Tafelmalerei des vierzehnten Jahrhunderts*, Bern, 1967.

For the technique of *sgraffito*:

For comparison with the description given in the text, see the account of the development of the technique in Sienese painting in:

Muller, Norman E., 'The development of sgraffito in Sienese painting', *Simone Martini – Atti del convegno, Siena 27, 28, 29 marzo, 1985*, a cura di Luciano Bellosi, Florence, *c.* 1988, pp. 147–50.

For tooling and punch marks:

Skaug, Erling, 'The Rinuccini Tondo: an 18th. century copy or a 14th. century original?', *Atti del Convegno sul Restauro delle Opere d'Arte, Firenze, 2–7 novembre, 1976*, 2 vols. [I: text; II: illus.], Florence, 1981, Vol. I, pp. 333–9, Vol. II, pp. 571–5.

Skaug, Erling, 'Punch marks: what are they worth? Problems of Tuscan workshop interrelationships in the mid-fourteenth century: the Ovile Master and Giovanni da Milano', in *La pittura nel XIV e XV secolo: il contributo dell' analisi tecnica alla storia dell'arte . . .*; edited by H.W. van Os and J.R.J. van Asperen de Boer, Bologna, 1983, pp. 253–82.

Catalogue no. 7
Attributed to Jacopo di Cione: *The Crucifixion*

Offner, R., and Steinweg, K., 1965, pp. 75–82.

For the use of verdigris in an oil medium for a green glaze, over gold:

Delsaux, Nicole, et al., June 1988, pp. 69–73.

Wyld, Martin, and Plesters, Joyce, 'Some panels from Sassetta's Sansepolcro Altarpiece', *National Gallery Technical Bulletin*, 1, 1977, p. 12.

Catalogue no. 8
Attributed to Jacopo di Cione: *The San Pier Maggiore Altarpiece*

Fava, Monica Bietti, 'San Pier Maggiore: una chiesa scomparsa dalle origini a tutto il trecento.' Unpublished doctoral thesis, Università di Firenze, Florence, 1977–78.

Gronau, H.D., 'The San Pier Maggiore Altarpiece: a reconstruction', *The Burlington Magazine*, LXXXVI, 1945, pp. 139–44.

Offner, Richard, 'A Florentine panel in Providence and a famous Altarpiece', *Studies*, Museum of Art, Rhode Island School of Design, Providence, 1947, pp. 53ff.

Offner, R., and Steinweg, K., 1965, pp. 31–74.

For the geometry and proportions of the altarpiece:

Frankl, Paul, 'The secret of the mediaeval masons; with an explanation of Stornaloco's formula by Erwin Panofsky', *Art Bulletin*, XXVII, 1945, pp. 46–64.

Cämmerer-George, Monika, *Die Rahmung der toskanischen Altarbilder im Trecento*, Strasburg, 1966, plate VIII (and p. 55, referring to Giotto's *Badia Polyptych*).

See also the references on proportional systems and number symbolism listed under 'Preliminary Drawing'.

For examples of varnish recipes:

Bolognese Manuscript, Merrifield, M.P., 1849, Vol. II, nos. 206–7, pp. 488–91; no. 262, pp. 520–3.

For the supposed survival of an egg-white varnish:

Serra, Alfio del, 'A conversation on painting techniques', *The Burlington Magazine*, CXXVII, 1985, pp. 4–16, especially p. 4.

On the use of egg-white varnishes by 18th- and 19th-century restorers:

There are many references both for and against the practice of using egg white varnishes on cleaned pictures from the late 17th century onwards: Paillot de Montabert, for example, writing in 1829, attributes certain types of crack occurring in the paint film to the use of temporary egg-white varnishes, while Tingry, writing in 1803, gives instructions for their preparation and use, repeated in later editions of his book:

Paillot de Montabert, J.N., *Traité complet de la peinture*, 9 vols., Paris, 1929; Vol. IX, chap. 622, p. 699.

Tingry, P.F., *The painter and varnisher's guide*, 2nd edn., London, 1816, chap. III, pp. 70–1.

See also, for example:

Lucanus, Fr.G.H., *Vollständige Anleitung zur Erhaltung, Reinigung und Wiederherstellung der Gemälde . . .*, Halberstadt, 1842, part 2, p. 30 (against the use of egg-white varnishes).

Piles, Roger de, *Élémens de peinture pratique*; new edn., revised by Charles-Antoine Jombert, Amsterdam, Leipzig, Paris, 1776, chap. VII, pp. 174; 176 (recommending their use).

Sanderson, William, *Graphice: the use of the pen and pencil, or, the most excellent art of painting*, London, 1658, p. 86 (against the practice).

The excellency of the pen and pencil, London, 1668, p. 106 (in favour of the practice).

For the identification, and subsequent removal, of a non-original egg-white varnish:

Allden, Mary, and Beresford, Richard, 'Two altar-pieces by Philippe de Champaigne: their history and technique', *The Burlington Magazine*, CXXXI, June 1989, pp. 395–406, especially p. 405.

For pattern books and model books of drawings:

Ames-Lewis, Francis, *Drawing in early Renaissance Italy*, New Haven and London, 1981, pp. 14, 63–4, 79–80.

For the reference to Tuccio di Vanni in the documents:

Cocchi, Arnaldo, *Le chiese di Firenze dal secolo IV al secolo XX*, Vol. I, *Quartiere di San Giovanni*, Florence, 1903, pp. 97–105 (on San Pier Maggiore), especially p. 100.

For Matteo di Pacino:

Boskovits, Miklós, *Katalog der Gemälde: frühe italienische Malerei*, Gemäldegalerie, Berlin, 1987, pp. 112–13.

Scientific investigation of 14th-century Italian easel paintings and related topics:

This section includes a selection of reports of the examination of paintings dating from the 14th century or thereabouts, not referred to above. Most of the reports give some account of scientific examination of the paint film or panel, or discuss an aspect of the method of painting. Certain early accounts and reports describing conservation treatment only have been excluded from this list, except for those having some bearing on material discussed in the catalogue.

Accounts based on Cennino Cennini's *Il libro dell'arte*:

Bensi, Paolo, 'La tavolozza di Cennino Cennini', *Studi di storia delle arti*, 1978–9, pp. 37–85.

Muller, Norman E., 'Three methods of modelling the Virgin's mantle in early Italian painting', *Journal of the American Institute for Conservation*, 17, 2, 1978, pp. 10–18.

Nikolaus, Knut, 'Untersuchungen zur italienischen Tafelmalerei des 14. und 15. Jahrhunderts', *Maltechnik-Restauro*, 79, 1973, pp. 142–92; 239–48.

See also the paper by Gordon and others, 1985, referred to under Cat. no. 6.

General accounts including some relevant material:

Comprendre, sauver, restaurer: la campagne de restauration des primitifs italiens du Musée du Petit Palais, 1966–76 [Exhibition catalogue, compiled by Ségolène Bergéon and Elisabeth Mognetti], Avignon, 1976.

Delbourgo, Suzy, 'Application of the electron microprobe to the study of some Italian paintings of the fourteenth to the sixteenth century', *Conservation and Restoration of Pictorial Art . . .*; edited by Norman Brommelle and Perry Smith, London, 1976, pp. 27–35.

Gay, Marie Christine, 'Application of the staining method to the cross-sections in the study of media of various Italian paintings of the fourteenth and fifteenth centuries', *Conservation and Restoration of Pictorial Art . . .*; edited by Norman Brommelle and Perry Smith, London, 1976, pp. 78–83.

Metodo e scienza: operatività e ricerche nel restauro; edited by Umberto Baldini [Catalogue of an exhibition held in the Palazzo Vecchio, Florence, 23 June 1982–6 January 1983], Florence, 1982. Includes brief accounts of work on two mid- to late 13th-century panel paintings.

Investigation of individual paintings:

Baldini, Umberto, and Casazza, Ornella, *The Cimabue Crucifix*: published in conjunction with the exhibition of the restored Crucifix at the Royal Academy, London, 12 February–4 April 1983. On the restoration of the Cimabue *Crucifixion*, Santa Croce, Florence. There are many other accounts of this restoration (see above under 'Panel Construction', for example) and specifically of the method of in-painting used, based on digital image processing. One account of this method is included as an example:

Casazza, Ornella, and Franchi, Paolo, 'Art for the ages', *Perspectives in computing*, 5, 1, 1985, pp. 4–13.

See also Brink, J., 1978, cited above under 'Preliminary Drawing'.

Goist, David C., Riggs, Ann Keck-Henderson, and Hessling, Janet W., 'Study of an early Italian triptych', *The International Journal of Museum Management and Curatorship*, 7, 1988, pp. 165–72.

Hoenigswald, Ann, 'The "Byzantine" Madonnas: technical investigation', *Studies in the History of Art*, 12, 1982, pp. 25–31. See also the article by Hans Belting, pp. 7–22, on the Italian origin of these paintings, the Kahn *Madonna* and the Mellon *Madonna*, dated *c.* 1280, in the National Gallery of Art, Washington.

Muller, Norman E., 'Ambrogio Lorenzetti's *Annunciation*: a re-examination', *Mitteilungen des Kunsthistorischen Institutes in Florenz*, XXI, 1977, pp. 1–12.

Rinuy, Anne, and Schweizer, François, 'A propos d'une peinture florentine de Trecento: une contribution à la définition de critères d'authenticité', *Genava*, XXXIV, 1986, pp. 95–112. On Jacopo del Casentino's *Madonna and Child*, Musée d'Art et d'Histoire, Geneva, dated *c.* 1340–50 (part of a triptych). See also:

Bosshard, Emil D., 'Malt ein Florentiner Meister des 14. Jahrhunderts auf eine verwurmte Holztafel?', *Maltechnik-Restauro*, 93, 4, 1987, p. 50.

White, John, 'The reconstruction of the polyptych ascribed to Guariento in the collection of the Norton Simon Foundation', *The Burlington Magazine*, CXVII, 1975, pp. 517–26, especially pp. 517–18 on the backs of the panels.

Wolters, Christian, 'A Tuscan Madonna of *c.* 1260: technique and conservation', *Studies in Conservation*, 2, 1955, pp. 87–96.

Appendix 4: Tables, and other miscellaneous references

i) Table of Pigment Prices

Borsook, Eve, 'Jacopo di Cione and the guild hall of the Judges and Notaries in Florence', *The Burlington Magazine*, CXXIV, 1982, pp. 86–8.

Ciampi, Sebastiano, *Notizie inedite della Sagrestia pistoiese de' belli arredi del Campo Santo pisano . . .*, Florence, 1810, document XXIX, pp. 145–50.

Fehm, Sherwood A., *Luca di Tommè: a Sienese fourteenth-century painter*, Carbondale and Edwardsville, 1986, documents, pp. 191–204.

Ladis, Andrew, *Taddeo Gaddi: critical reappraisal and catalogue raisonné*, Columbia and London, 1982, documents, pp. 253–63.

Mazzei, Lapo, *Ser Lapo Mazzei: lettere di un notaro a un mercante del secolo XIV . . .*, per cura di Cesare Guasti, Florence, 1880, Vol. II, Appendix II, pp. 383–414.

Offner, Richard, and Steinweg, Klara, *A critical and historical corpus of Florentine painting*, Section IV, Vol. III, *Jacopo di Cione*, Florence, 1965, p. 42.

Piattoli, Renato, 'Un mercante del Trecento e gli artisti del tempo suo' [2nd article: documents], *Rivista d'Arte*, XI, 1929, pp. 433–4.

Poggi, Giovanni, 'La Cappella del Sacro Cingolo nel Duomo di Prato e gli affreschi di Agnolo Gaddi', *Rivista d'Arte*, XIV, 1932, documents 1385–96, pp. 355–76.

Wilkins, David G., *Maso di Banco: a Florentine artist of the early Trecento*, New York and London, 1985, doc. 5, pp. 119–20.

ii) Weights and measures

Alexander, J.H., *Universal dictionary of weights and measures, ancient and modern, reduced to the standards of the United States of America*, Baltimore, 1850. (Arranged alphabetically.)

Balducci Pegolotti, Francesco, *La pratica della mercatura*; edited by Allan Evans, Cambridge, Mass., 1936, pp. 190–203. Probably compiled around 1339–40, although some of the information given may date from an earlier period. He refers to the silver *grosso* being minted (p. 192) although Spufford (cited below, p. xxiv) writes that it was withdrawn from circulation in 1296. See p. 191 for the *metadella*; p. 197 for a comparison of Florentine and Sienese pounds (100 Florentine = 103 Sienese).

CRC Handbook of Chemistry and Physics, 68th edn., Boca Raton, 1987; for conversion factors, pp. F.294–307.

Finiello Zervas, Diane, 'The Florentine *braccio da panna*', *Architectura*, IX, 1979, pp. 6–10.

Finiello Zervas, Diane, 'The *trattato dell'abbaco* and Andrea Pisano's design for the Florentine Baptistry doors', *Renaissance Quarterly*, XXVIII, 1975, p. 491, note 24.

Martini, Angelo, *Manuale di metrologia ossia misure, pesi e monete in uso attualmente e anticamente presso tutti i popolo*, Turin, 1883, pp. 206–8.

Merrifield, Mary P., *Original treatises dating from the XIIth. to the XVIIIth. centuries on the arts of painting*, London, 1849, Vol. II, pp. 896–8.

Spufford, Peter, Wilkinson, Wendy, and Tolley, Sarah, *Handbook of medieval exchange*, London, 1986; introduction and pp. 1–58.

See also: Cipolla, Carlo M., *Studi di storia della moneta, I: I movimenti dei cambi in Italia dal secolo XIII al XV*, Pavia, 1948, pp. 56–62; 132–214.

White, John, *Duccio: Tuscan art and the medieval workshop*, London, 1979, p. 36 and note 26, p. 177.

Dictionaries:

Battaglia, Salvatore, *Grande dizionario delle lingua italiana*, Turin, 1961– (in progress).

Battisti, Carlo, and Alessio, Giovanni, *Dizionario etimologico italiano*, 5 vols., Florence, 1950–7.

Photographic Credits

Assisi, San Francesco (Treasury): Plates 41 and 42, Crucifix, Attributed to the Blue Crucifix Master.

Barnard Castle, Bowes Museum: Plate 3 Sassetta, *The Miracle of the Eucharist*, 36.7×40.6 cm.

Berlin, Gemäldegalerie: Figs. 63 and 68 Ugolino di Nerio, X-radiographs.

Boston, Courtesy, Museum of Fine Arts: Plates 87 and 88 Duccio, *Crucifixion with Sts Nicholas and Gregory*, centre panel 60.8×39.3, wings 45.3×19.5 cm.

Florence, Archivi Alinari: Fig. 1 Jacopo di Cione, *Madonna dell'Umiltà*. 104×64 cm, Florence, Accademia; Fig. 12 Taddeo Gaddi, Polyptych, 215×245 cm, Pistoia, San Giovanni Fuorcivitas; Fig. 61 Interior of Santa Croce, Florence; Fig. 80 Duccio, *Deposition*, Siena, Museo dell' Opera del Duomo; Fig. 83 Nardo di Cione *Paradise*, Florence, Santa Maria Novella; Fig. 89 Nardo di Cione, *The Trinity with Sts Romuald and John the Evangelist*, 292×212 cm, Florence, Accademia; Fig. 121 Pietro Nelli and Tommaso del Mazza(?), *The Virgin and Child Enthroned with Saints and Angels and Scenes from the Lives of the Virgin and Joseph*, Impruneta, Collegiata di Santa Maria.

Florence, Foto Scala Plate 1 Pietro

Lorenzetti, Polyptych, Arezzo, Santa Maria della Pieve; Plate 2 St Francis Master, *The Verification of the Stigmata*, Assisi, Upper Church of San Francesco; Plate 5 Duccio, *The Maestà: Virgin Enthroned with Saints and Angels*, 212×425 cm, Siena, Museo dell'Opera del Duomo; Plate 6 Duccio, *The Rucellai Madonna*, 450×292 cm, Florence, Uffizi; Plate 8 Ambrogio Lorenzetti, *Allegory of Good Government*, fresco, Siena, Palazzo Pubblico, Sala 'dei Nove'; Plate 9 Giotto, Crucifix, Florence, Santa Maria Novella; Plate 10 St Francis Master, *The Christmas Crib at Greccio*, Assisi, Upper Church of San Francesco; Plate 40 St Francis Master, *Crucifix talking to St Francis*, fresco, Assisi, Upper Church of San Francesco; Plate 49 Giotto, *The Entombment*, Settignano, I Tatti, Berenson Collection; Plate 114 Andrea di Cione (Orcagna), The Strozzi Altarpiece, 160×296 cm, Florence, Santa Maria Novella, Strozzi Chapel; Plate 170 Jacopo di Cione, *The Coronation of the Virgin*, 350×190 cm, Florence, Accademia; Plate 171 Andrea and Jacopo di Cione, *St Matthew Triptych*, 291×265 cm, Florence, Uffizi.

Graz, Photo: Akademische Druck und Verlagsanstalt: Plate 19 *Tacuinum sanitatis*, Codex Vindobinensis Vienna, Nationalbibliothek.

Hall, Dr Allan, Environmental Archaeology Unit, University of York: Plate 33 Weld (*Reseda Luteola*).

Munich, Artothek: Plate 49 Giotto, *The Last Supper, The Crucifixion* and *The Descent into Limbo*, Munich, Alte Pinakothek.

New York, Copyright © 1989 by the Metropolitan Museum of Art: Plate 49 Giotto: *The Nativity with the Epiphany*.

Paris, Photo: Bibliothèque Nationale: Plate 7 Ms.12.420 fol. 86.

Paris, © Réunion des Musées Nationaux: Plate 39 Master of St Francis, Crucifix, 96.5×73 cm; Plate 105 Ugolino di Nerio, *Virgin and Child* (detail), Paris, Musée du Louvre.

Perugia, Galleria Nazionale dell'Umbria: Figs. 26 and 27 Workshop of the Master of St Francis, Crucifix, front and back.

Siena, Foto SBAS: Plate 63 and Fig. 42 Circle of Guido da Siena, *The Annunciation* (detail) and *St Peter Enthroned, with Four Stories from his Life*, Siena, Pinacoteca Nazionale.

Skaug, Erling: Fig. 81 Punchmarks adapted from drawings; Fig. 96 Photographs of details of punchmarks.

Index of Painters and Paintings